extraordinary leaves

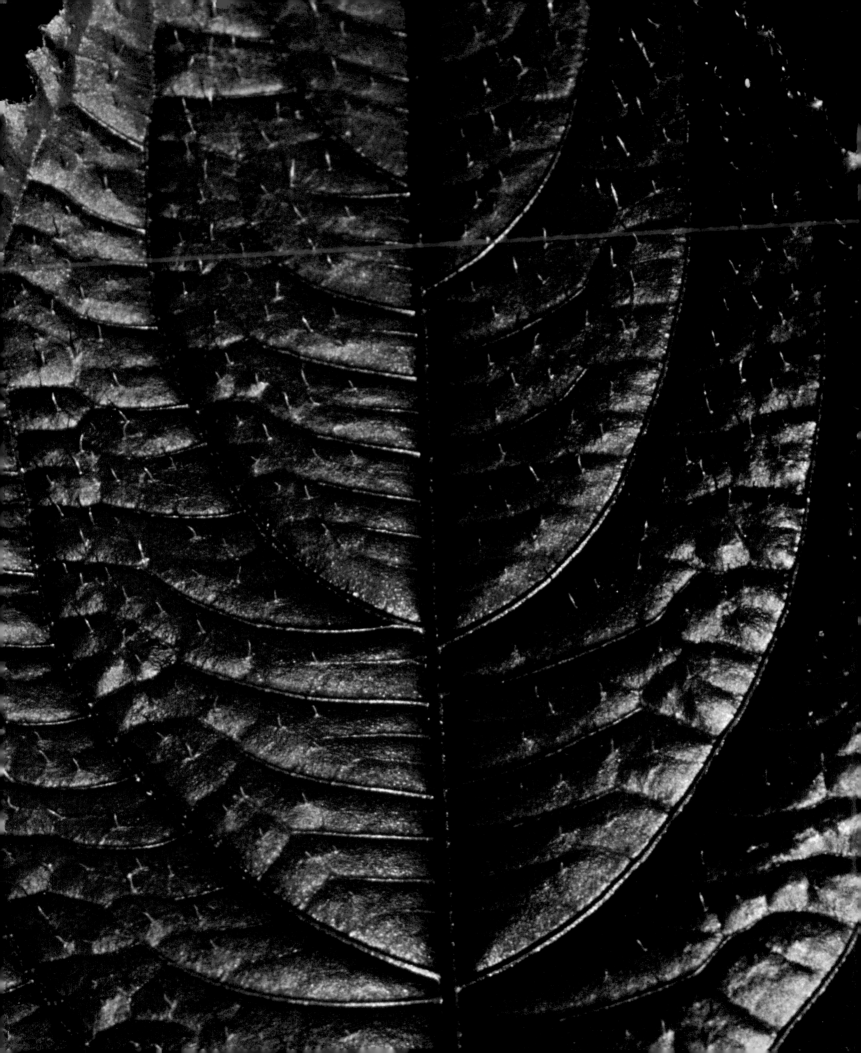

extraordinary leaves

photographs by Stephen Green-Armytage text by Dennis Schrader

A FIREFLY BOOK

Published by Firefly Books Ltd. 2008

First printing

Publisher Cataloging-in-Publication Data (U.S.)
Green-Armytage, Stephen.
 Extraordinary leaves / photographs by Stephen Green-Armytage; text by Dennis Schrader.
[272] p. : col. photos. ; cm.
Includes index.
Summary: A personal guide to a botanist's world, with color photographs that capture the beauty of foliage in such categories as color, shape, texture and pattern.
ISBN-13: 978-1-55407-387-0
ISBN-10: 1-55407-387-1
1. Leaves – Pictorial works. 2. Photography of leaves.
I. Green-Armytage, Stephen. II. Title.
779/.34092 dc22 TR726.L42G5336 2008

Library and Archives Canada Cataloguing in Publication
Green-Armytage, Stephen
 Extraordinary leaves / text by Dennis Schrader ; photographs by Stephen Green-Armytage.
ISBN-13: 978-1-55407-387-0
ISBN-10: 1-55407-387-1
1. Leaves. 2. Leaves—Pictorial works. I. Green-Armytage, Stephen II. Title.
QK649.G74 2008 581.4'8 C2008-900832-4

Published in the United States by
Firefly Books (U.S.) Inc.
P.O. Box 1338, Ellicott Station
Buffalo, New York 14205

Published in Canada by
Firefly Books Ltd.
66 Leek Crescent
Richmond Hill, Ontario L4B 1H1

Cover and interior design by Sonya V. Thursby, Opus House Incorporated

The publisher gratefully acknowledges the financial support for our publishing program by the Government of Canada through the Book Publishing Industry Development Program.

Printed in China

Page 6 Japanese Maple *(Acer japonica)* >
< Page 2 Persian Shield *(Strobilanthes dyeranus 'Persian Shield')*
Page 8 Begonia Escargot *(Begonia rex 'Escargot')* >

contents

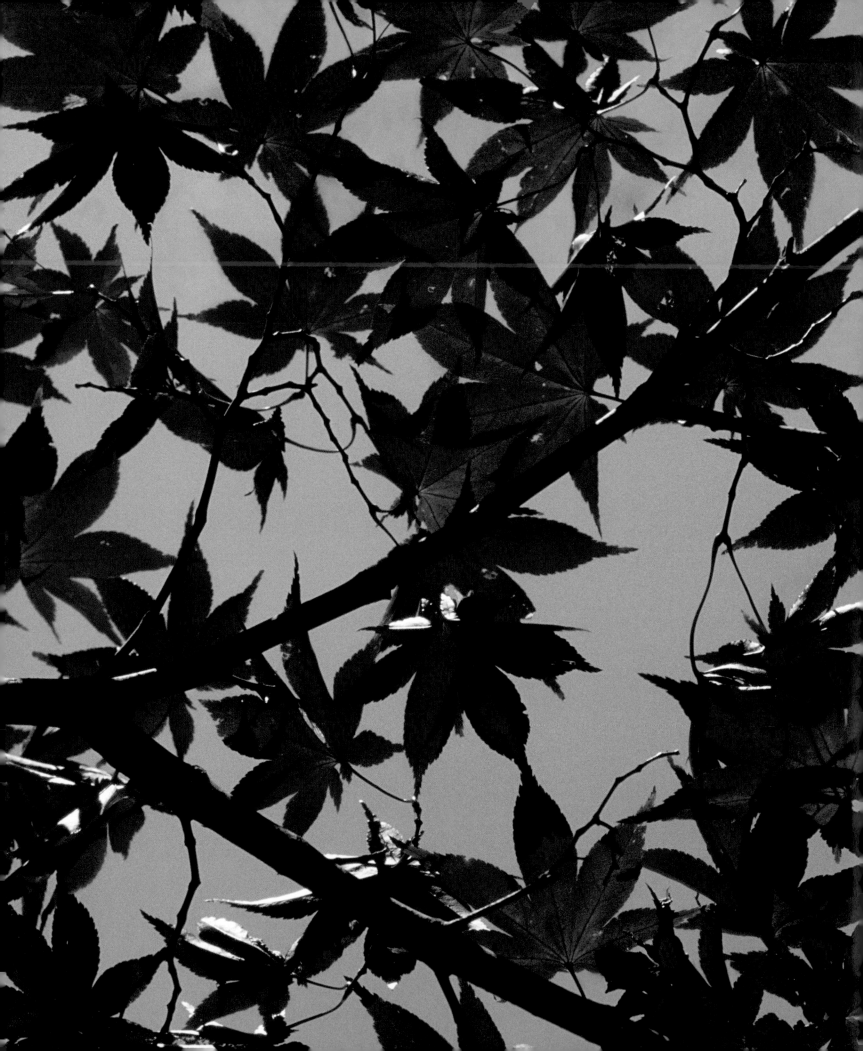

Stephen Green-Armytage

MY EYES WERE OPENED to the potential of foliage as a book subject when I visited a nursery near Cleveland, Ohio. While my wife and a friend were shopping for some specific plants, I wandered into some greenhouses and saw row upon row of Coleus, Caladium, Heuchera and more. I had always liked the shapes of certain leaves, but until then I had not properly registered that some leaves were not only wildly colorful, but also had beautiful patterns. In addition, there seemed to be several hundred of them in this one nursery alone.

As I explored the greenhouses in Ohio, I very soon had the idea there should be a well-illustrated book that displayed these wonderful plants. My next thought was that I would like to take the photographs for such a book. I became curious to know if it had already been done — it seemed to be a subject crying out for a handsome volume. In my research I found books that were instructional or scientific rather than being celebrations of the beauty of leaves. There are fine pictorial volumes displaying flowers such as orchids and roses, but not leaves. Much later we did find a book that had a similar agenda to this one, but it was published decades ago and was long out of print. Some of the pictures were very handsome, but others were rather dull, and the printing quality and layout design were well below today's standards.

For my previous books, I had done the research and writing myself, but I never considered doing so in this case. The subject was clearly far too large for me. A friend of a friend put me in touch with Dennis Schrader. Dennis has an academic background in botany, horticulture and landscape design, and now owns and operates a marvelous nursery that breeds and nurtures a large number of exotic plants. In addition, he is a well-respected author and lecturer, and has been seen frequently on television, giving practical advice as well as information that is as interesting to casual gardeners as it is to professionals.

We have not set out to do an encyclopedic book, but have concentrated on leaves that are beautiful and interesting. Knowledgeable readers may look through the book and wonder why some of their own favorites have not been included. As I was introduced to more and more plants, I found that even a large book like this could not include all of my own favorites, let alone all of the other leaves suggested by professionals.

At an early stage I decided not to photograph palms. Although their fronds are their leaf elements, the individual fronds are not particularly photogenic. (I made an exception for the Fishtail Palm, since instead of fronds it has neat rows of small triangular leaves.) Similarly I ignored succulents, cactus plants, needles and grasses, although a few broad-leaved grasses may have slipped in.

By chance, the cultivation of ornamental foliage is becoming increasingly popular. I had not set out to be a cheerleader for this growing trend, but am glad that more and more people are aware of the decorative potential of foliage. I am seeing increasing numbers of handsome leaves in private and public gardens, in window boxes and in street planters. While we will always love the seasonal appearance of flowers like tulips and chrysanthemums, it is great to have beauty that endures for many months, and in some cases even year round in mild climates and indoors.

Our acknowledgments will show how many people helped to make it all possible. I particularly appreciated the experts who entered into the spirit of what I was doing, drawing my attention to plants I might have overlooked and communicating their own enthusiasm for beautiful leaves. I hope they will be pleased with the book, proud of their contributions and feel I have done justice to the subject. At the same time, I hope that readers who had never given much thought to leaves will now be appreciating them with fresh eyes.

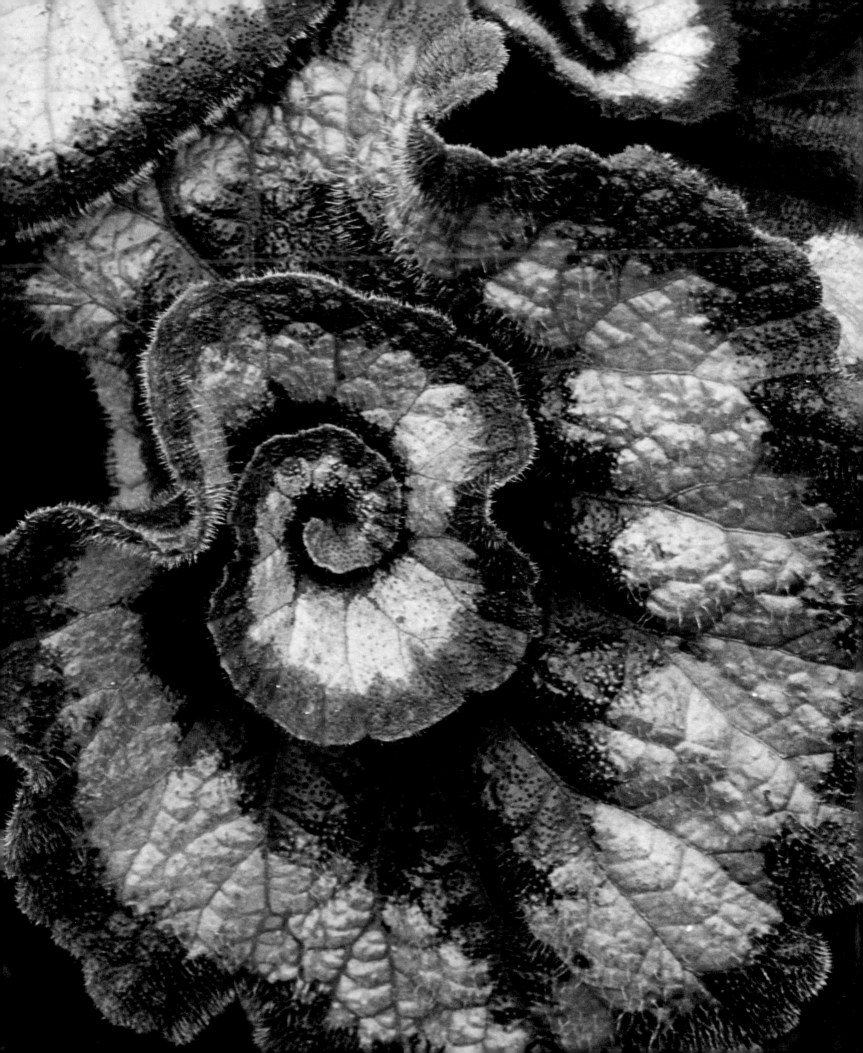

Dennis Schrader

I HAVE BEEN INTERESTED in plants as far back as I can remember. For some reason I always gravitated toward the rare, exotic and hard-to-grow plants. The ones with green leaves were okay … but add a stripe of white or a hint of red or yellow and my pulse would quicken. But, as every type of collector realizes later on in their obsession, you can't have it all. The same thing is true for plant collecting.

When we started our wholesale greenhouse business, we had 17 acres of land and planned one 30' x 100' greenhouse. Once the greenhouse was built, it seemed so huge that we wondered how in the world we would ever fill it. Within days the greenhouse was overflowing with just the collection. Hardly any space was left over for growing plants. We had to make some tough choices in order to commandeer a production area. Soon we were building more greenhouses and filling them as quickly as they were completed. Sixteen years and three acres of growing space later, I still have an intense appreciation for exotic plants, especially those with colorful foliage.

My first book touched on all subjects dealing with growing non-hardy plants in temperate gardens as well as interesting hardy plants that portray a "tropical style." The majority of foliage plants mentioned in that book are colorful — sometimes outlandishly so. While working on *Extraordinary Leaves*, however, I gained a new appreciation for all leaves, not just the peacocks of the plant world but the sparrows as well.

When Stephen first contacted me and asked to come to Landcraft to photograph some leaves (a request we get many times a year), I agreed, thinking it would be a brief business acquaintance of a few days. I had come across one of Stephen's previous books, and enjoyed the photographs immensely. On subsequent visits we developed a friendship and mutual respect, and made plans to collaborate on *Extraordinary Leaves*. I found it interesting to work with a non-horticultural person. Stephen had a different way of looking at things. He would often gravitate to the simplest solid green leaf and see its interesting vein pattern. Initially I was unimpressed. But on closer examination of a leaf he may have picked from our fields — or even the most humble of weeds that he pulled out of a crack in the pavement — the details of shape, venation or texture would surprise me and give me a deeper appreciation for his vision. The subtle details, characteristics and intricacies of simple leaves are indeed astonishing, and with the addition of some color, a few well-placed indentations or possibly some thorns or hairs, a leaf morphs into an entirely different thing. These are the leaves we love … and through the process of working on this book, my fascination with leaves has once again peaked. Recently, I have been adding to our collection; plants that I have known about for some time but had overlooked have grabbed my attention anew. *Sarrancenia*, *Nepenthes*, hundreds of *Caladium* hybrids and some new species of *Amorphophallus* and *Alocasia* have all found new homes in our greenhouses.

Writing this book has been a pleasurable learning process as well. I have greatly enjoyed researching the plants, finding out their stories, interpreting data and adding my own personal experiences, and then compiling the information in a way that would complement Stephen's images. I have also had an excellent motivation to take a deeper, more intimate look at all aspects of leaves, their many uses, their place in history, the science behind what's going on in a leaf, and the unadulterated, simple beauty of the leaf itself. And I hope that looking through these pages will lead you to a new-found appreciation as well.

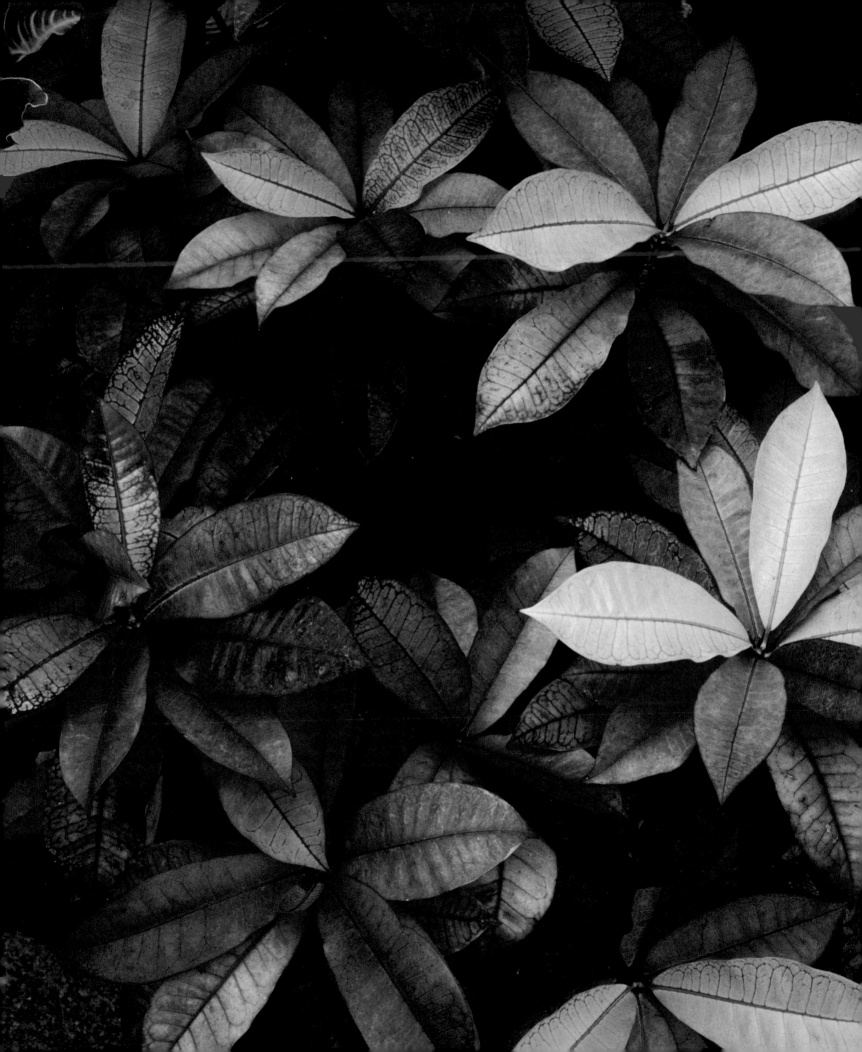

color

THE OBVIOUS COLOR that comes to mind when we think of leaves or foliage is basic green. Green is a soothing color, creating a calming effect. Its very mention brings to mind lush rolling meadows, the emerald sweep of a well-maintained lawn or the endless green of a tropical rain forest. Green can be interpreted as non-committed; it has no agenda and it does not scream, "Look at me!" as some other colors do. Many people may look at a meadow or forest of green leaves and think it ordinary and uniform in color, only to find on closer inspection that it's actually made up of many colors.

Leaves are painted many shades of green, from the dark, almost black-green of leaves hidden in shadow to the pale yellow or almost white leaves that have sunshine drumming down on them. Blended together, they create an overall effect of solid green. When leaves are positioned horizontally, their top and bottom surfaces are quite often different shades; the top surface is always darker thanks to an abundance of chlorophyll. Vertically oriented leaves are usually the same color on both sides.

In a landscape, green is the perfect background to highlight other colors; a solid green garden would have to rely heavily on structure and texture to pull it together and make it work. Green is a great unifier as well — consider the way a boxwood (*Buxus* sp.) hedge outlines and ties together gardens of many colors, shapes and sizes. Gardening with colors is a challenge — add the wrong hue or shade into a perennial flower border and it becomes a disaster. The same goes for foliage color. Using colorful leaves opens up the horticultural pallet since leaf color can be played off of flower color as well as other foliage color.

Colorful leaves are the ones that stand out and say, "Here I am." They do it for a number of different reasons. One is attraction. It is not only humans that are attracted to colorful leaves; insects, birds and animals all recognize colorful leaves or at least shades of a color. Some of the colors are saying, "Come and have a bite to eat (and while you're here, collect some pollen or seeds and scatter them around)." Other colorful leaves are saying, "Warning! I am poisonous. Eat, touch or mess with me at your own risk!" Some insects can only see specific colors and are drawn to plants for a particular reason, usually having to do with procreation.

The meanings and associations of colors are very often transposed onto leaves.

Brighter, hotter colors like red, orange and yellow are saying something like, "Caution, stop, beware!" A sea of green beckons to be entered and grazed upon. Some innocent-looking leaves are designed to attract unsuspecting prey. They may look fresh, plump and ready to eat but hide their true nature; some contain an irritating or potentially deadly toxin, or are fashioned in a certain way in order to trap and digest their life-sustaining prey. The 'Black Walnut' tree (*Juglans nigra*) has foliage that looks harmless enough but secretes the compound juglone, which suppresses or even kills many types of plants trying to grow beneath it.

A leaf's age can be a factor in its color. Some leaves live on for many years, remaining bright and crisp, but most leaves have a predetermined life span and inevitably fade and die off, turning into compost and replenishing the soil. In temperate regions where autumn comes into play, there is an entirely different set of rules regarding color. At season's end, foliage displays are intensified by cool weather, as their green is transformed to vibrant yellows, oranges and reds.

Some plants are bred specifically for their colorful foliage. Coral bells, or alum root (*Heuchera* sp.), have gone through tremendous amounts of hybridization, with almost 50 species native to North America. Most wild Heuchera have rather plain mid-green leaves, but hundreds of recent introductions have far more exciting leaf colors ranging from deep purple-black, to red, pumpkin, lime and silver, with all combinations of intricate venation. Tropical and tender plants such as *Acalypha, Alternanthera, Begonias, Caladium, Coleus, Croton, Canna, Ipomoea* and fancy-leaved *Geranium* are just a few of the spectacular tender plants grown for foliage color.

Almost all hardy perennials, trees and shrubs have cultivated varieties that are flamboyant members of the family. The variegated, *aura* (golden yellow) or *atropurpurea* (deep burgundy red) selections are considerably more colorful and exciting then most of the species they originated from. Breeders are constantly introducing new plants sporting wildly colored leaves; tens of thousands of new colorful foliage plants have been brought to the market, spreading new genetic material around the world. Michael Pollan, author of *Botany of Desire*, asks an interesting question: "Are we using the plants to get what we want or are the plants using us?"

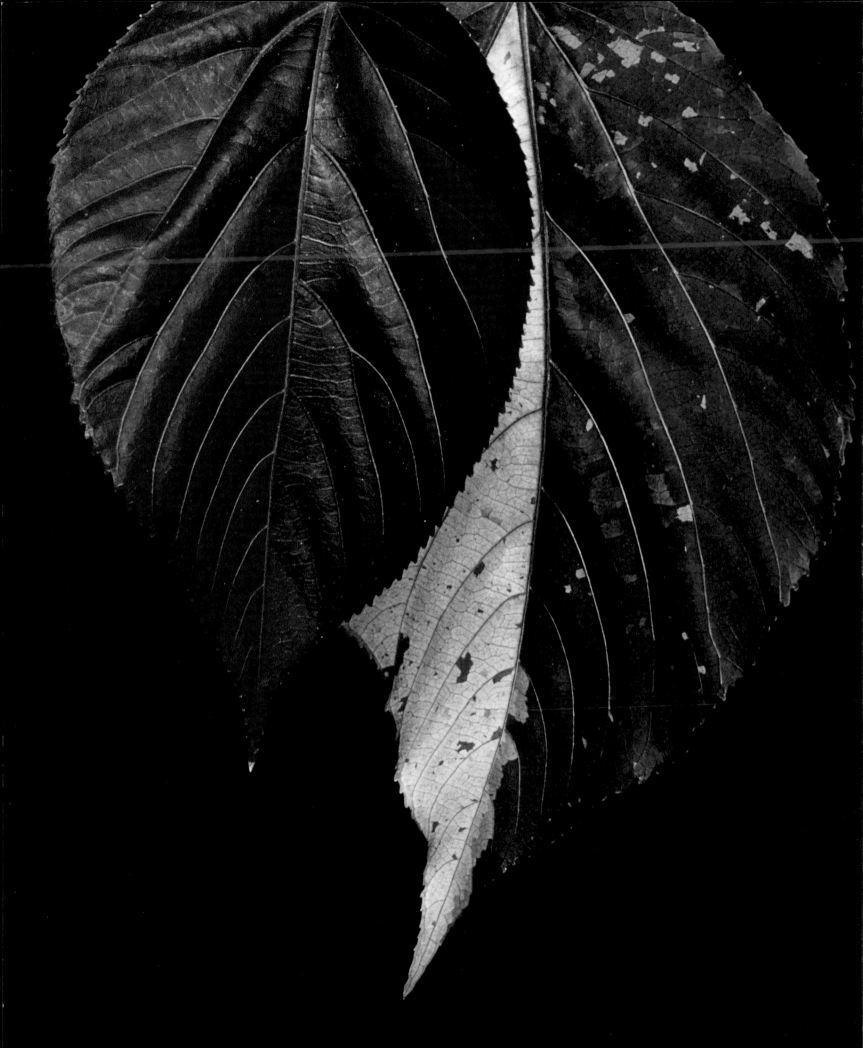

< Giant Leaf Acalypha *(Acalypha wilkesiana 'Miltoniana')*

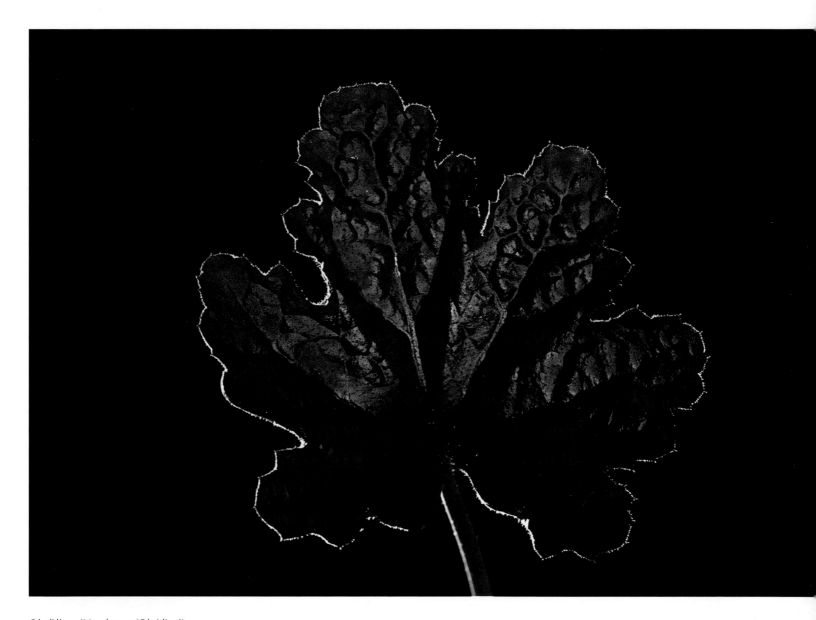

Obsidian *(Heuchera x 'Obsidian')*

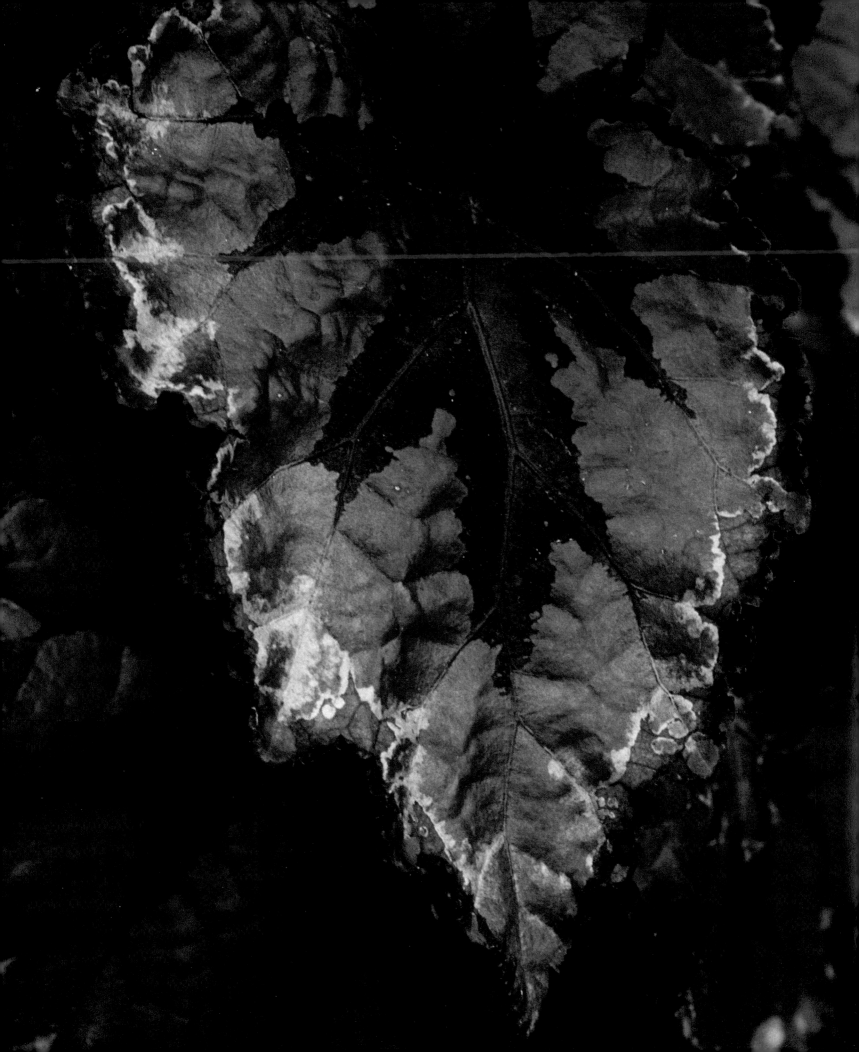

< Begonia Omaha Beefsteak *(Begonia rex 'Omaha Beefsteak')*

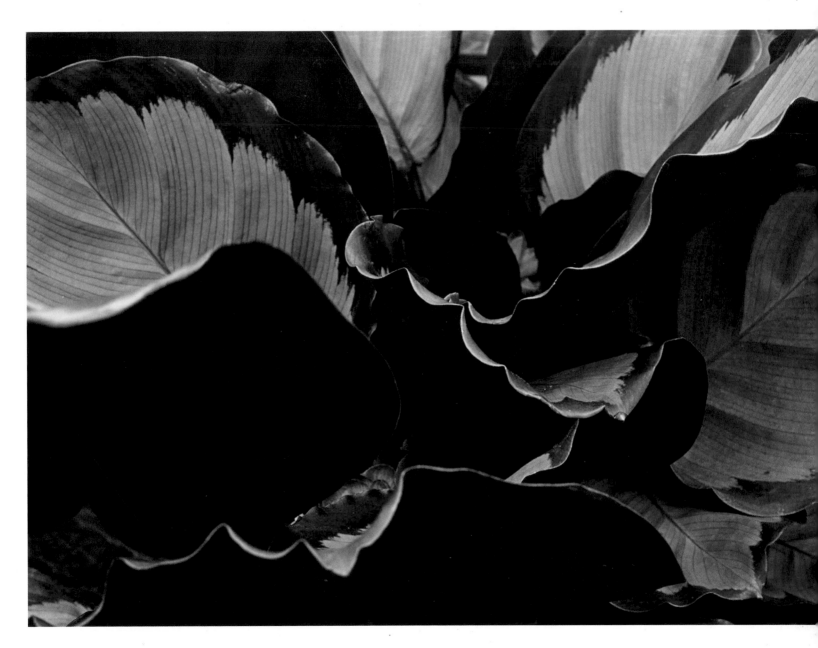

Corona Prayer Plant *(Calathea 'Corona')*

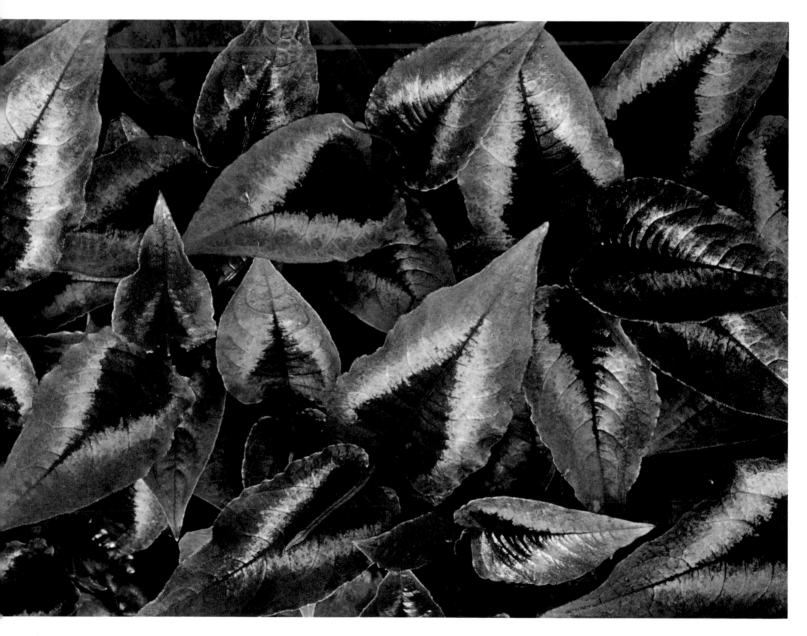

Knotweed *(Persicaria microcephala 'Dragon's Eye')*

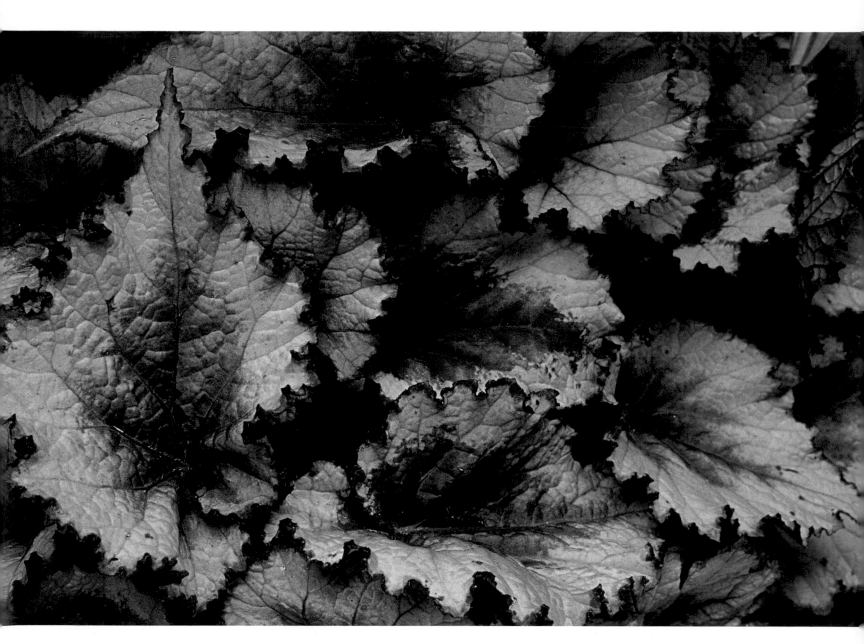

Begonia Large Celia (*Begonia rex 'Large Celia'*)

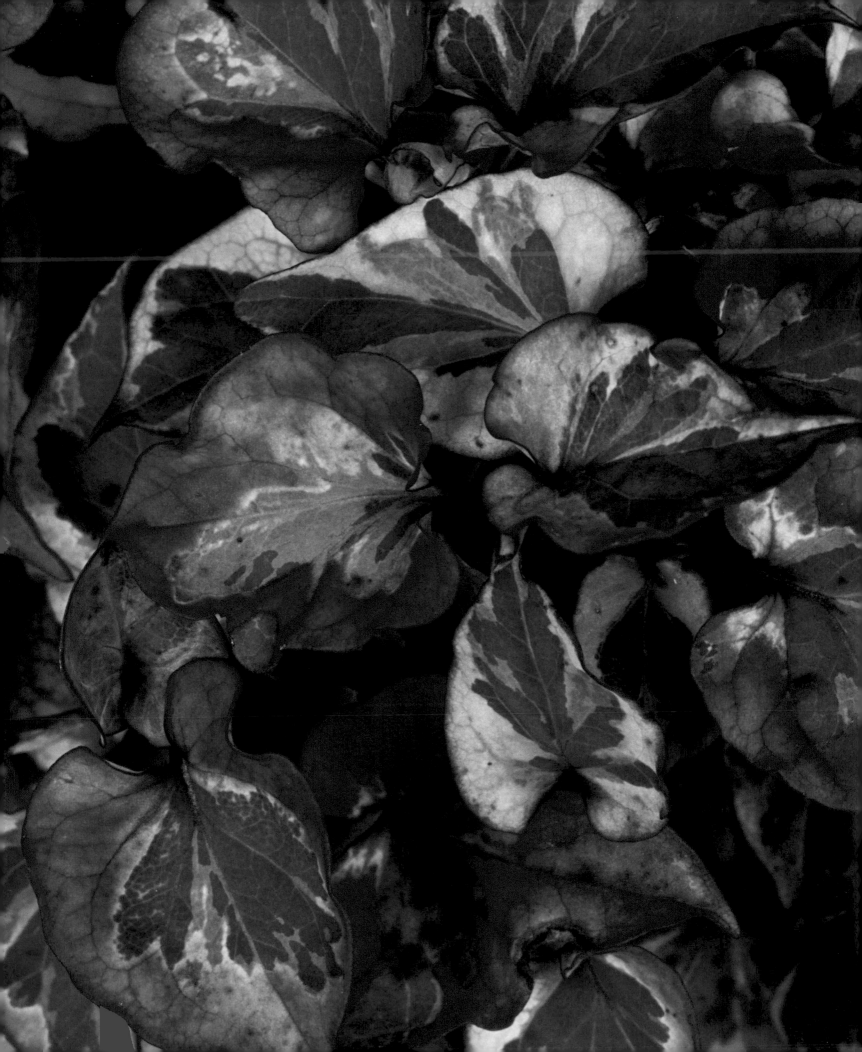

< Chameleon Plant *(Houttuynia cordata 'Chameleon')*

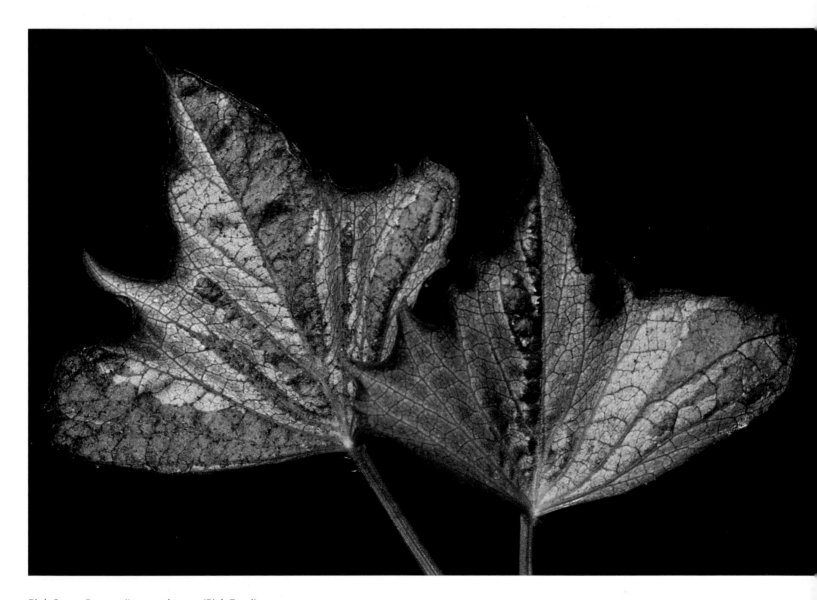

Pink Sweet Potato *(Ipomoea batatas 'Pink Frost')*

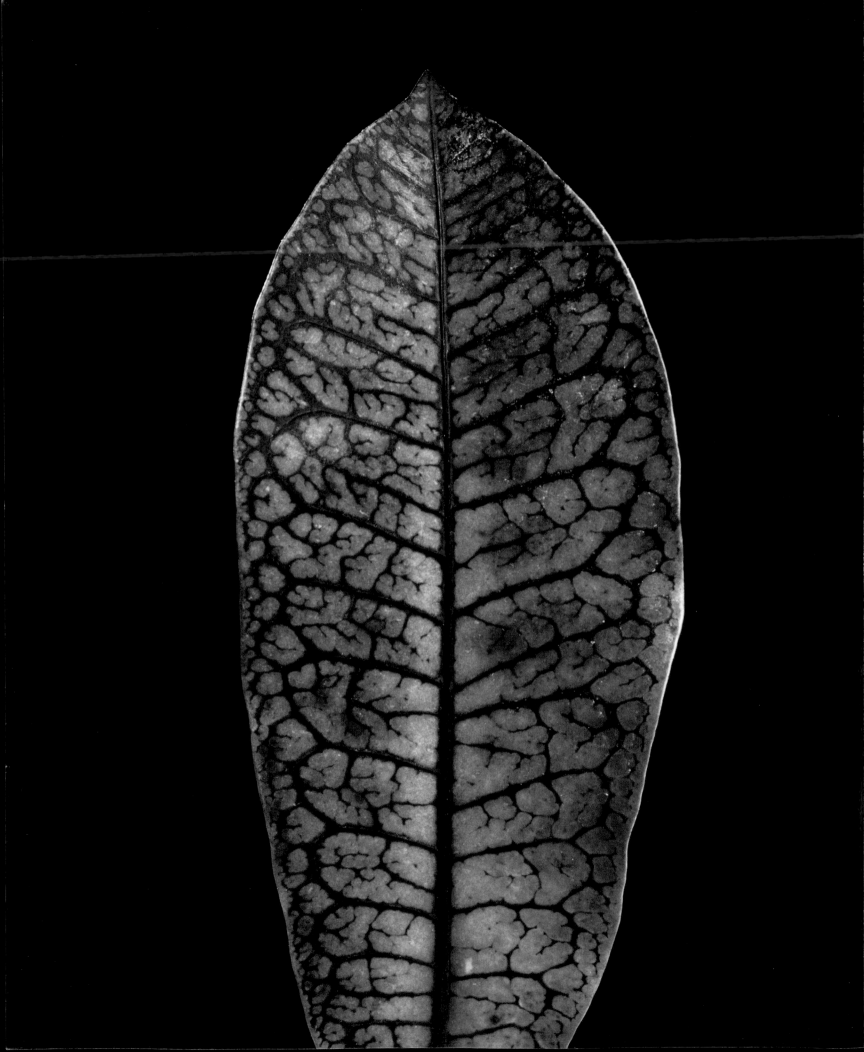

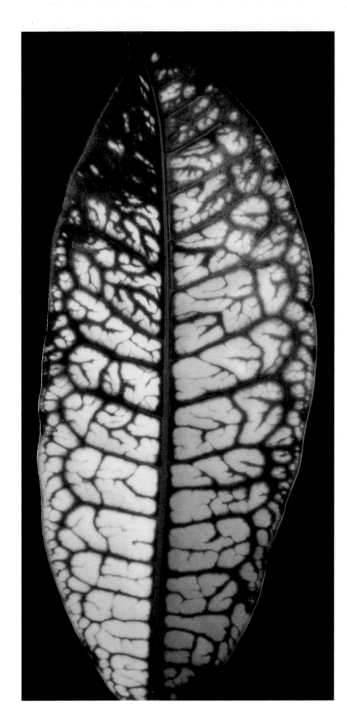
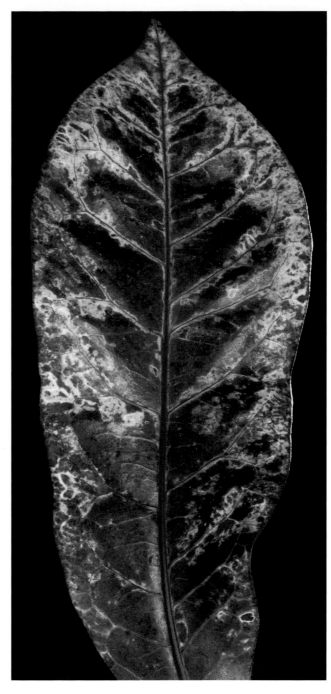

Croton *(Codiaeum variegatum)*

Flowering Maple *(Abutilon hybrid 'Paisley')*

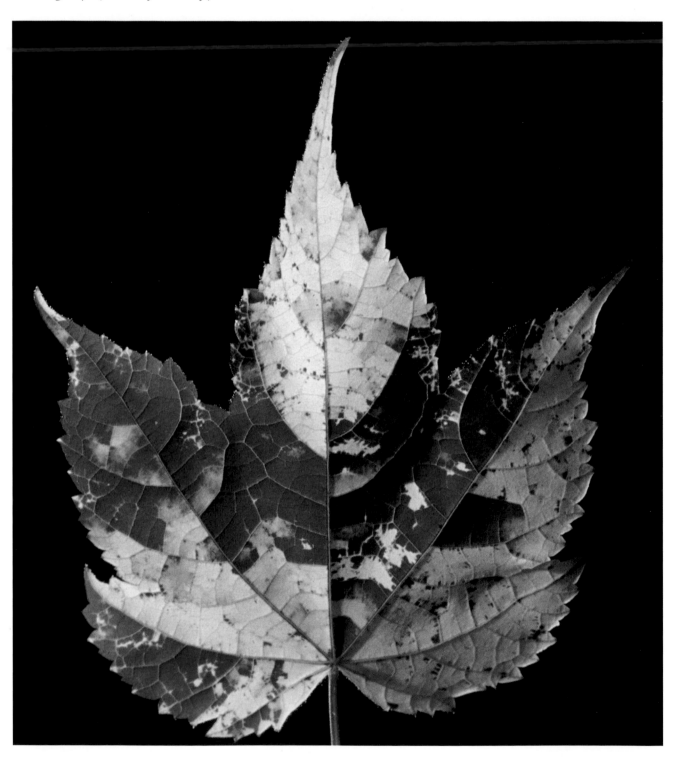

Variegated Japanese Knot Weed *(Fallopia japonica 'Variegata')*

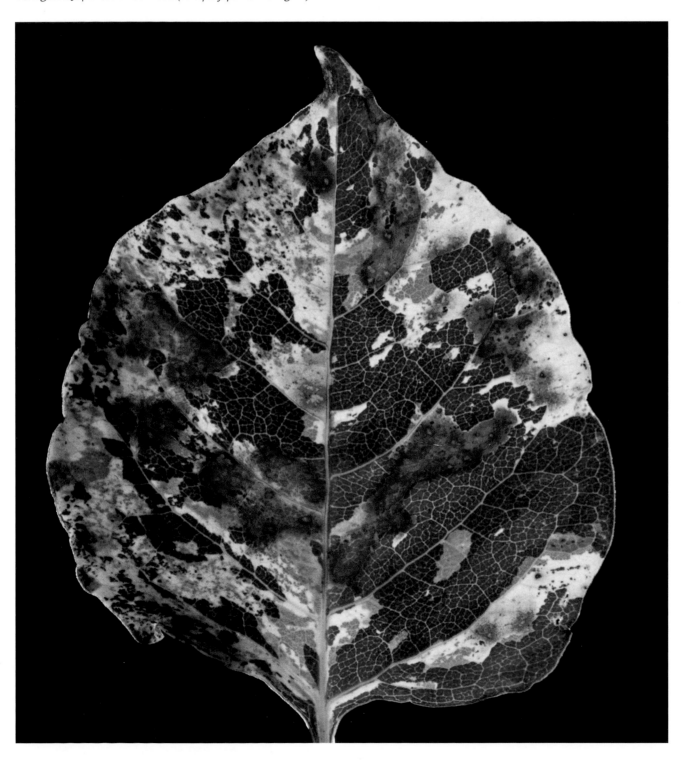

poinsettia

EUPHORBIA PULCHERRIMA, which goes by the common name of poinsettia, is native to Mexico and several other locations in Central America. It was introduced into the United States in 1825 by Joel Poinsett, who was an avid amateur botanist and the Minister (Ambassador) to Mexico from 1825 to 1830.

Long before the poinsettia was the holiday plant, the Aztecs used it as a dye. They called it *cuitlaxochitl*, which can be translated as "excrement flower." Birds would eat the seeds and deposit them somewhere, and so it seemed that the seeds would germinate and grow from bird droppings. In modern day Mexico, *cuitlaxochitl*

means "star flower," a much more agreeable definition.

Left to grow on their own, poinsettias are tall, straggly, bare-kneed, weedy-looking roadside plants. The colorful part of the plant is actually a bract that surrounds the insignificant small yellow flowers. The poinsettia monopoly, unchallenged until the mid-1990s, was led by the Paul Ecke Ranch in Encinitas, California, the largest producer of poinsettia in the world. Their technique was to graft two different species together and transfer a type of harmless phytoplasma bacteria that induced the much-sought-after stocky, full, tabletop characteristics of modern-day plants. When university researchers discovered the technique and published the information, the monopoly came . to an end, spreading floral Christmas cheer throughout the world.

Poinsettia *(Euphorbia pulcherrima)*

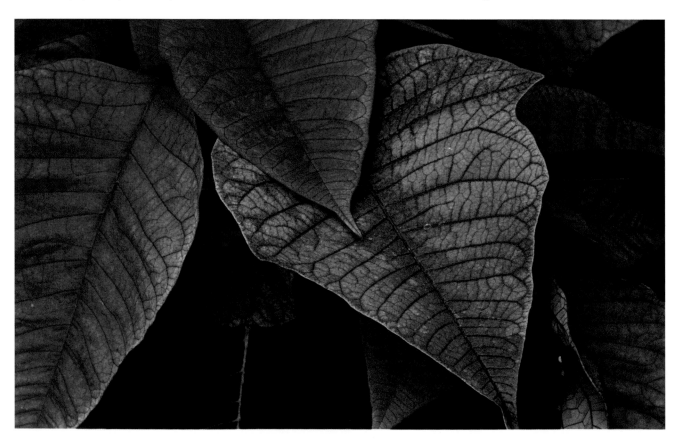

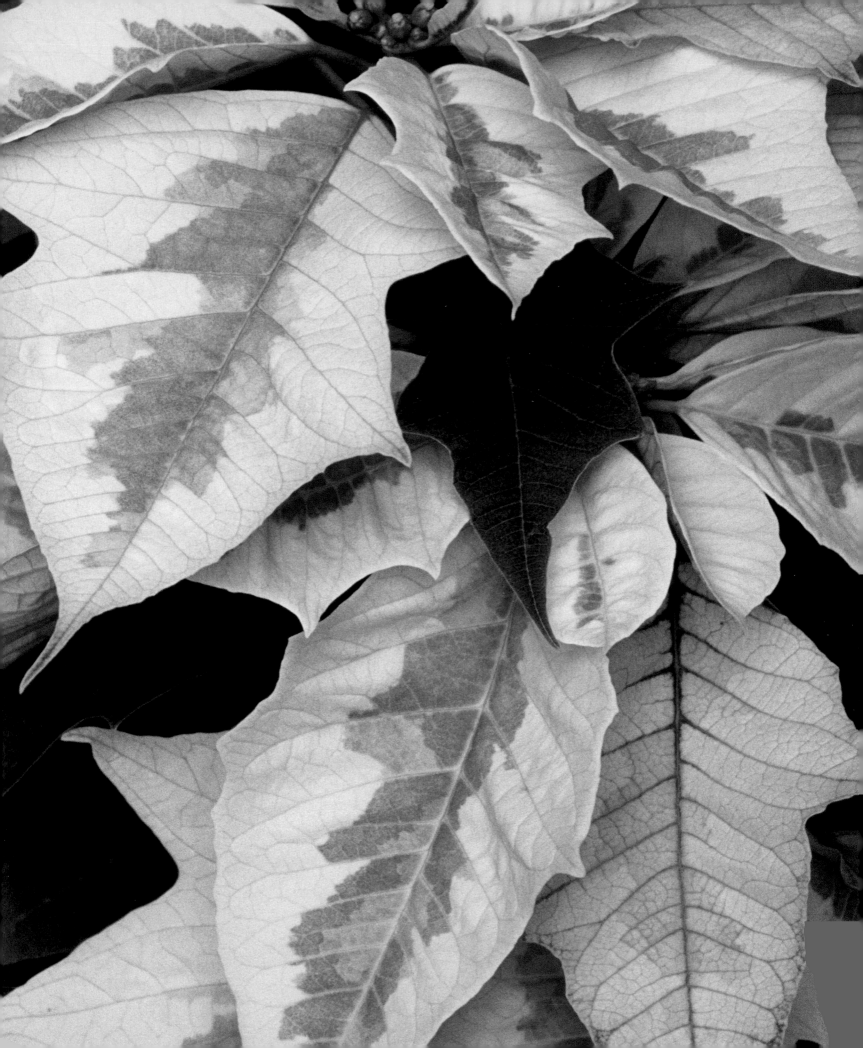

cotton

THREAD COUNT ISN'T THE ONLY THING we think of when it comes to cotton ... No matter where you live, cotton is likely a part of your everyday life. It coddles us at night as we sleep, feels comfortable next to the skin when we get dressed, and is the main ingredient in the manufacture of jeans, our most common piece of clothing. Cotton is an important component in millions of industrial products and home furnishings. Byproducts of cotton make up a large percentage of ingredients in cattle, poultry and pet feed; cottonseed oil is used in salad dressing and margarine.

Gossypium hirsutum is cotton's botanical name, and the shape of its flowers indicates its close relation to hibiscus, both being in the Malvaceae family. About 40 species of cotton can be found throughout most tropical and subtropical areas of the world. The common name "cotton" comes from the Arabic word *qutn*, which reveals cotton's origins in the Middle East. Cotton has been in use for over 7,000 years. Ancient people from Egypt to Peru cultivated cotton and used the fibers for cloth and rope.

The labor-intensive harvesting of cotton didn't change for thousands of years. The first cotton mill, built by Samuel Slater in 1790, provided a quicker way to remove the cotton fibers from the seeds. Eli Whitney's cotton gin revolutionized the cotton industry by greatly increasing worker production. A hundred years earlier, at the height of the British Empire's power, the manufacturing of cotton cloth had been outlawed in England and her colonies because of potential competition with wool manufacturing, then an incredibly powerful industry.

The cultivation of cotton as an ornament is comparatively rare, considering that over 7.2 billion pounds of cotton are generated annually by about 19,000 square miles of plants. But nothing beats the sight of a black-leaved cotton plant adorned with fluffy white bolls of cotton tastefully positioned in a flowerbed.

Black Leaf Cotton *(Gossypium herbaceum 'Nigra')*

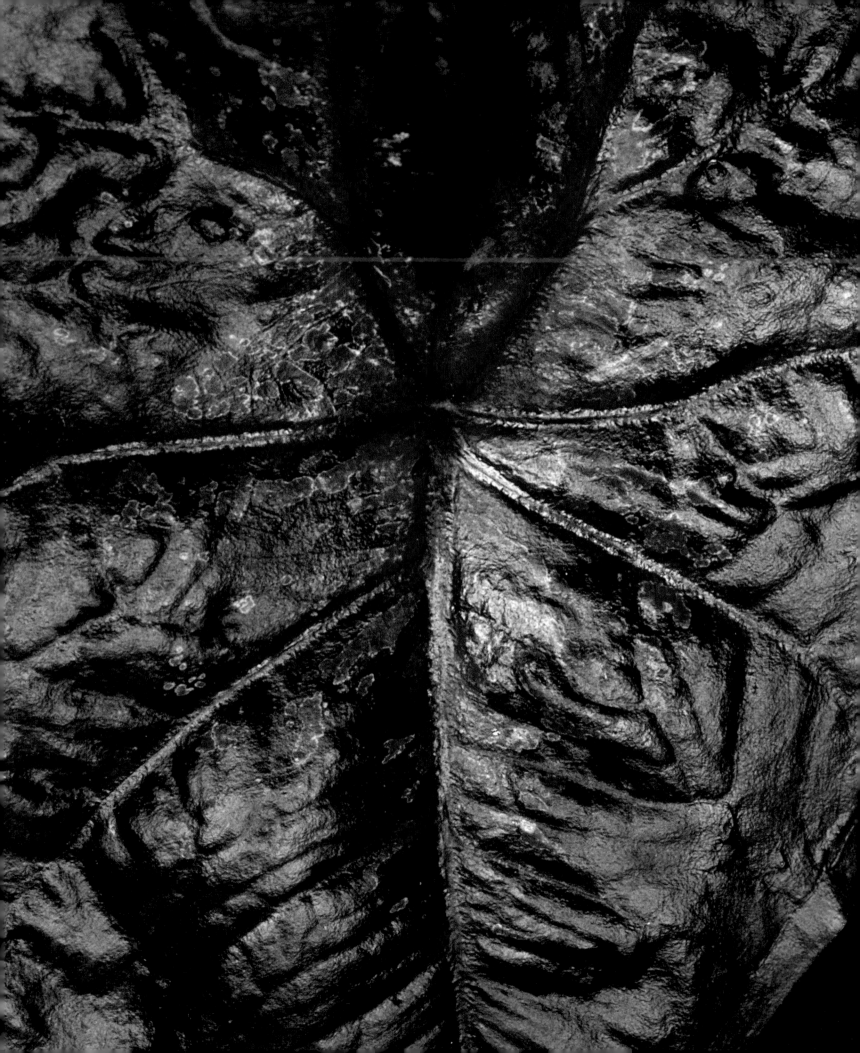

caladium

CALADIUMS (*Caladium* sp.) occasionally go by the common names of Elephant Ear, Heart of Jesus and Angel Wing — rather apt descriptions considering the standard leaf shape. They are native to the tropical areas of South and Central America where they grow on the shady jungle floor. Caladiums were first introduced to Europe in early 1700 as hothouse plants. That was the basic caladium, bearing largish leaves with red and green coloration — nothing special compared to what's available today. Uninteresting as they were, however, they became an overnight success. Later, in the Victorian era, caladiums had another surge of popularity and were planted in lavish bedding schemes.

In 1893, ornithologist and horticulturist Dr. Henry Nehrling moved from Wisconsin to central Florida and started a botanical garden with over 1,000 different types of caladium. After a severe freeze in 1917 he relocated the garden to the shores of Lake Istokpoga near Lake Placid, Florida, where the caladiums thrived. Fast-forward to today, and there are an estimated 1,500 named cultivars. Highlands County, Florida is the self-proclaimed caladium capital of the world. It has over 1,200 acres in production, which help fill the demand for bulbs nationally and through out the world. Every August the city's caladium festival attracts thousands of people. The varied activities include air-conditioned bus tours of the caladium fields, bulb and plant sales, caladium arts and crafts booths, caladium history displays, refreshments and entertainment.

Thailand is currently the hot spot for caladium breeding. New colors, shapes and sizes, which are available only in limited quantities, are driving the market. Thai dwarf fancy-leaf caladiums are a tribute to modern hybridization. The older forms are being replaced by newer ones, round leaves are replacing heart-shaped leaves of similar colors and patterns, and the new hybrids are bringing along with them a fifty-fold increase in price.

For many collectors, lusting after these rare and beautiful plants is an obsession. The frenzy around new caladium cultivars rivals the passion that drove the European tulip trade in the early 17th century. Enthusiastic collectors from all over the world search through crowded and bustling caladium markets for extraordinary combinations of colors and shapes. The caladium craze is also fueled by the hybridizer's desire to outdo Mother Nature by creating entirely new leaf shapes: elongated, oval, round, double-leaved, sheathed, lancet, bamboo-shaped — and even transparent.

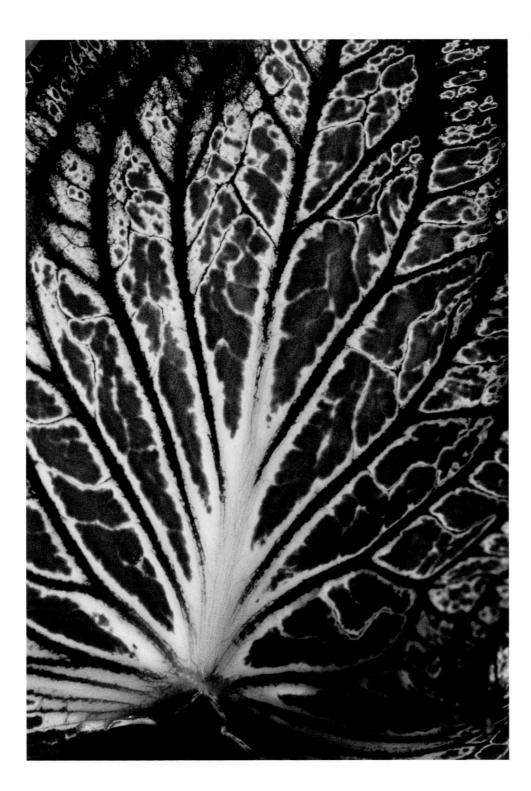

Thai Beauty Caladium
(Caladium x hybrid 'Thai Beauty')

Caladium White Queen *(Caladium bicolor 'White Queen')* >
Caladium Aaron *(Caladium bicolor 'Aaron')* >

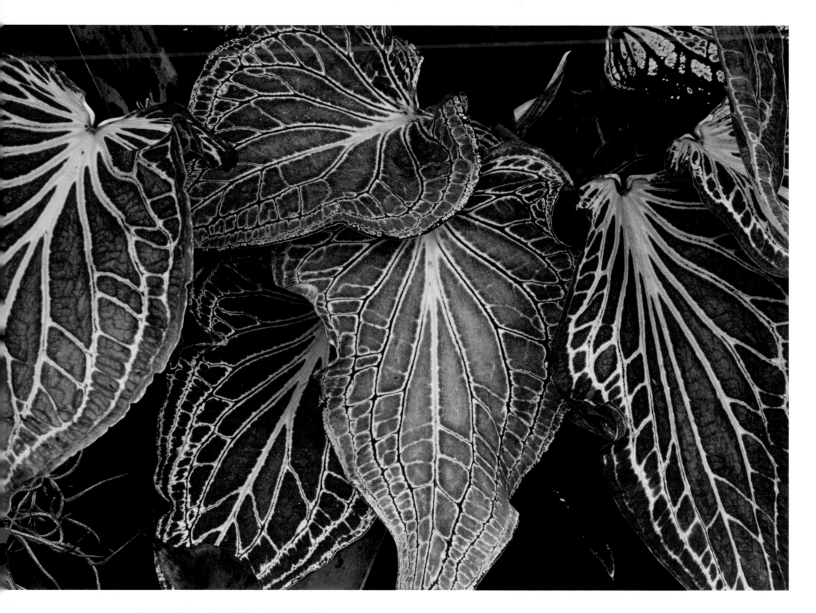

Thai Caladium *(Caladium 'Thai hybrid')*

extraordinary leaves

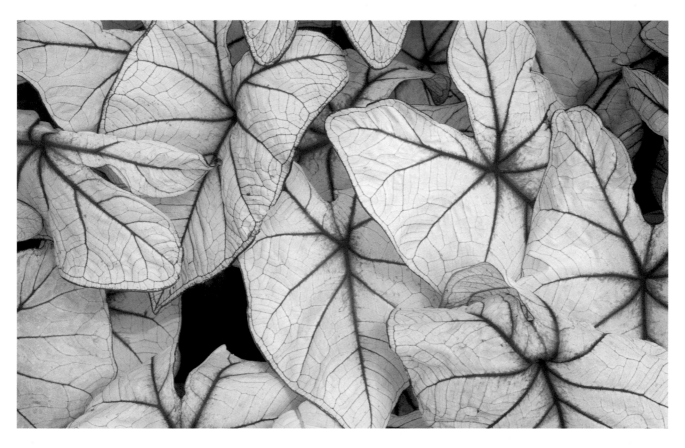

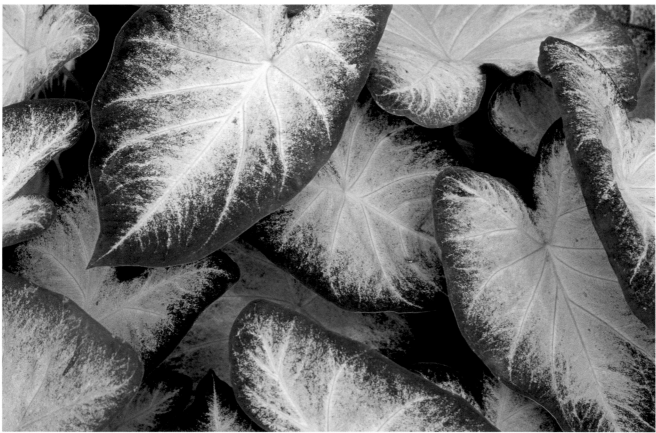

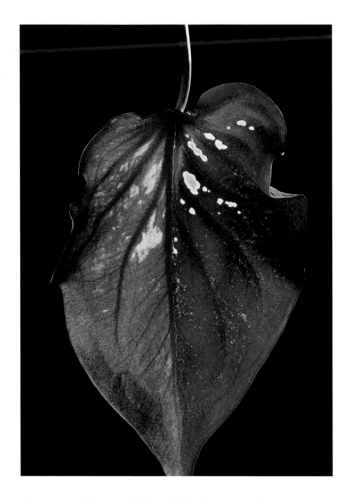

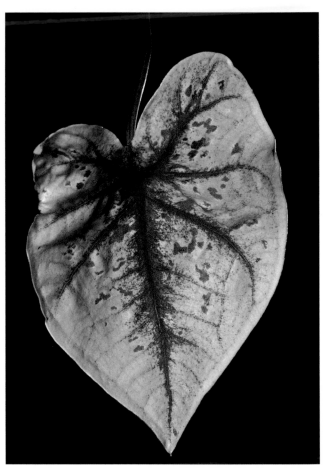

Yin-Yang Caladium *(Caladium x hybrid 'Yin-Yang')*

Yellow Blossom Caladium *(Caladium x hybrid 'Yellow Blossom')*

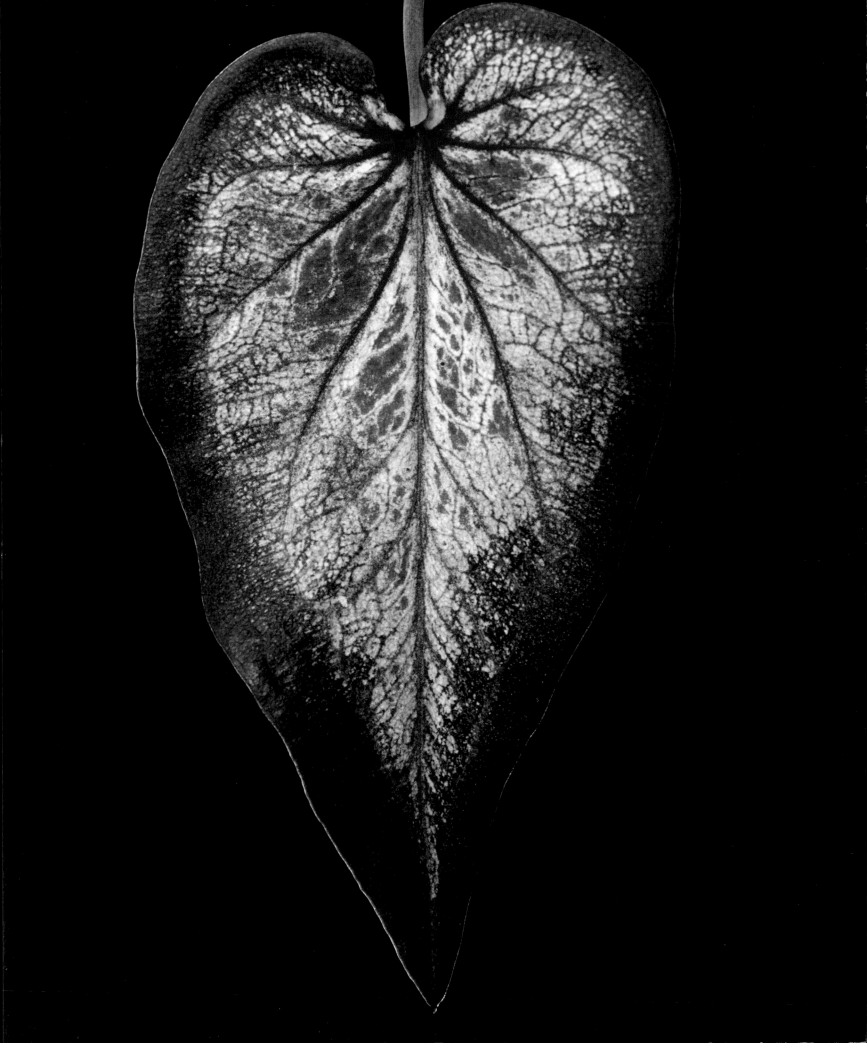

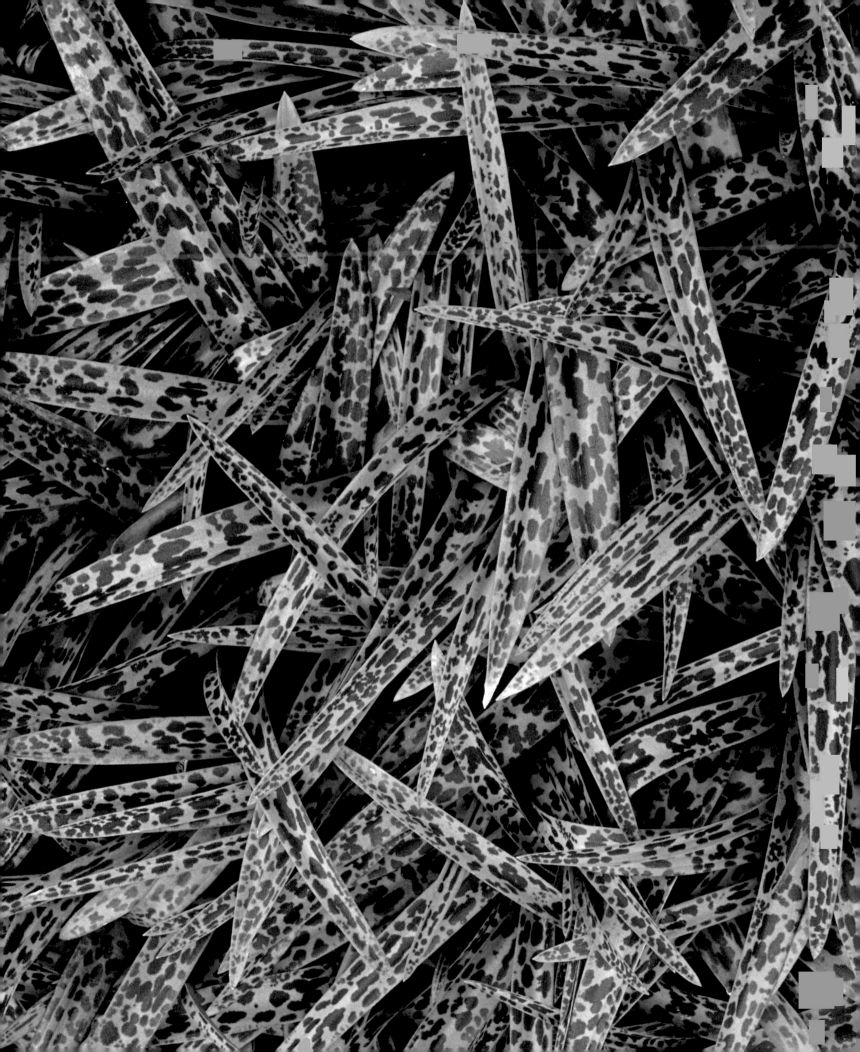

pattern

PATTERNED LEAVES are among the most spectacular leaves in nature. They can be found in every genus and species, and are native to all geographic locations. Their designs encompass a broad range, from dots, spots and lines to complex veining, striping and blotching in virtually every imaginable combination and color.

Variegation simply implies changing the look of something, especially by adding color. Variegated or patterned leaves come about in a few different ways. Some variegated effects are easily attained by the simple reflection of light from a leaf's surface. In some cases, a small pocket of air is trapped beneath the surface of a highly textured leaf, giving off a variegated effect. This type of variegation, when foliage may look blistered or puckered with white or silver patches, is commonly found on Angel Wing begonias, on some cucumber and melon vines and on tender as well as hardy cyclamen.

Sometimes leaves with a slightly hairy or pubescent zone will catch light and reflect it, giving the leaf a patterned look, as occurs in some *Rex begonia* types and species of *Helichrysum* and *Tradescantia*. Venal variegation is present when only the veins of the leaf are lacking in green pigments but other pigments are present. Thousands of leaves display this type of variegation: tender plants such as cannas, impatiens, gingers, *Alocasia*, *Sanchezia*, and many hardy plants like *Heuchera*, (*Forsythia giraldiana* 'Golden Times'), *Hydrangea*, as well as variegated honeysuckle (*Lonicera* sp.), *Ajuga*, (*Brunnera macrophylla* 'Jack Frost') and many forms of *Pulmonaria*.

Another type of variegation results from a plant's inability to produce chlorophyll in parts of the leaf. This type usually results in white, cream or yellow contrasting markings on a basic green leaf, and is often found in the meristem, or growing tip, of a plant. When this blanching happens, the leaf will tend to have a lighter-colored leaf margin that appears as a stripe along its edge. There needs to be a sustainable balance of green photosynthesizing tissue and white non-photosynthesizing tissue in a leaf. If the leaf becomes too white, it will be unable to support the plant. Plants with this type

of variegation often contain *marginata* in their name, as with the beautiful Elephant Ear (*Xanthosoma 'Albo Marginata'*) and (*Hosta undulata 'Albo Marginata'*).

Variegated plants are often weaker, slower-growing and more susceptible to insects and diseases. They also take longer to root and are often grafted onto non-variegated rootstock, so that the grafted variegated top part of the plant will have the benefit of a larger, more vigorous root system. Some grafted plants are notorious for having the tendency of suckering rootstock, sending up shoots from just below the graft line.

When green pigments are masked by another type of pigment, they actually absorb specific wavelengths of light while reflecting others. Carotenoids are responsible for hot colors like red, orange and yellow in plants such as *Acalypha, Croton* and some gingers. Water-soluble anthocyanins are responsible for cooler colors like dark red, blue and purple in plants such as the burgundy foliage of Crimson King Maple (*Acer platanoides 'Crimson King'*) and (*Cercis canadensis 'Forest Pansy'*). Betalains are another type of water-soluble pigment that provides reds and yellow colors, and are used as a natural dye. They are found in many plants and leaves such as beets, amaranth and Swiss chard.

Different pigments sometimes mask green leaves in patterns like fancy-leaved zonal geraniums, Prayer plants (*Maranta* sp.) and *Calathea* sp., which have the common names of Rattlesnake plants or Peacock plants thanks to their outrageously patterned foliage. Viruses can also be the cause of variegation in leaves. Some can be harmful, as with mosaic viruses (tobacco mosaic virus, for example), or merely decorative, as in plants such as *Abutilon* (*Abutilon pictum 'Thompsonii'*).

Many plants have a plain green form that mutates into a colorful variant for one reason or another. These variants quite often become cultivated varieties that are preferred over the original. Gardeners are especially attracted to unusually variegated plants and even perpetuate these weird chimeras, which left on their own would naturally disappear back into the gene pool.

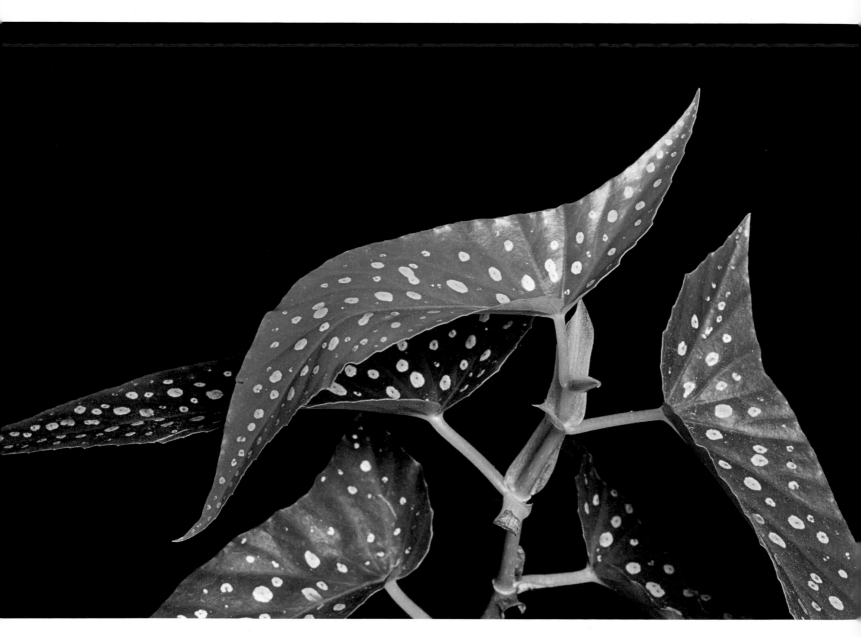

Angel Wing Begonia *(Begonia 'White Ice')*

extraordinary leaves

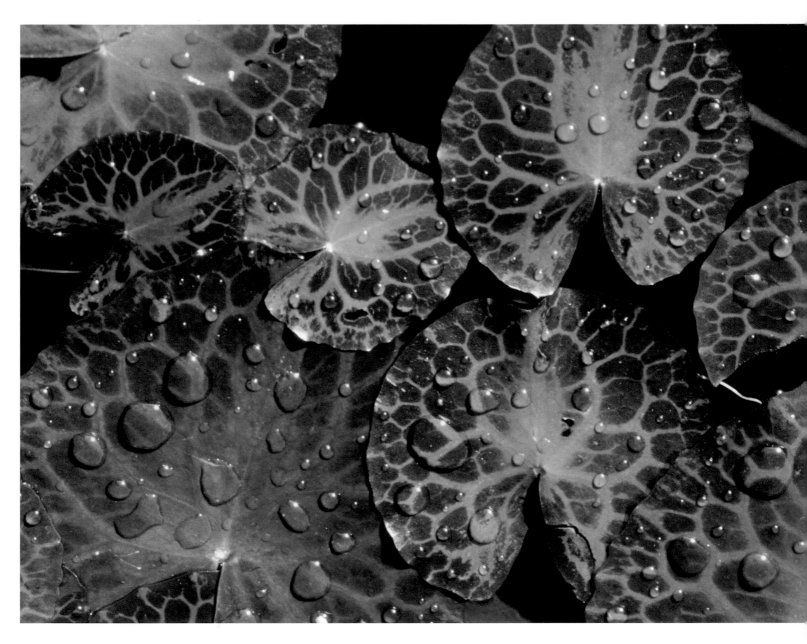

Chocolate Snowflake *(Nymphoides geminata)*

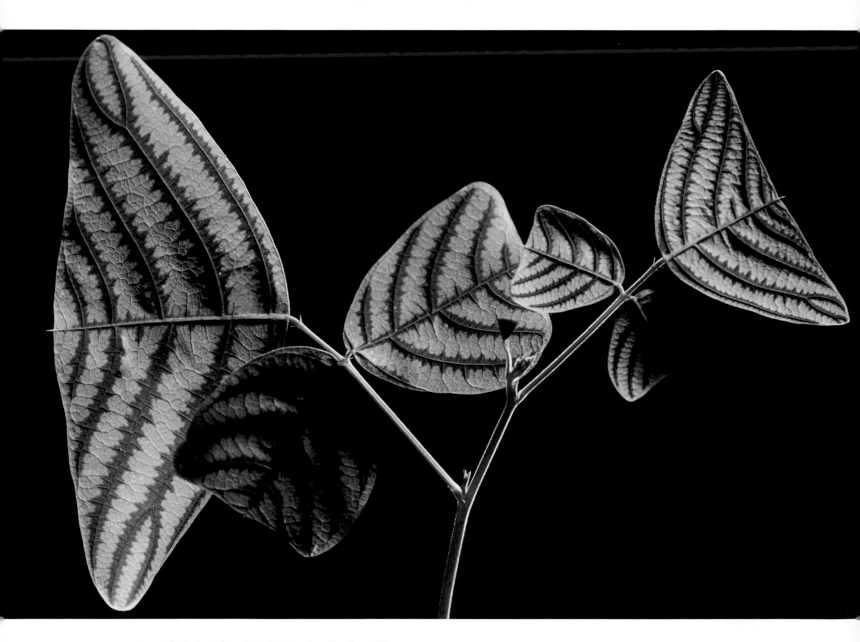

Butterfly Stripe Plant *(Cristia obcordata 'Swallowtail')*

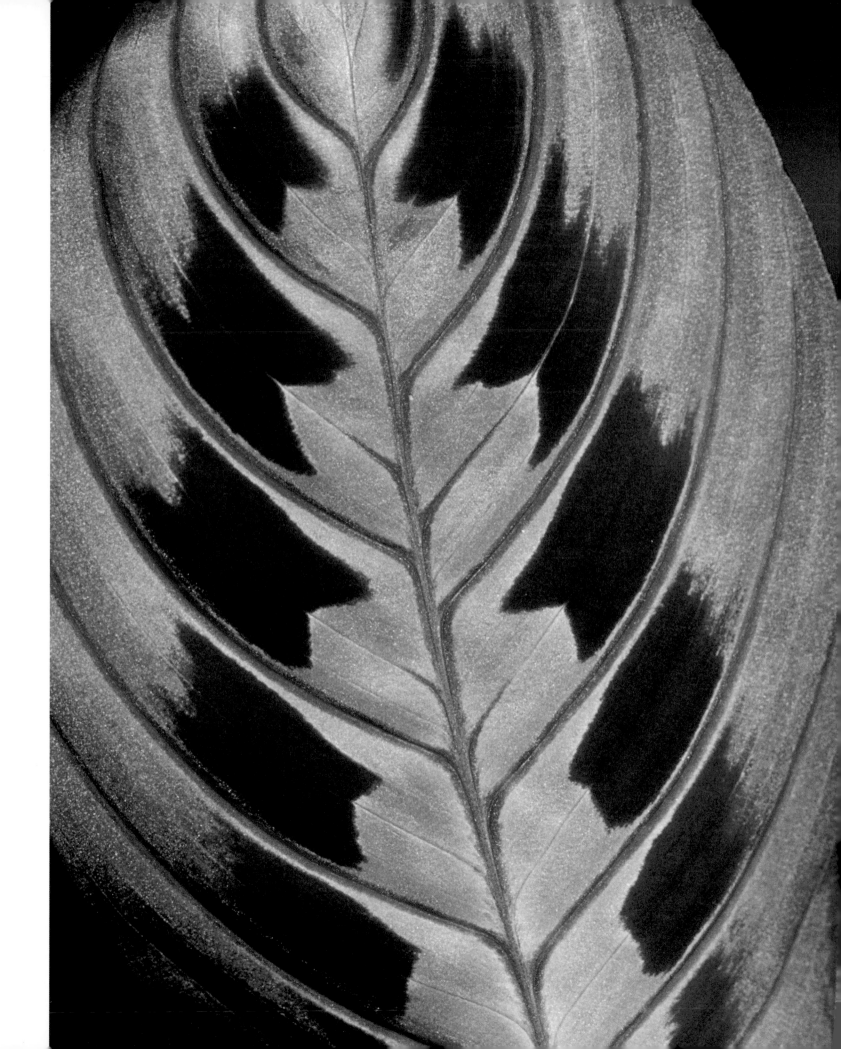

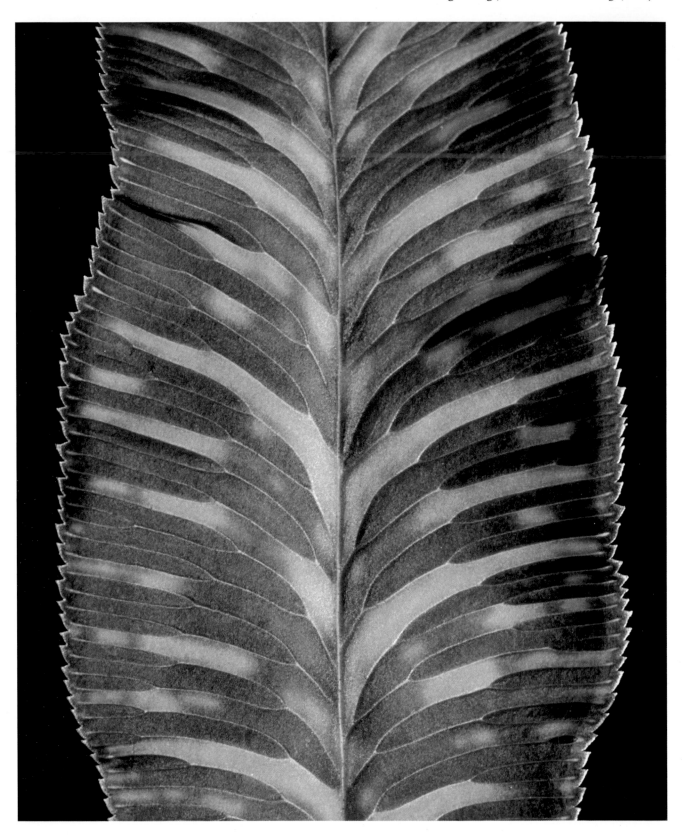

Variegated Tongue Fern *(Pyrrosia lingua 'Ogon Nishiki')*

extraordinary leaves

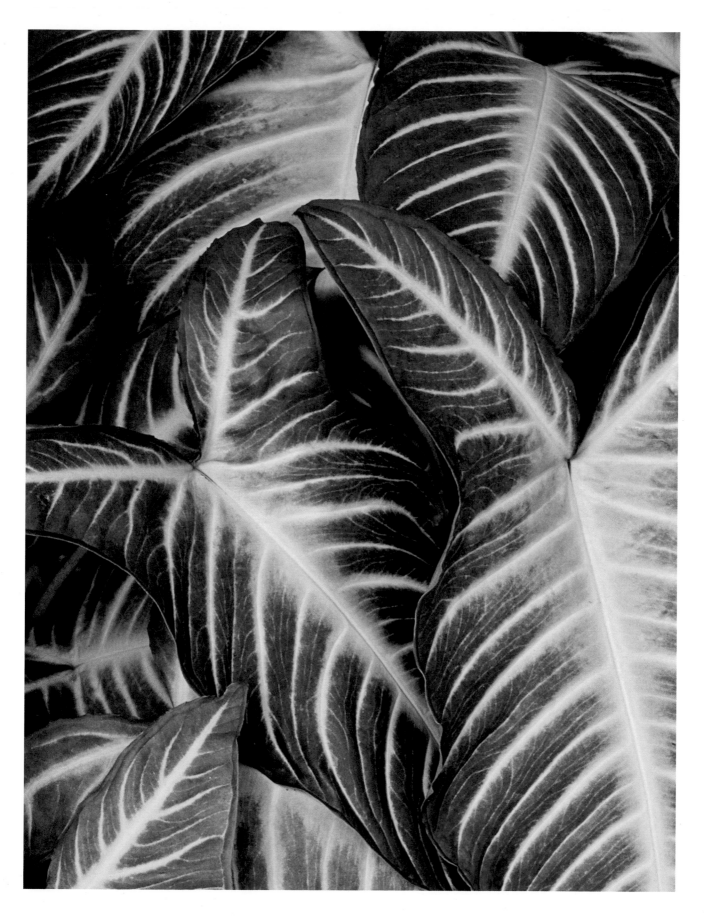

pattern

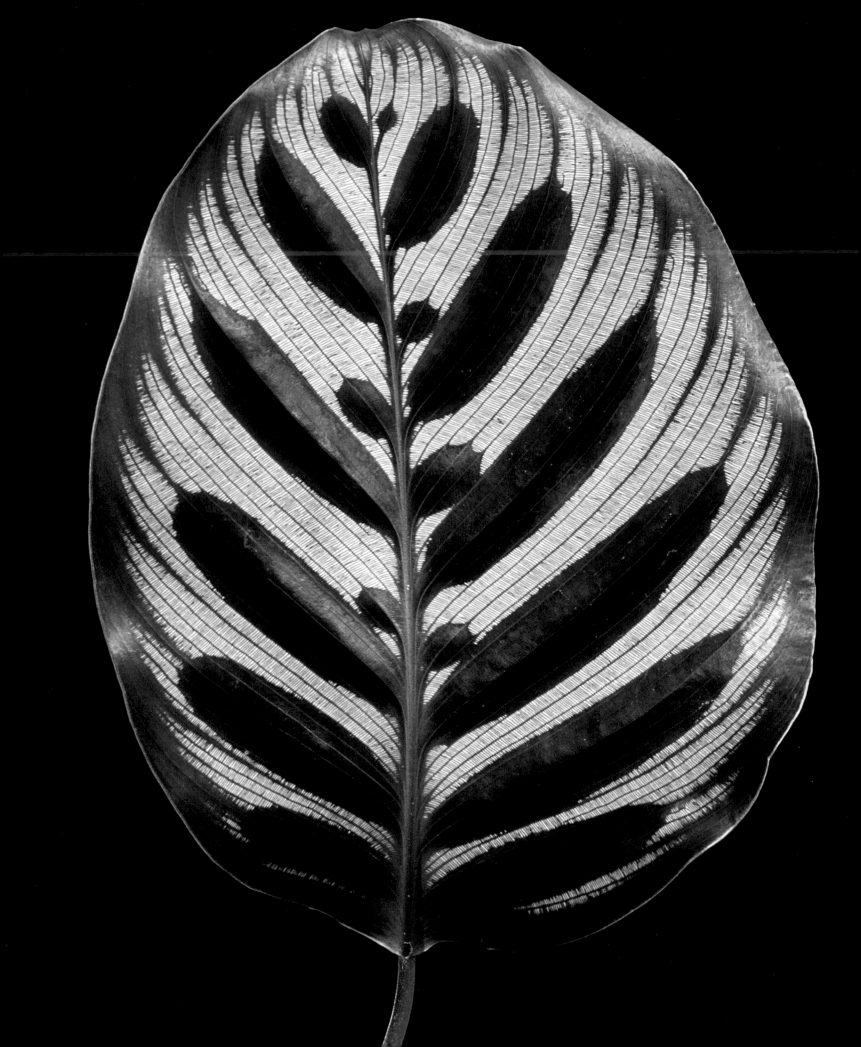

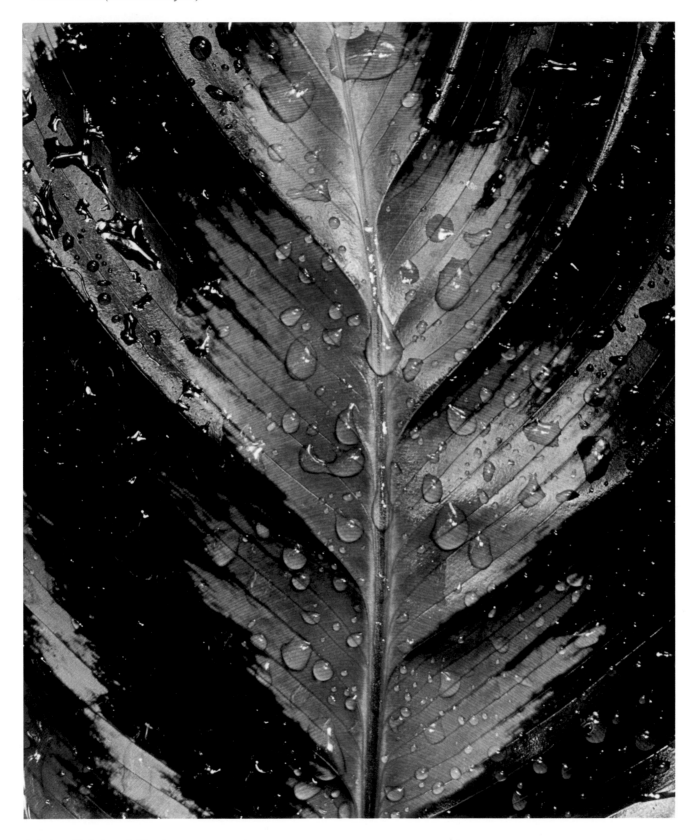

Calathea *(Calathea veitchiana)*

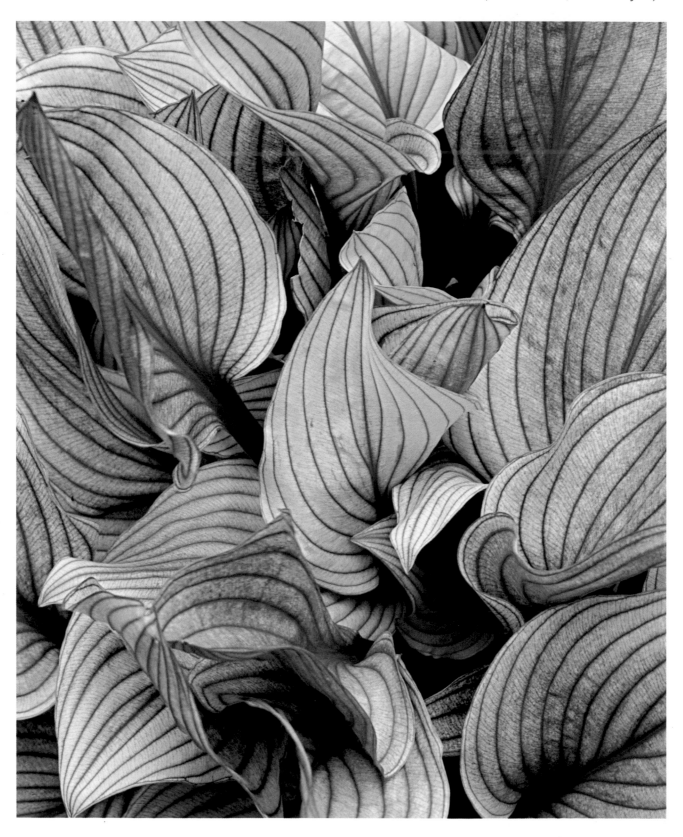

Hosta *(Hosta x 'White Wall Tire')*

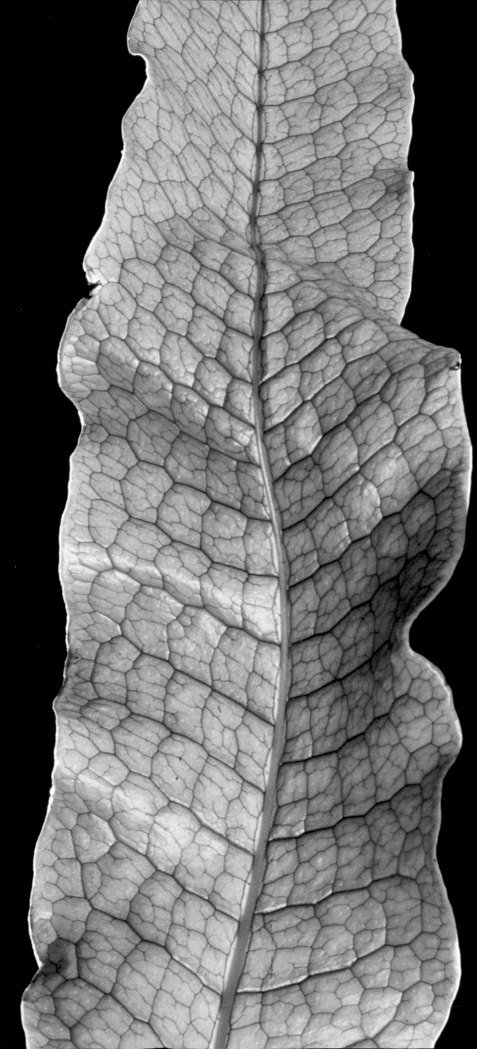

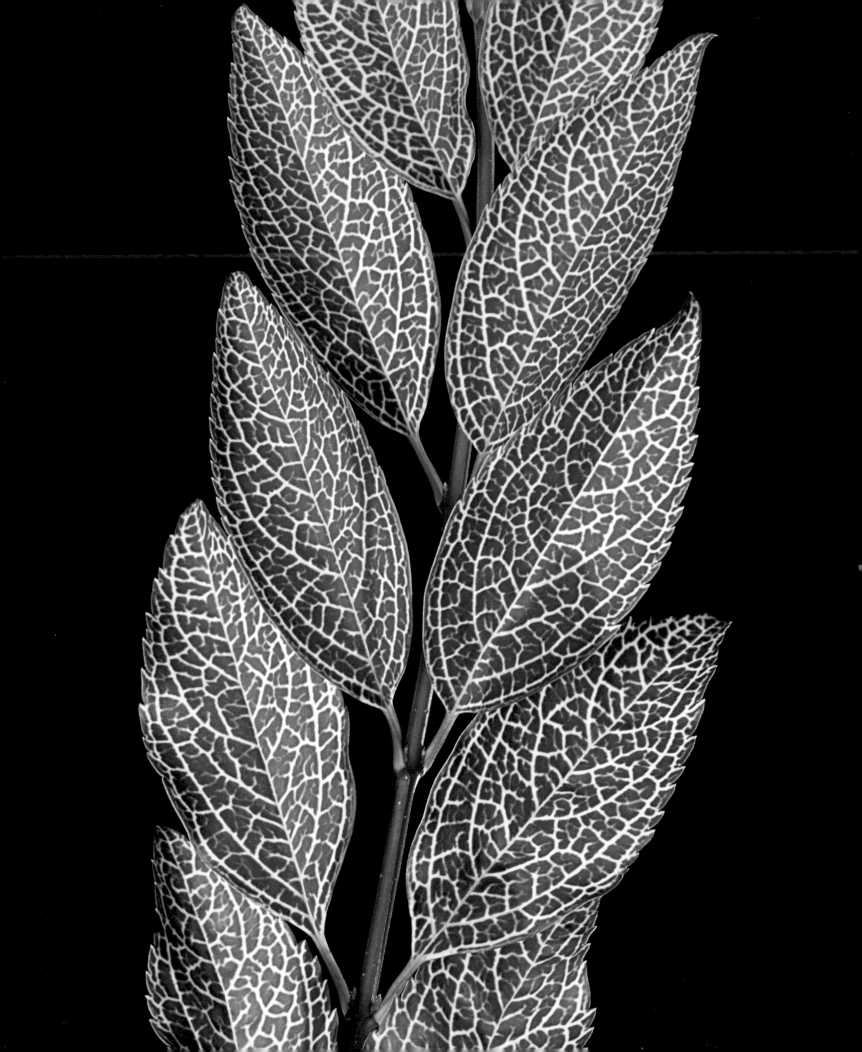

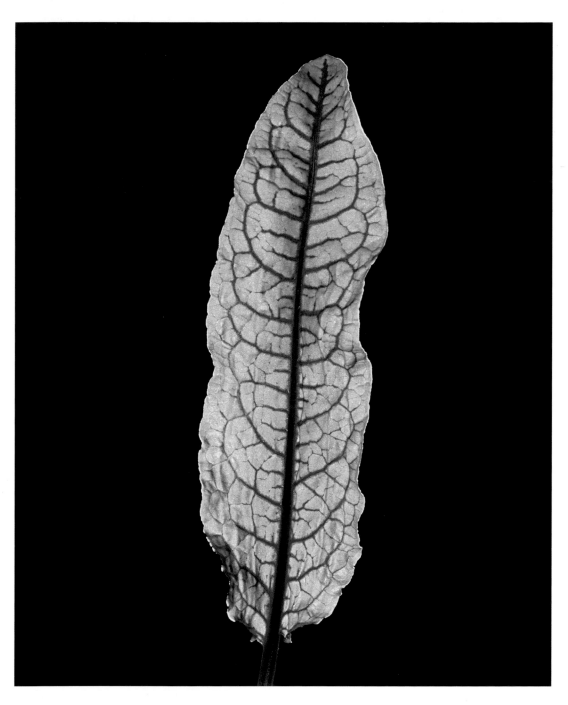

Red-Veined Dock *(Rumex sanguineus var. Sanguineus)*

canna

Canna Phaison *(Canna x generalis 'Phaison')* >
Canna Pretoria *(Canna x generalis 'Pretoria')* >

CANNA LILIES, as *Canna* sp. are sometimes called, are not actually in the lily family. They are the only genus in the Cannaceae family. The name "canna" comes from the Celtic word for cane, or possibly the Greek word *kanna*. Another common name is Indian Shot, as the seed was used as gunshot in the 1800s. The seeds are also used as beads and placed inside gourds to make musical instruments.

Although cannas have naturalized in most tropical and subtropical regions, they are native to the Southern United States, and Central and South America. They are also planted extensively in temperate regions as decorative garden plants. They were first introduced to Western horticulture in the 1600s, but before that they were grown as an agricultural crop. Canna tubers contain a high concentration of starch and have been in cultivation for over 5,000 years as a food source.

Cannas have come a long way from their humble beginnings as lanky, small-flowered plants. Considerable hybridization has occurred to enhance their flower size and color and produce interesting leaves. Hybridization started in France during the 1800s and spread though Europe and then back to the Americas where cannas originated. One of the biggest boosts to cannas' popularity was the 1893 Chicago World's Fair, where massive plantings were bedded out. Shortly after that cannas went out of fashion and were rarely used in planting designs. In recent years they have become all the rage again, being used in mixed borders, annual plantings and containers.

Canna Pretoria *(Canna x generalis 'Pretoria')* >

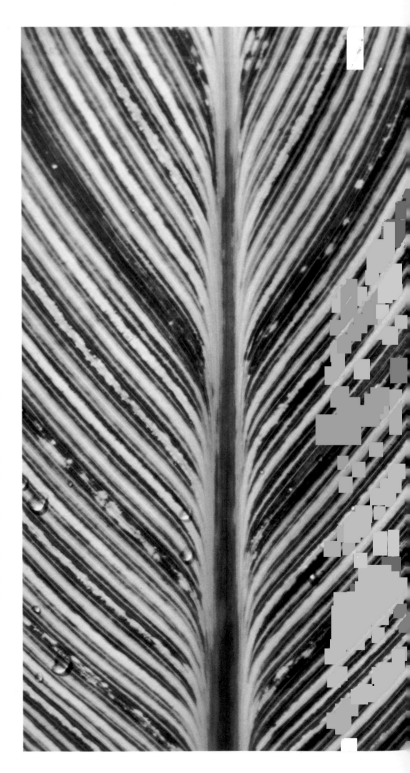

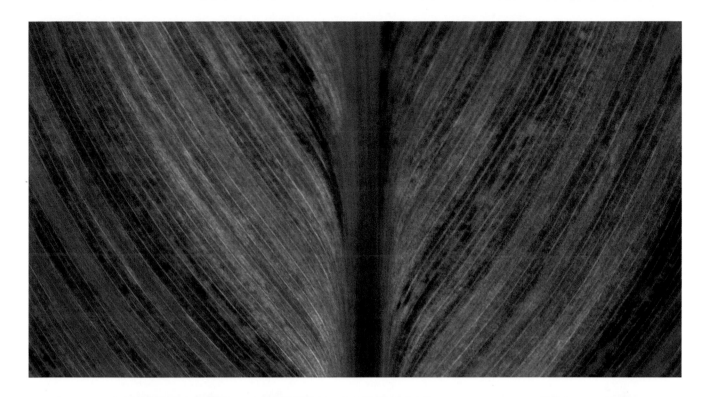

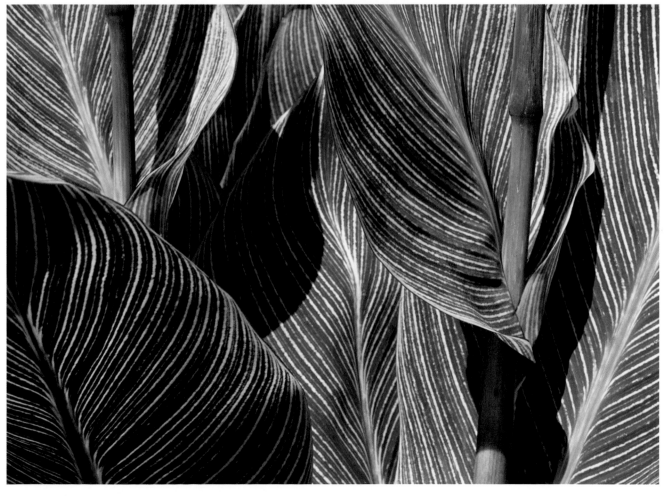

rex begonia

REXES ARE THE SHOWGIRLS of the Begonia family. They are also referred to as King Begonias and Painted Leaf Begonias because of their wildly patterned leaves. Members of the 1,500 species-strong family can be found throughout Central and South America, Africa and Asia, growing in all types of climate ranges from humid rainforests to freezing temperate regions.

The tender rex begonia types are native to the rain-soaked Assam Mountains of India. The British plant hunter Charles Simons first introduced them to Europe in the mid-1800s. They were very soon bred with other begonia species, and hundreds of hybrids were introduced. Rex hybrids were Victorian favorites, grown primarily for their wondrously shaped colorful foliage rather than their flowers, which are small and often hidden by the showy leaves.

Foliage patterns consist of any combination of dotted, splashed, streaked, swirled and blotched, in a plethora of colors such as iridescent black, apple green, metallic silver, red, purple, pumpkin, pink and plum. Some leaves are deeply puckered or serrated, while others are covered with contrasting hairs that add another dimension to their exotic beauty. The heavily veined leaves often take on a painted quality with contrasting colors.

The propagation of rex begonias is quite simple: a healthy leaf is sliced into 1-inch (2.54 cm) squares, each containing a section of vein, and the squares are placed on top of a sterile, damp potting mix. Within a few weeks they will take root, and after about eight weeks plantlets identical to the mother leaf will start to form on the edges of the squares.

Begonia Denver Lace *(Begonia rex 'Denver Lace')*

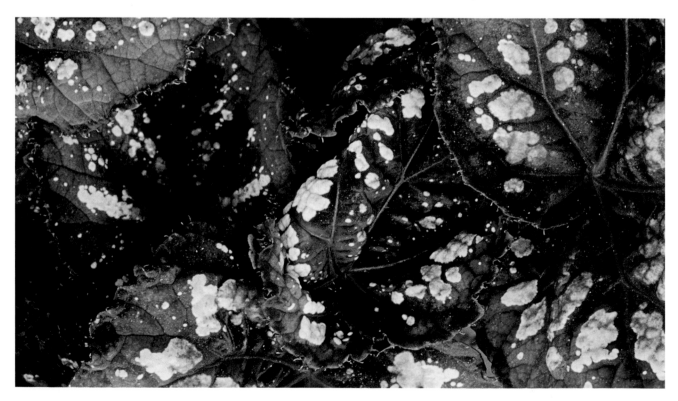

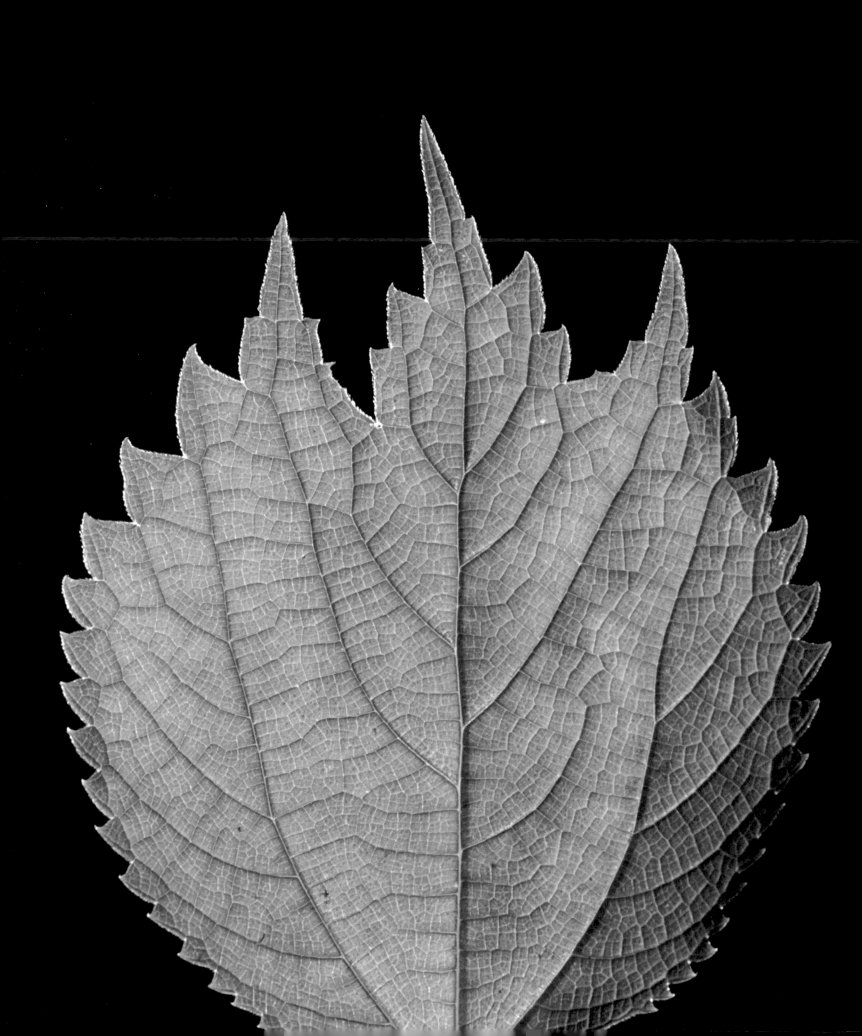

edges

WHILE OFTEN OVERLOOKED, leaf margins and leaf edges have some outstanding characteristics. A solid-edged leaf with no indentations is appropriately referred to as "entire." Entire leaves can typically be found on a wide variety of trees and shrubs, but without the addition of some texture or a spectacular color they are rather plain in appearance. Add a sensuous curve and it's a whole other story.

A leaf's margin surrounds it entirely, from the base through the mid-section around to its tip. From one end to the other, it can be either a fairly straight run or appear to be a rollercoaster ride of ins and outs. The margins of some leaves rival snowflakes with their intricate patterns. Lobed leaves are quite common, but not all lobes are equal. Leaves that are lobed and point toward the central vein similar to the shape of a feather are referred to as "pinnately lobed," whereas leaves whose lobes all point to the base like a palm leaf are described as "palmately lobed."

When it comes to originality, oaks, members of the genus *Quercus*, are a perfect example of the possible diversity of margins within a single genus. Oaks include evergreen as well as deciduous trees and just about all of them have interesting leaves with interesting margins. The Sawtoothed Oak (*Quercus acutissima*) is appropriately named for its serrated margined leaves; the Valley Oak (*Quercus lobata*) is also aptly named for its deeply lobed leaves. Japanese maples, members of the genus *Acer*, are a diverse group as well. The leaves can be rounded and rather squat-shaped, making a bold statement in the landscape. Or they can be so deeply and finely lobed that they have the appearance of lace.

Some plants have different types of edges on their leaves depending on their age or the leaves' location on the plant. Distinctive differences can easily be seen among *Eucalyptus* sp., mulberries (*Morus* sp.), assorted ferns and begonias.

There are plants in all corners of the globe with thorny or "spinose" leaf edges. Members of the holly (*Ilex*), *Rosa* and *Solanum* genera are just some of them. Spines anywhere on leaves serve as protection, discouraging predators from climbing onto them and eating them.

Acanthus montanus is an interesting tender perennial that sports a staggering array of different leaf edge types. It is called a "pinnatisect" leaf in reference to its deep, pinnate cuts, which reach toward the midrib. It is also considered "spinos," because of its spines, "lacerate," because of the irregular broad and shallow cuts that give it a torn appearance, and "anastomosing," because its veins form a network that unite at their point of contact. Obviously this plant could go by any number of names but its common name, the Crocodile plant, seems to fit the bill.

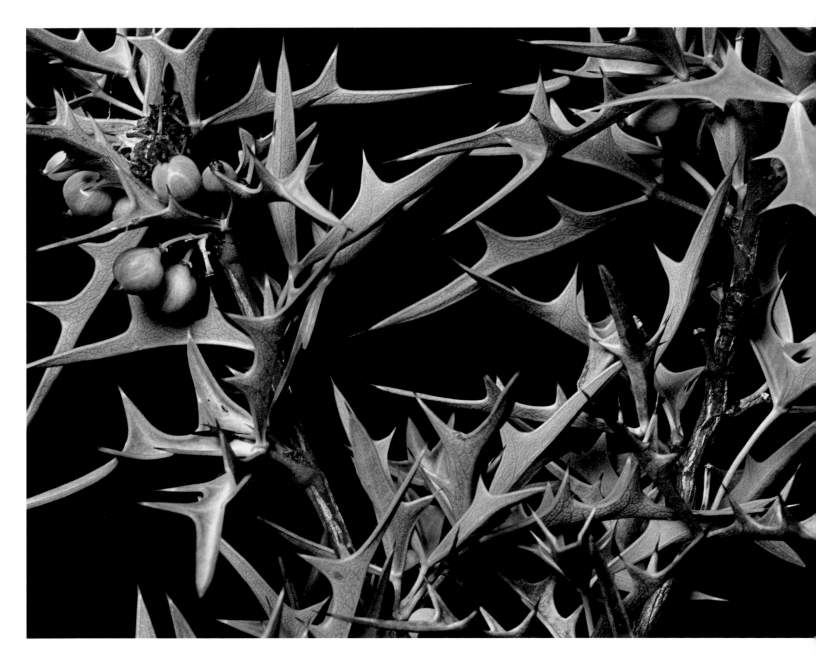

Currant of Texas *(Mahonia trifoliolata 'Algerita')*

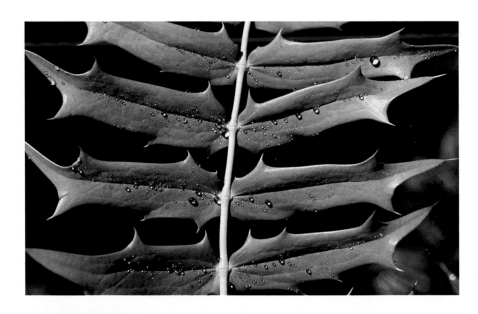

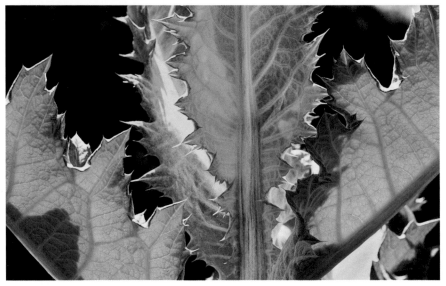

Oregon Grape Holly *(Mahonia sp.)*
Thistle *(Cirsium sp.)*

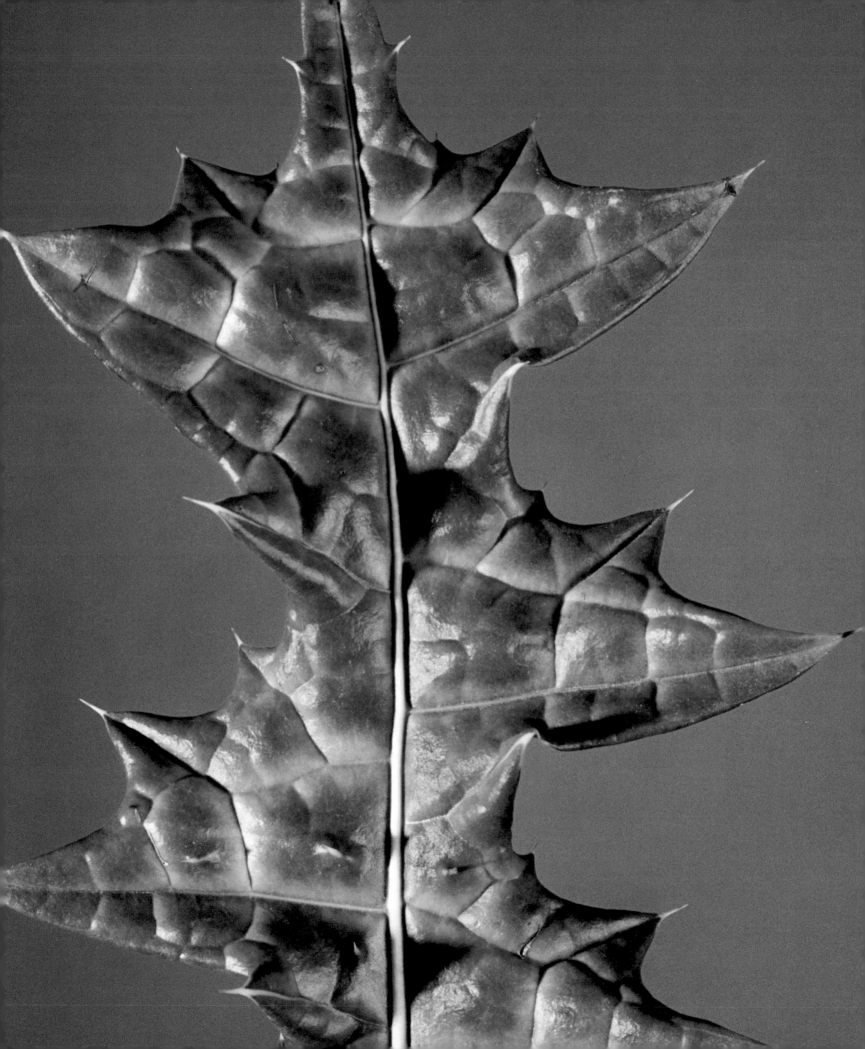

Swamp White Oak *(Quercus bicolor)* >

Northern Red Oak *(Quercus rubra)* >

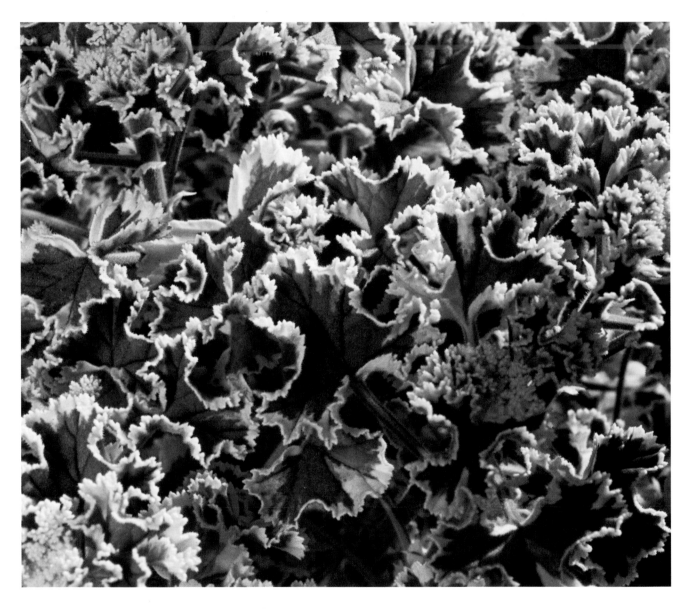

Geranium French Lace *(Pelargonium crispum 'French Lace')*

extraordinary leaves

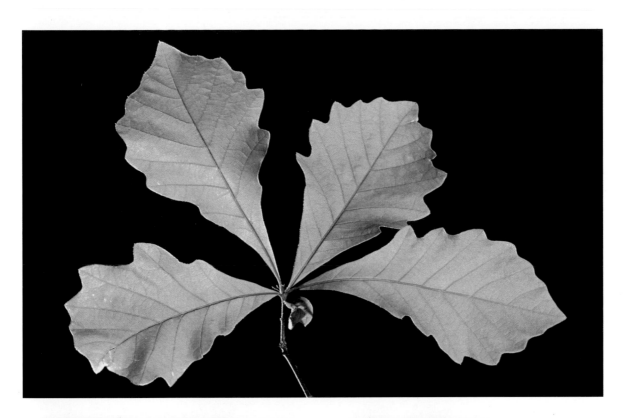

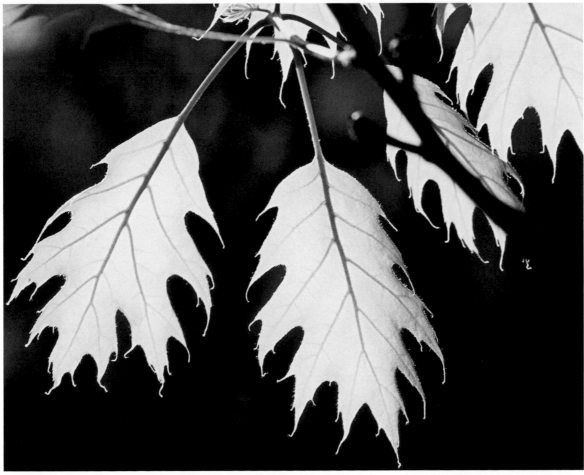

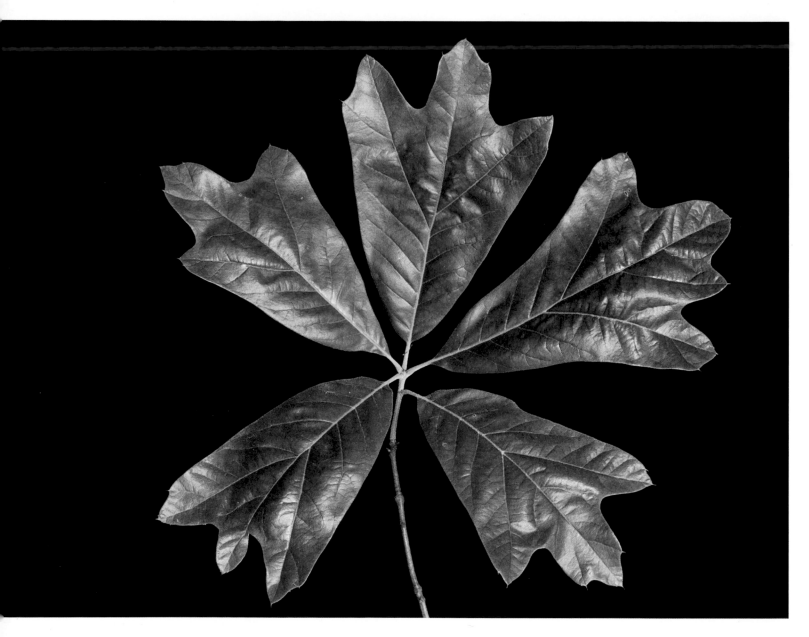

Blackjack Oak (*Quercus marilandica*)

extraordinary leaves

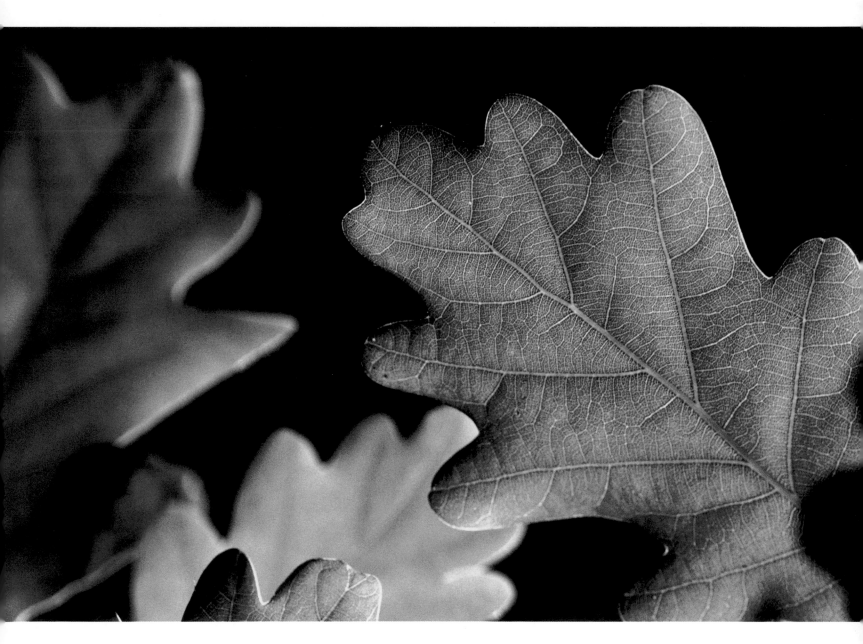

White Oak *(Quercus alba)*

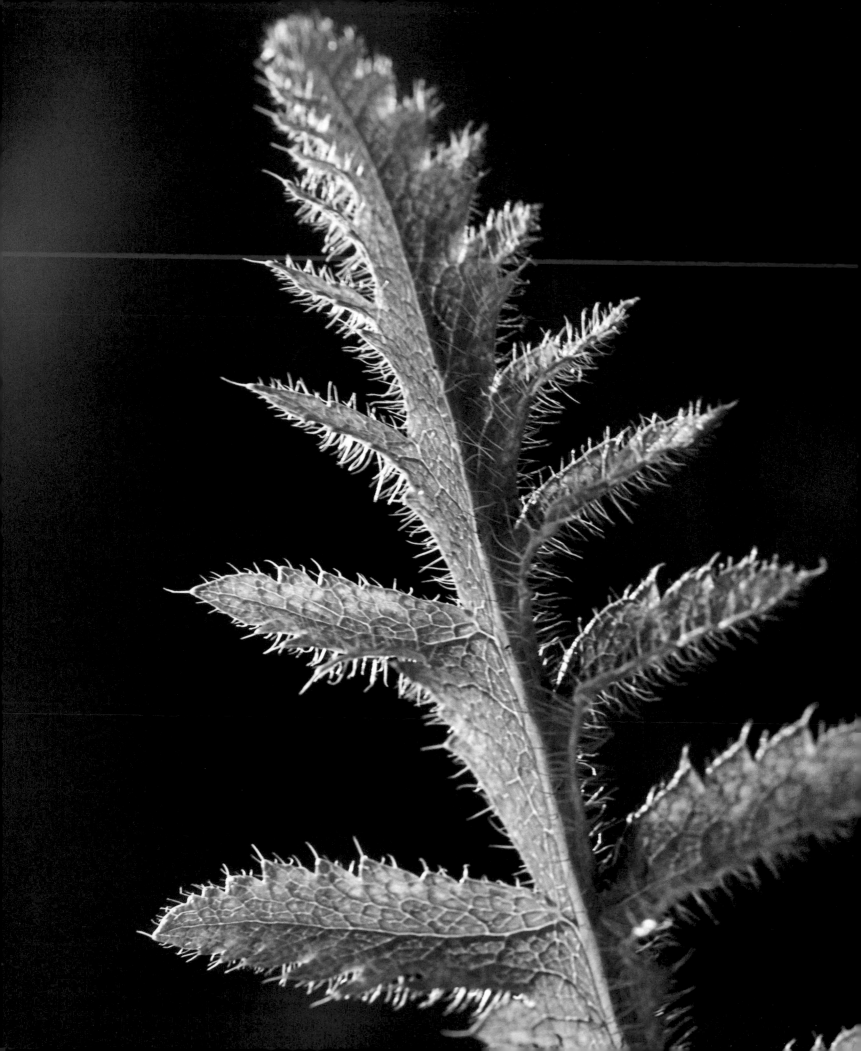

< Oriental Poppy *(Papaver orientale 'Queen Alexandria')*

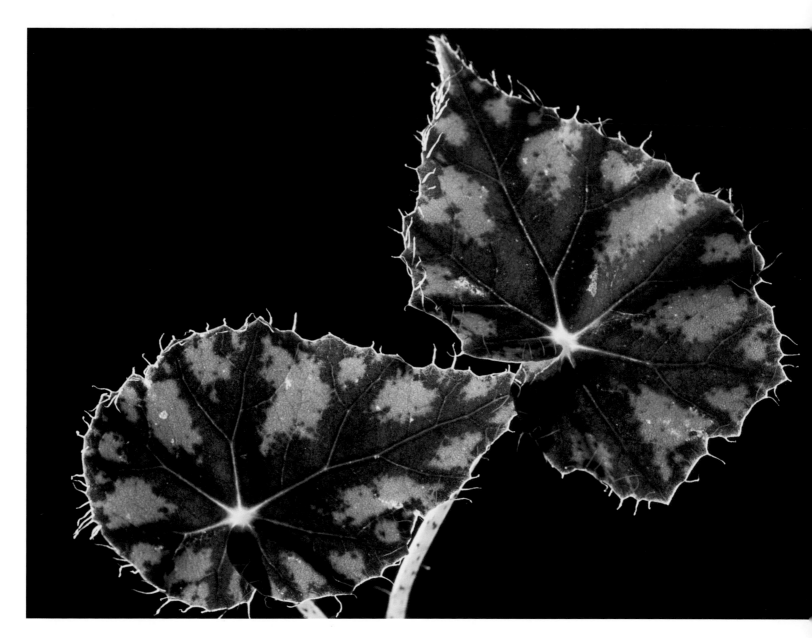

Eyelash Begonia *(Begonia bowerae 'Nigromarga')*

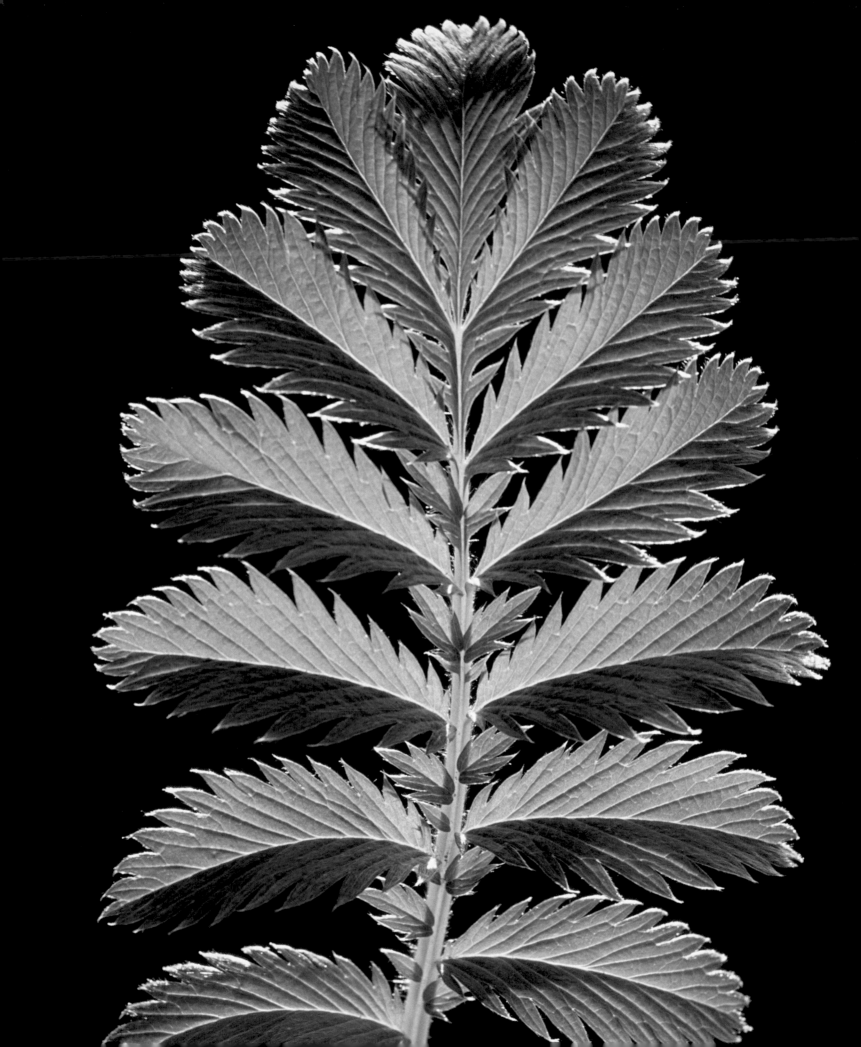

< Wild Tansy *(Tanacetum vulgare)*

Banksia *(Banksia sp.)*

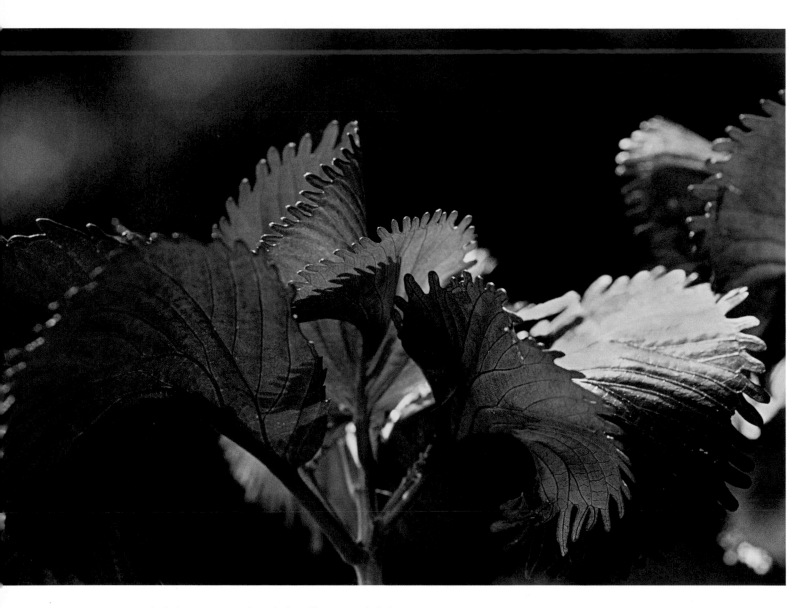

Haleakala Copper Leaf *(Acalypha wilkesiana 'Haleakala')*

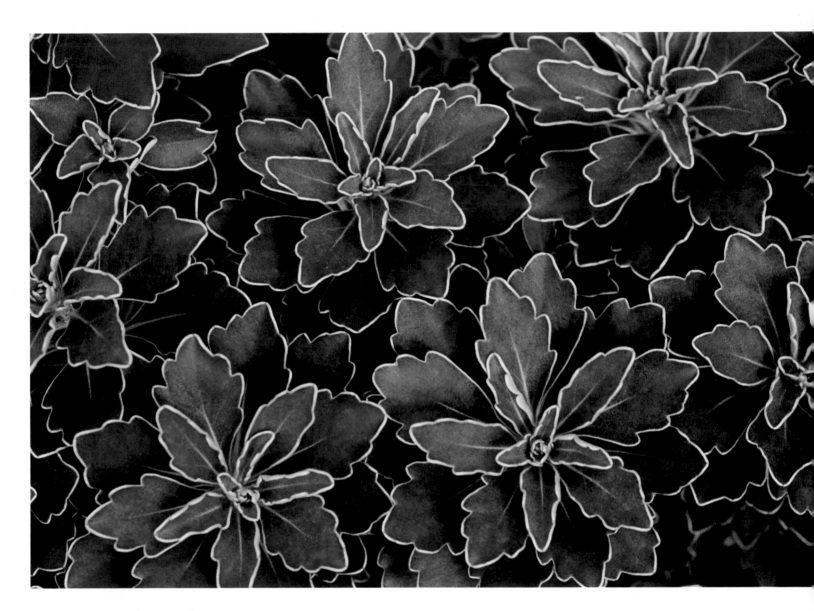

Pacific Mum *(Leucanthemum pacificum)*

hellebore

HELLEBORES (*Helleborus* sp.) are a group of perennial plants native to parts of Europe, Greece, Turkey and Asia Minor, with one species hailing from China. They are widely referred to solely by their Latin name, *Hellebore*, derived from the Greek words *elein* and *bora*, which combine to mean, "injure — food" because of the extremely toxic properties found in their tuberous roots. Their common names, Christ Herb, Christmas Rose and Lenten Rose, which refer to the Hellebores' blooming period, are quite

fitting. Heralding the first sunny, warm days of winter and early spring, Hellebore buds will even push their way through a light covering of snow. It's best to remove the previous years withered foliage to show off the new blossoms, which are quickly followed by lush supple leaves.

Being among the best plants for a winter performance, Hellebores come in an exceedingly wide range of flower colors including many pastel shades of cream, pink, yellow and red, and are often being dotted and spotted. Recent breeding programs have worked on interesting foliage displays as well, adding to this beautiful plant's year round appeal.

Hellebore *(Helleborus sp.)*

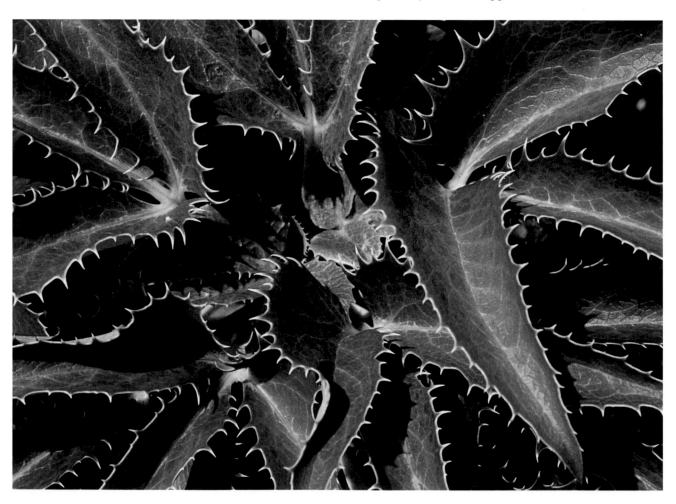

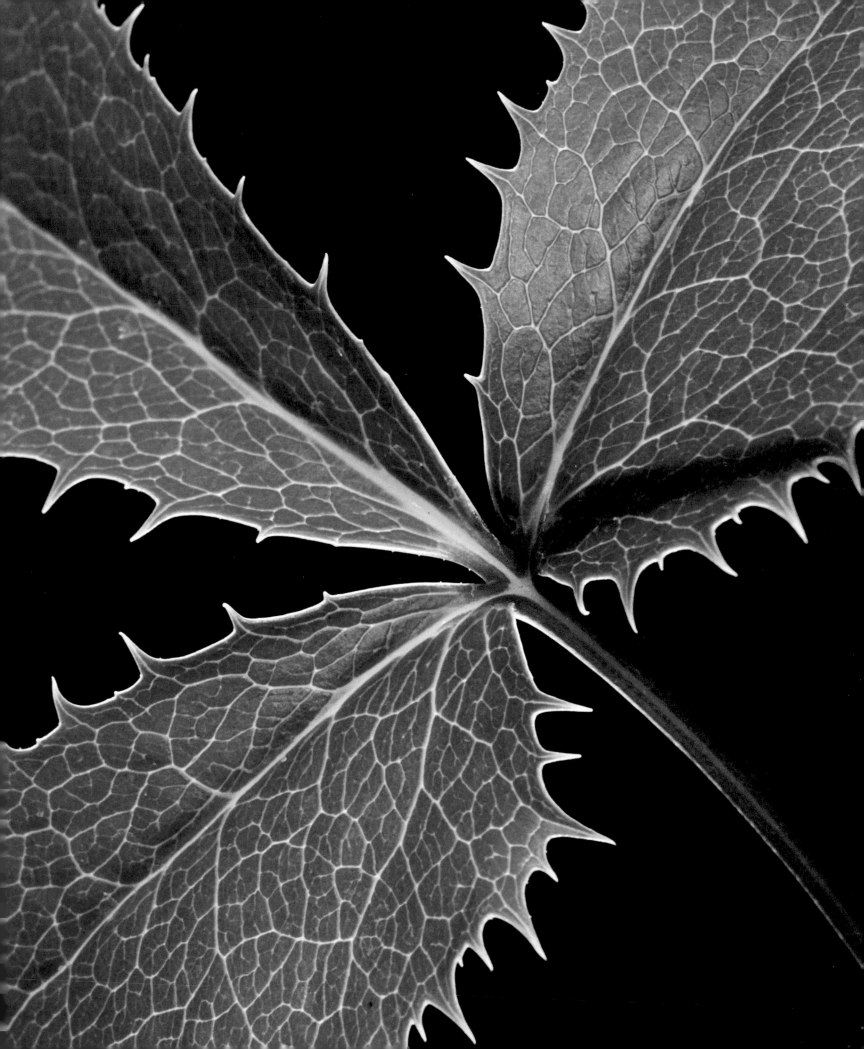

marijuana

CANNABIS SATIVA has many common names, some well known and used globally, others derived from regional slang. To risk sounding like the sound track to the musical *Hair*, we could rhyme off a few of its most colorful pseudonyms: Mary Jane, MJ, pot, dope, doobie, ganja, grass, green, hash, hemp, nugget, reefer, stash and shee-ba. It also goes by Mexican gold, Colombian gold, Thai weed, Indica, Wacky tobacky and Maui wowy.

Cannabis is grown commercially all over the world and has naturalized in quite a few regions. It has numerous uses. Cultivation for its fiber, called hemp, is a booming industry all over the world excluding the U.S.A., where it is illegal to grow the plant for any purposes. Hemp is used to make hundreds of products, including rope, paper and all types of textiles. Its oils and seeds are used in health foods and it is an increasingly popular source of "green" fuel.

Evidence that cannabis was being used for its psychoactive and physiological effects dates back to 8,500 BC. It is known to have been a component of Neolithic tribal rituals, and many ancient peoples — early civilizations in Iraq, Iran, Syria and Turkey as well as people in Central and Northern Europe, North Africa, Russia, China, Nepal and India — incorporated marijuana in their religious ceremonies. Shamans and spiritual leaders would burn the flowers and inhale the smoke to bring on trances and spiritual hallucinations. THC, or tetrahydrocannabinol, is the chemical responsible for the psychoactive properties in cannabis.

Religious organizations that base their beliefs around cannabis culture have also been founded within the past 100 years. Some even consider cannabis the Eucharist and its consumption a sacrament. The Rastafarian religious movement, started in the 1930s, included the use of cannabis, and its rituals have spread throughout the world. Marijuana was first introduced into North America by Indian laborers. After slavery was abolished, indentured workers were imported from India, and they brought their customs, foods and religions with them.

Until the early 20th century, there were no restrictions on the consumption of cannabis for recreational use. Nowadays, attitudes have changed. In many countries, small amounts of cannabis are confiscated if discovered, and its possession may be punishable by just a fine. In parts of the Middle East and Southeast Asia, penalties can be as strict as life imprisonment or execution.

Marijuana has been used for thousands of years in the treatment of medical conditions. Pro-cannabis organizations have touted the benefits of cannabis use in relation to depression, bipolar disorders, Alzheimer's disease, epilepsy, nausea, cancer, pain relief, multiple sclerosis, Tourette syndrome, glaucoma and AIDS. Synthetic extracts are being developed and researched for potential use as prescribed medications for some of these diseases and symptoms.

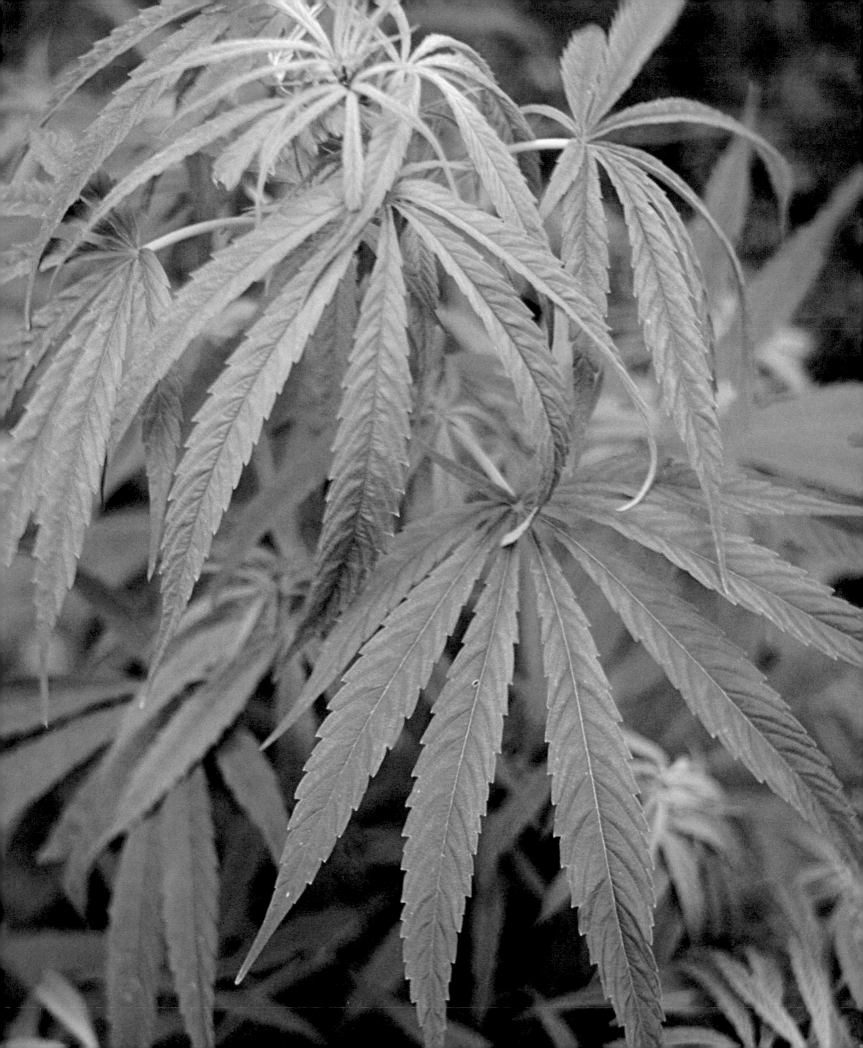

holly

ILEX, the botanical name for holly, is a large genus of plants that contains almost 1,000 species and cultivars. They can be found on all the continents except Antarctica and Australia. They are classified as shrubs or trees and range in size from dwarfs barely reaching a few inches tall to towering trees of 50 feet (15.2 m) or more. Most — not all — are evergreen, holding their leaves all winter. The typical holly leaf most people are familiar with is dark green and rather prickly around the edges; but many leaves are

pale green, variegated or golden-yellow and the texture can be smooth, crinkled or rough. Holly leaves come in all sizes as well, ranging from tiny round leaves that hug the stem to large floppy leaves that flutter in the breeze.

All hollies have a distinguishing characteristic: they have both male and female plants. A male must be fairly close to a female in order for pollination to occur. Although both will bloom, only the females set fruit. So, if you have a beautifully shaped female holly with dark luxuriant leaves and would like to have a nice crop of berries as well, hopefully there's a male somewhere in the neighborhood that will get the job done.

Variegated English Holly *(Ilex aquifolium 'Variegata')*

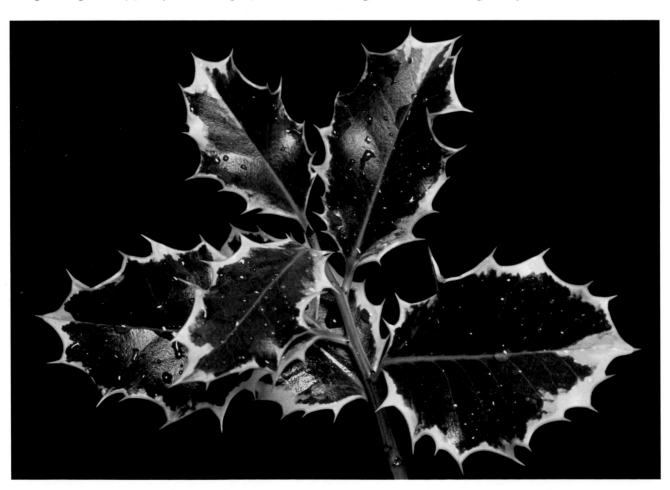

tetrapanax

TETRAPANAX PAPYRIFER goes by the common name of Rice-paper Plant or, in Chinese, *Tung-tsau*, which means "hollow plant." It's a native of Taiwan belonging to the Araliaceae family and is the only species in the genus *Tetrapanax*. It grows as a large shrub or small tree in most temperate and subtropical regions of the world. Typically it will attain a height of 4 to 16 feet (1.2 to 4.8 m) and spread extensively by means of underground runners. The dramatic gray-green, deeply lobed, maple-shaped leaves are quite broad, with a span of over 2 feet (0.6 m).

The name "rice-paper" is actually a misnomer, as it is the pith of the *Tetrapanax papyrifer* stem — not rice — that is used to make the smooth white paper. The paper was in use in China as early as 420 AD, but it wasn't until the mid-1800s that the plant was successfully brought to Europe. In Asia the pith of *Tetrapanax* was used to make artificial flowers and decorative hairpins, as it was easily formed, had good flexibility and strength, and could absorb dyes. Later in the 1800s it was formed into paper, which was then painted with watercolors.

Harvesting the plants to make pith paper became a widespread industry. The stems would have to be cut and the pith removed and dried out in the sun for several days. The lengths of pith were then peeled off in a long roll; highly skilled workers performed the peeling process with the use of special knives. Once peeled, the pith paper could be moistened and formed into shapes or relief patterns, and then painted or drawn on. Water-based hand-painted scenes became very popular in the West and tourists would buy them as postcards and picture books.

Tetrapanax also has some medicinal qualities. The pith paper has been used as a surgical dressing, the stem as a sedative, and the pollen for the relief of hemorrhoids.

Rice Paper Plant *(Tetrapanax papyriferus)* >

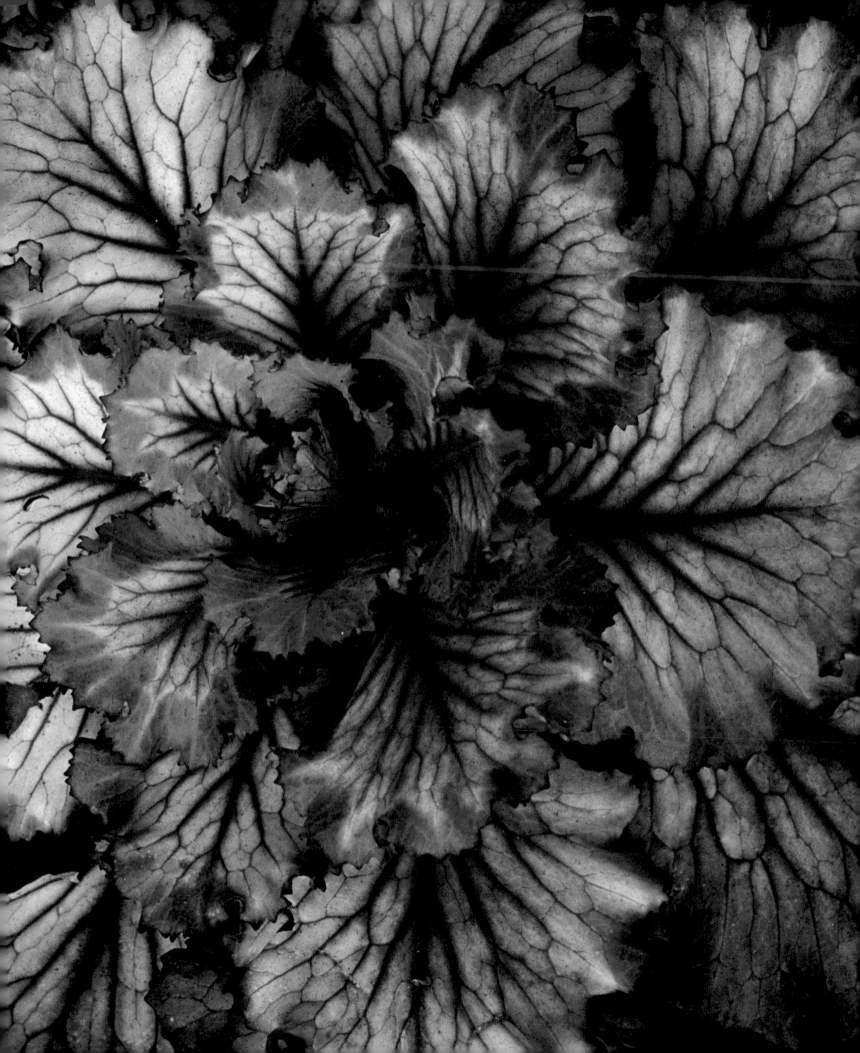

kale

< Flowering Kale *(Brassica oleracea)*

KALE IS ACTUALLY a form of cabbage. It is in the Brassica family along with many other vegetables such as collard greens, broccoli, cauliflower, kohlrabi and brussels sprouts. From the fifth to the 15th centuries, kale was one of the most common vegetables in Central and Northern Europe. It's easy to grow and extremely hardy, and the taste becomes sweeter and more flavorful after the plant has been exposed to frost.

The ornamental kales of today are just as nutritious as their plainer, less-festooned relatives, but they are a lot more fun to include in the garden. No autumnal garden display would be complete without its fair share of colorful kale and cabbage. Cool nights bring on the intense coloration of the leaves, which range from pure white to pink, red and deep purple. Leaf shape is also an interesting characteristic — combined, the edges of the ruffled leaves form large, highly decorative mounds.

The entire plant is undaunted by frost, snow and temperatures dipping well below the freezing point. Ornamental kales are great plants to grow near the kitchen door; if a garnish is needed for a mid-winter dish just reach outside and pick off a few leaves.

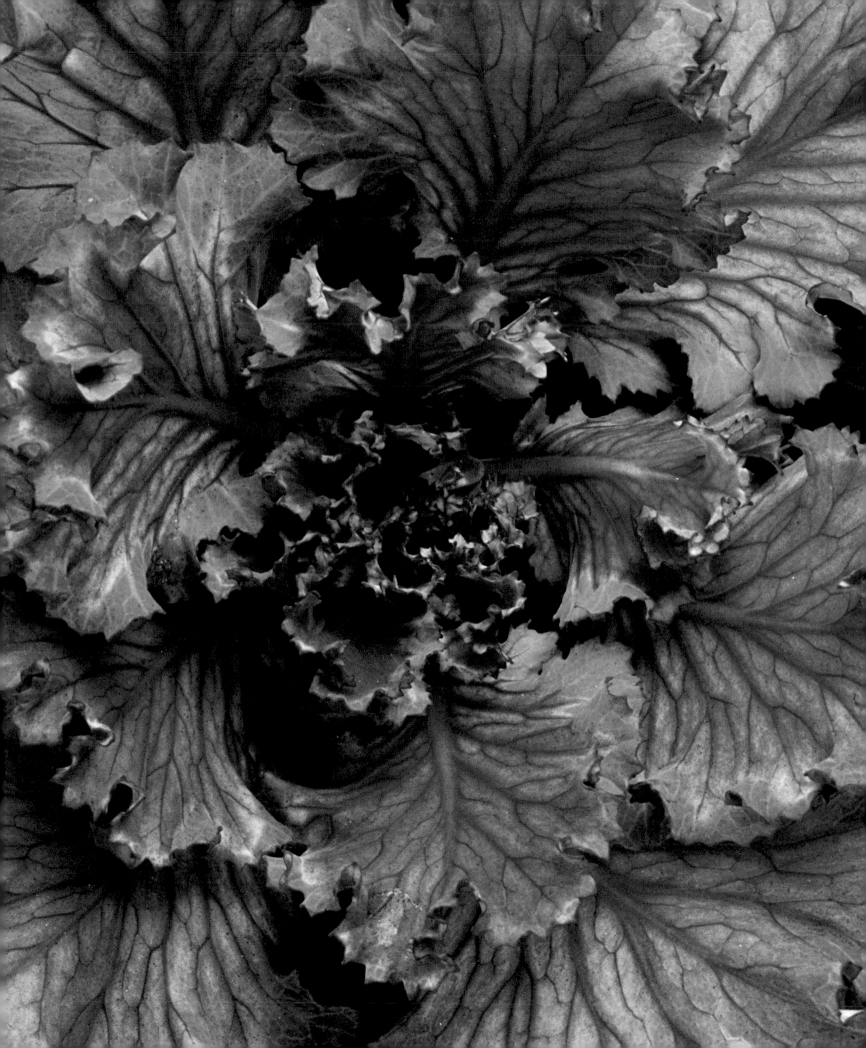

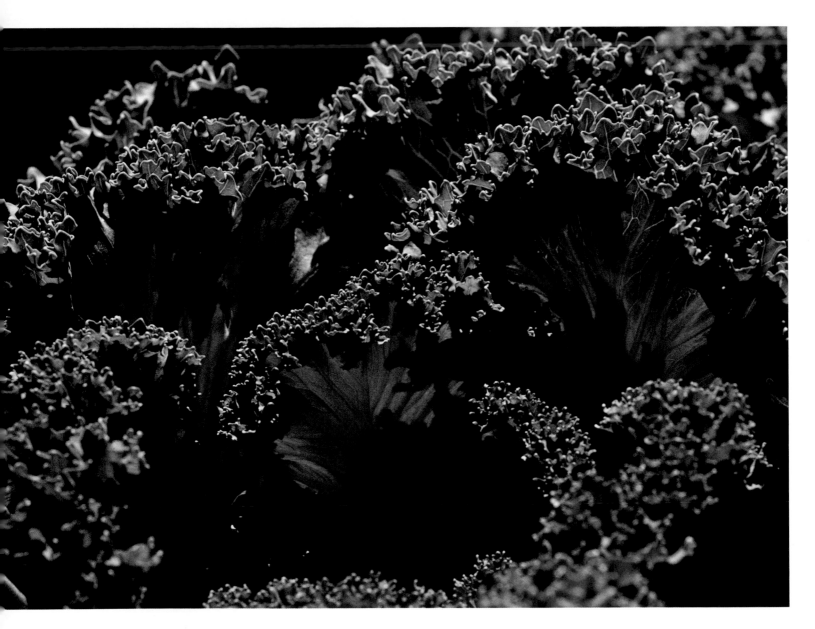

Flowering Kale *(Brassica oleracea)*

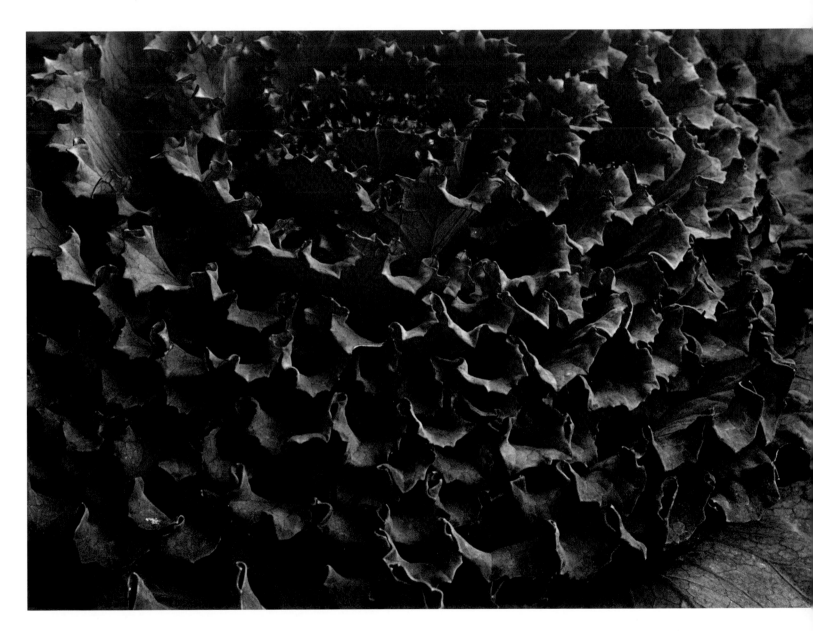

Chidori Red Flowering Kale *(Brassica oleracea 'Chidori Red')*

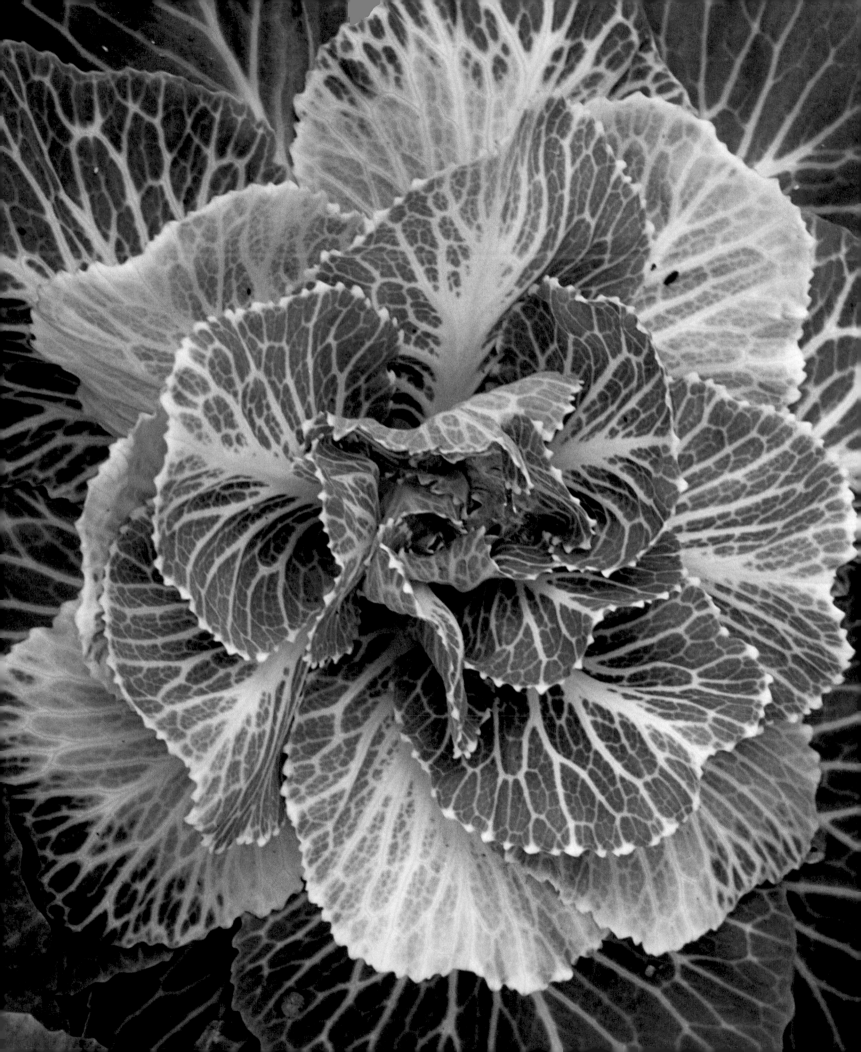

lettuce

LACTUCA SATIVA, or lettuce, as it is commonly called, is surprisingly in the daisy family. The lettuce that crowds our grocery store shelves today started out as a roadside weed. Through domestication and breeding lettuce has been miraculously transformed from a leafy, mildly bitter-tasting and nutritious plant to a compact, tight flavorless orb.

On the brighter side is the resurgence in popularity of organically grown leaf lettuce. Leaf-type lettuces come in a wide selection of shapes, sizes and colors. Tasty green leaf lettuce such as 'Waldmann's Dark Green' is the green grocers standby, and new types like 'Green Star' are grown to be eaten fresh from the garden or clipped as young plants and used in salad mixes. New introductions such as 'Blackhawk,' 'Marimba,' 'Antago' and 'Soltero' are all dark-red leaf types offering improved characteristics such as heat tolerance and disease resistance, and in some cases larger-sized, tastier and more colorful leaves.

Boston Lettuce *(Lactuca sativa 'Boston')* >
Red Leaf Lettuce *(Lactuca sativa 'Red Leaf')* >

< Flowering Kale *(Brassica oleracea)*

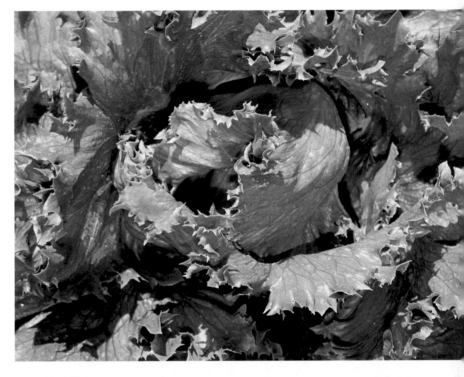

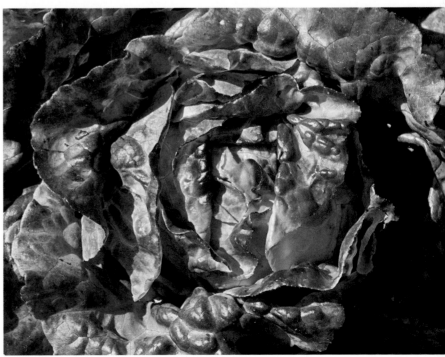

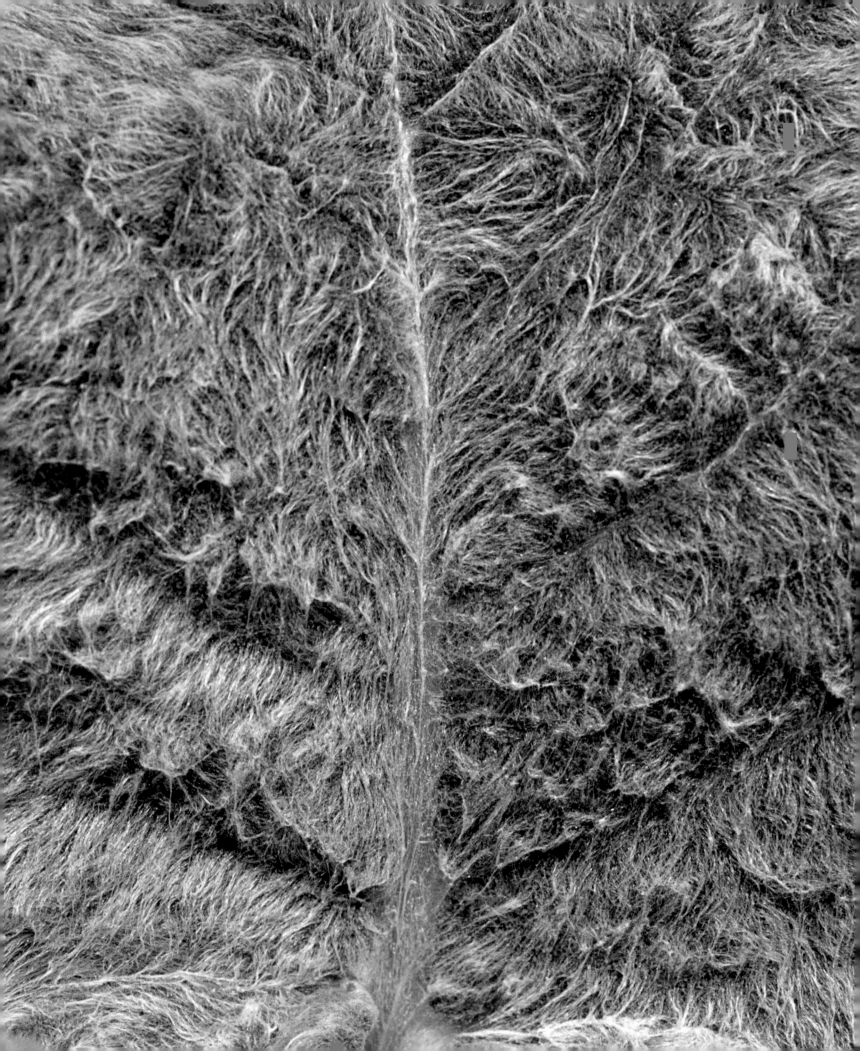

texture

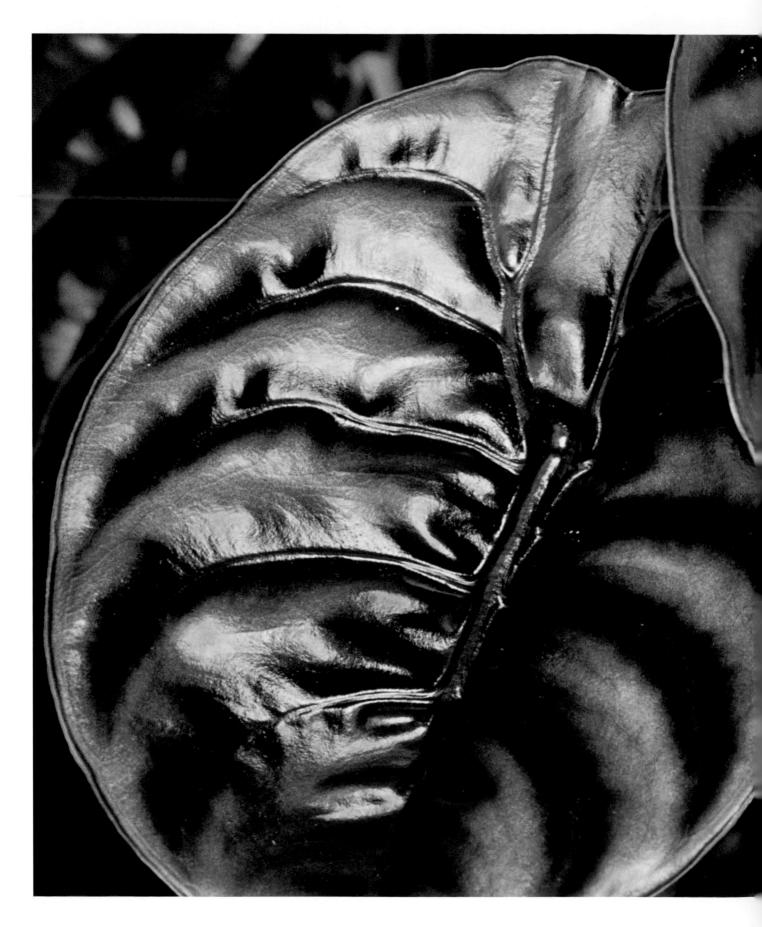

extraordinary leaves

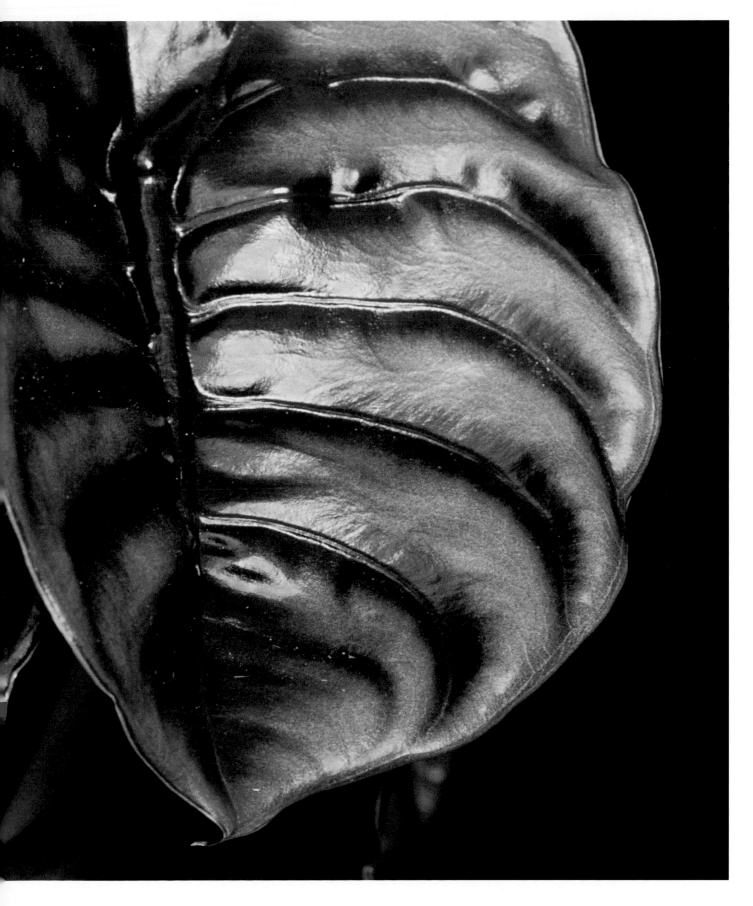

< Page 92 Copper Leaf Elephant Ear *(Alocasia cuprea)*

False Thistle *(Acanthus montanus)* >
Iron Cross Begonia *(Begonia masoniana)* >

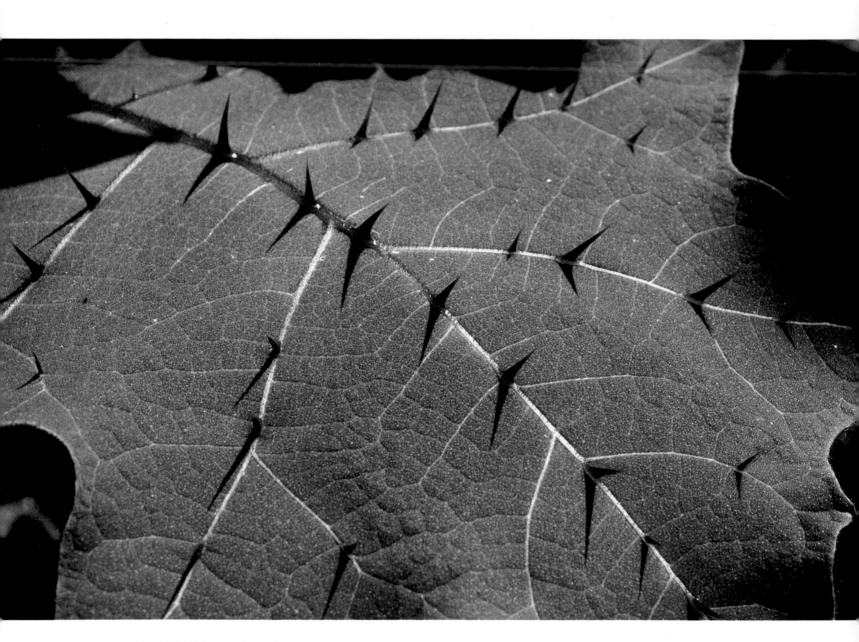

Naranjilla *(Solanum quitoense)*

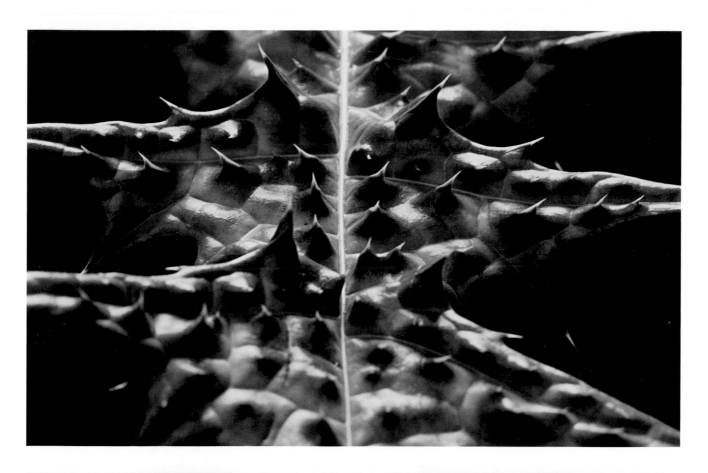

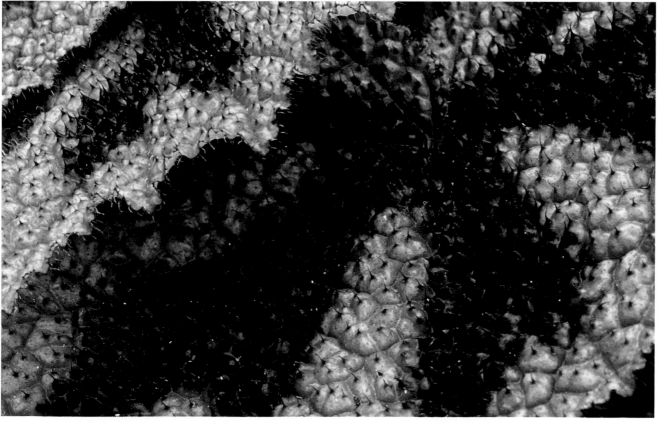

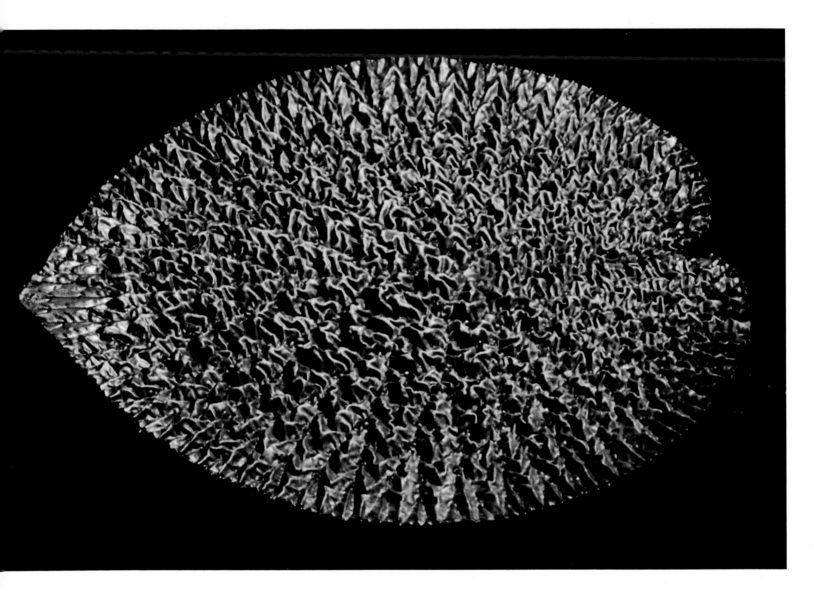

Prickly Waterlily *(Euryale ferox)*

extraordinary leaves

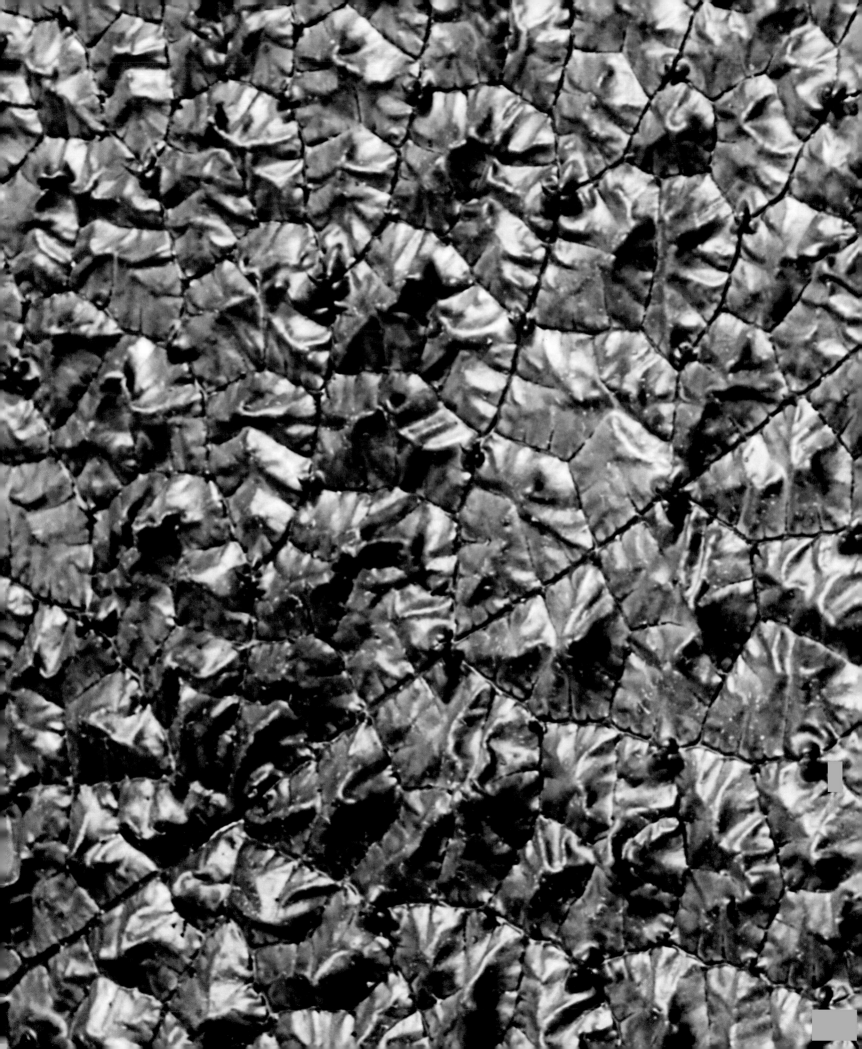

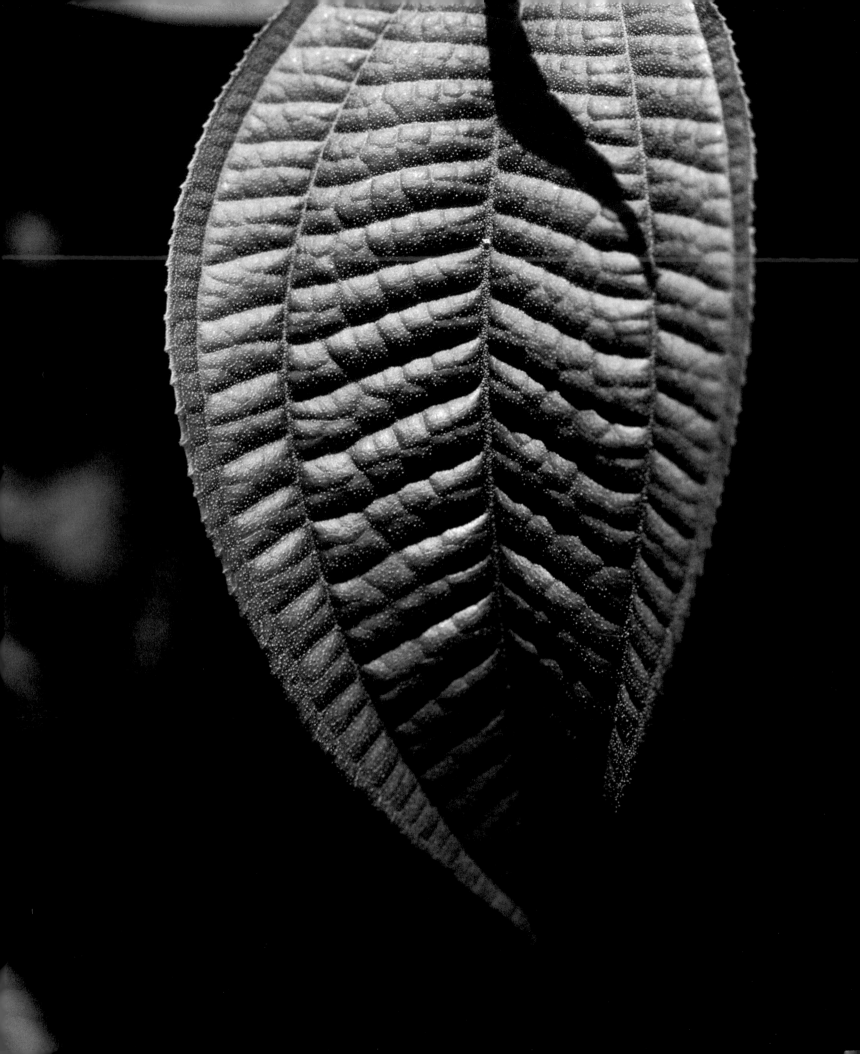

< Florida Clover Ash *(Tetrazygia bicolor)*

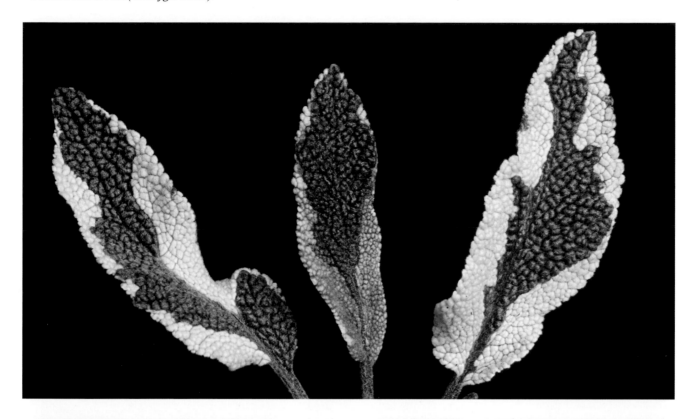

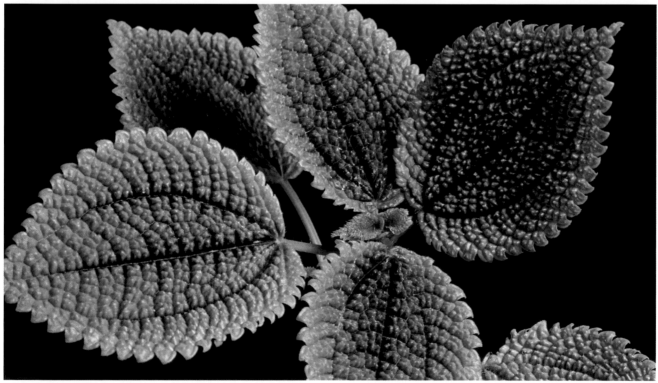

Salvia Tricolor *(Salvia officianalis 'Tricolor')*
Friendship Plant *(Pilea involucrata 'Moon Valley')*

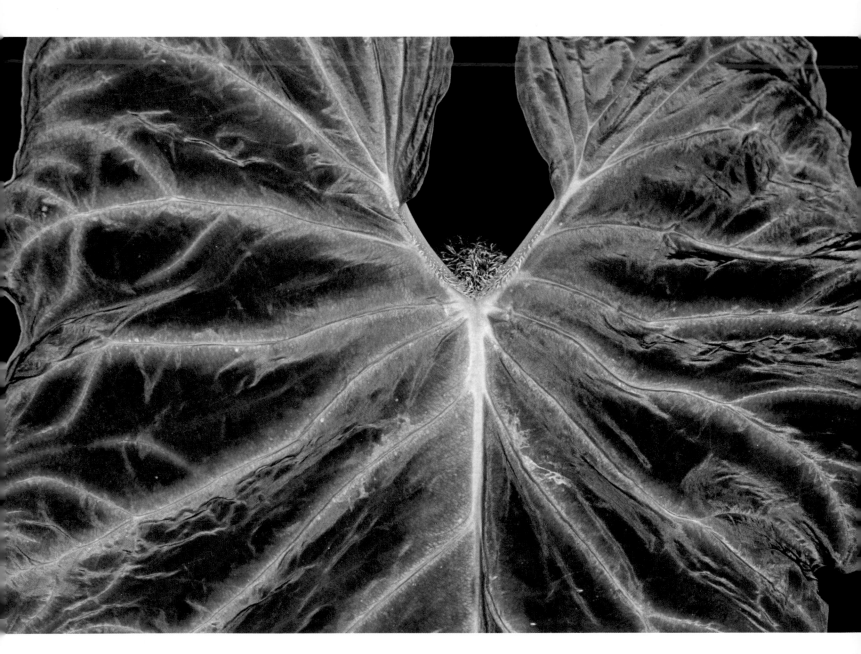

Giant Velvet Leaved Philodendron *(Philodendron verrucosum)*

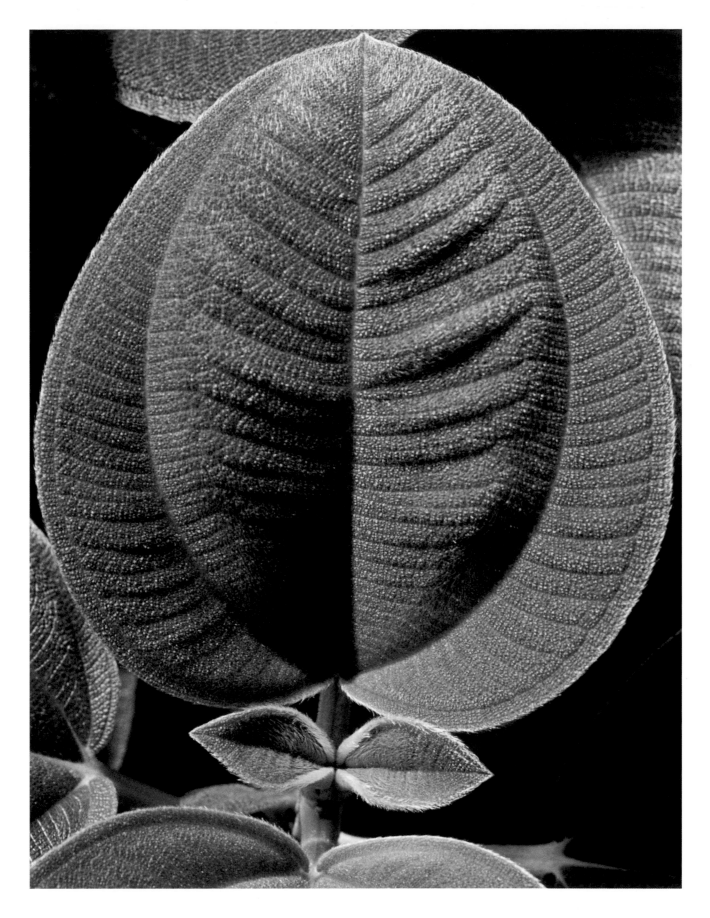

hosta

HOSTAS (*Hosta* sp.), which were named after Austrian botanist and physician Nicholas Host, are another group of plants whose Latin name is the same as their common name. They have a few other common names as well, such as Funkia and Plantain lily, and are in a genus of perennial plants containing about 40 species native to China, Korea and Japan. Hostas have become one of the most widely planted landscape perennials and are now cultivated all over the world.

Native stands of the oldest species (*Hosta plantaginea*) are still growing in Manchuria, South Korea and southern Japan. Hostas are a fairly recent arrival on the horticultural timeline, with some species being less than 15,000 years old. They were first introduced to Europe from Japan in the early 1800s by Philipp Franz von Siebold, the German physician and renowned plant collector. Extensive breeding in recent years has led to the appearance of over 5,000 cultivars, with new arrivals every year. Hostas are a diverse-looking group, with plants ranging from small ones classified as dwarfs, which have leaves about the size of a fingernail, to giants that attain leaf spreads of over 6 feet (1.8 m).

New and unusual cultivars of Hosta are quite the rage nowadays; foliage color, texture and shape are the utmost factors in breeding decisions. Most of the species are plain green, but new sports have appeared and cultivars have been developed with blue, gray and chartreuse leaf coloration. In addition to solid colors, every type of variegation, striping, margining and streaking imaginable can be found. Leaf textures range from smooth and glossy to intensely puckered, fluted and ruffled.

August Lily *(Hosta plantaginea)*

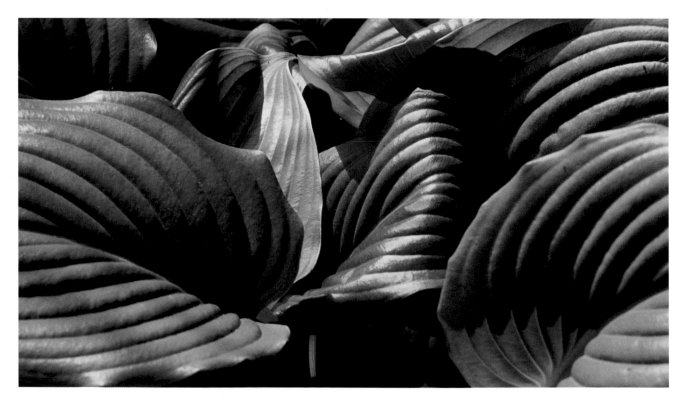

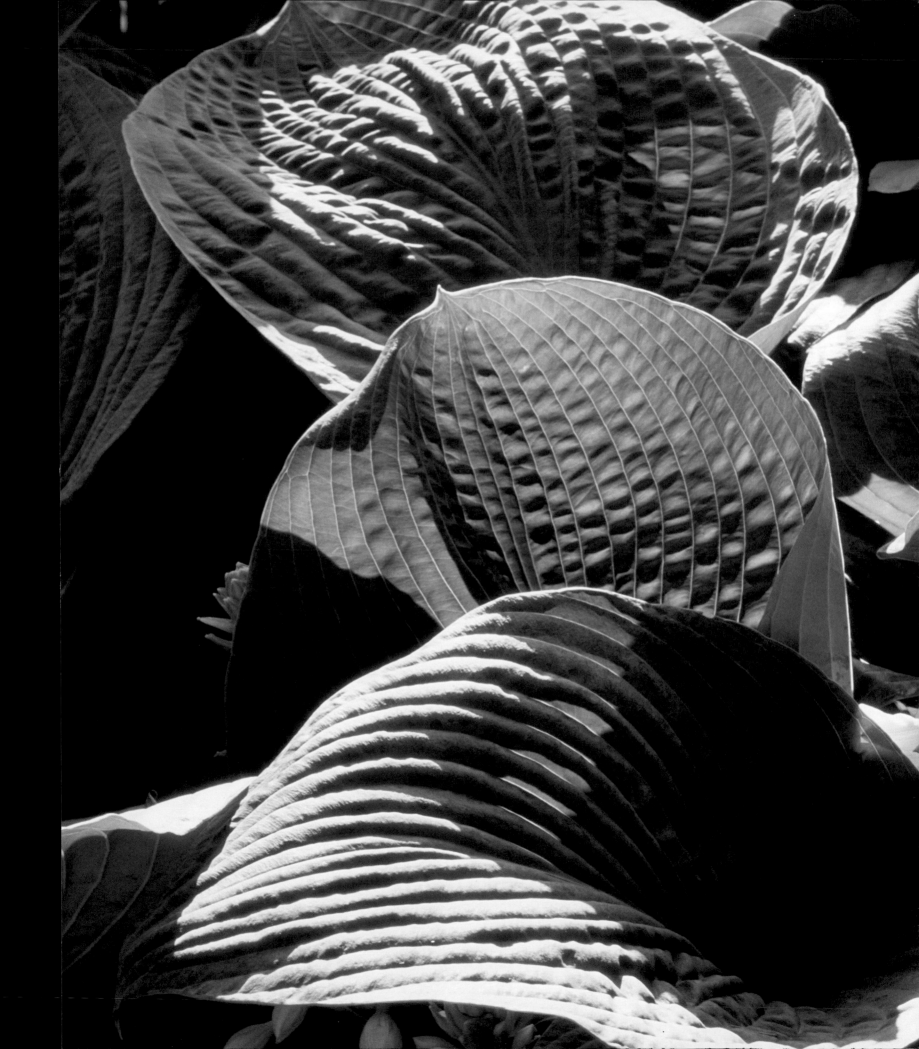

solanum

THE HUGE GENUS *Solanum* belongs to the family Solanaceae, which includes some very common everyday plants as well as bizarre and unusual ones. Members of this genus are part of almost all categories of plants including annuals, vegetables, perennials, trees and shrubs. The Solanaceae family, which is one of the largest, has about 85 genera and over 2,800 species, of which 1,400 are in the *Solanum* genus alone. They are distributed throughout most regions of the world, with the majority hailing from the Americas.

The word *solanum* is Latin for "Nightshade plant," a common name that derives from the pharmacological properties of the species. Solanaceae are referred to as the Nightshade family. Many common names for members of this genus convey negative or malevolent connotation: Cockroach Berry, Bittersweet, Wolf Apple, Devil's Thorn, Sodom's Apple and Bluewitch Nightshade, to name a few. The toxic and potentially fatal members of the family include Angel's Trumpet (*Brugmansia* sp.), Jimson Weed (*Datura* sp.), Mandrake (*Mandragora* sp.) and Deadly Nightshade (*Atropa belladonna*).

Belladonna is one of the most toxic plants found in nature; as few as three of the sweet, appetizing little berries, a small piece of root — or even a leaf — can be fatal. They all contain the alkaloid poison solanine, which acts as a natural insecticide to combat and defend against destructive insects and predators. Various members of the Solanaceae family contain toxins in only parts of the plant such as the fruit, leaves or stems, or even exclusively in the new growth.

Not all solanums are harmful. *S. betaceum*, or Tamarillo, the tree tomato, is grown as a food crop in much of South America, Portugal, New Zealand and parts of Africa. The egg-shaped fruits range from the size of a cherry to that of a plum tomato and grow on small well-branched trees reaching 16 to 18 feet (4.8 to 5.4 m). The sweet-tasting fruits are eaten raw and used as an ingredient in sauces and relishes.

S. quitoense, named after Quito, the capital of Ecuador, goes by the common name of Naranjilla or Lulo. Its edible fruits are eaten as well, and they can be juiced and made into a delightful beverage. Lulo is also grown as an ornamental. It has large beautiful khaki-colored leaves covered with decorative purple hairs and thorns, and small white star-shaped flowers that are followed by the fruit.

S. pyracanthum, another interesting solanum, is cultivated for its uniquely shaped leaves studded with bright orange Pyracantha-like thorns. Additional Solanaceae family members appreciated for their horticultural beauty are Brugmansia, with their beautiful large fragrant trumpet-shaped flowers, *Brunfelsia*, aka 'Yesterday-today-and-tomorrow,' flowering tobacco, petunias, *Solandra*, *Streptosolen*, *Datura*, *Cestrum* and ornamental peppers.

Some of the plants that we regularly use as food, spices and pharmaceuticals are in the nightshade family. Tomato, eggplant, pepper, tobacco and potatoes are all members and have some amount of solanine toxin in them, potatoes being among the highest.

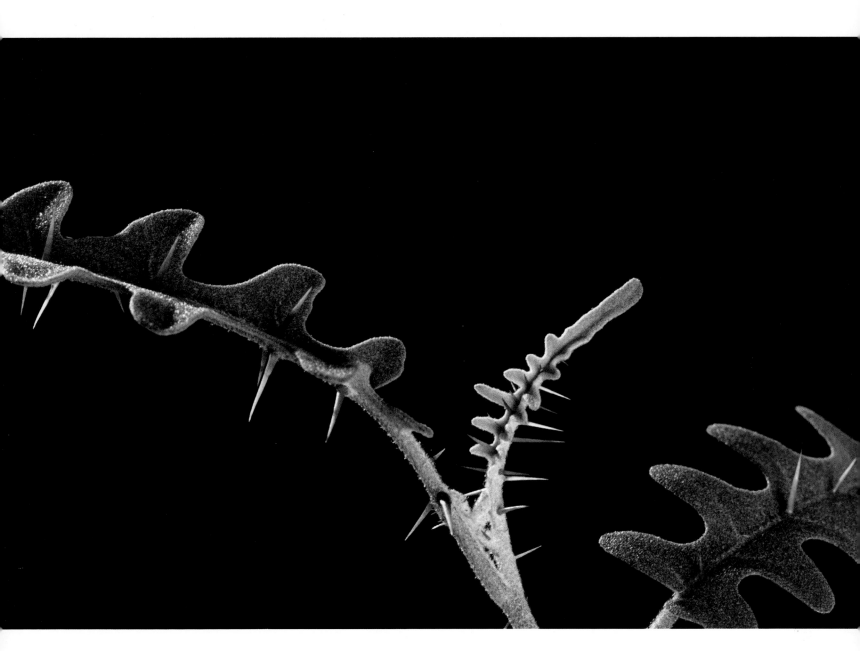

Porcupine Tomato *(Solanum pyracanthum)*

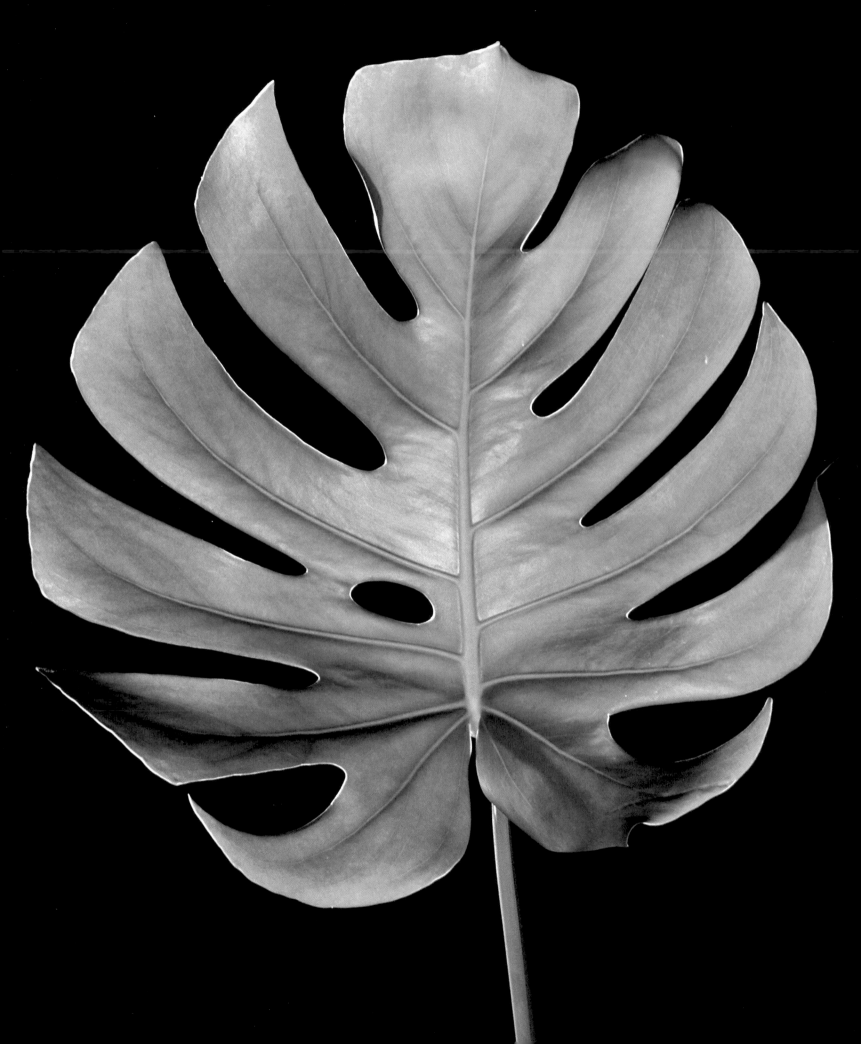

shape

DESCRIPTIONS OF THE SHAPES of leaves can be a bit more detailed than "thin," "round" or "maple-like." Fascinating descriptive names, their origins based on ancient Latin terminology, have been in use for thousands of years. Taxonomic botany — that is, the naming of plants — uses descriptive terms referring primarily to the reproductive parts of the plant. Leaf arrangements and shapes are usually employed as secondary descriptors. Adjectives such as "ensiform," for instance, which means "sword-shaped and having an acute point," would best describe a blade of grass or the leaf of an iris.

Some Latin words are fairly easy to recognize and understand. An example would be "orbicular," which is used to describe leaves that are perfectly round or orb-shaped like those of the nasturtium or water lily. But there are lots of such words that don't reveal their meaning quite so easily: "flabellate," coming from the Latin word *flabellum* meaning "fan," accurately describes the shape of ginkgo leaves. "Panduriform," an adjective derived from the Latin word *pandura*, translates to "three-string lute," so leaves having a fiddle shape would have the term added to their name.

Sometimes what we would generally consider a single leaf is actually made up of numerous leaflets. The leaf itself may only be a fraction of an inch long but arranged with others in a pinnate, bipinnate — or even tripinnate — design. Such arrangements sometimes take on enormous proportions and make an entire configuration look huge.

As a result, leaves can take on very un-leaf-like shapes and become so changed in appearance that they actually look like something else. Plants have developed leaf shapes by adapting and evolving to meet their specific needs. Leaves have turned into supports to hold plants up, drip tips for self-watering, cups to feed themselves and even nurseries to grow their young. Plants such as the *Amorphophallus bulbifer* have developed to form nodules on their leaves that mature into bulblets and then are gently deposited to the forest floor as the leaf dies. The mother fern has tiny replicas of itself growing along the edges of the leaf, so that when they mature they are easily brushed off and set free to establish a new generation.

Pitcher plants (*Sarrancenia*) and Monkey cups (*Nepenthes*) have evolved with specialized leaf adaptations that help them obtain nutrients. They trap unsuspecting insects, frogs, lizards and even small mammals, and digest them in leaves shaped like cups. The Venus fly trap (*Dionaea muscipula*) has an appendage at the end of its leaf that looks like a small fanged mouth. When an insect lands or crawls into it, small hairs trigger the leaf to snap shut and slowly digest the victim.

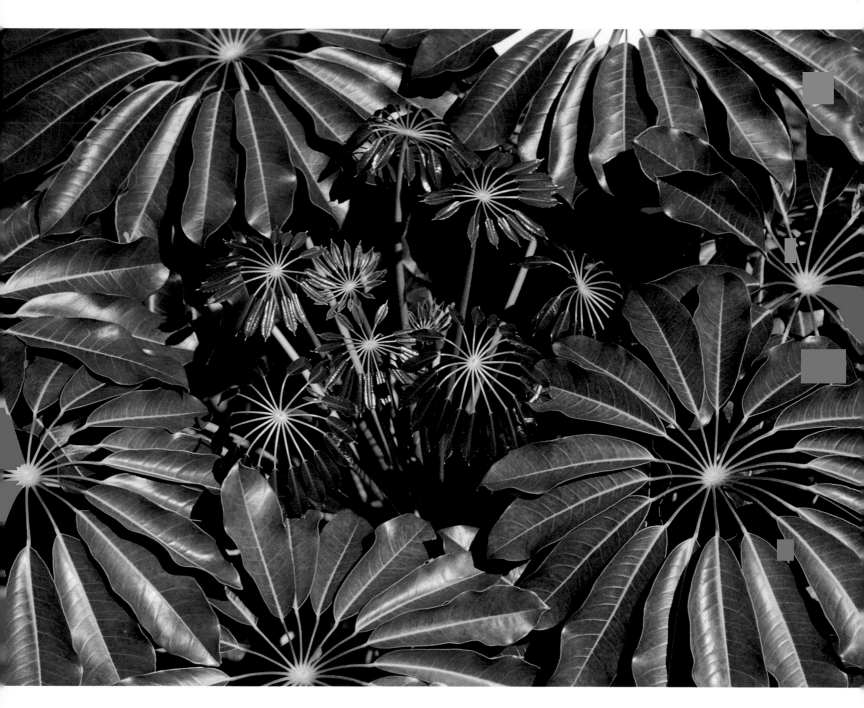

Umbrella Tree *(Schefflera arboricola)*

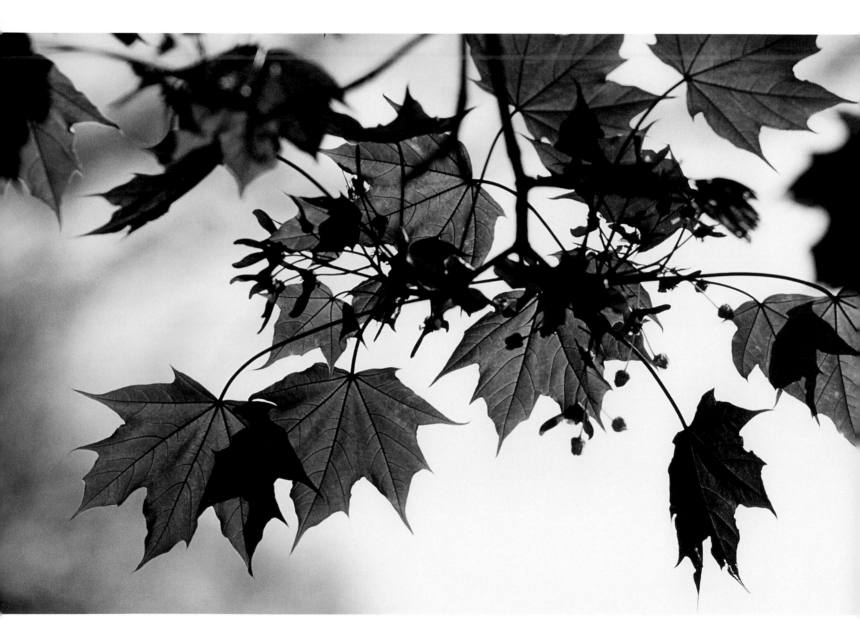

Schwedler Norway Maple *(Acer platanoides 'Schwedler')*

extraordinary leaves

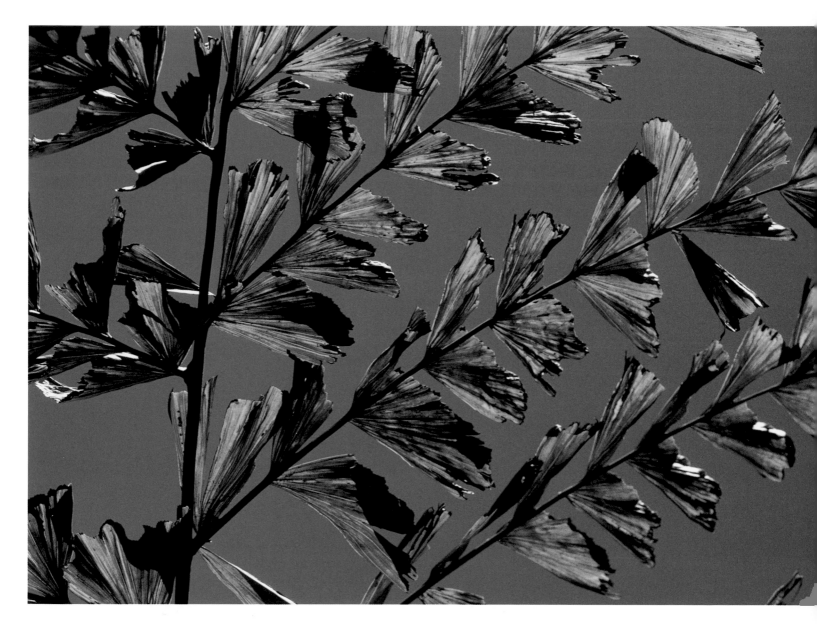

Fishtail Palm *(Caryota mitis)*

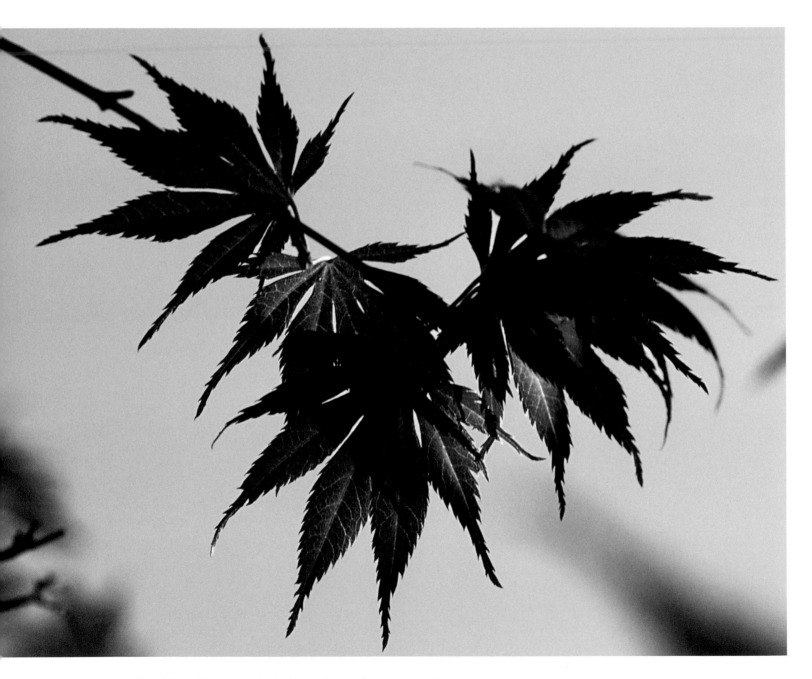

Blood-leaved Japanese Maple *(Acer palmatum 'Atropurpureum')*

extraordinary leaves

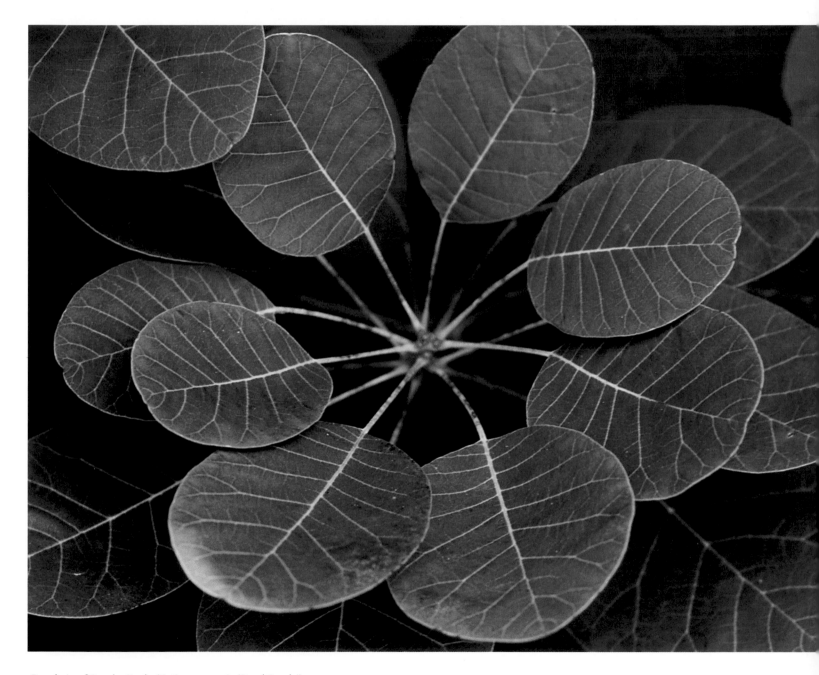

Purple Leaf Smoke Bush *(Cotinus coggygria 'Royal Purple')*

shape

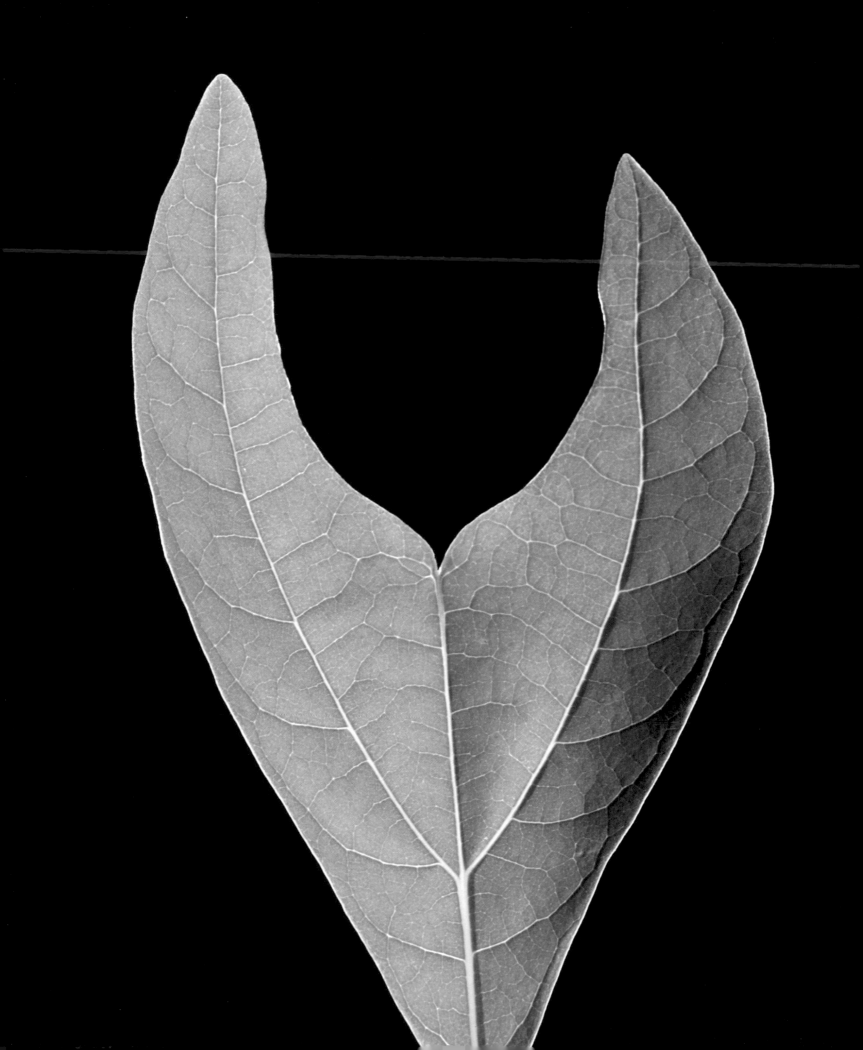

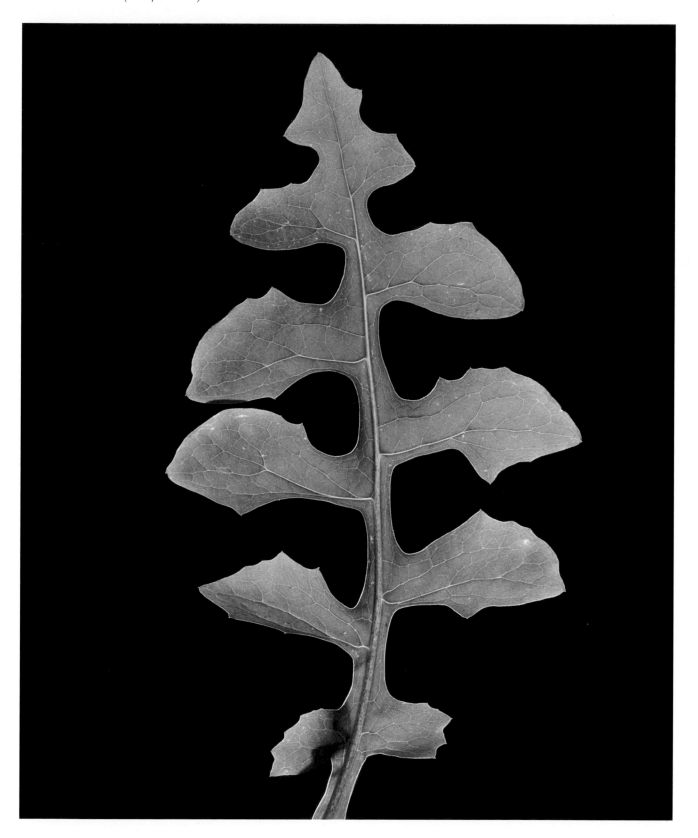

Rattlesnakeroot *(Prenanthes sp.)*

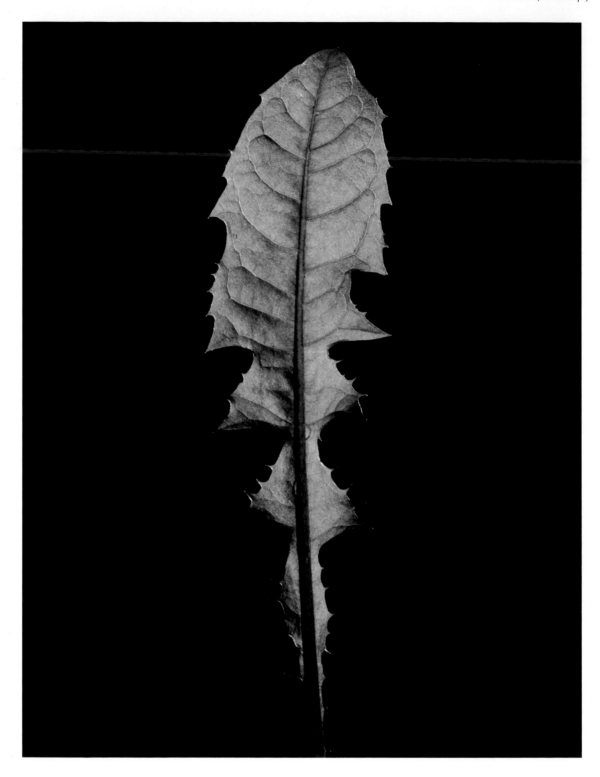

Dandelion *(Taraxacum officinale)*

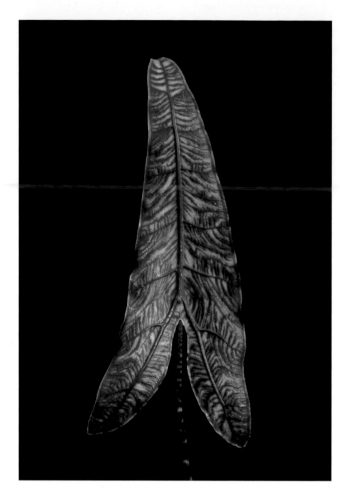

Alocasia Reticulata *(Alocasia zebrina 'Reticulata')*

Croton *(Croton sp.)*

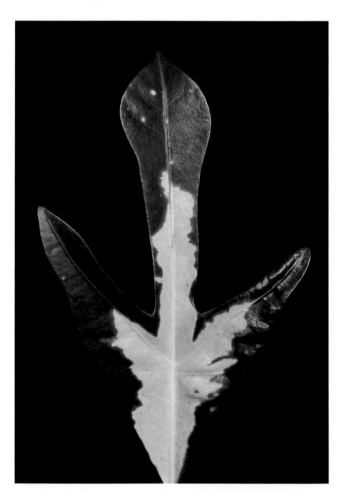

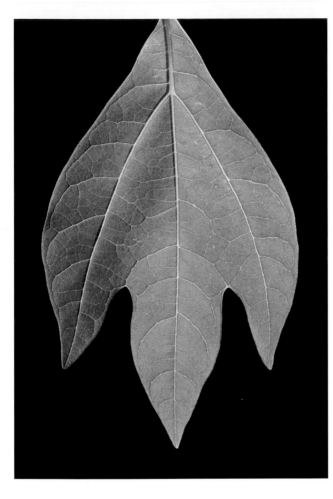

Chinese Sassafras *(Sassafras tzumu)*

Sweet Caroline Potato Vine
(Ipomoea batatas 'Sweet Caroline Bronze')

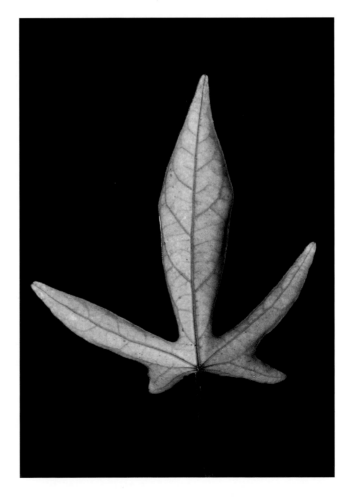

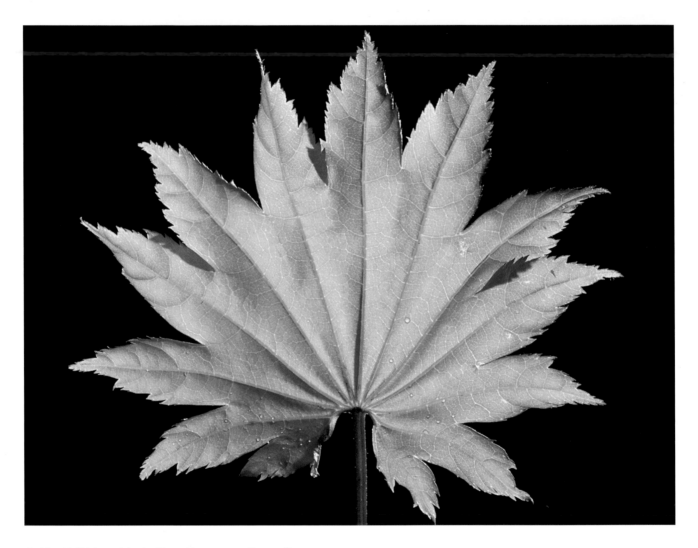

Golden Full Moon Maple *(Acer shirasawanum 'Aureum')*

extraordinary leaves

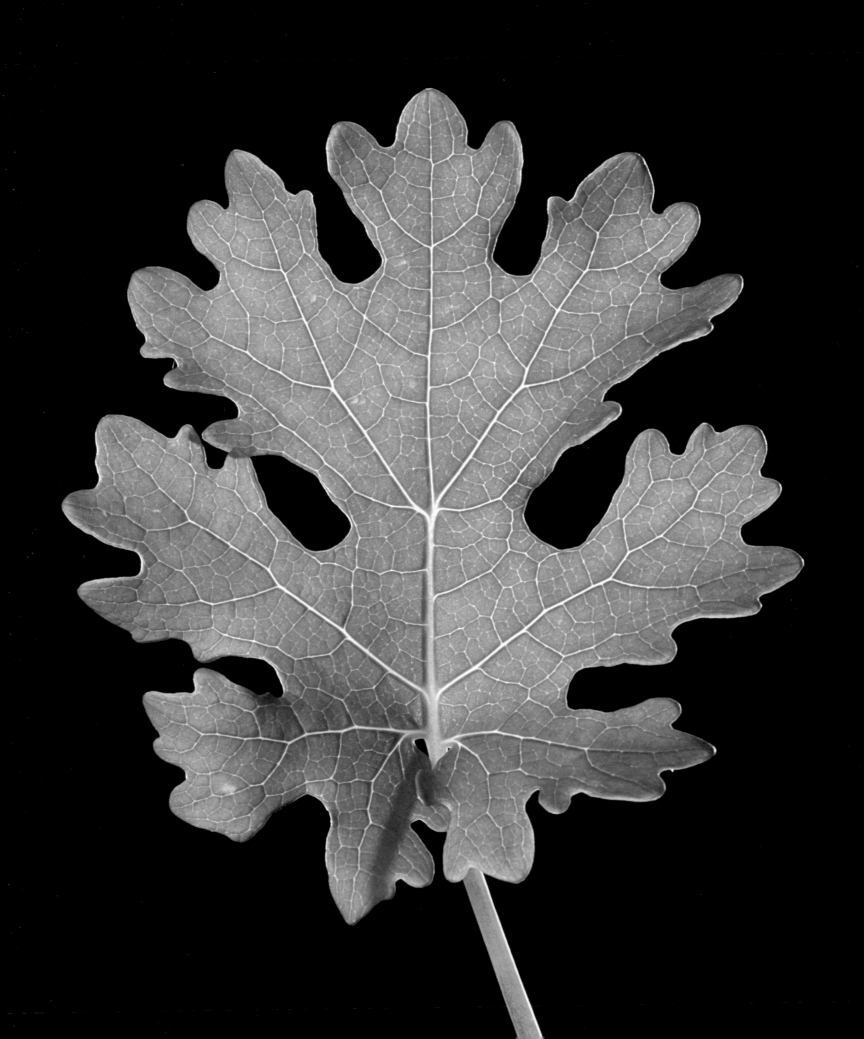

Swiss Cheese Vine *(Monstera obliqua 'Leichtlinii')* >

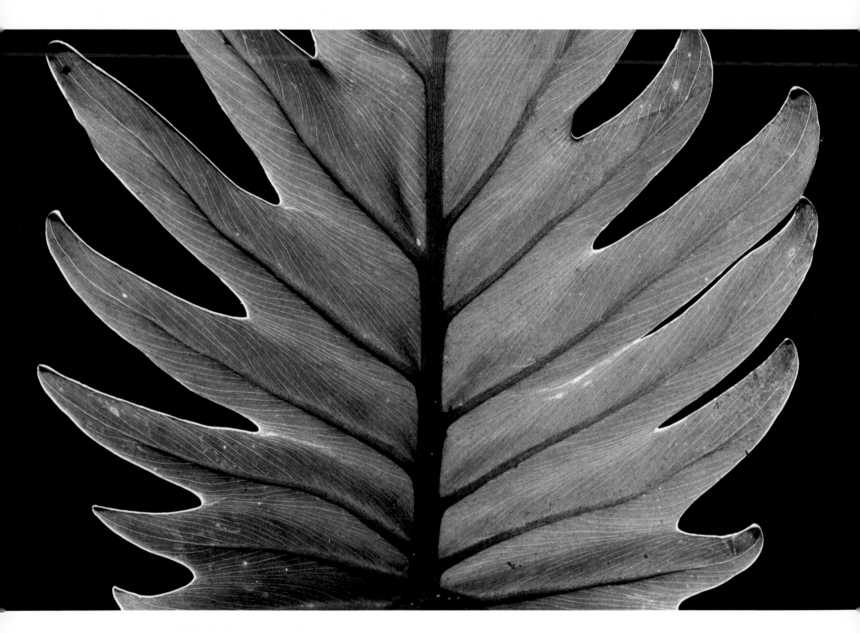

Cut Leaf Philodendron *(Philodendron selloum)*

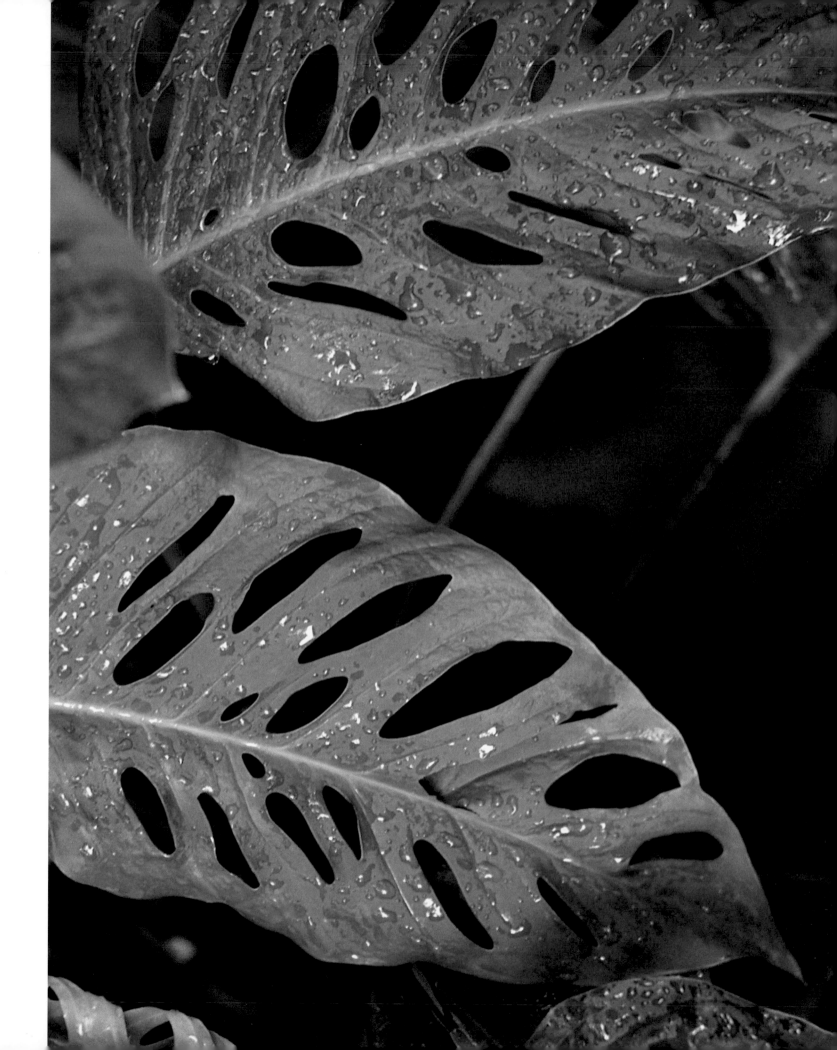

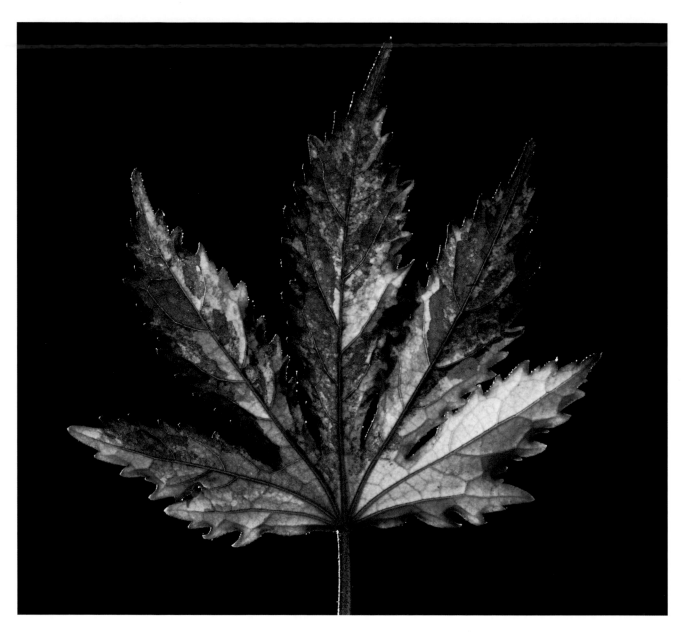

Hibiscus Haight Ashbury *(Hibiscus acetosella 'Haight Ashbury')*

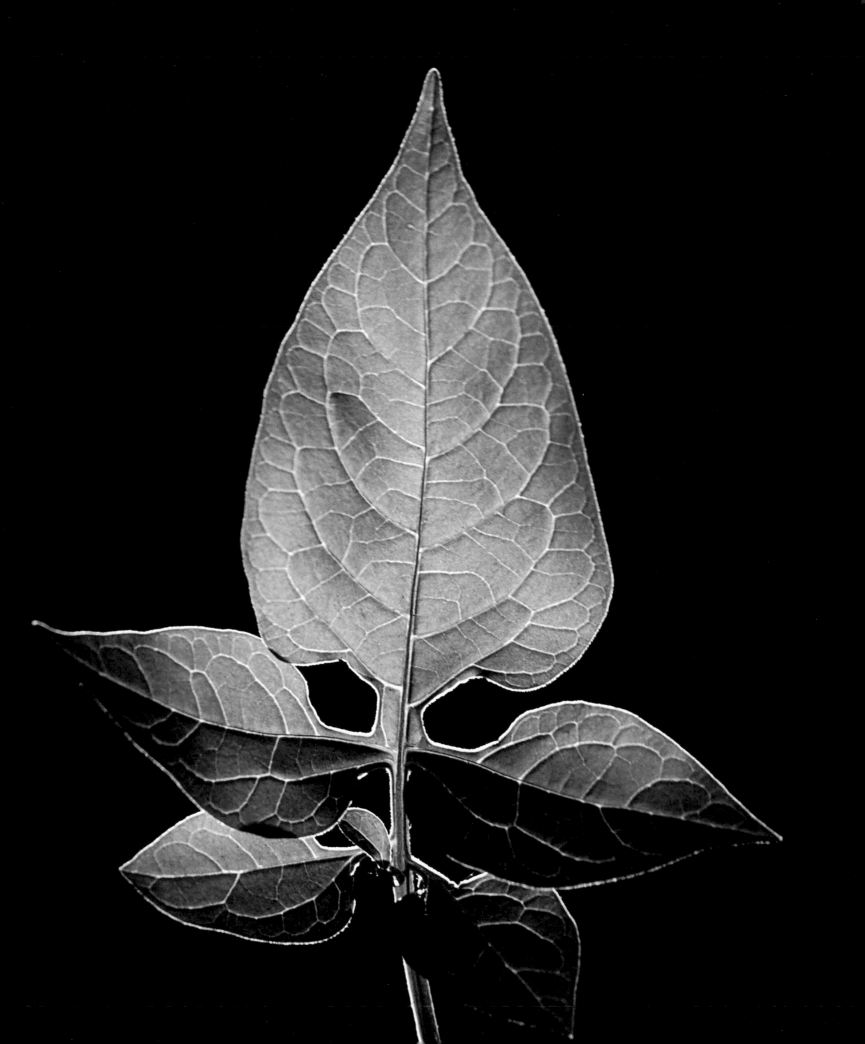

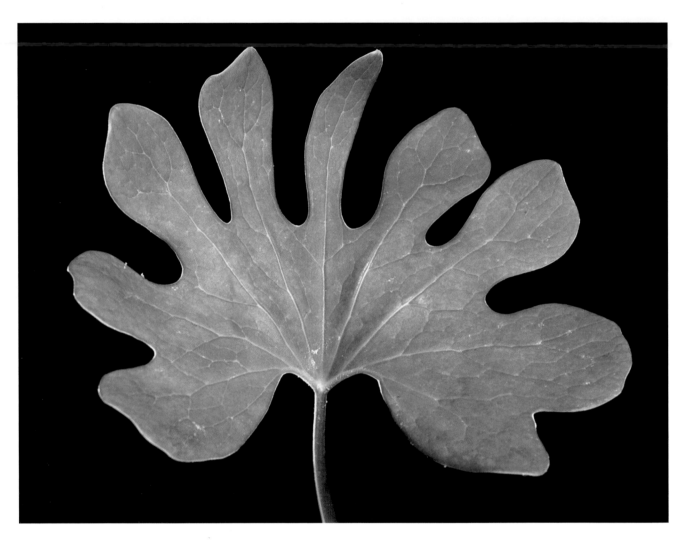

Bloodroot *(Sanguinaria canadensis)*

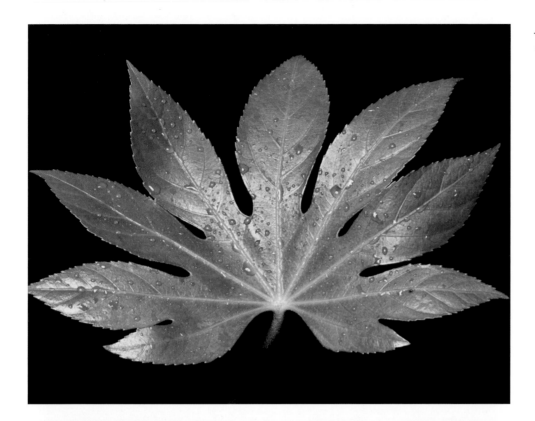

Japanese Aralia
(Fatsia japonica)

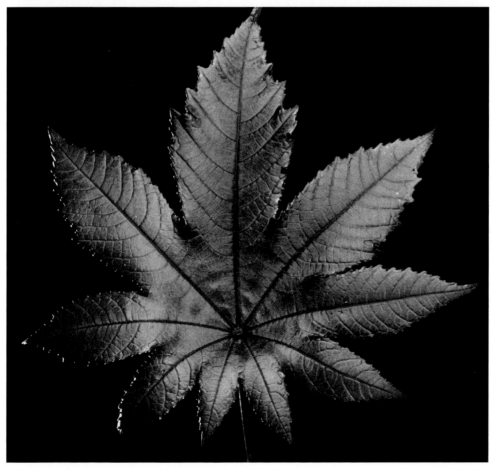

Red Spires Castor Bean
(Ricinus communis 'Red Spires')

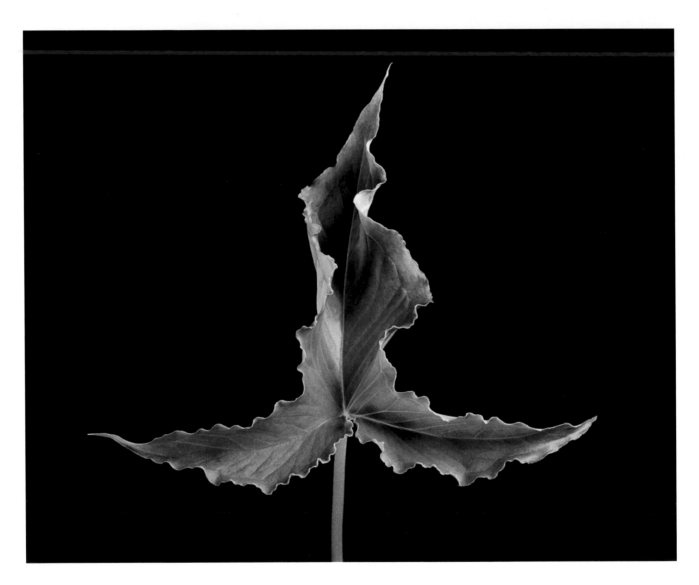

Crow-dipper *(Piniella ternata 'Ban-Xia')*

extraordinary leaves

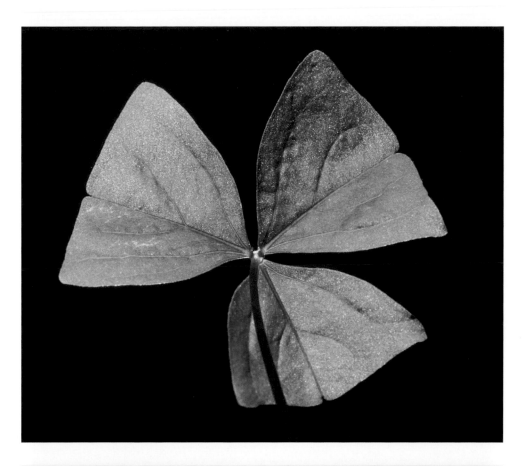

Wood Sorrel *(Oxalis sp.)*

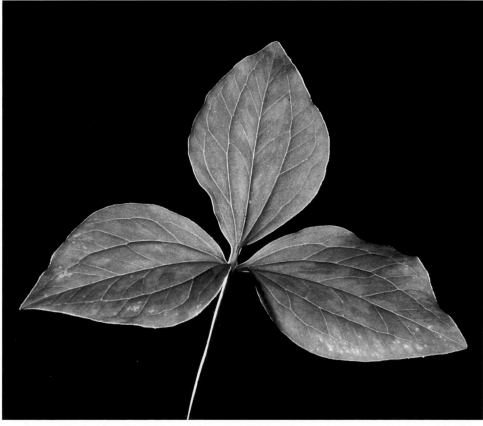

Large-flowered Trillium
(Trillium grandiflorum)

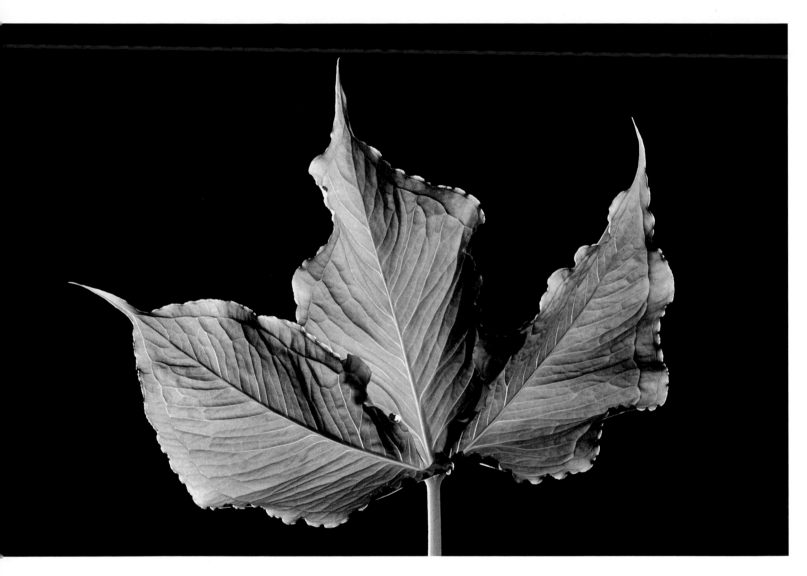

Crow-dipper *(Pinellia ternata)*

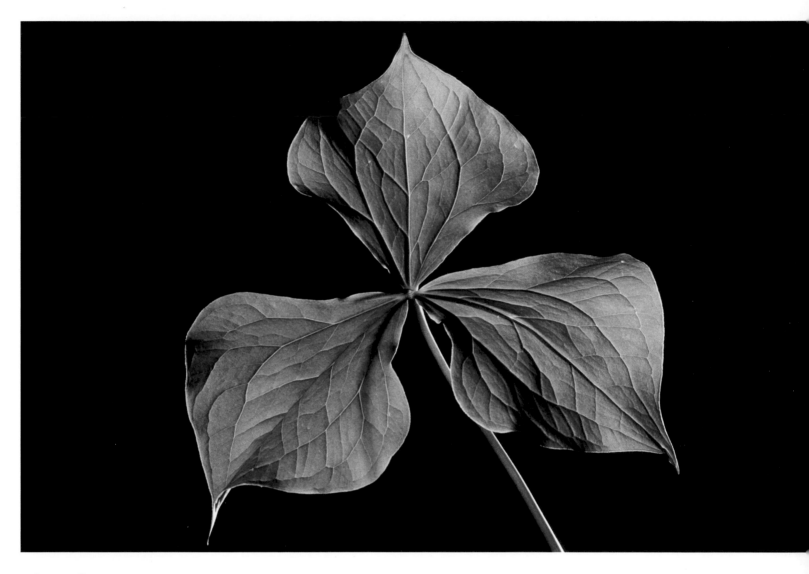

Trillium *(Trillium sp.)*

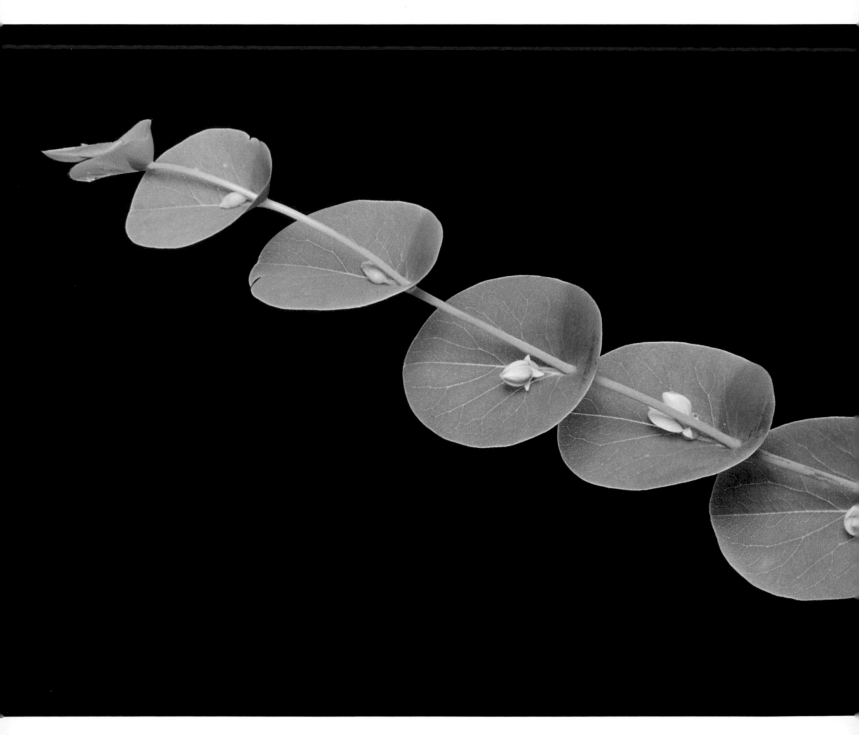

Catbells *(Baptisia perfoliata)*

extraordinary leaves

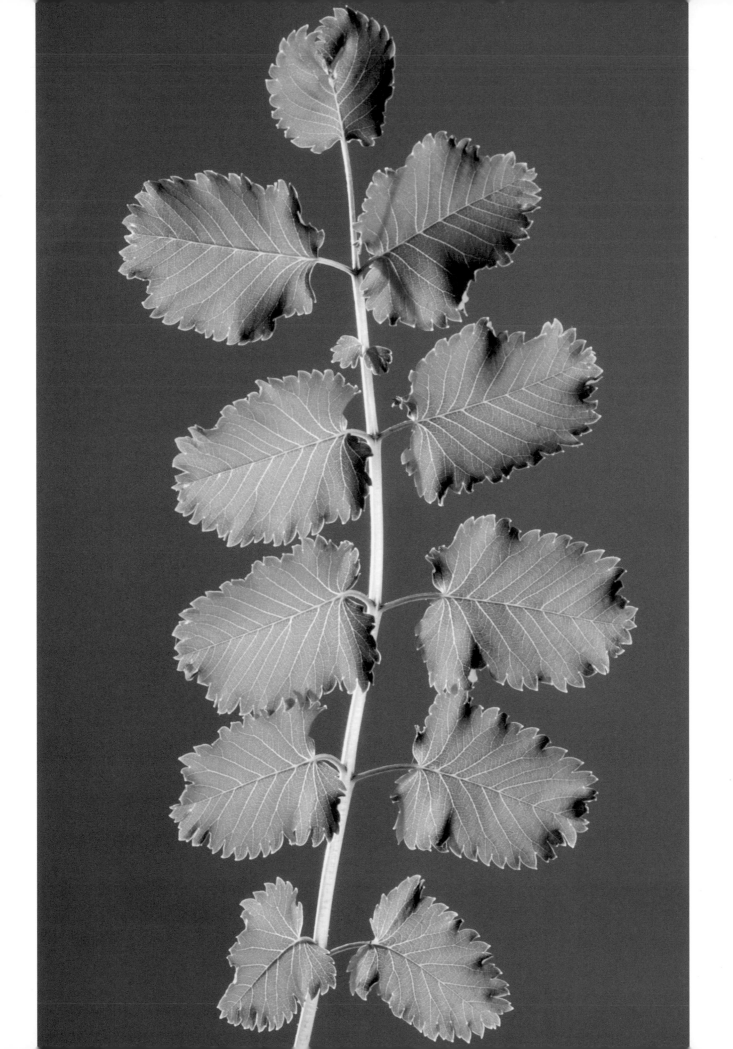

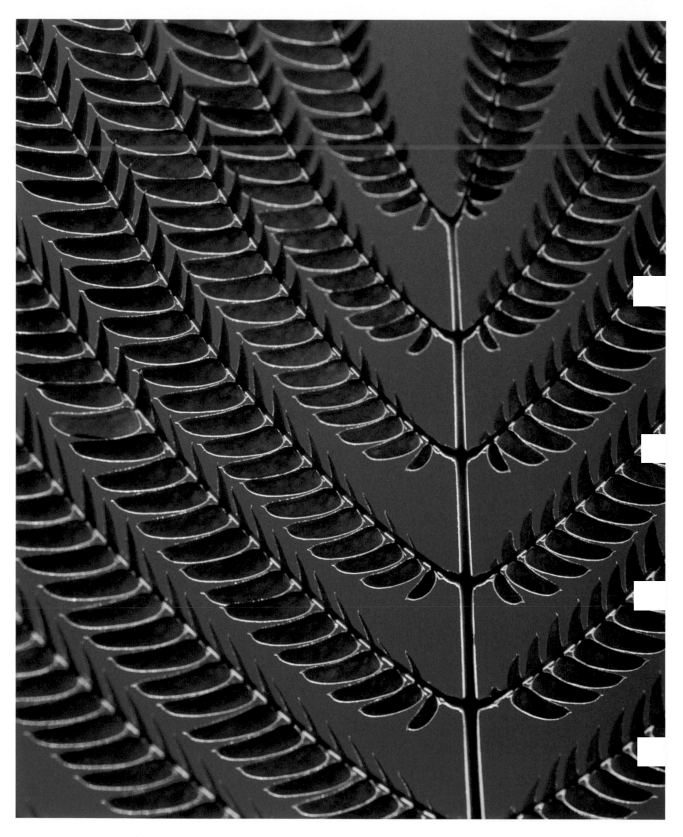

Mimosa Silk Tree *(Albizia julibrissin)*

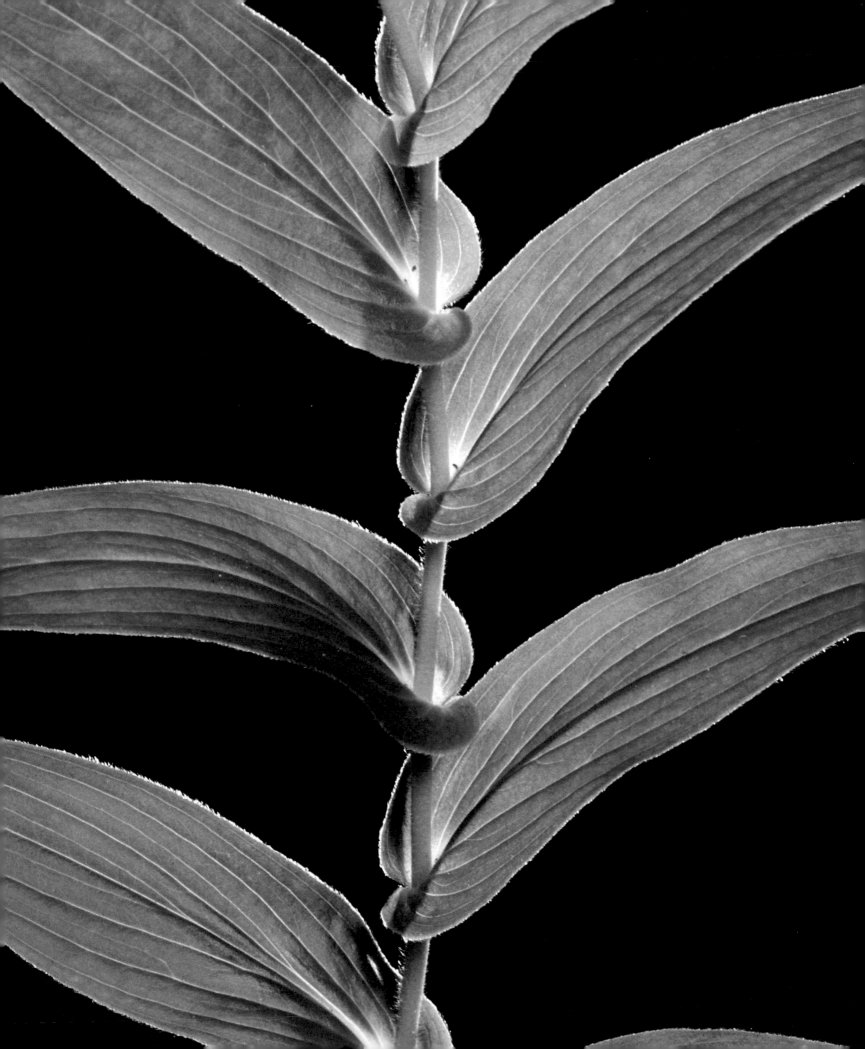

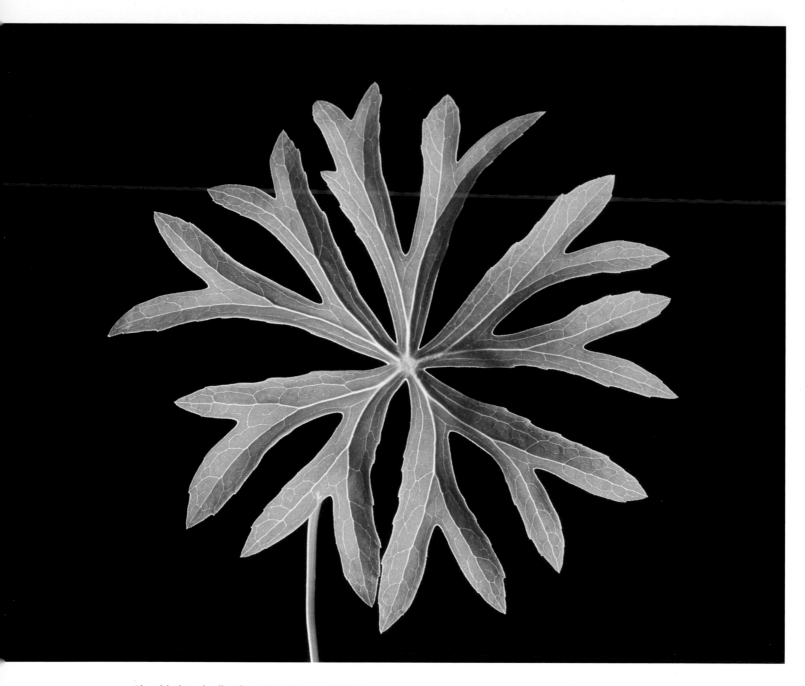

Shredded Umbrella Plant *(Syneilesis aconitifolia)*

extraordinary leaves

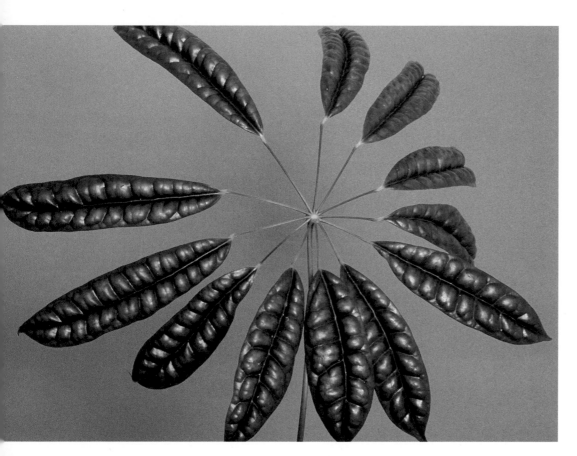

Umbrella Tree
(Schefflera arboricola 'Shining Star')

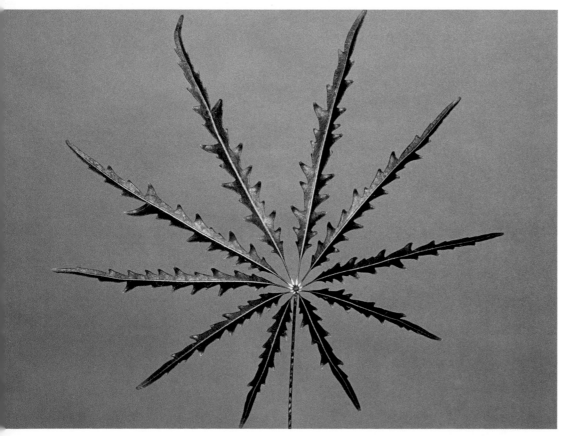

False Aralia
(Schefflera elegantissima)

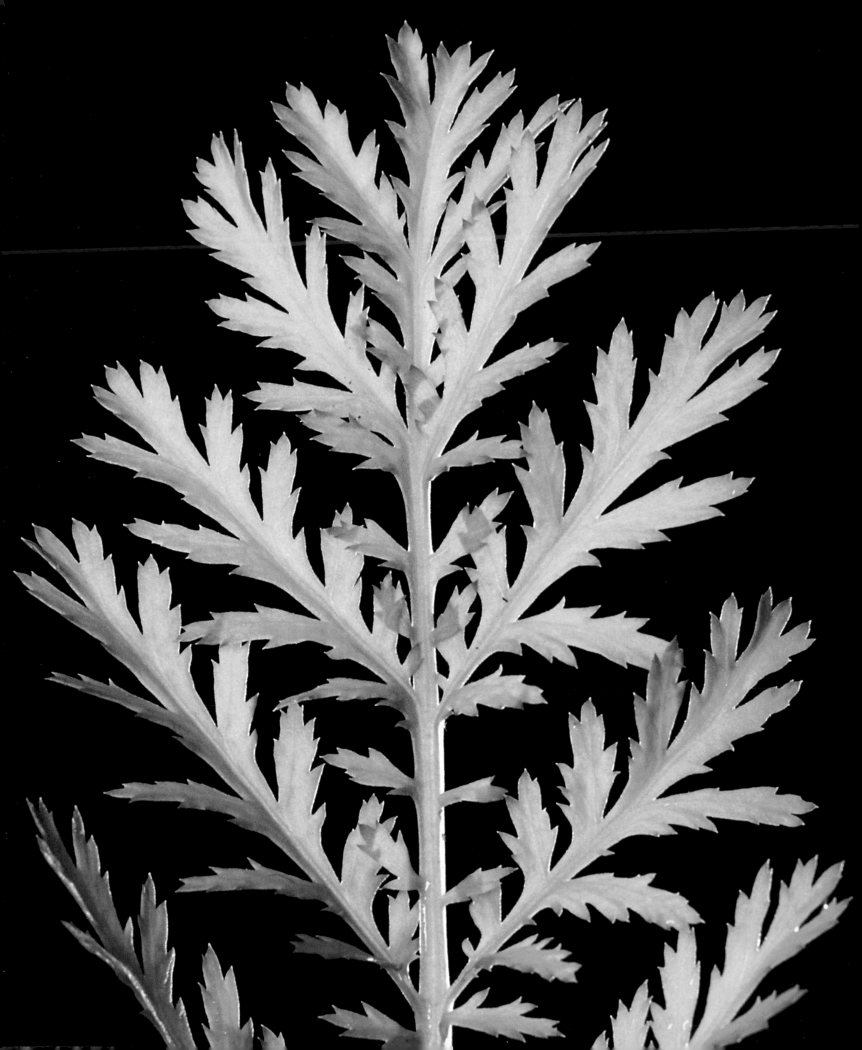

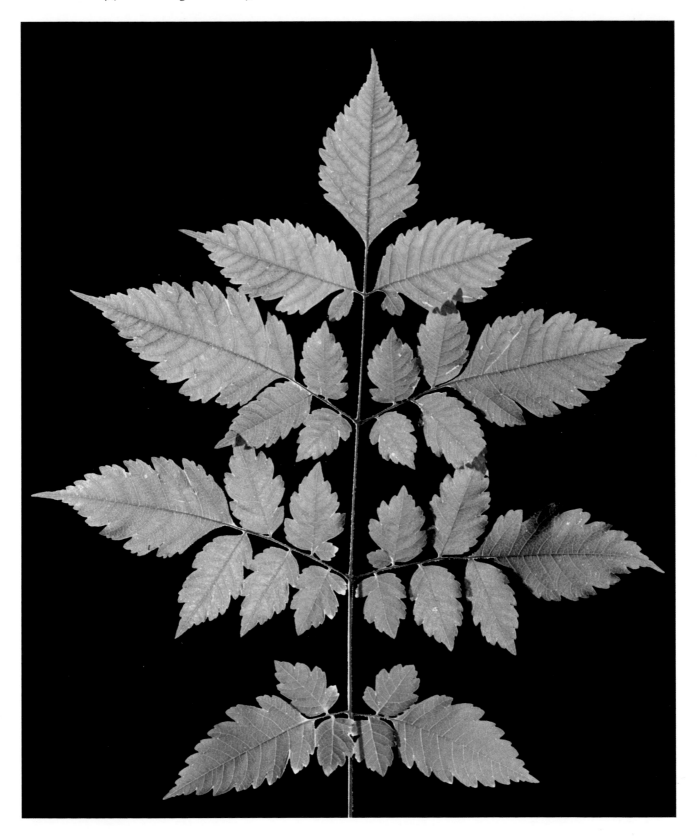

Golden Raintree *(Koelreuteria paniculata)*

Cut Leaf Philodendron *(Philodendron selloum)*

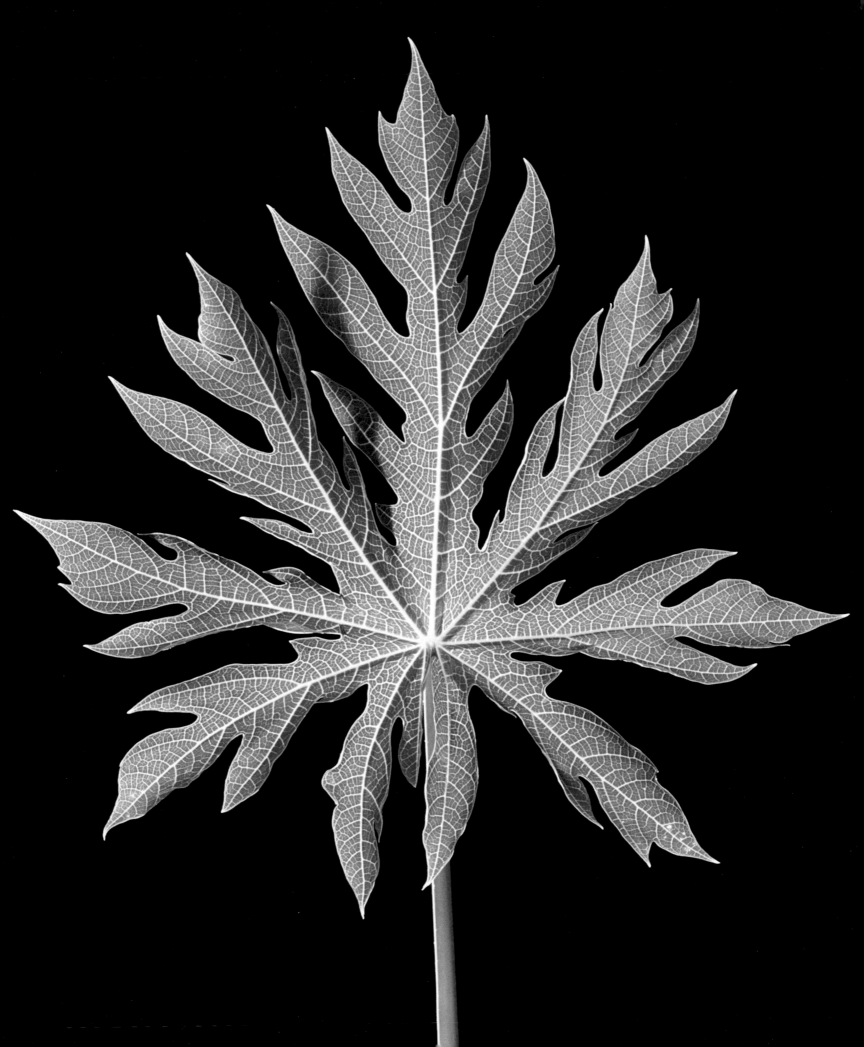

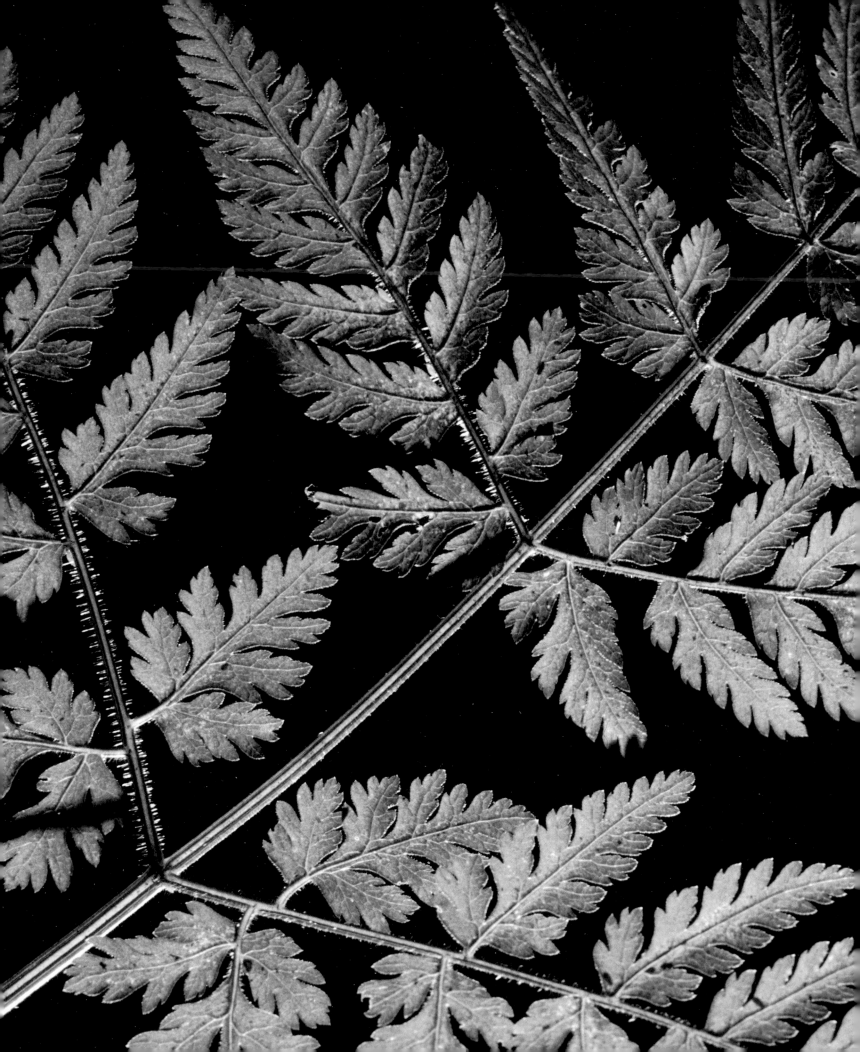

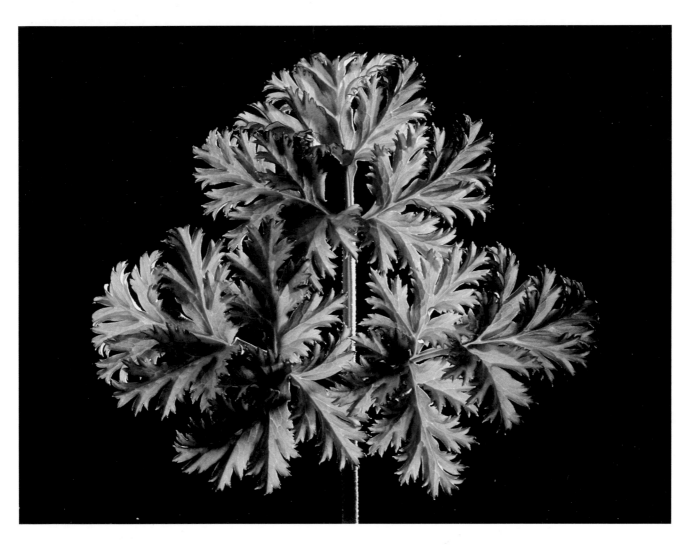

Hollandia Windflower *(Anemone coronaria 'Hollandia')*

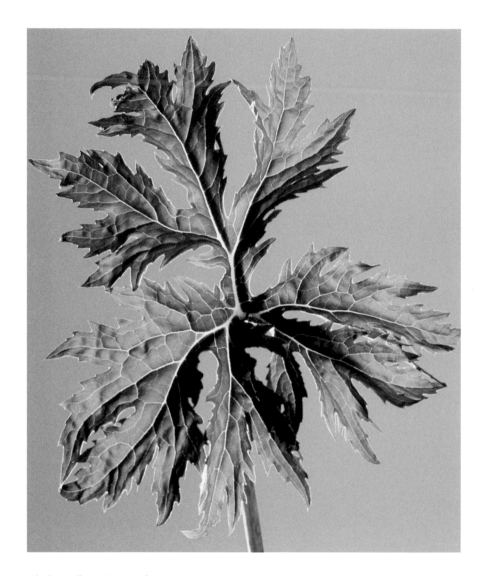

Glade Mallow *(Napaea dioica)*

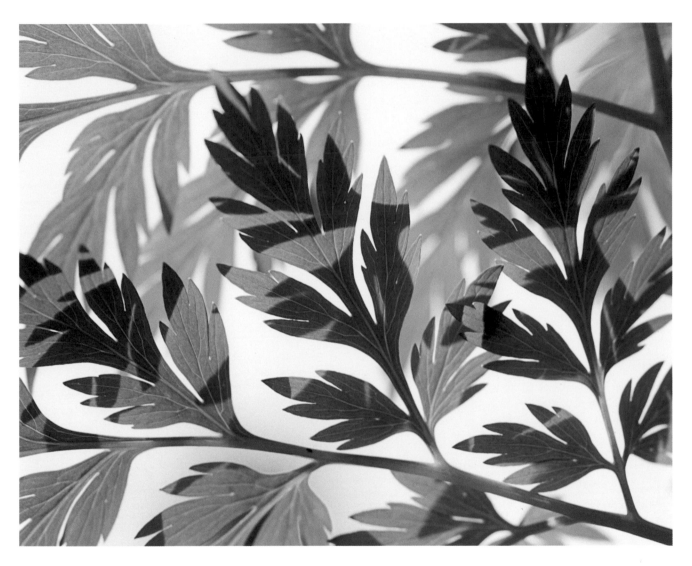

Bleeding Heart *(Dicentra sp.)*

insectivorous

INSECTIVOROUS PLANTS are a fascinating group. They come in many shapes, colors and sizes yet their most interesting feature is their leaves, which have a very specific purpose — eating other living things. These leaves have become so modified that they actually developed into the mouths, throats and stomachs of the plant.

Carnivorous plants are native to North and South America, South East Asia, Europe, China, Australia and India. There are about 625 species of plants that attract animals then trap and digest them. The majority of them are found in boggy areas where fertility is low but a few do exist in near-desert conditions on limestone cliffs. The traps are considered active if they close on their prey, or passive if they stay motionless waiting for the prey to fall into them.

Insectivorous plants trap and consume their prey in many ways. Pitfall traps are usually utilized by pitcher plants. Their long tubular leaf shapes form a small pool at the bottom, which is filled with digestive enzymes. There are often hairs on the bottom of the cup as well, to help entangle the prey and keep it where it can be easily digested. Pitfall traps also have smooth sides that make it difficult for the prey to escape.

Sticky traps have an adhesive surface where unsuspecting insects get stuck if they land or crawl onto it. Snap traps are much like a jaw: a hinged leaf closes quickly, triggered by fine hairs.

Bladder traps are often, but not exclusively, found growing in water. They suck in their prey by forming a vacuum. Once the prey is inside, a hinged door closes and the prey is digested. Lobster-pot traps are simple but effective — they are easy to get into but almost impossible to escape. They are tunnel-shaped, with inward-facing hairs that force the prey to head inward toward the lower part of the leaf where it can be digested.

The Pitcher plant (*Nepenthes*), also known as 'Monkey Cups,' has 120 species, the majority of which come from Borneo. There are many hybrids, as breeders are constantly working to achieve larger, more colorful "cups." The tropical pitcher plant will mature into a vine that clambers through the treetops or clings to rock outcroppings. The bulbous appendage is filled with a watery digestive broth simmering with insects and small vertebrates.

Sarracenia include tender as well as hardy plants. They grow in boggy, peaty, nutrient-poor soils. They feed themselves by using nectar to lure insects into their elongated tubular leaves, filled with a deadly bath.

The Venus Flytrap (*Dionaea muscipula*) is one of the most popular carnivorous plants, and can regularly be found at nurseries and garden centers. Growing in bog-like conditions, these ground-hugging little plants have a hungry, snapping appendage at the ends of their leaves. These jaws have tiny hairs on them that instantly snap shut when triggered, embracing their prey. Once caught, the little victim is slowly digested.

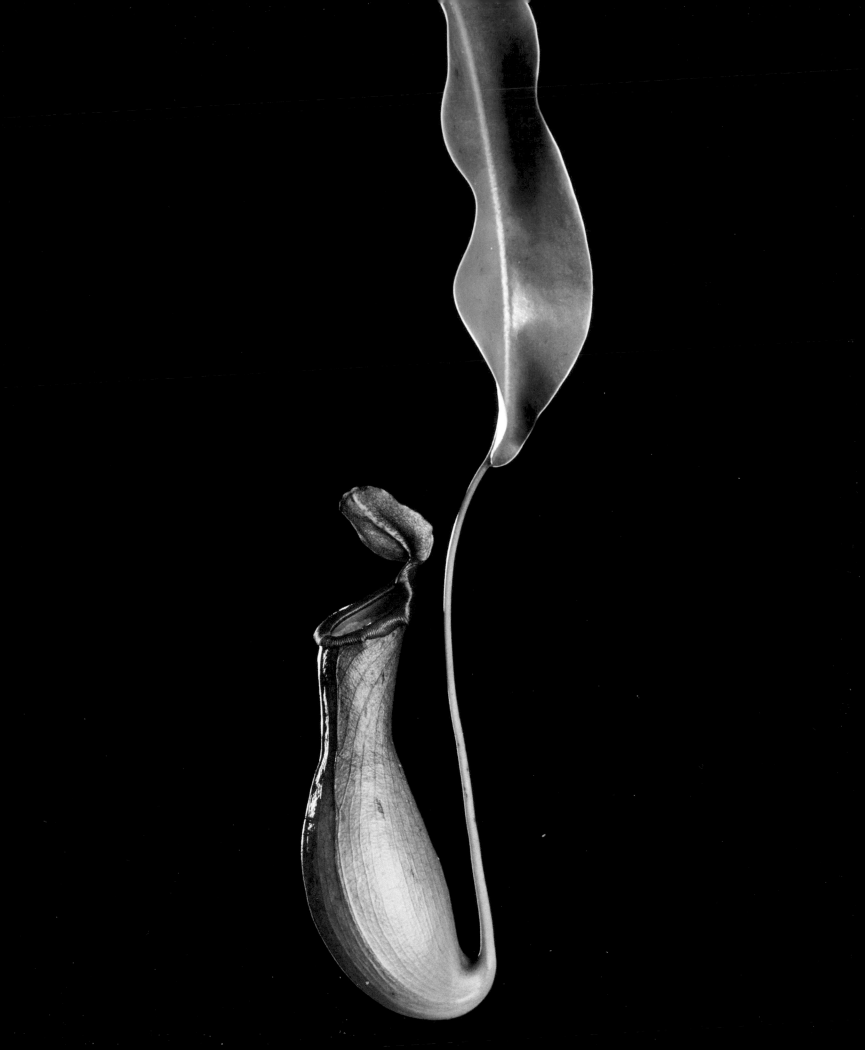

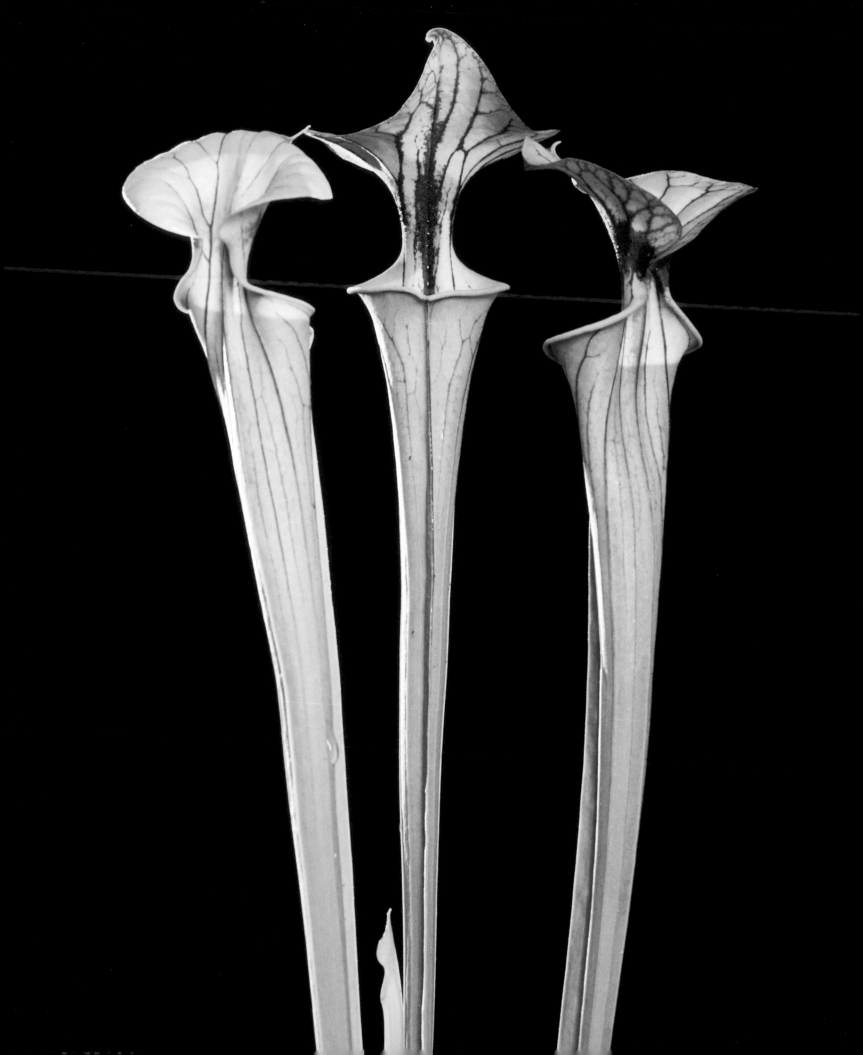

< Yellow Trumpet Pitcher Plant *(Sarrancenia flava 'Yellow Trumpet')*

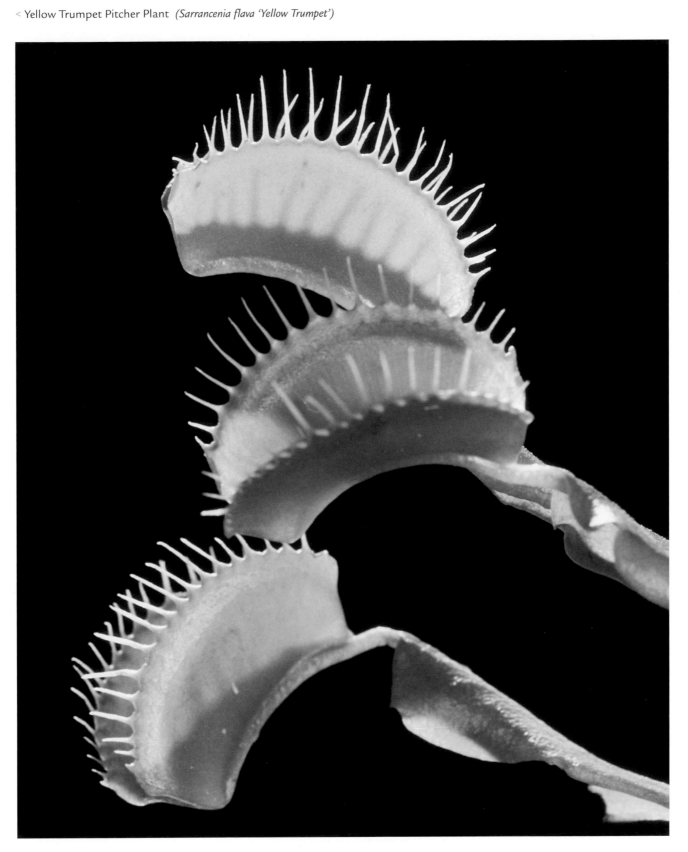

Venus Fly Trap *(Dionaea muscipula)*

amorphophallus

AMORPHOPHALLUS is a strange plant with a strange name derived from Greek. *Amorpho* means "misshapen," and *phallus* means "penis" ... misshapen penis is a very descriptive as well as colorful explanation of what this leaf looks like as it pokes its way out of the soil.

Arising from an underground tuber, a solitary leaf appears that could be as small as a quarter or as large as a huge umbrella with a diameter of 6 feet (1.8 m) or more. Before the leaf emerges, the plant blooms with one spathe-shaped flower that can also be of an enormous size. The flower structure is actually made up of a large spadix with hundreds, sometimes thousands, of individual flowers at its base.

The largest species of Amorphophallus (*Amorphophallus titanum*), commonly called Titan Arum, is native to the rainforests of central Sumatra and very rarely blooms. When Titan does flower it is quite spectacular, and the entire flowering structure can be as much as 10 feet (3 m) tall and 4 feet (1.2 m) wide. In the United States there are only 17 recorded blooms of this spectacular plant. When they do bloom tens of thousands of people flock to see the giant. Another common name for the plant is Corpse Flower — justly so since the flower gives off the unmistakable fragrance of rotting flesh and is pollinated by flies and insects attracted to carrion.

Devil's Tongue (*Amorphophallus konjac*) >

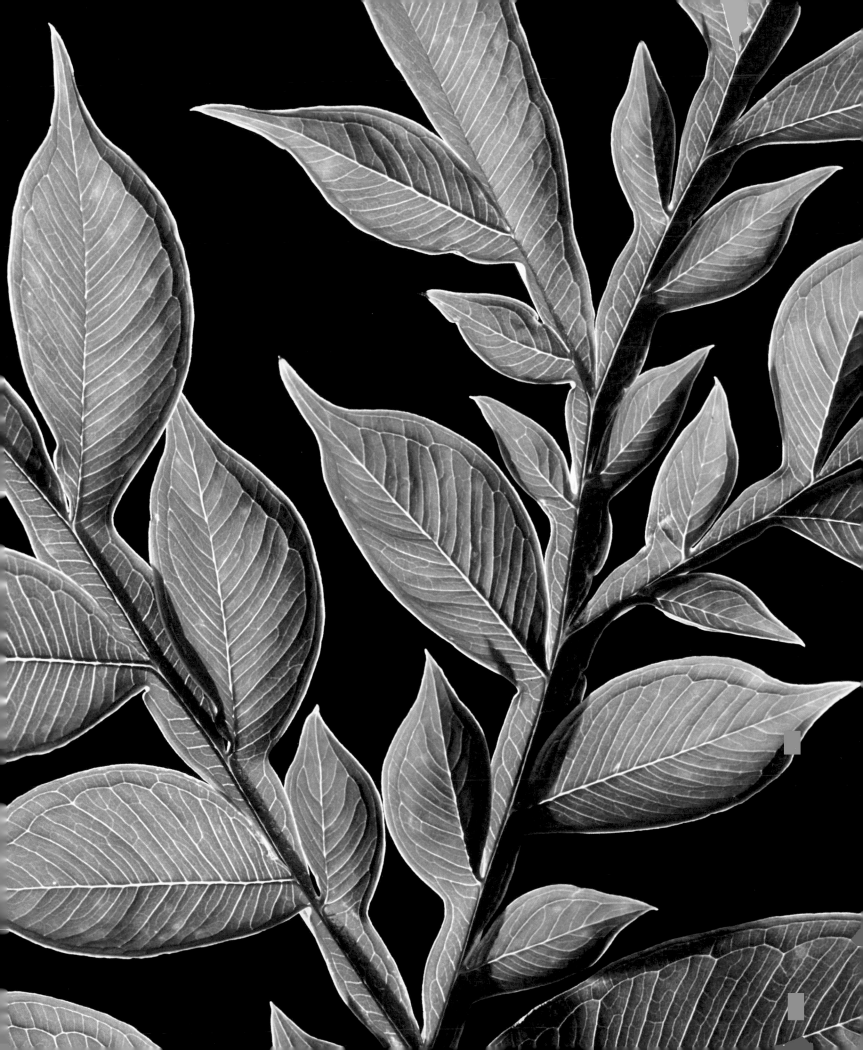

lotus

NELUMBO NUCIFERA is the botanical name for one of the perennial aquatic plant known as the lotus. They are grown for their beautiful showy flowers, tasty roots and seeds, dried seed pods and huge attractive circular leaves. *N. nucifera,* which is native to much of southern Asia and into the Middle East, has spread rapidly around the globe thanks to its beauty and its cultivation as a nutritious food. *Nelumbo lutea,* the Native American yellow flowering lotus, can be found growing in the Southeastern United States, Central America and the West Indies.

All parts of the lotus plant — seeds, flowers, roots and young leaves — can be eaten, and the older leaves are used to wrap food. It was first introduced to the west as a horticultural oddity in 1787 by Sir Joseph Banks, who had accompanied Captain Cook on his first three-year voyage around the world. Banks was also the first direc-

tor of the Royal Botanical Gardens in London, England.

Much earlier, in 639 AD during the Arab conquest, the lotus plant was brought to Egypt, where it was quickly incorporated into Egyptian mythology, representing the sun, creation and rebirth.

Throughout India the lotus is a strong religious symbol representing an awakening to a spiritual way of life. It is the sacred water-lily of Hinduism as well as Buddhism. There are many references and associations between the lotus and divine symbols — Vishnu is known as the 'Lotus-Eyed One'. Part of the epic *Mahabharata* spoken by Krishna (the divine one) refers to the lotus leaf and signifies its importance. "One who performs his duty without attachment, surrendering the results unto the Supreme Lord, is unaffected by sinful action, as the lotus leaf is untouched by water." Nowadays a lotus tattoo is a popular symbol worn by people who have gone through hard times and have overcome personal difficulties.

Lotus *(Nelumbo nucifera)*

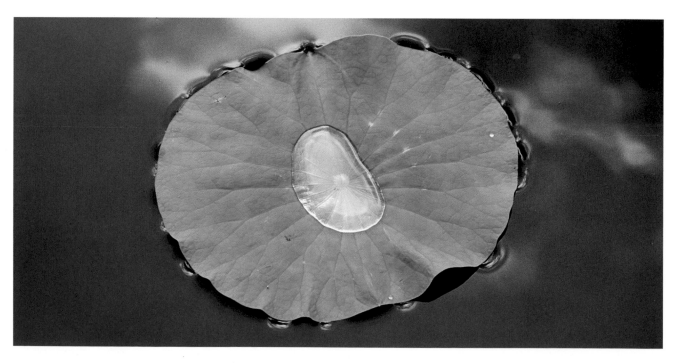

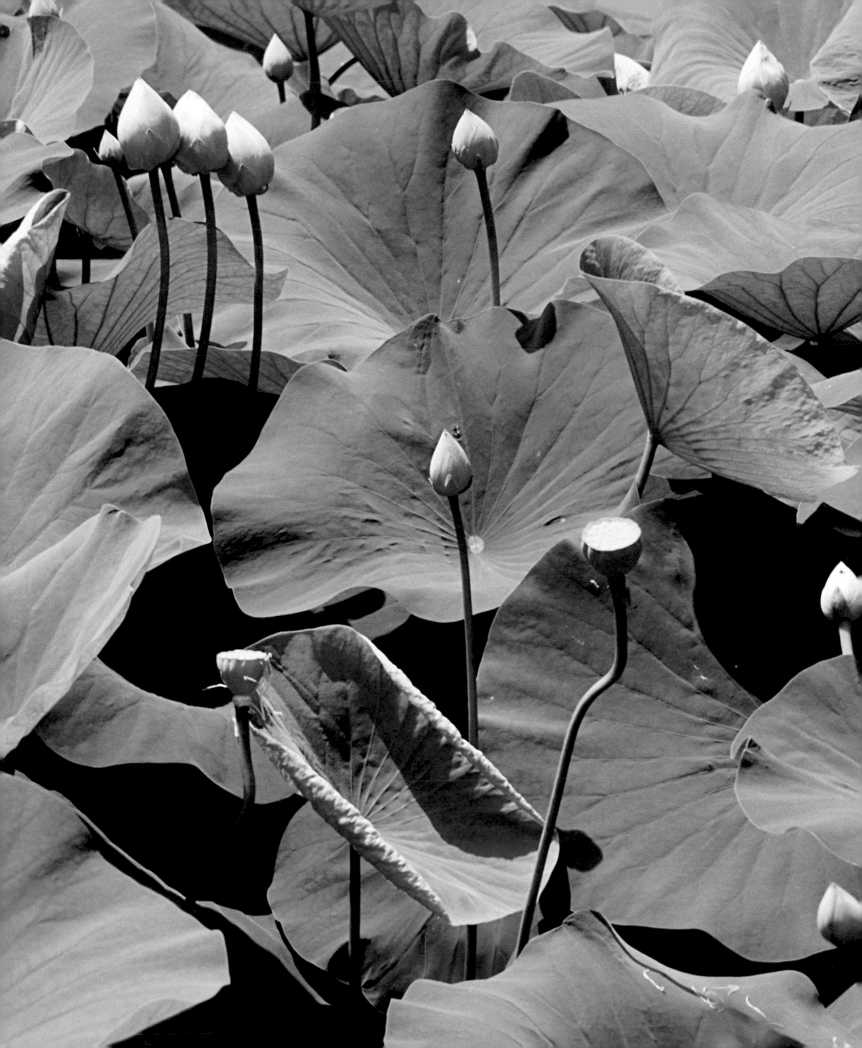

mulberry

Red Mulberry (*Morus rubra*) >

MORUS, as the mulberry is called, is a genus of about 15 species of trees native to most temperate regions of the world, the greatest concentration being in Asia. Although they do set edible fruit that is consumed by humans as well as wildlife, mulberries are most renowned for their foliage. It's not that they are decorative or fragrant or particularly special in any visual way. The primary significance is that the mulberry is the only food source for the silk worm. Leaves of *Morus alba*, the white mulberry, are what the worms eat. Native to much of Asia but naturalized throughout the world, the white mulberry easily breeds with local populations of other mulberry species, forming hybrids and possibly depleting native stock.

In China the cultivation of the white mulberry as a food source for silk worms began almost 5,000 years ago. One of the legends of the way silk was discovered is that a Chinese empress was drinking her tea under a mulberry tree when a silkworm cocoon fell into her cup. She plucked it out and started to unravel it, thus discovering how silk filament could be harvested.

The secret of silk production was guarded for close to 3,000 years, but eventually spread to Japan, Korea and India and later to the Middle East and Western Europe. Silk was considered a luxury item in most countries and has been in trade for thousands of years. Trade in silk was responsible for the silk routes, along which all types of merchandise were also traded. The routes went from Beijing to Korea, Japan, India and parts of South East Asia, across the Middle East to the Mediterranean and into Africa.

The silk worm is entirely dependent on humans to survive and would eventually have become extinct if man had not domesticated it. To survive, silkworms must be housed and protected from the elements and constantly fed white mulberry leaves. Raw silk is produced by the worm's salivary glands. The silk is used to form a protective cocoon that covers the vulnerable pupa.

A single silkworm cocoon is made up of one filament that can be from 1,000 to 3,000 feet long; it takes 2,000 to 3,000 cocoons to make one pound of silk. To meet the needs of silk production today, about 10 billion pounds of white mulberry leaves are devoured annually by hungry worms.

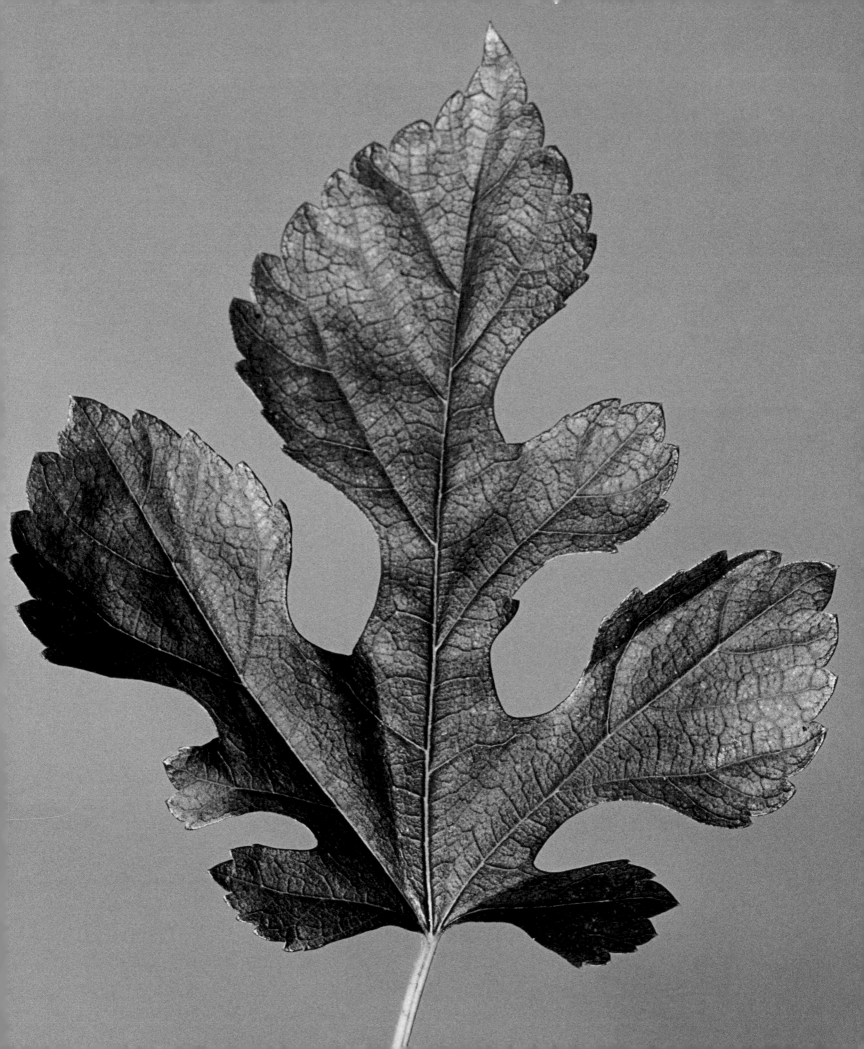

artemisia

ARTEMISIA SP. is a fairly large group of perennial plants in the daisy family and is native to most temperate regions of the world. The common names of sagebush, sagewort, mugwort and tarragon all hint at the herbal qualities of artemisia, but the name "wormwood" brings to mind *Artemisia absinthium*, the elixir of the Gods.

The medicinal uses of wormwood date back thousands of years to ancient Greece and Egypt. It was mixed with wine to make a stomachic to aid digestion and an antipyretic to lower body temperature. It also served as a tonic and stimulant and was useful for poultices. In more recent times wormwood has been used as a cure for intestinal parasites — and it also repels fleas and moths.

It wasn't until 1797 that Henry-Louis Pernod started distilling absinthe as an alcoholic beverage. The three herbs used in its production — anis, fennel and wormwood — were referred to as the "holy trinity." The recipe was supposedly developed by Swiss nuns as an elixir. During the late 1800s and early 1900s absinthe became highly fashionable throughout Europe, especially in France. Although absinthe's alcohol content was quite high, coming in at close to 80 percent, it was served diluted with water, lowering the alcohol content closer to that of wine.

The drinking of absinthe became an elaborate ritual. First, about an ounce of absinthe was poured into a glass, and then a slotted spoon holding a sugar cube was placed on top. Ice water was slowly poured over the sugar, dissolving it into the absinthe and mixing it into an opaque, pale green cocktail. Parisian café society was a vibrant haunt for the bohemian literary and artistic elite. The likes of Vincent van Gogh, Toulouse-Lautrec, Edgar Degas, Arthur Ribaud, Paul Verlaine and Edouard Manet would all dance with the "green fairy" into the early morning hours.

Wormwood *(Artemisia sp.)* >

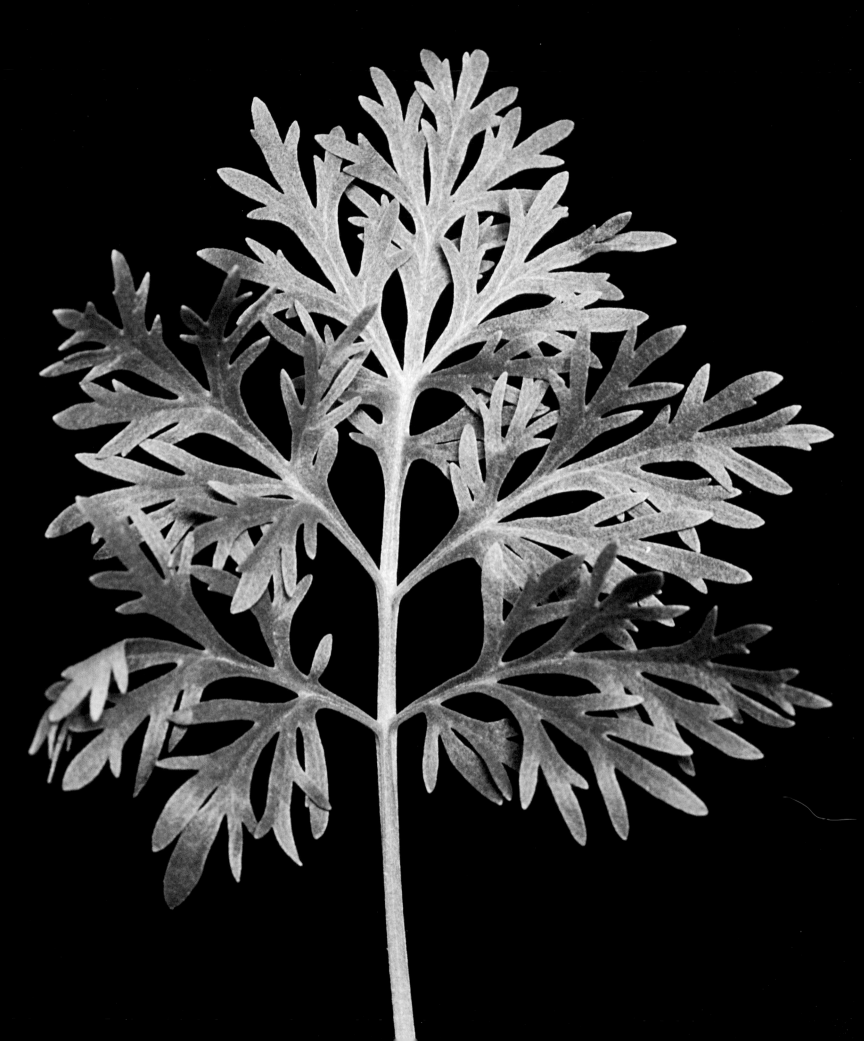

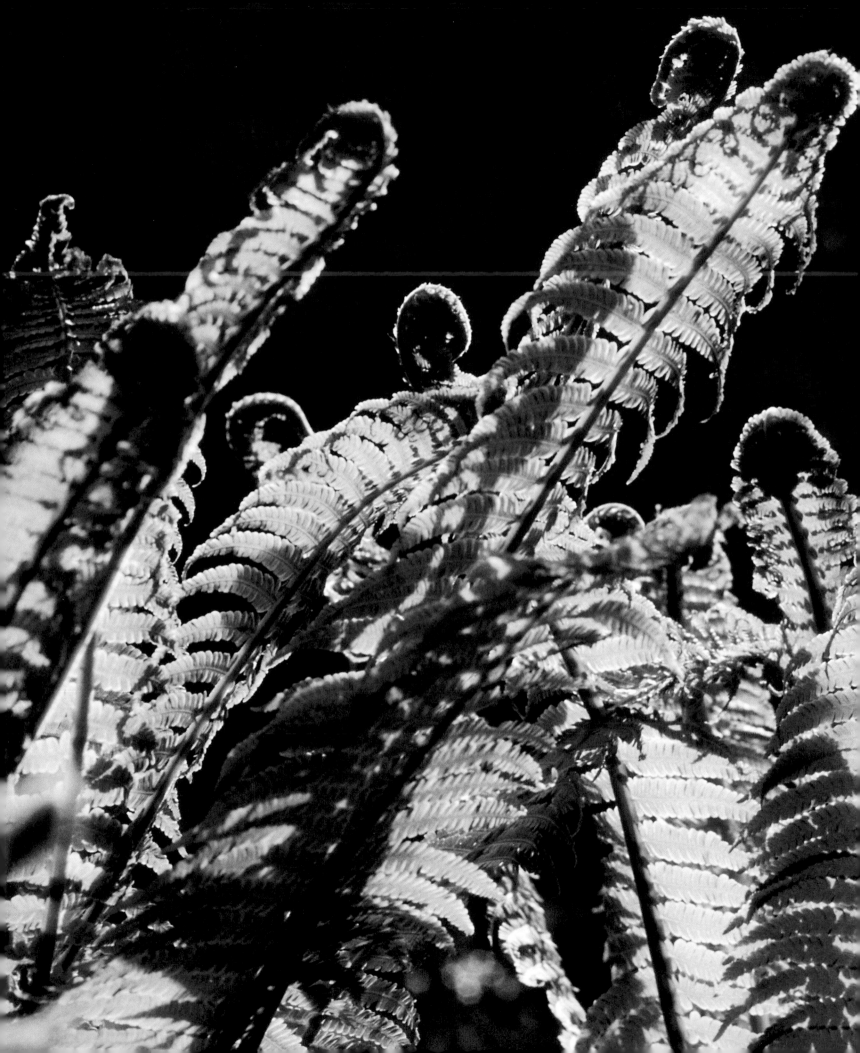

ferns

FERNS ARE ONE OF THE OLDEST GROUPS of plants in existence. They've been around for more then 300 million years and are found just about everywhere on the planet. The study of ferns is called pteridology, from the Greek word *pteris*, meaning "fern." It can be a lifelong science, considering that there are about 20,000 species and hybrids.

Ferns grow in all types of habitats. Their liking for woodlands, forests and jungles is well known; but some also do quite well in dry desert conditions, alpine areas or even floating on water. Ferns come in all shapes and sizes, ranging from the giant tree ferns native to Australia and New Zealand, which grow to heights of 60 feet (18.2 m) or more, to the tiny, little floating fern called *Azolla*. The Dicksoniaceae family (one of the tree fern families) native to New Zealand has been growing on earth for close to 200 million years without any change in its characteristics.

All ferns are non-flowering and, rather than producing seeds, they reproduce by spores. A single plant will produce billions of spores in its lifetime but very few will land somewhere suitable to grow. The spores need the right amount of moisture and light. When that's accomplished, a tiny single-celled organism starts to grow, eventually forming a little green heart-shaped plant call a prothallium that is only about a half inch across and lies close to the ground. On the underside of the prothallium grow both male and female organs. The males produce spermatozoids, which swim via a droplet of water to the female's egg. Once the egg is fertilized, a fern plant will start to grow.

Ferns are among the plants that have the most beautiful foliage. Their leaves come in a wide variety of sizes, shapes, and colors — some round, some delicate as a snowflake and some even antler-like in appearance. Ferns have been major players in horticulture since Victorian and Edwardian times, when tender specimens were grown as house plants or in glass cases that were built to maintain high humidity and mimic the conditions of a tropical rain forest. In addition to being popular house plants, ferns are also used extensively in the landscape as ground covers and specimen plants. They are also important in the cut green market.

Pellaea rotundifolia, the Button ferns native to Australia and New Zealand, are members of the genus called 'cliff brake ferns' because of their ability to grow on rocky cliff faces. They are very attractive ferns that do well as house plants and as garden plants in mild areas. Each thin, wiry stem has perfectly round half-inch dark green leaves resembling buttons attached along it.

The Bird's Nest fern (*Asplenium nidus*), is named because of its vase-shaped growth habit, and at the center of the vase the new leaves are formed resembling a bird's nest. Bird's Nest ferns are native to tropical Southeast Asia, India and East Africa, and can be found either terrestrially or epiphytically (growing on the ground or up in trees). The Japanese Bird's Nest fern (*Aspleniumantigun 'Victoria'*) is a beautiful ruffled leaf form.

Platyceriumn sp. are known as Staghorn ferns, and as their name suggests, are dramatic ferns with large antler-shaped leaves. There are 18 species and all are epiphytic. They have adapted to many different climatic regions, from dense rain forests to semi-desert conditions. Staghorn ferns are native to Africa, Madagascar, South East Asia, Australia, South and Central America, and India.

The Maidenhair fern genus has 200 species, all of which are delicate-looking, with leaflets arranged on thin wiry stems. The genus name, *Adiantum*, comes from a Greek expression meaning "not wetting," in reference to the leaf's ability to shed water. The genus contains hardy as well as tender species from South America, Asia and New Zealand, with two additional species from North America and one from Europe. They like high humidity and can be found growing naturally on rock faces near waterfalls.

Athyrium niponicum 'Pictum', known as the "Japanese painted fern" is a very colorful and hardy fern native to Japan, Korea, and China, and survives in most temperate regions. Planted throughout the world as a landscape perennial, it has beautiful 18-inch fronds (45.7 cm) that are a soft metallic gray with veining of red to pink. Some other varieties such as 'Ursula's Red,' 'Pewter Lace,' 'Burgundy Lace,' 'Red Beauty' and 'Pictum Cristatum' are colorful additions to the painted fern group.

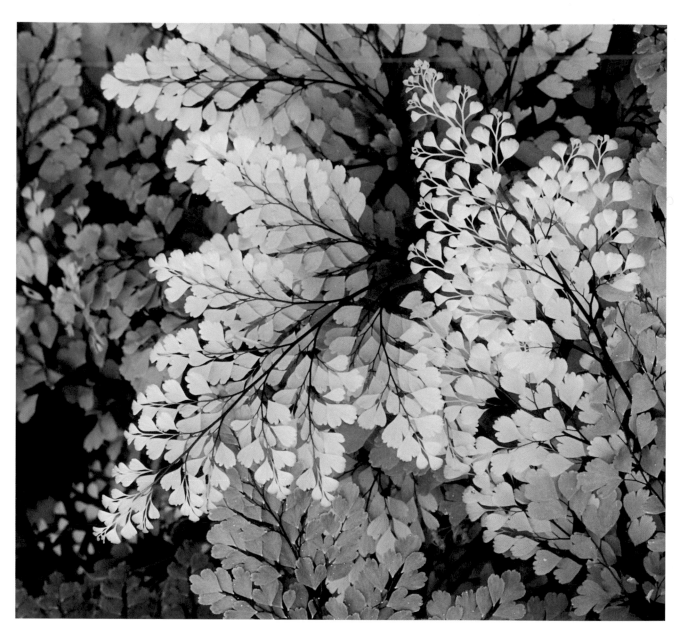

Maidenhair Fern *(Adiantum sp.)*

extraordinary leaves

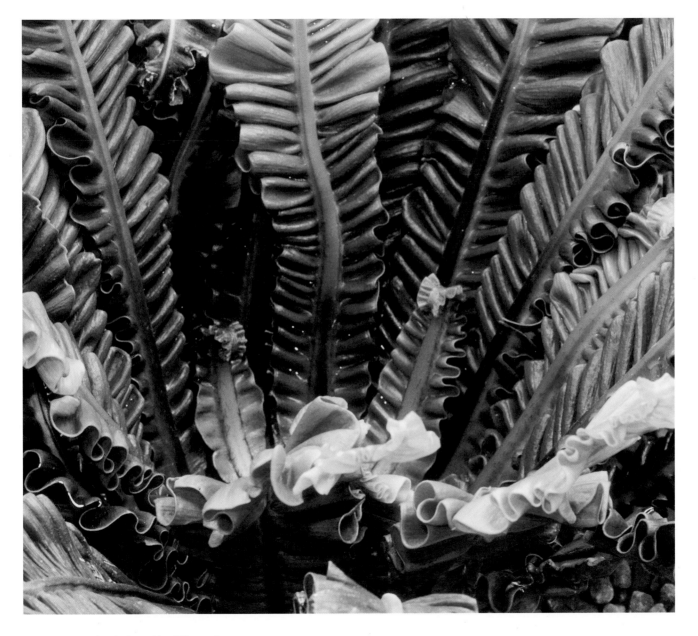

Lasagna Fern *(Asplenium nidus 'Plicatum')*

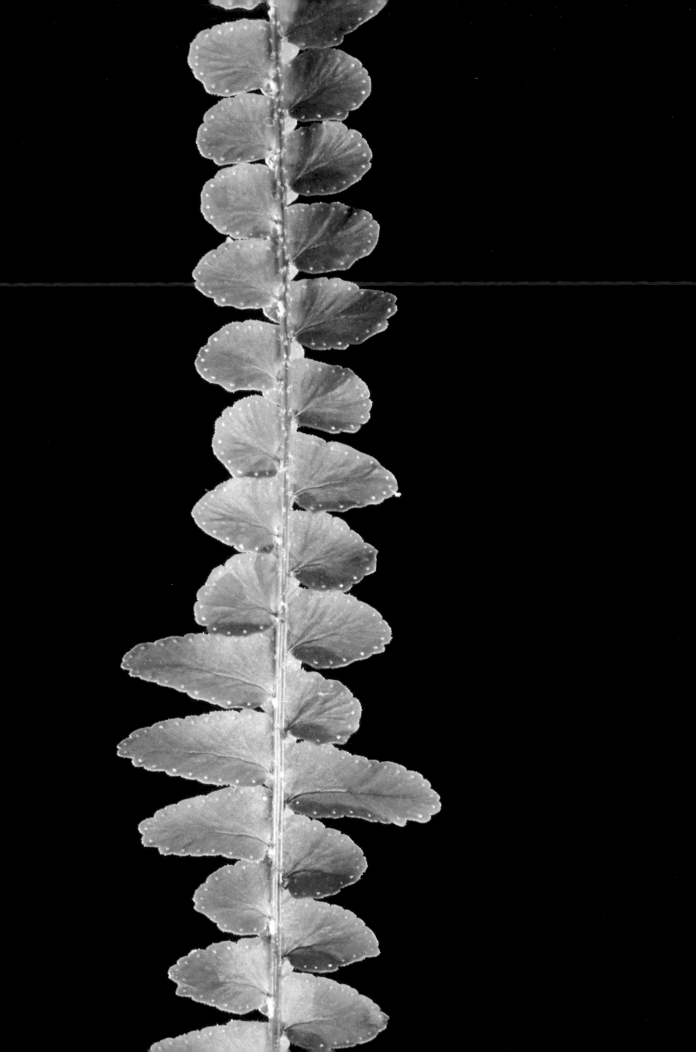

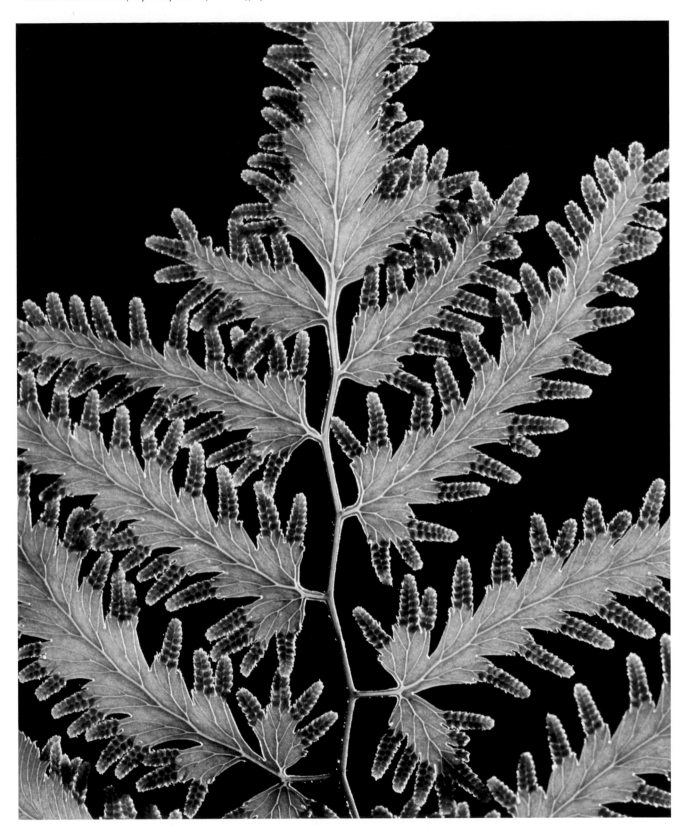

Japanese Climbing Fern *(Lygodium japonicum)*

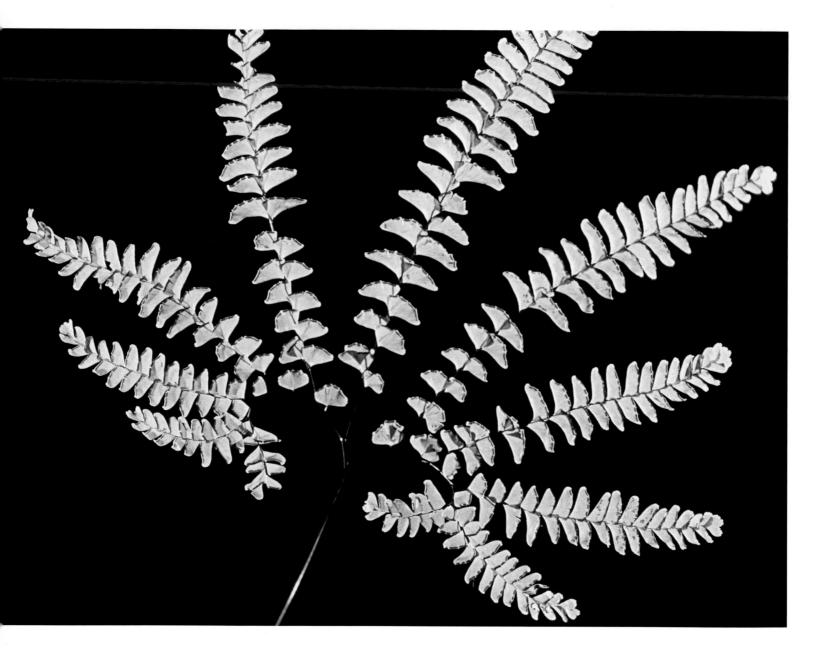

Northern Maidenhair Fern *(Adiantum pedatum)*

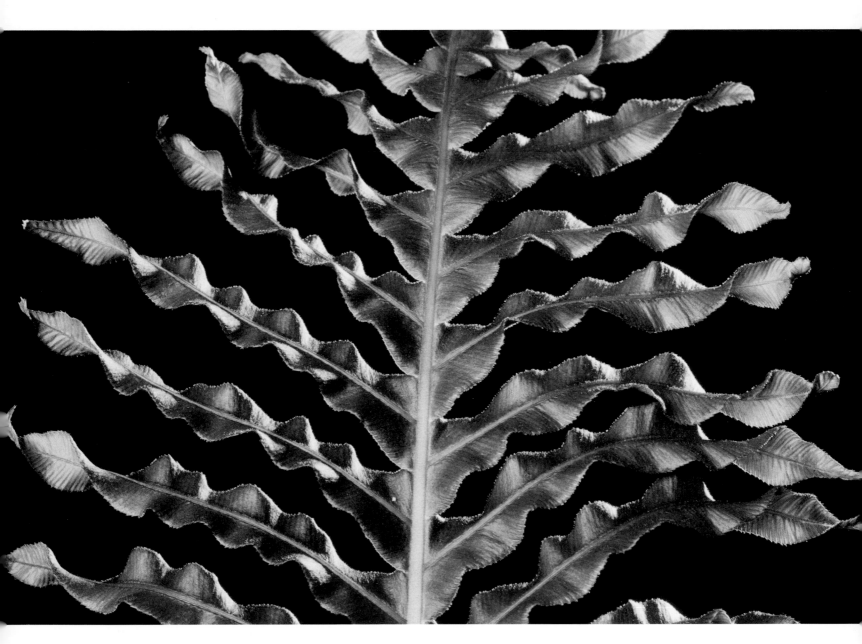

Red Leaf Tree Fern *(Blechnum brasiliense 'Crispum')*

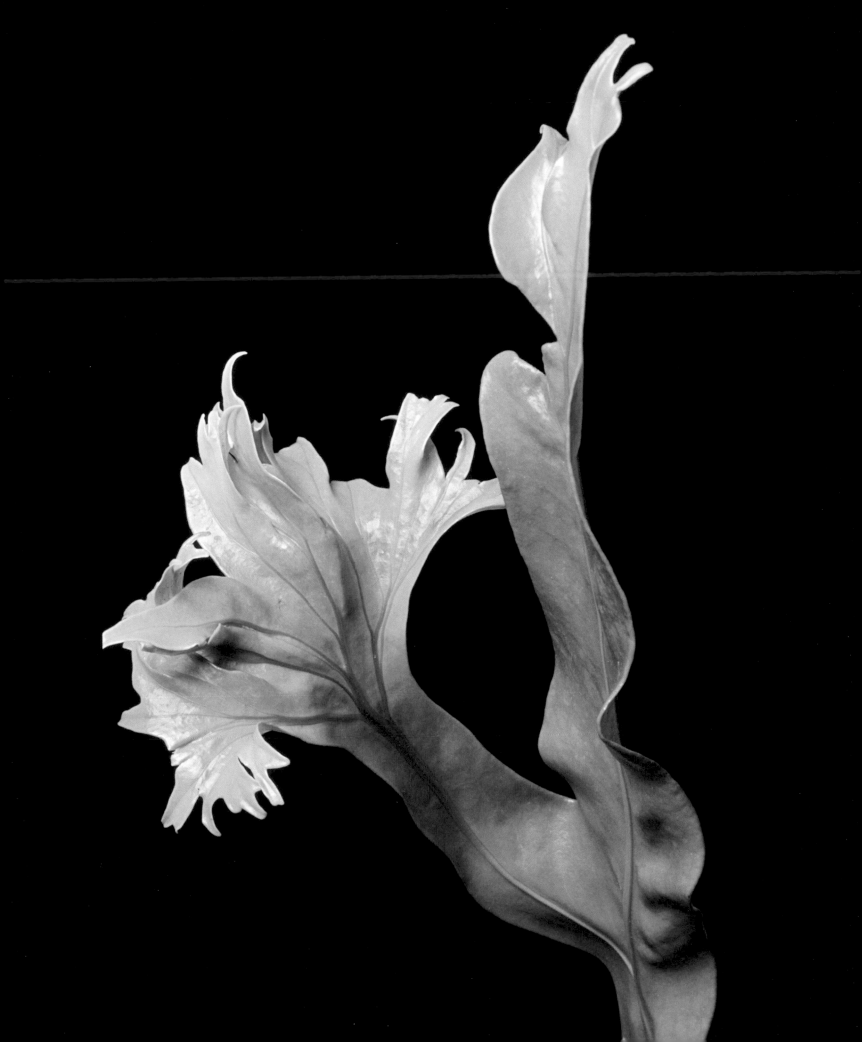

< Elkhorn Fern *(Polypodium punctatum 'Crested Elkhorn Fern')*

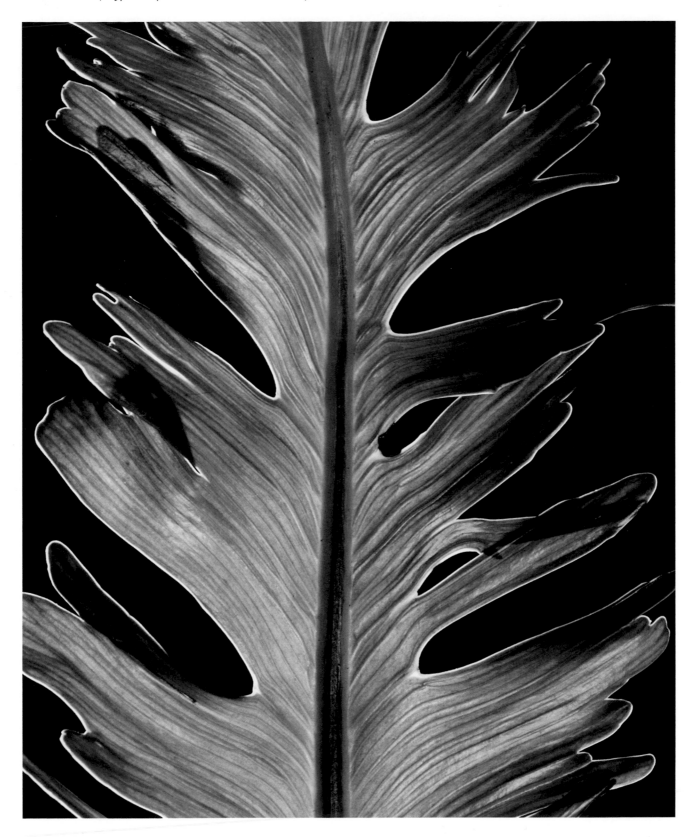

Bird's Nest Fern *(Asplenium sp.)*

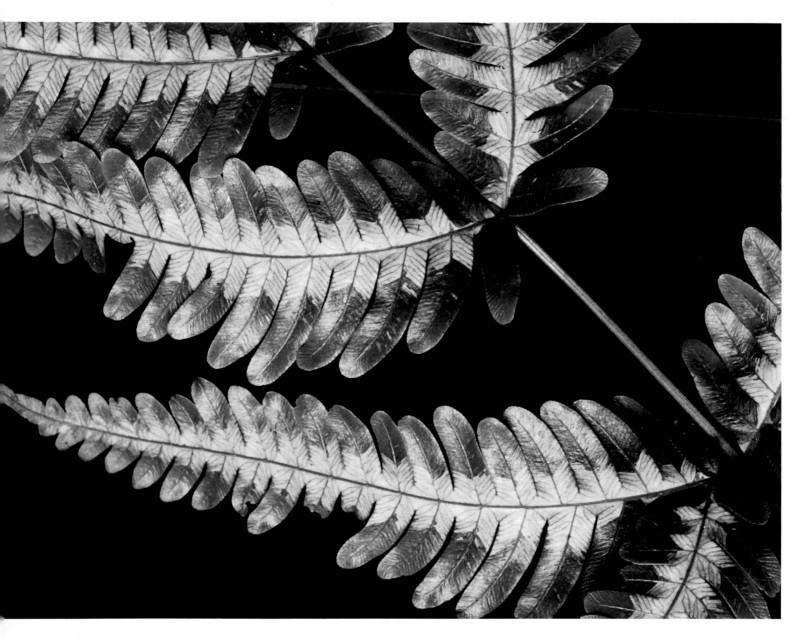

Silver Brake Fern *(Pteris argyraea)*

extraordinary leaves

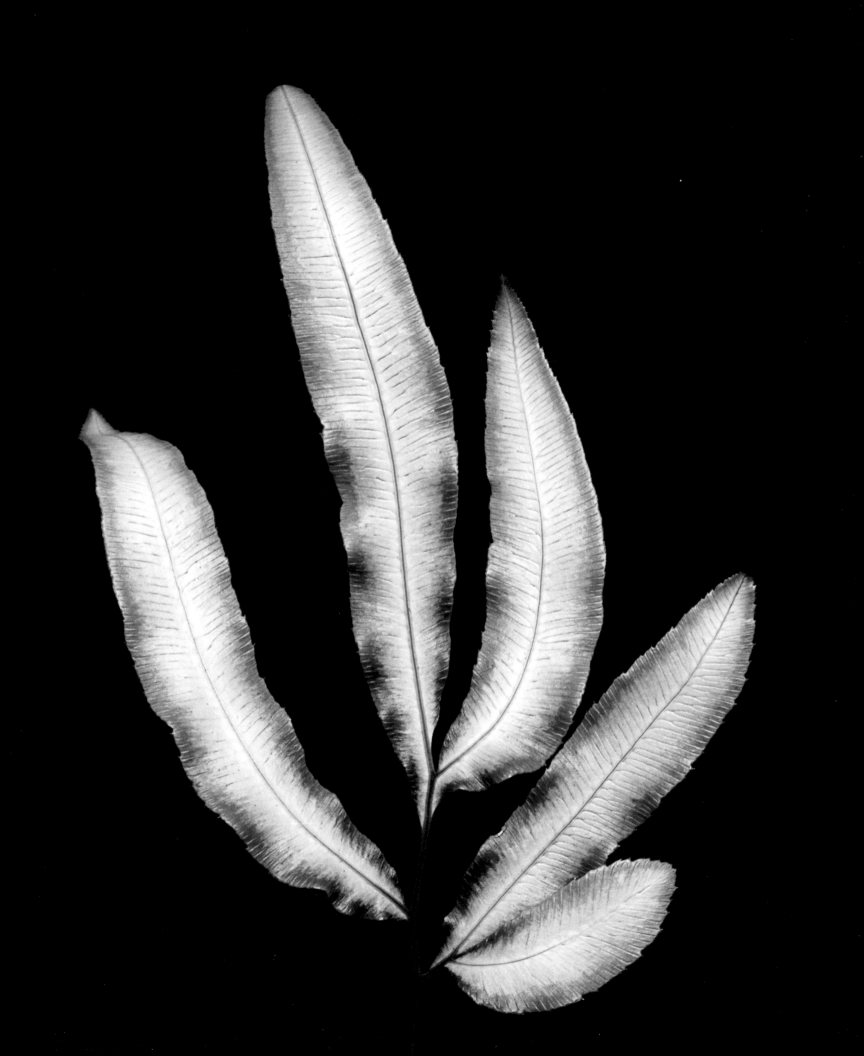

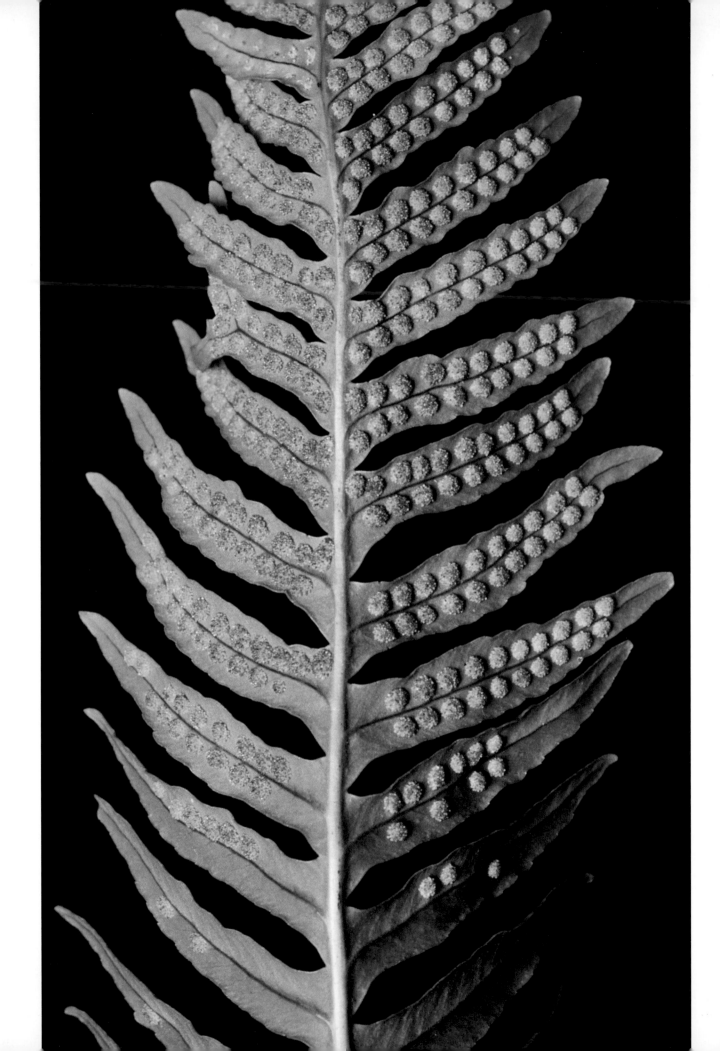

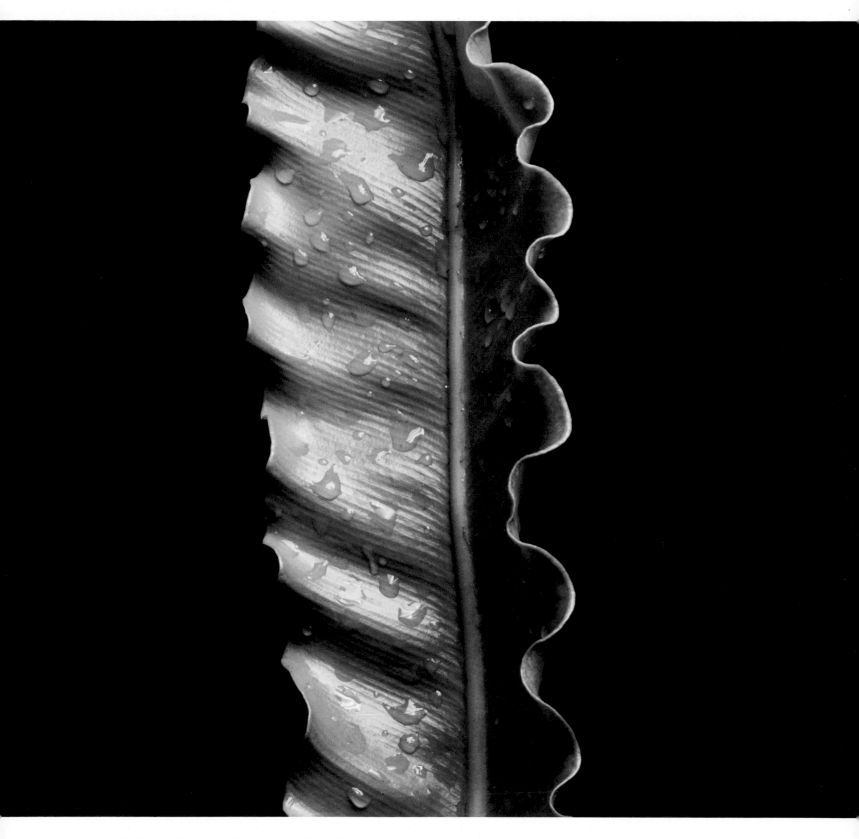

< Dwarf Tree Fern *(Blechnum sp.)*

Japanese Bird's Nest Fern *(Asplenium antiquum 'Victoria')*

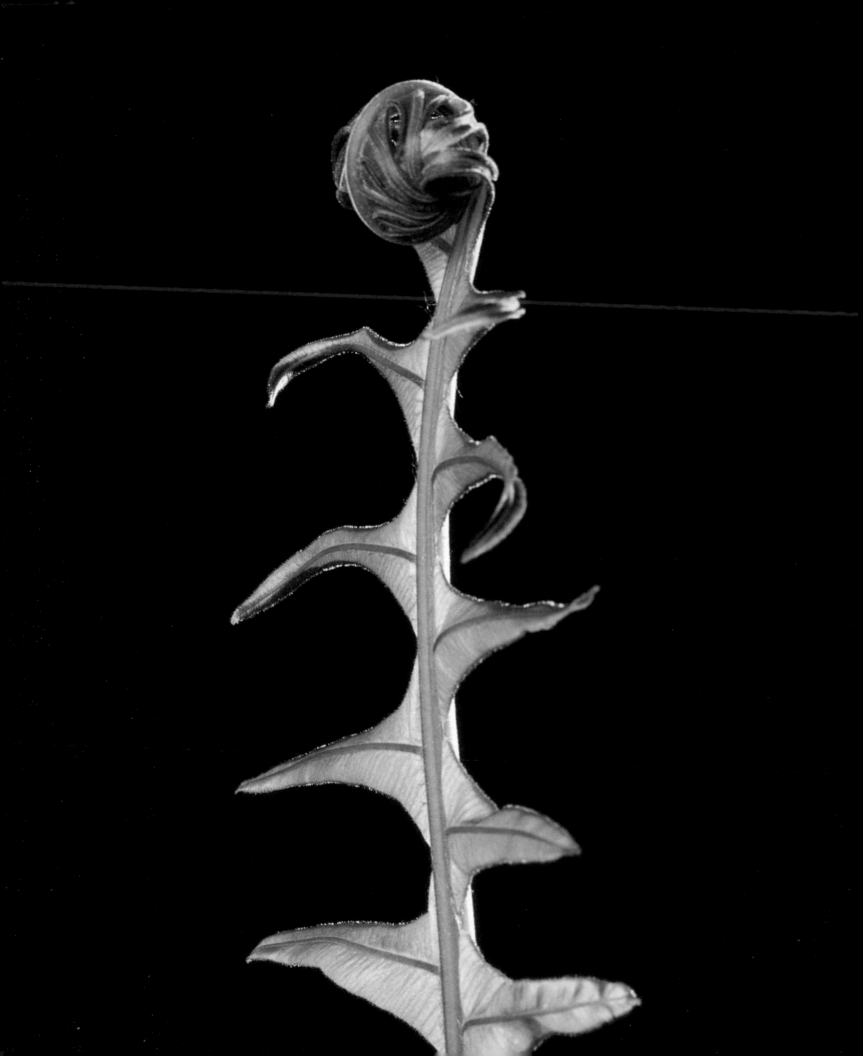

< Red Leaf Tree Fern *(Blechnum brasiliense 'Crispum')*

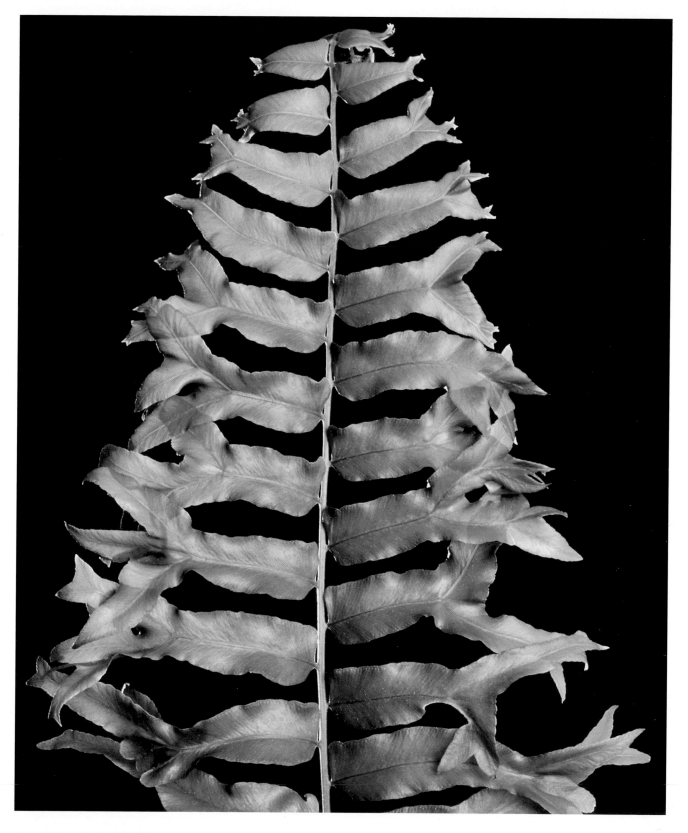

Fishtail Fern *(Nephrolepis falcata)*

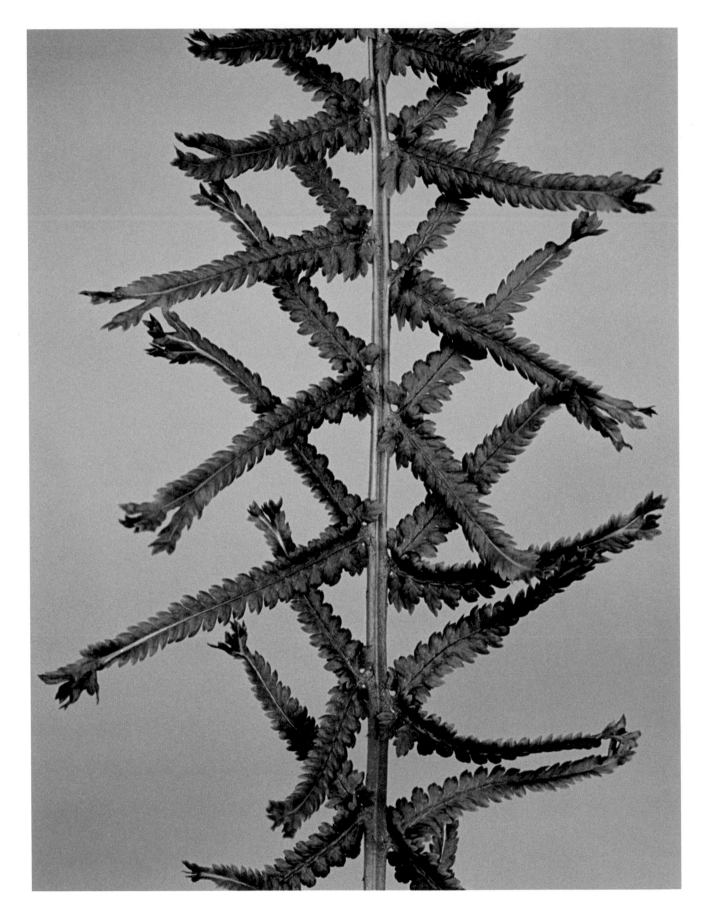

< Dre's Dagger Lady Fern *(Athyrium filix-femina 'Dre's Dagger')*

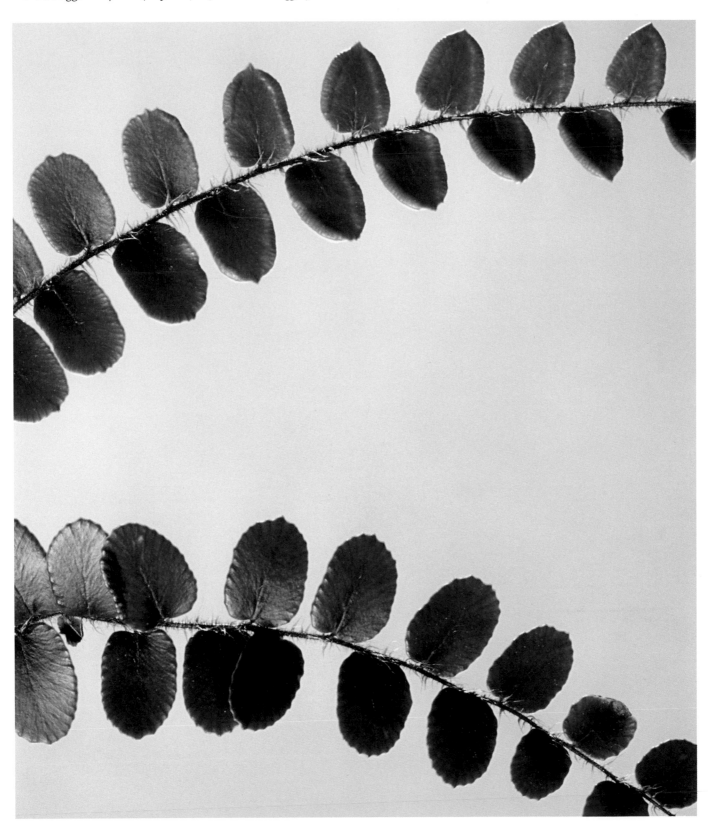

Button Fern *(Pellaea rotundifolia)*

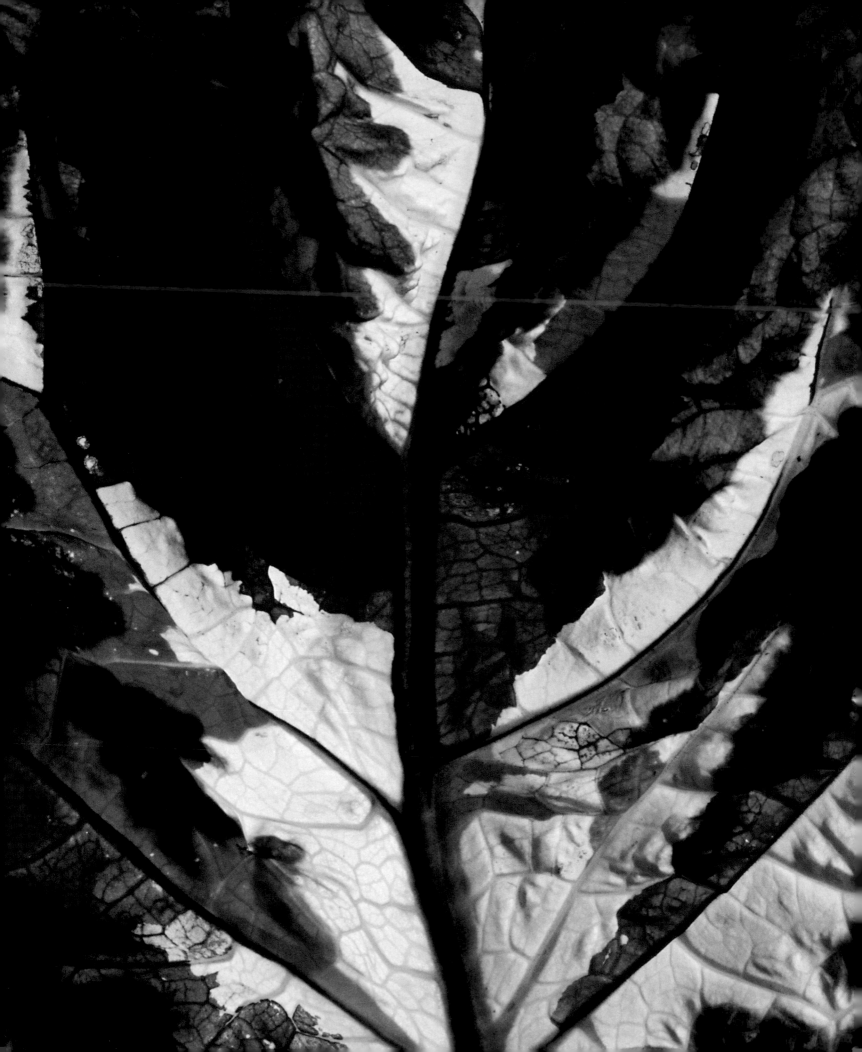

coleus

< Coleus Kong Mosaic *(Solenostemon scutellariodes 'Kong Mosaic')*

COLEUS BLUMEI got its name from the Greek word *koleos*, meaning "sheath," referring to the stamens of the flower, which are bunched together. The second part of the name honors the German botanist Karl Ludwig Blume. Coleus has a few other common names such as Flame Nettle, Painted Nettle and Joseph's Coat. This terminology all changed in 1990 when taxonomists reclassified coleus and came up with the new scientific name of *Solenostemon scutellarioides*.

Coleus, which is in the mint family and a close relative to the *Plectranthus* of South Africa, is native to Southeast Asia. European traders brought a few species back from Indonesia in the mid-1800s. People were intrigued and excited by this new plant, and extensive breeding resulted in numerous hybrids. In the Victorian era, coleus again reached a peak in popularity with English and North American gardeners, and new cultivars were auctioned off at extraordinary prices. Over the years coleus eventually fell out of favor as a bedding and house plant but there has recently been a resurgence of interest.

Breeding coleus for particular characteristics is quite straightforward, as traits from the parent plants are easily inherited by the seedlings. Since coleus reproduce, grow and set seed very quickly, many generations can be trialed and evaluated in just one year.

Contemporary breeding programs have developed coleus that are sun-tolerant and have decreased flower production. Once a plant has been selected for commercial distribution, it is vegetatively propagated by cuttings to ensure that the desired characteristics are carried forward with each plant. Interesting new plants can also be found as sports or mutations growing from the parent plant.

Coleus breeding can easily be accomplished as an at-home windowsill horticultural project. All that is needed are two different coleus plants that have been allowed to cross pollinate and set seed, some soil, and a partly sunny location.

Over 1,400 named cultivars of coleus now exist, and the list is still growing, with many new ones arriving by the day. There are societies devoted to coleus, and the website http://coleusfinder.org lists an amazing array of cultivars with outrageous and hilarious names. Some striking examples are: Religious Rudabaga, Fishnet Stockings, Texas Parking Lot, Smallwoods Driveway, Careless Love, Big Blonde, Lipgloss, Meandering Linda, Yada Yada Yada, Dead Drunk, Blood Bath, Drama Queen and Pistachio Nightmare.

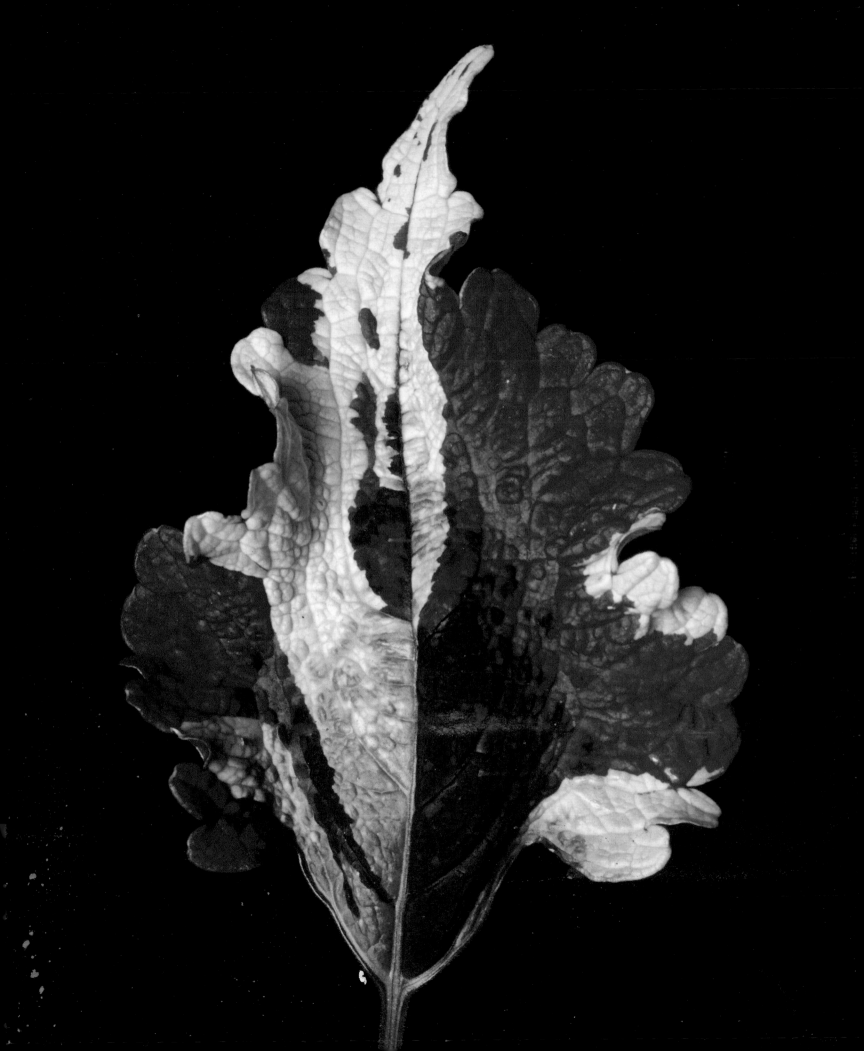

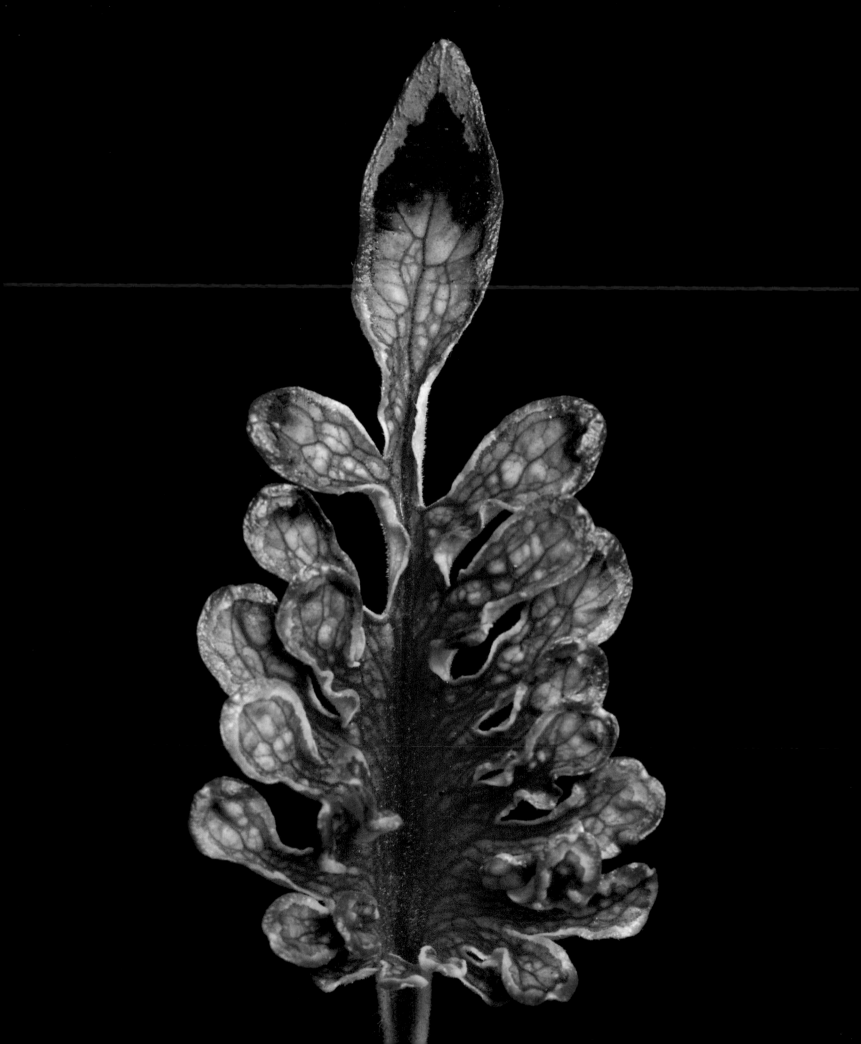

< Coleus Curly Magenta *(Solenostemon scutellariodes 'Curly Magenta')*

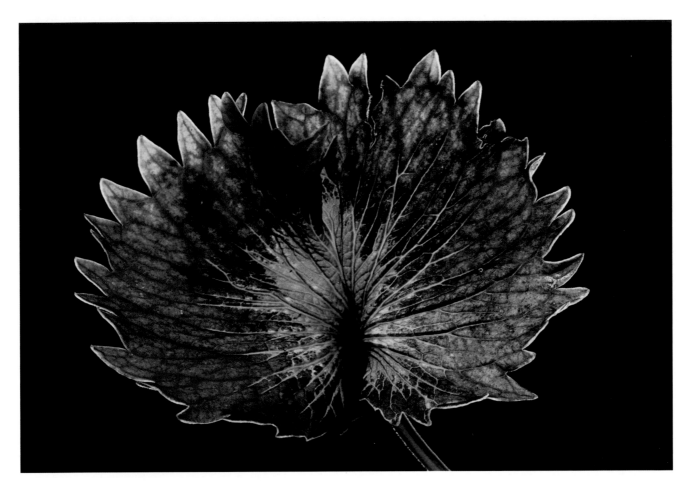

Coleus Tilt-A-Whirl *(Solenostemon scutellariodes 'Tilt-A-Whirl')*

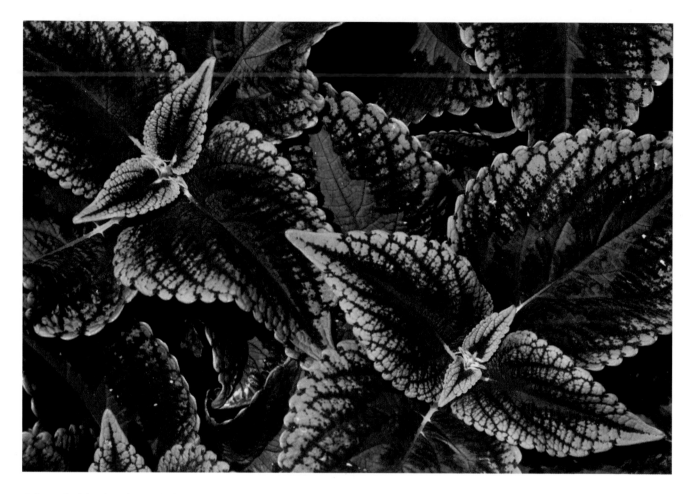

Coleus Florida City Altoon *(Solenostemon scutellariodes 'Florida City Altoon')*

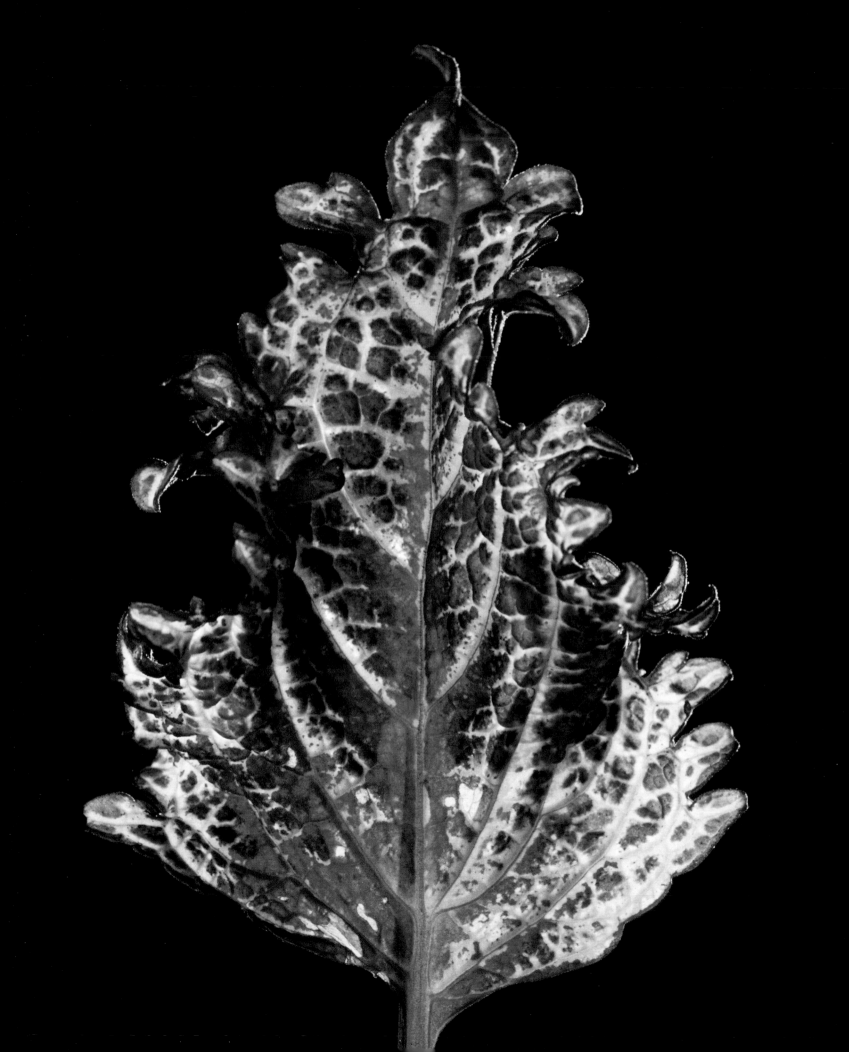

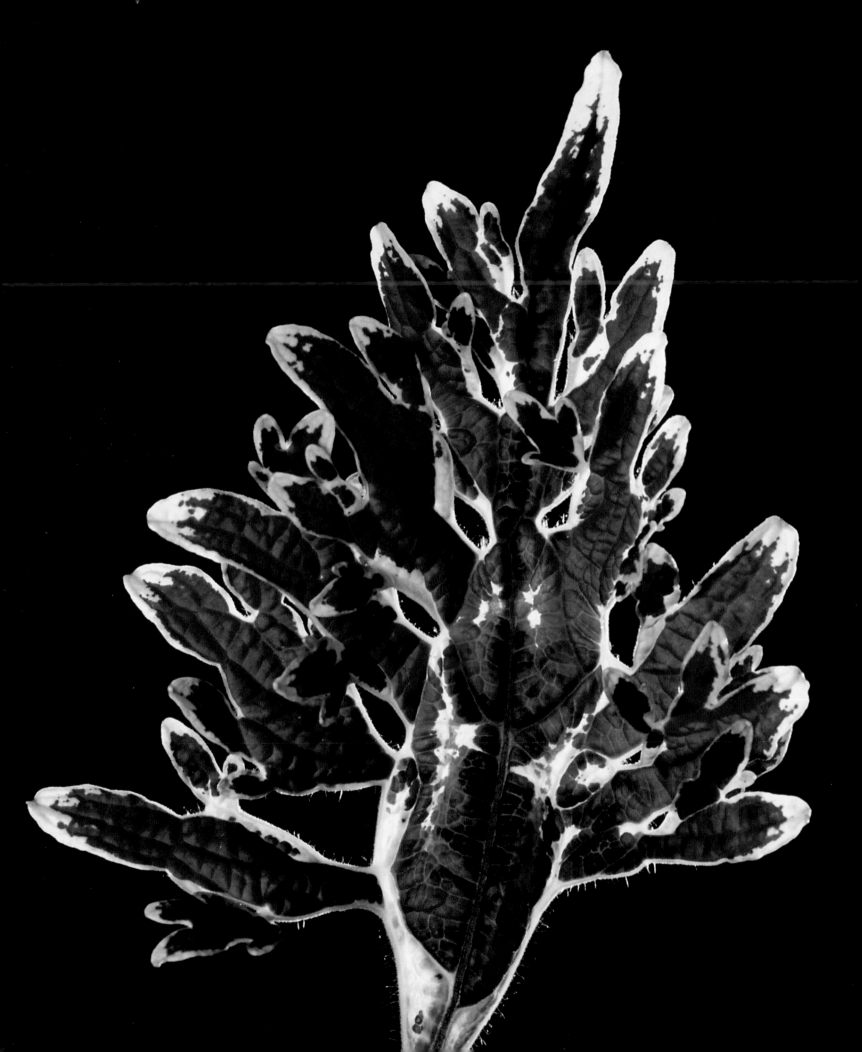

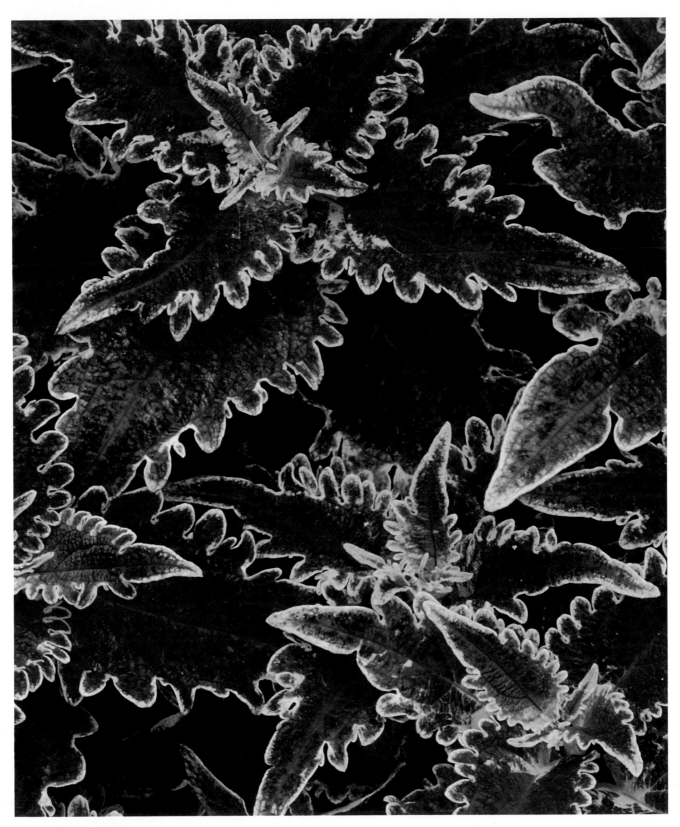

Coleus Tiger Lily *(Solenostemon scutellariodes 'Tiger Lily')*

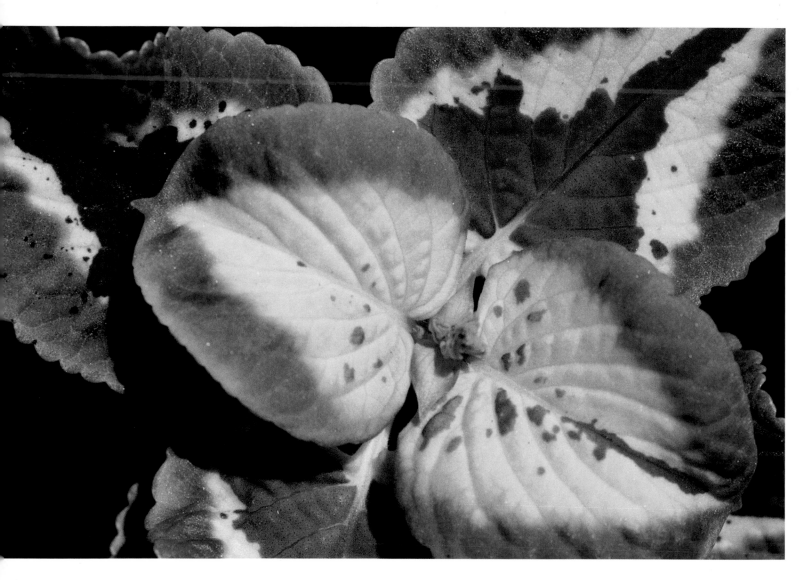

Coleus Wizard Rose *(Solenostemon scutellariodes 'Wizard Rose')*

extraordinary leaves

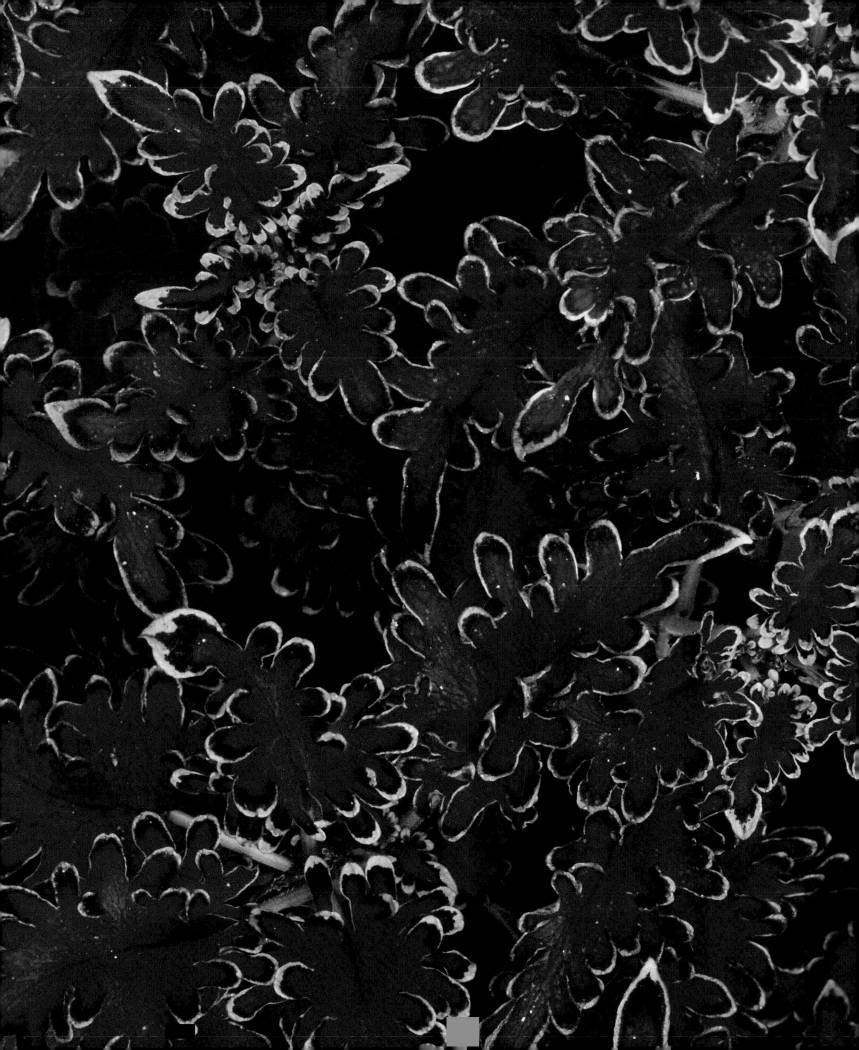

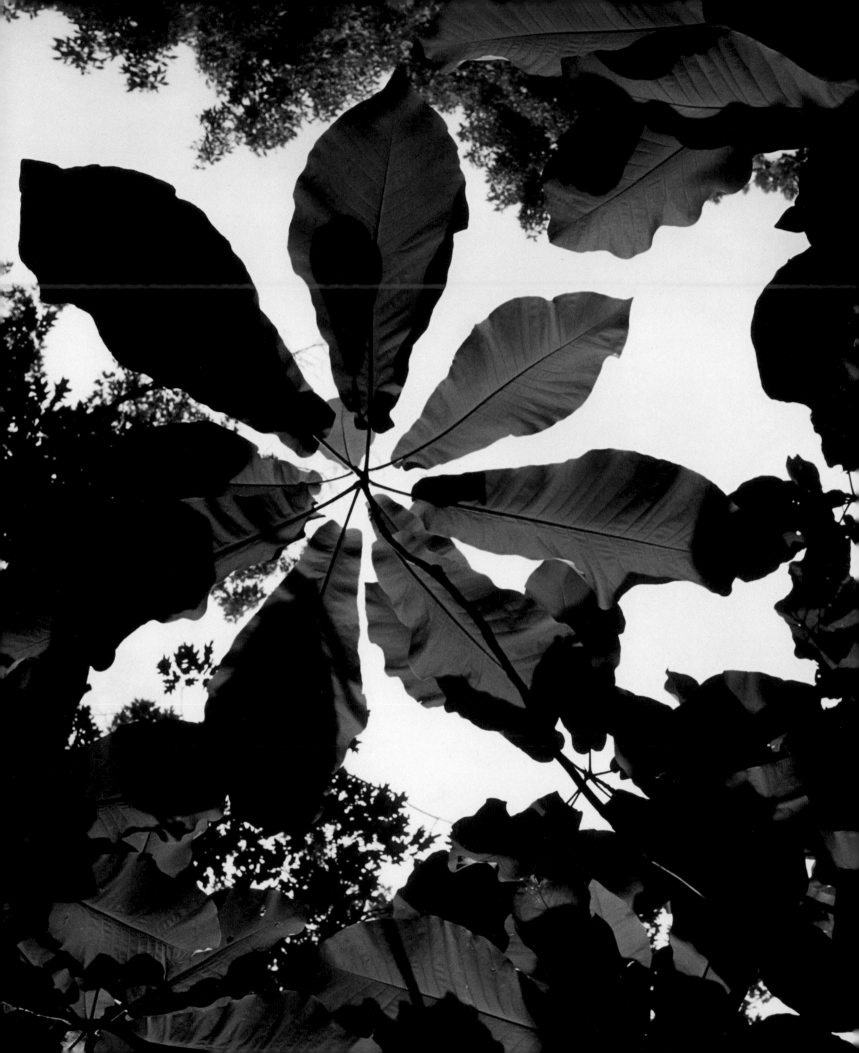

size

SIZE DOES MATTER ... just as much in the horticultural world as everywhere else. Leaves large and small have developed their size for specific reasons — whether to collect more sunlight or to avoid it. In general, larger leaves exist where sunlight is less plentiful and there's not much wind to tear them up. Large leaves also need adequate amounts of rainfall to sustain their size.

There are of course exceptions to the rule. Palm fronds, some of the largest leaves in the plant world, can be found happily growing on windswept beaches in full sun. Small leaves are generally associated with desert regions — small leaf, less exposure to the sun and less surface to lose water from. There are exceptions to that line of thought as well ... the tiny leaves of mosses are most often found growing in dense shade with an overabundance of moisture.

Leaves of gigantic proportions easily date back 200 million years to the age of the dinosaur. We still have remnants of plant life from those times and some of them look as if they should have a giant sauropod munching on a leaf. Some of the largest-leaved plants found on earth belong to the genus *Gunnera*, a group of 40 to 50 species of herbaceous perennials native to the Neotropics, Hawaii and New Zealand. The species *Gunnera manicata* from Brazil can have leaves up to 6 feet (1.8 m) wide and 12 feet (3.6 m) long. Gunneras are a typical example of plants with large leaves in that they enjoy growing in a shaded location alongside stream beds. Many plants with large leaves in the arum or Araceae Family — *Alocasia, Anthurium, Colocasia, Caladium, Philodendron* and *Xanthosoma*, for instance — go by the common name of Elephant Ear, which pretty well perfectly describes them.

Most of these plants are from tropical regions, and their leaves grow to amazing sizes in order to catch whatever sunlight reaches them on the rainforest floor. Plants

with large leaves are not relegated only to the jungle or woodland, however. They can be found right in the vegetable patch. The leaves of squash, melons, pumpkins and zucchini all have large leaves. During the summer months the speed of their growth is staggering, and they need tremendous amounts of sunlight to fuel growth and encourage the production of fruit.

Plants with small leaves sometimes have so many little leaves growing together that they look big. Plants in the genus *Asparagus* include the edible asparagus (*A. officinalis*) and some of the ornamental species. *A. plumosus*, *A. densiflorus* and *A. sprengeri* all appear large thanks to the sheer quantity of their tiny, almost hair-like leaves. But leaves of diminutive stature are not specific to herbaceous plants alone; many woody trees and shrubs have miniature leaves. Members of the genus *Cotoneaster* are popular landscape shrubs with leaves not much larger in size than a nail head. They give the overall effect of a cascade of foliage, providing movement to a landscape.

Thyme (*Thymus*), the edible, step-able landscape herb that can be walked on with little damage, is a genus of close to 350 species. It is a ground-hugging aromatic perennial native to North Africa, Europe and much of Asia, but has now been introduced throughout the world. Each leaf is hardly bigger than a drop of water, but when grown as a ground cover it will form a mat several feet wide.

Plants that have adapted to alpine regions have also taken on stunted characteristics in response to climatic conditions. Intense exposure to the sun, high winds, low incidence of rainfall and subfreezing temperatures all contribute to leaf size. The same species of plant growing at lower altitudes would have larger leaves than its bonsai-sized neighbor living at the tree line. So size does matter ... and bigger is not necessarily better.

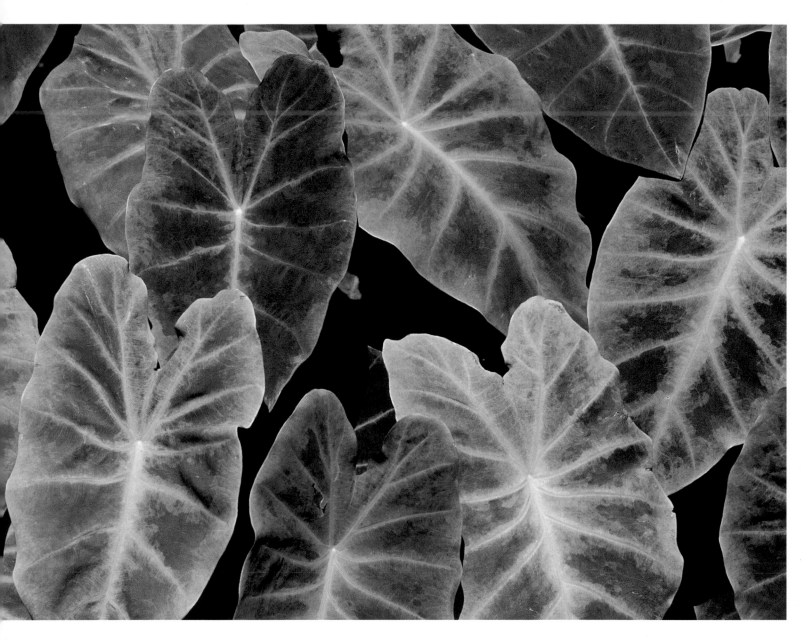

Imperial Taro *(Colocasia esculenta 'Illustris')*

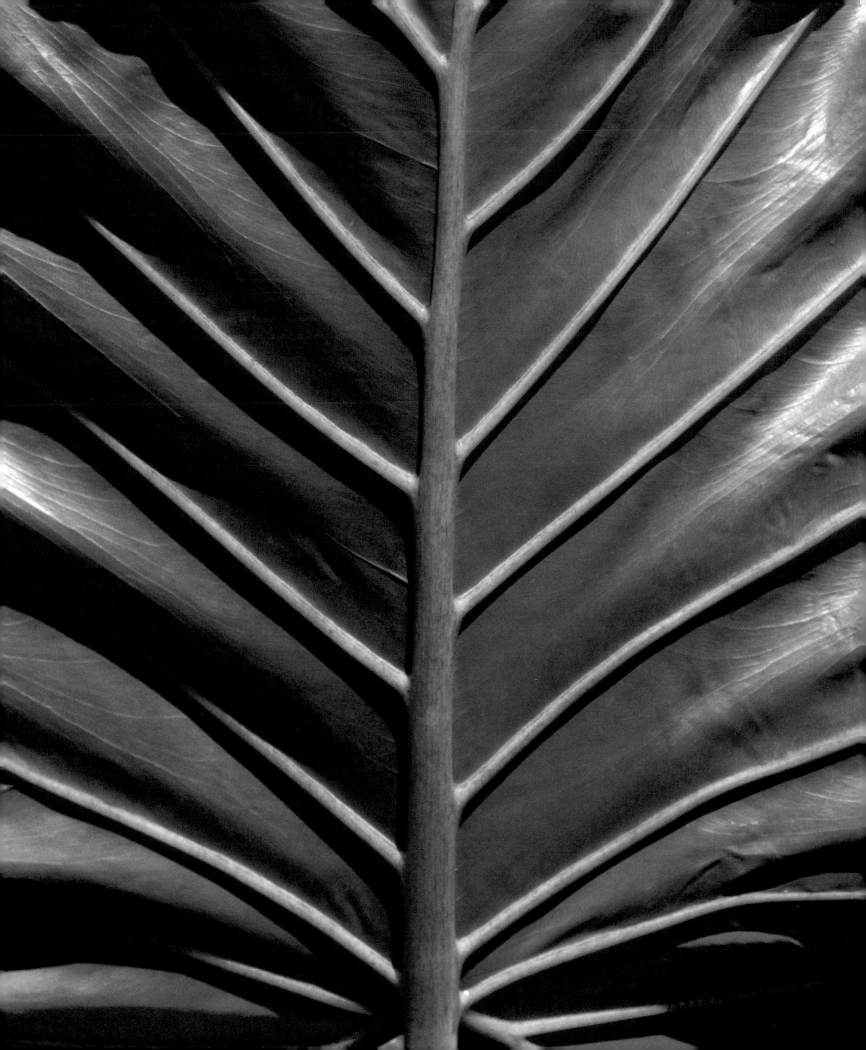

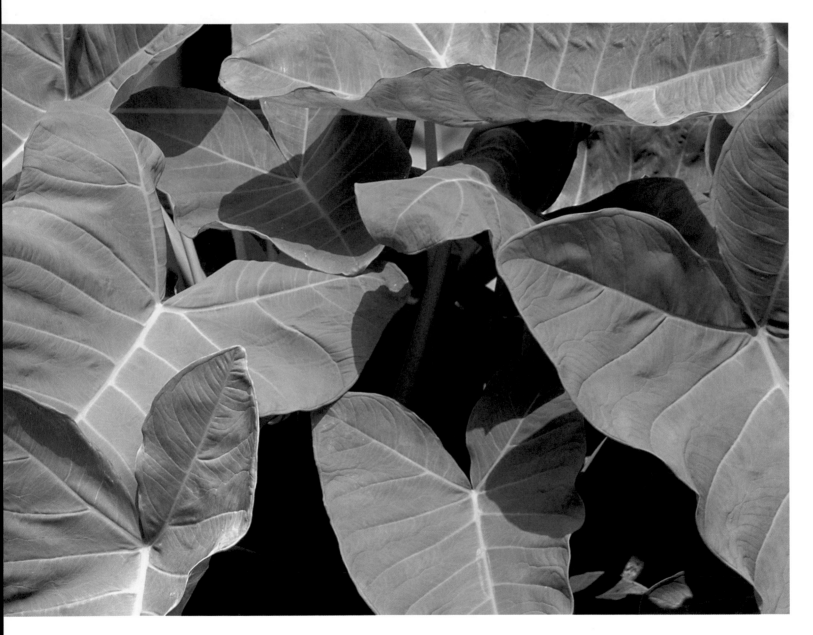

Golden Arrow Leaf Plant *(Xanthosoma sagittifolium 'Chartreuce Giant')*

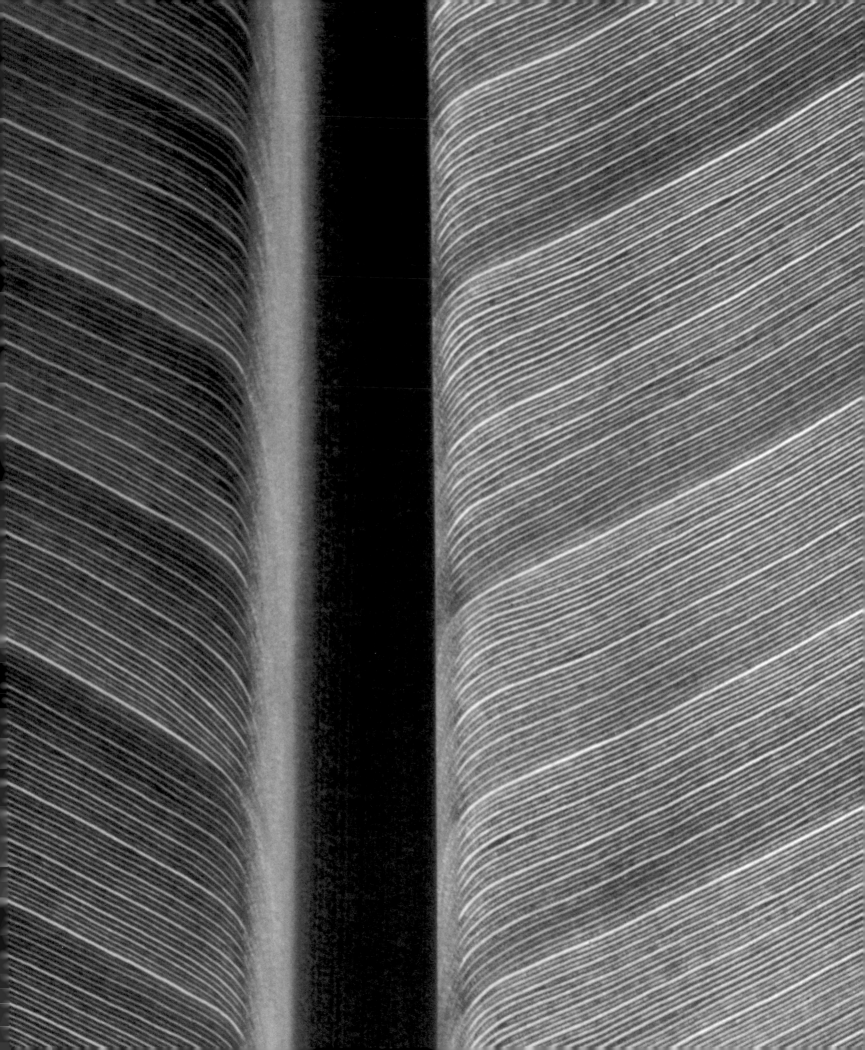

banana

THE NAME 'BANANA' is believed to have originated from the Wolof language, which is spoken in sub-Saharan Africa and was adopted by the Spanish and Portuguese. The Latin name, *Musa* sp., refers to one of the three genera in the family Musaceae. Although often thought of as trees, bananas are actually short-lived, gigantic herbaceous plants that die to the ground after blooming and setting fruit. There are over 50 species of bananas and plantains but only two are bred for their edible fruit. As a result of hybridization, mutation and natural selection, countless cultivars now exist, each recognized for its own particular qualities.

The first organized banana plantation is believed to have been in southeastern China and dates back to 200 AD. Bananas are native to Southeast Asia, Indonesia, the Philippines, Papua New Guinea and Australia, but are grown commercially in 132 countries throughout the tropics. Although they are cultivated primarily for their fruit, bananas are also grown for their fiber and foliage and for their attractiveness as decorative garden plants. They range in size from dwarfs of about 18 inches (45.7 cm) to towering tree-like proportions of 25 to 30 feet (7.6 to 9.1 m). Banana leaves are oval or paddle-shaped and are usually large in proportion to the rest of the plant.

Since banana leaves are waterproof, they are useful as umbrellas or as platters to serve food. And they are also commonly used to wrap food such as tamales for cooking. Bananas are sometimes grown as secondary crops to provide shade and protect other crops such as coffee. In Japan, banana leaves are used in the production of banana cloth from which kimonos are made. And in parts of Africa, hundreds of leaves are attached together to make costumes for ritual ceremonial dances.

In Hawaii, *Musa Ae Ae*, or Koae, the 'Variegated Royal Banana,' was sacred and could only be grown and eaten by the royal family. It grows to a height of about 16 feet (4.8 m) and its leaves can extend to 6 feet (1.8 m) or more. The spectacular variegated foliage is a kaleidoscope of dark and light green, white, cream and washes of silvery gray. Ae Ae produces bunches of green and white striped fruit that, when peeled, display a scrumptious cream-and-white striped interior.

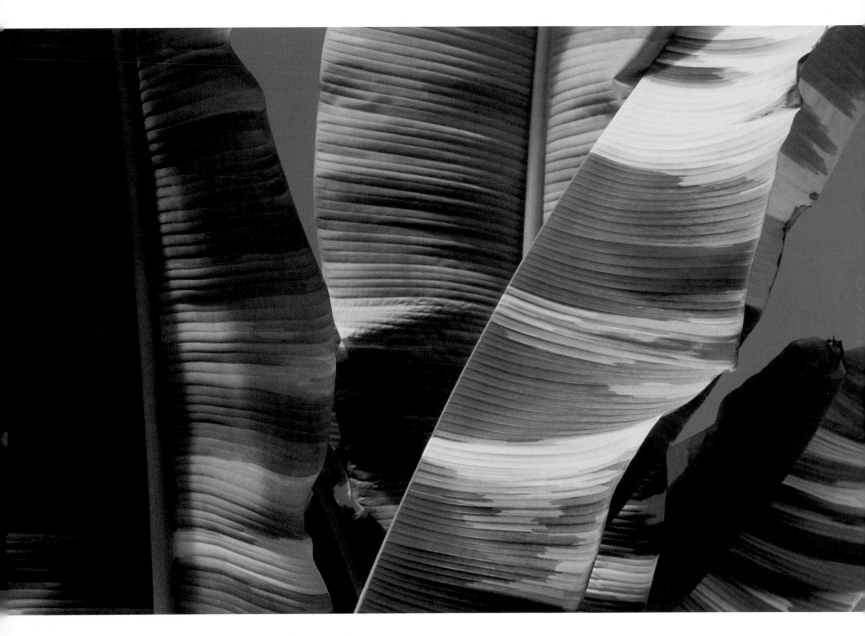

Variegated Hawaiian Banana (*Musa x paradisiace Ae Ae*)

victoria amazonica

A DRAMATIC EXAMPLE of leaf size is *Victoria amazonica*, a giant lily pad whose leaves are among the largest in the plant kingdom. They can measure almost 9 feet (2.7 m) in diameter — even the smallest measure 4 feet (1.2 m) across. Their original botanical name, *Victoria regia*, was introduced by British horticulturalist John Lindley in honor of Queen Victoria. The name was later changed to *Victoria amazonica*.

The Czech botanist Thaddeus Haenke is reportedly the first European to have discovered specimens of the plant, when he was in Peru in 1801. Later, in 1832, the German naturalist Eduard Poeppig gave the first published account of *Victoria amazonica*, but mistakenly called it *Euryale amazonica*, thinking it to be a relative of the Prickly waterlily (*Euryale ferox*) from Asia. The first correct documentation is attributed to Sir Robert Hermann Schomburgk. While on a geographical and botanical expedition in eastern Guyana in 1836, he collected the first specimens of *Victoria amazonica* from the Berbice River in eastern Guyana and sent them to England. Queen Victoria was presented with one of the first flowers ever to bloom in England. Coaxing it into bloom was no easy task. An entire greenhouse was built on the Duke of Devonshire's estate especially to cultivate this hard-to-grow, tender giant.

The 1851 Great Exhibition of the Works of Industry of All Nations held in Hyde Park, London, also referred to as the Crystal Palace Exhibition, was the first in a series of world fairs celebrating the achievements of industry, technology and culture. Joseph Paxton, the Duke of Devonshire's head gardener, was intrigued by the leaf structure of *Victoria amazonica*. The huge floating leaves are marvels of engineering. The configuration of the bottom of the pads consists of an intricate and sophisticated arrangement of cross members and interlocking lattices linked together to provide strength and at the same time trap air to provide buoyancy. Paxton combined his experience of building the greenhouses on the duke's estate with the lessons he learned from the huge lily pads and worked with civil engineer William Henry Barlow, to design the glass structure housing the show. The Crystal Palace was a monumental undertaking. The framework of the renowned glass and cast-iron structure covered more than 19 acres and was sheathed with over a million square feet of glass.

Victoria amazonica is night-blooming, and has large wonderfully fragrant blooms. In early evening it's possible to watch the pure white petals unfurl as the flowers open. When the blooms are fully open on their first night, they are scented with a ripe pineapple-like fragrance and, through a thermochemical reaction, actually heat up as much as 20 degrees. It's at this stage that they attract their pollinator, a large brown flying beetle. The beetle is captured in a sensuous frenzy of heat, fragrance and pollen, and an all night orgy ensues; at dawn it's time for the flower to close, trapping the beetle within the bloom. Twelve hours later, the next evening, the beetle is released and allowed to visit neighboring flowers, bringing along with it the gift of pollen. And so the life cycle of *Victoria amazonica* continues.

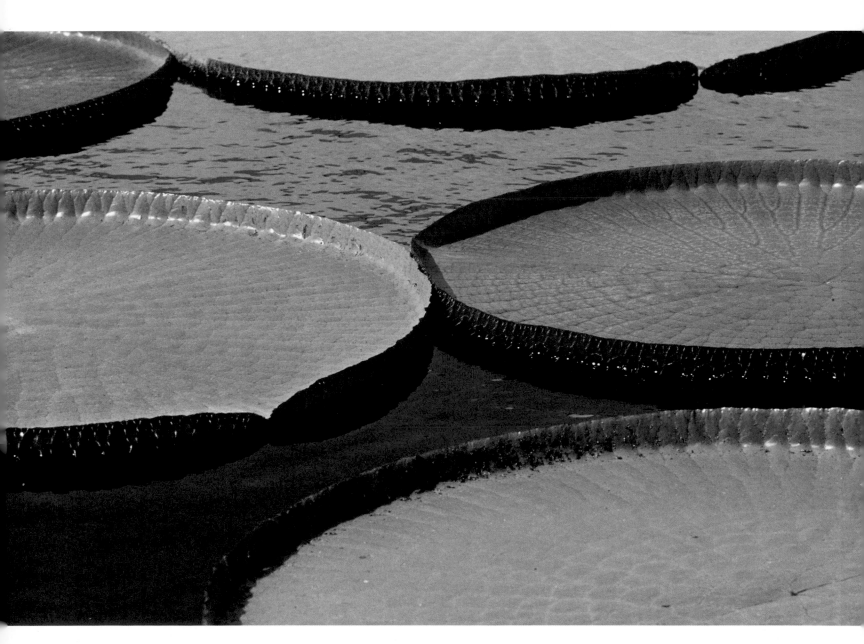

Giant Waterlily *(Victoria amazonica)*

tobacco

NICOTIANA, the botanical name for tobacco, belongs to the Nightshade or Solanaceae family and is native to the Americas, Africa, Australia and the South Pacific. It's named after Jean Nicot, who presented tobacco to the French court in 1561. The actual name "tobacco" is believed to come from the Spanish word *tabaco*.

Tobacco has been in cultivation for almost 5,000 years, and has been smoked one way or another for over 4,000 years. The Aztecs considered it a sacred herb and used it in religious ceremonies, and depictions of Mayans smoking tobacco date back to 1,400 BC. In fact, it has played an important part in the religious life of almost all Native America cultures.

Once introduced to Europe by early traders, tobacco soon became widely popular. At the time, most tobacco was being grown in the southern United States where its production had a large influence on the slave trade.

Tobacco can be smoked by means of pipes, cigars and cigarettes; it can be chewed, sniffed as snuff, and drunk as tobacco juice. When mixed with water, tobacco is an effective organic insecticide and vermicide. It also has a use as a treatment for wasp and bee stings.

Tobacco leaves are harvested in two ways: pulling individual leaves as they mature, and cutting the leaves off at the base and harvesting the entire plant. The leaves can be cured in several ways. Air-cured tobacco is allowed to dry naturally; fire-cured leaves are hung in a barn that is heated by fires kept burning continuously, producing a smoky taste; flue-cured tobacco leaves are heated in a structure with an outside heat source so they do not acquire a smoky taste.

The curing of tobacco leaves provides flavor and can impart a fruity, tea, or rose taste. The technique can take a week or up to several months, depending on the method. After being cured, tobacco is sorted into different grades, baled and sold to tobacco manufacturers.

Ornamental tobacco is grown for its fragrant flowers (*Nicotiana sylvestris*), its colorful foliage (*Nicotiana langsdorffii 'Variegata'*) or for its statuesque appearance (*Nicotiana glauca*). All are popular garden plants.

Nicotiana alata, called Jasmine tobacco, is grown mostly for its sweetly fragrant, tube-shaped flowers. *N. alata* is easily grown as an annual and will bloom quickly from seed. Although the species has a pure white flower, cultivated varieties have been produced in numerous colors including shades of pink, red, yellow, green and salmon.

Nicotiana glauca, tree tobacco, is native to South America but has naturalized in many areas. It can reach a height of 6 feet (1.8 m) and has large bold, blue-green leaves. Small greenish-yellow tubular flowers form on top of the plant.

Nicotiana langsdorffii is an exotic-looking tobacco from Chile and Brazil. It grows to about 3 feet (0.9 m) high and is topped with a multitude of small apple-green bell-shaped flowers. It works well mixed in borders with other bolder plants.

Nicotiana sylvestris, also native to South America but widely distributed as a garden plant, grows to a height of 3 to 4 feet (0.9 to 1.2 m) and produces clusters of pure white 6-inch (15.2 cm) tubular flowers. The foliage is large, coarse and light green. *N. sylvestris* is thought to be one of the parents of *Nicotiana tabacum*.

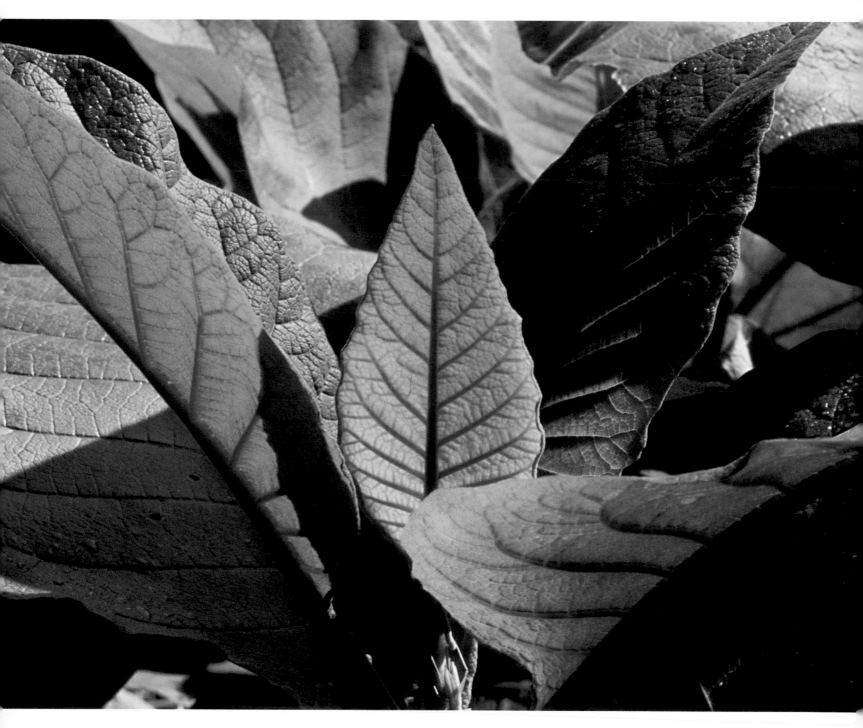

Tobacco *(Nicotiana sp.)*

New Zealand Brass Buttons *(Cotula squalida 'Platt's Black')*

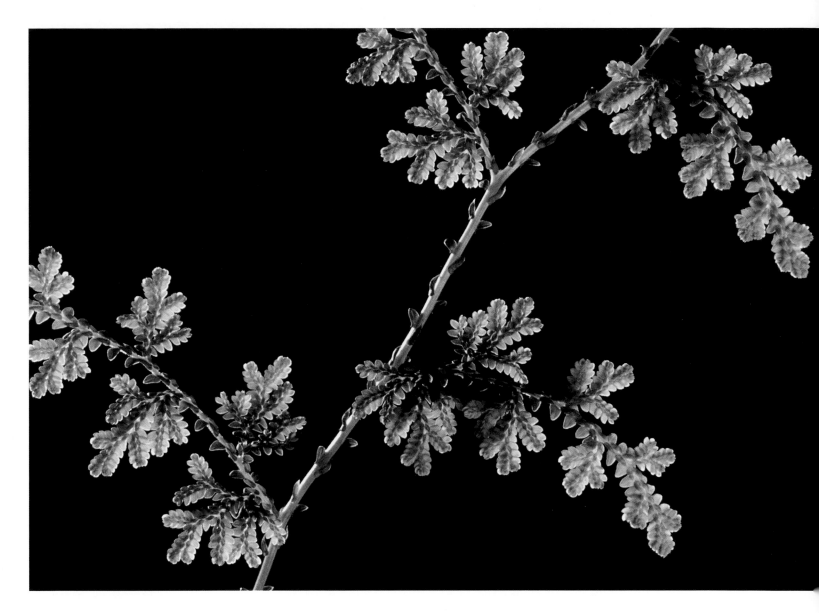

Spikemoss *(Selaginella sp.)*

< Peacock Spikemoss *(Selaginella uncinata)*

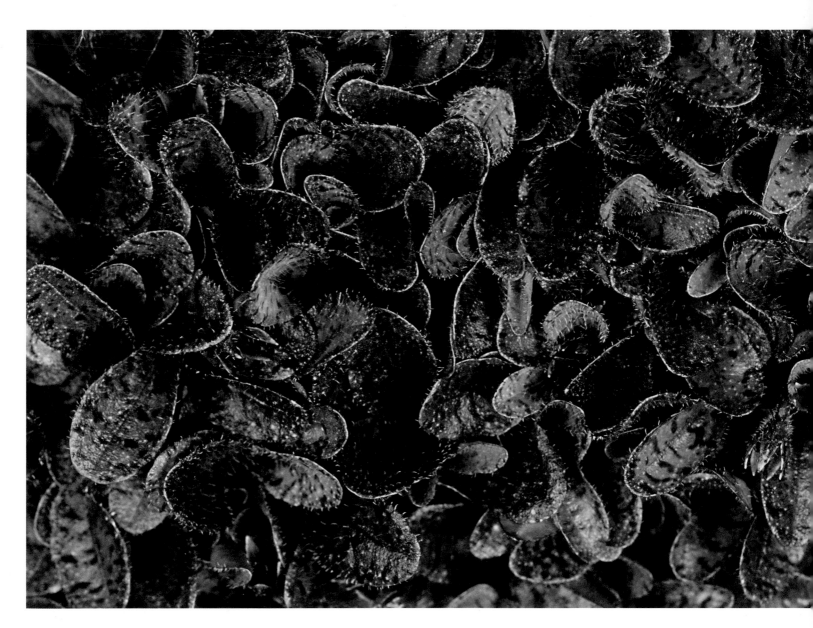

Alpine Rush *(Mazus radicans)*

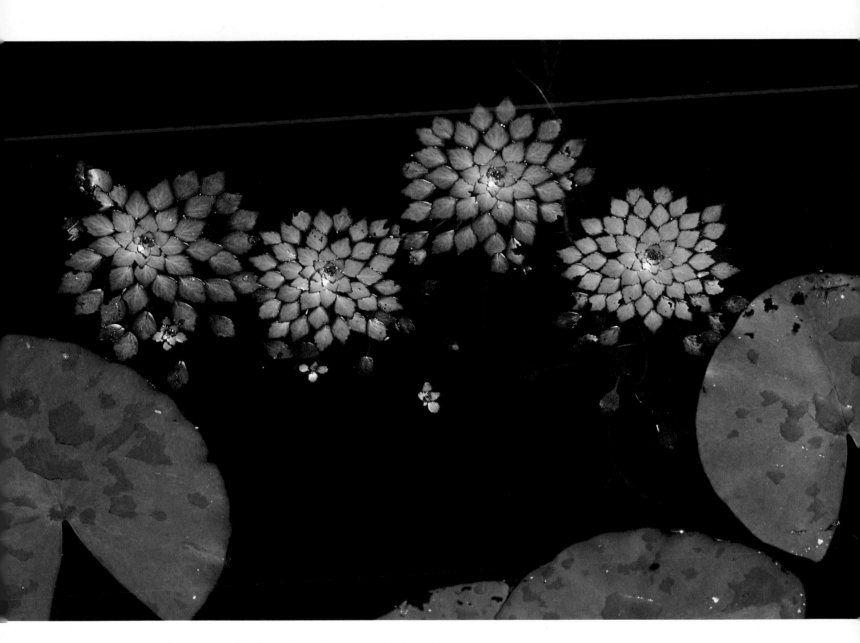

Mosaic Plant *(Ludwigia sidoides)* with Water Lily *(Nymphaea sp.)*

extraordinary leaves

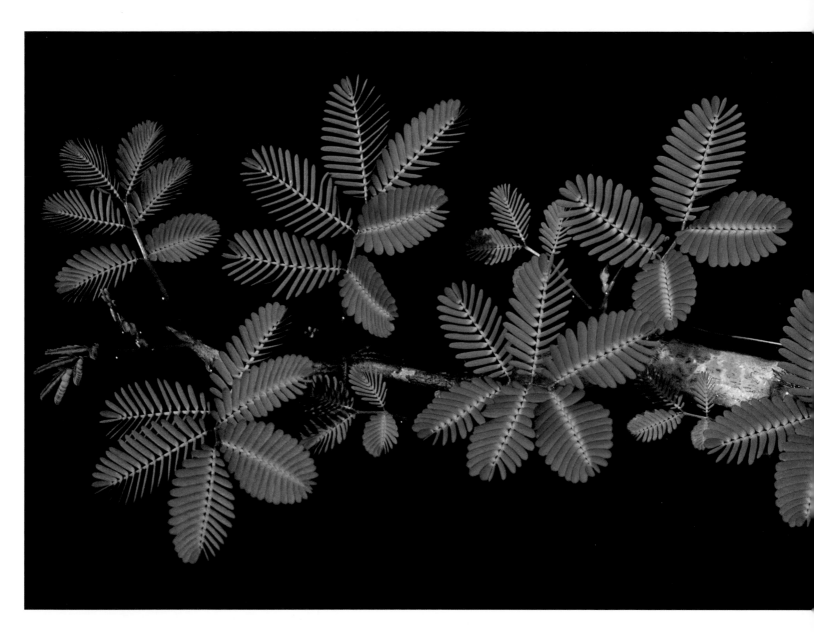

Sensitive Plant *(Neptunia oleracea)*

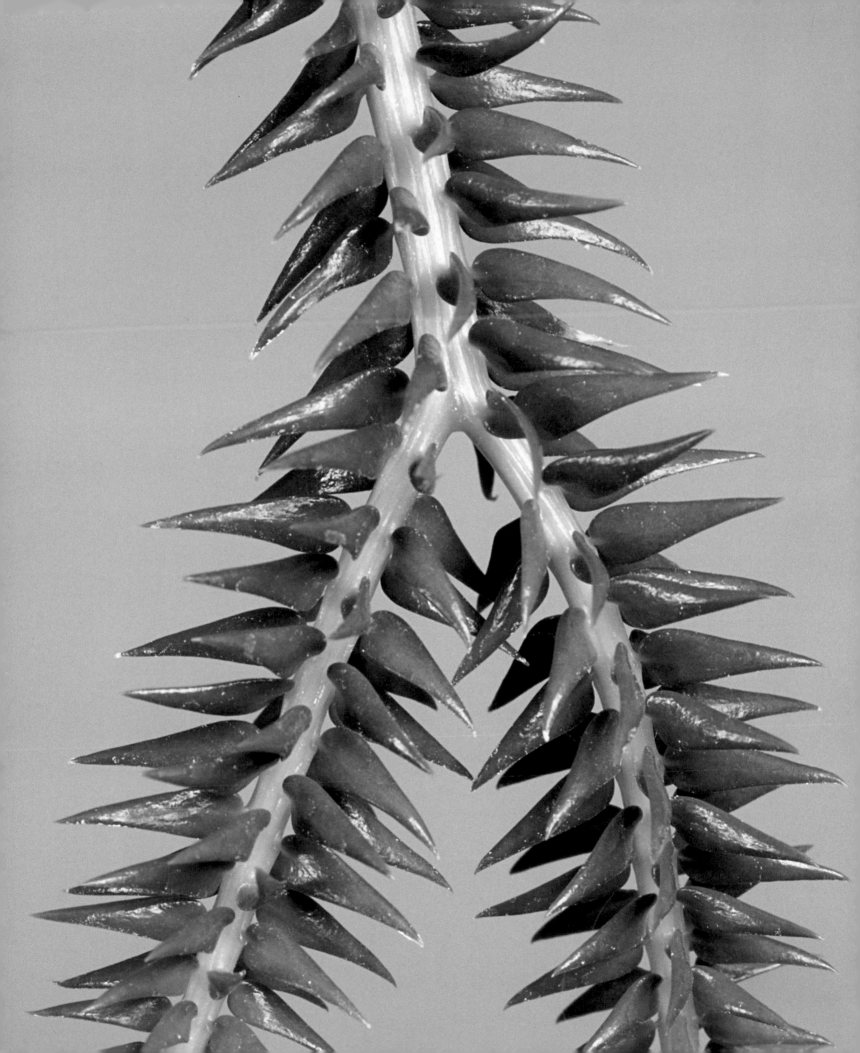

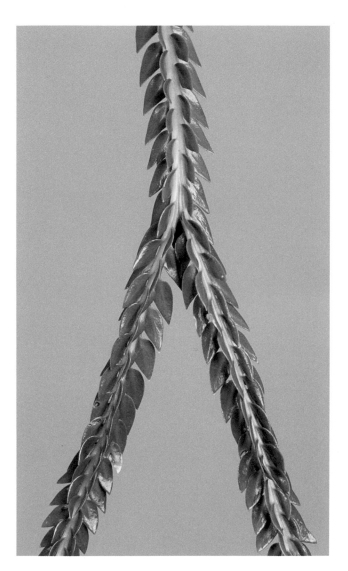

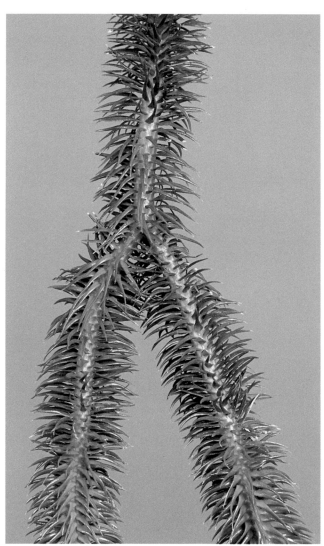

Club Moss *(Lycopodium sp.)*

Tassle Fern *(Lycopodium squarrosum)*

moss

EVIDENCE HAS DETERMINED that mosses are one of the most primitive plant life forms. The first fossil records, which date back some 450 million years, situate them in the Silurian age and suggest that they are among the first plants to grow on land. There are over 10,000 species of moss and they can be found on every continent. They range in size from barely visible to large-branched shrub or fern-like forms. A patch of moss is actually a cluster of tiny plants whose individual leaves are almost impossible to see.

Mosses grow best in damp, shaded areas with adequate moisture. Some grow exclusively as water plants and others can live through drought periods and then re-hydrate after a rain. Mosses are natural compasses. They grow on the shadiest sides of trees or rocks — on the north side above the equator and south side below the equator. They always grow away from the drying effects of the sun.

The horticultural industry relies heavily on mosses. Peat moss is used extensively as a soil amendment and component in "soilless" mixes. Worldwide, 50 million cubic yards a year are harvested, dried and bailed. Large quantities of peat are also used as fuel, primarily in Finland and Ireland.

Mosses are also used for aesthetic purposes. Japanese gardens and rock gardens incorporate mosses for their ability to portray age and impart a sense of tranquility and peace. Entire gardens built with specialized structures called mosseries were popular in the 19th century. The recipe for growing moss is to collect some fresh moss, add the moss to buttermilk, beer or yogurt, add some potter's clay (to help the moss stick to the surface you want it to grow on), puree in a blender, then spread it on the surface. Keep shaded and well misted, and in a few weeks you will have your own mossery.

Moss *(Bryophyta sp.)*

moss

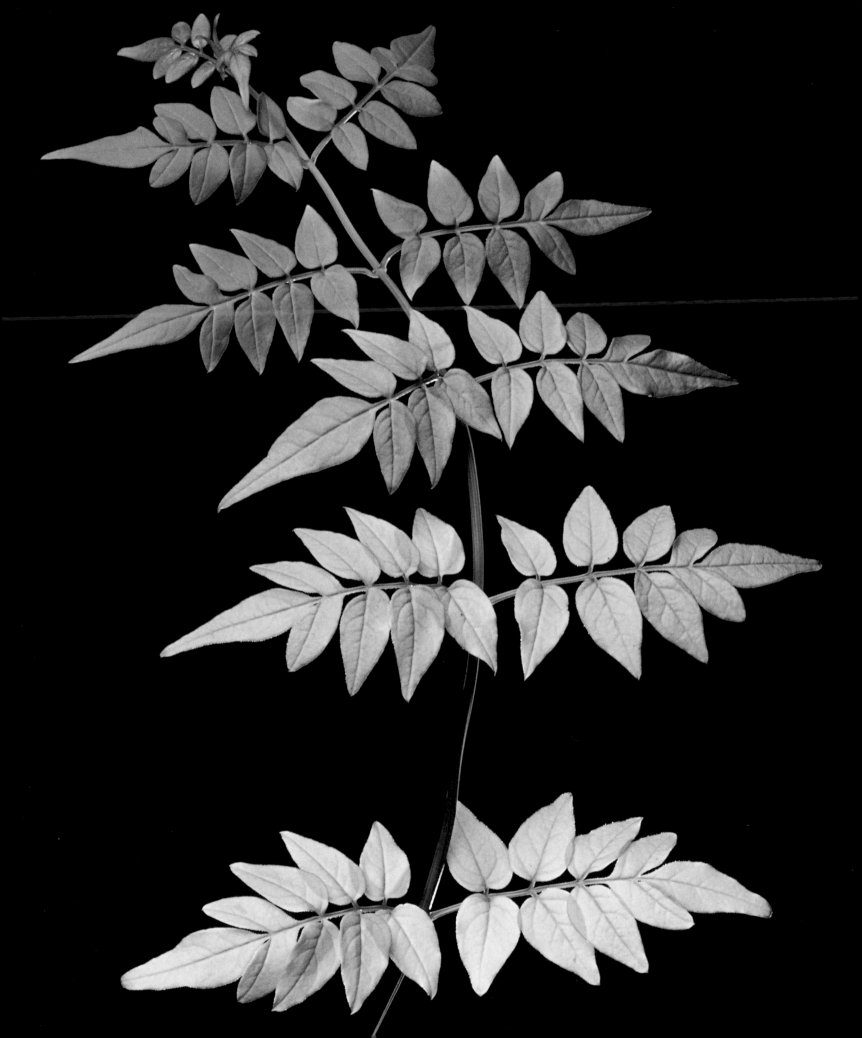

vines

VINES COME AND GO as they please. If left to their own devices, they will scramble up a tree, arbor, fence or wall. If there is nothing to climb on, they are perfectly happy to double over and become ground cover. Vines climb by a number of means: "twining vine" stems move around encircling vertical supports, following the sun in a phototropic manner. Some examples are Wisteria (*Wisteria* sp.), Morning Glory (*Ipomoea* sp.), Mandeville, Jasmine (*Jasminum officinale*) and Golden Hops (*Humulus* sp.). Climbing vines, such as ivies (*Hedera* sp.), Creeping Fig (*Ficus pumila*), Boston Ivy (*Parthenocissus tricuspidata*) and Virginia Creeper (*Parthenocissus quinquefolia*) adhere to their surface of choice by rootlets or small adhesive disks.

Other types of climbing vines are those with flexible tendrils that reach out and wrap around a support. These include Rex Begonia vine (*Cissus discolor*), grapes (*Vitis* sp.), and Passion flower (*Passiflora* sp.). When some vines reach their destination or turn a particular age, they metamorphose. With age, ivy will start to show signs of becoming a shrub and will send out branches that no longer twine but grow on their own. If pieces of this new type of growth are rooted on their own, they will continue growing as a shrub, showing no vine-like characteristics. On the jungle floor, philodendron seedlings search out the darkest, shadiest areas. They grow towards the darkness knowing that the shadow is created by something upright that will hopefully be a suitable ladder to climb up into the tree canopy — this is called skototropism (reverse phototropism). When young, many philodendron species are commonly called "shingle plants" as their leaves overlap and hug the vertical structure they are growing on, thus resembling shingles. Once they grow and mature they turn into the more commonly known split leaf philodendron.

Vines are an important aspect of a landscape, giving objects they climb on an extra dimension. Flowering vines have the advantage of adding additional color when in

bloom and sometimes add fragrance as well. A variegated vine planted to grow on a solid green leafed tree will add a visual element. Vines come in all shapes and sizes; from the small, tender delicate twining vines like *Thumbergia alata* to the huge woody trunk and branches of wisteria. A massive growing vine can easily take down or crush an arbor of small proportions, so positioning is important.

When used as screening, vines can provide almost instant coverage where it's needed. Deciduous vining plants are welcome seasonal additions in the garden; in summer, vines offer shade and give a cooling effect. In the winter months when the leaves have fallen, the naked branches allow sun to filter in and warm the space. It is important to find the right vine for the right place.

Vines cross all categories; they may be annuals, vegetables, hardy as well as tropical, woody and perennial plants. They can be found in all types of environments, ranging from desert conditions to the densest rainforest. Some desert-dwelling vines grow as caudex-forming plants. During the dry season the plant goes dormant, and nutrients and water are stored in the large corm. Come the rainy season, and the vine will appear and grow to amazing proportions.

No discussion of vines can be complete without the mention of Kudzu, the Godzilla of the plant world, introduced to the United States from Japan in 1876 as a forage crop. It's a perennial vine in the genus *Pueraria* and, ironically, is related to the pea. It's capable of growing to 60 feet (18.2 m) in one season and reaching a mature length of over 100 feet (30.4 m). It has been known to cover entire houses as well as surrounding trees and shrubs. It can grow a foot a day and its massive tap root can reach down 12 feet (3.6 m) into the earth. Fortunately, it cannot withstand freezing temperatures and is destined to spend its days in the south.

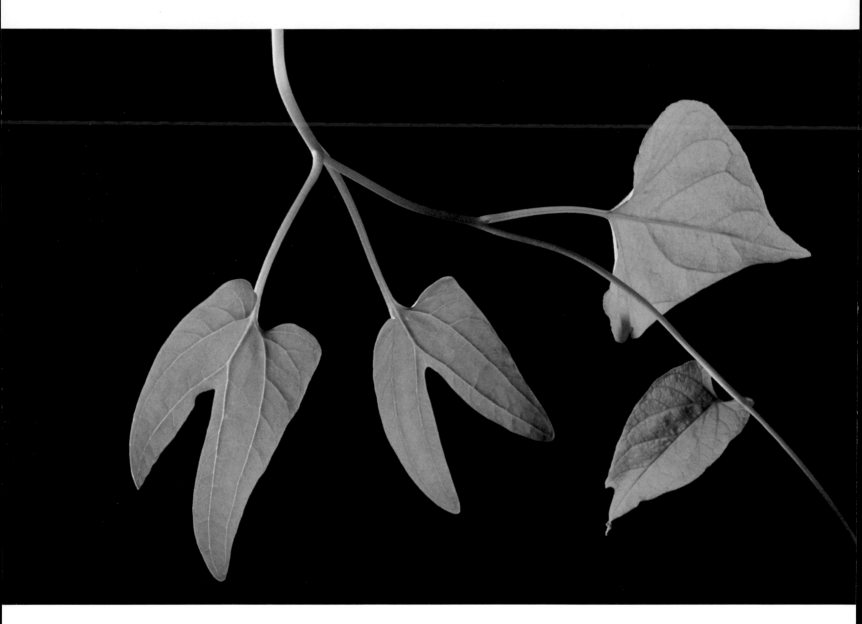

Morning Glory *(Ipomoea sp.)*

extraordinary leaves

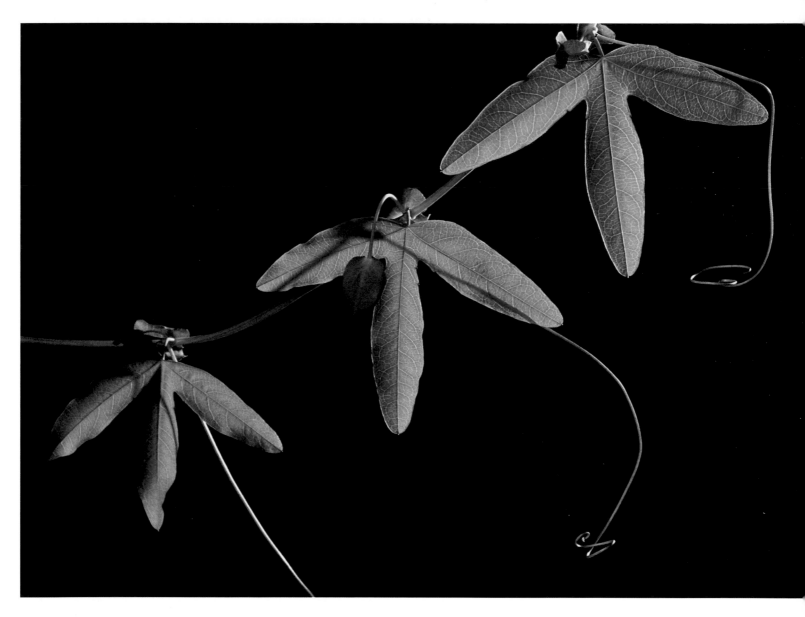

Passion Flower (*Passiflora sp.*)

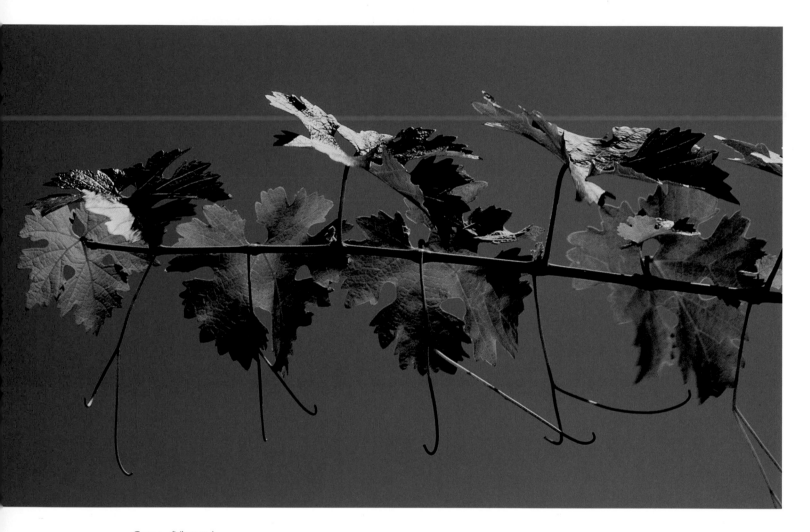

Grape *(Vitus sp.)*

extraordinary leaves

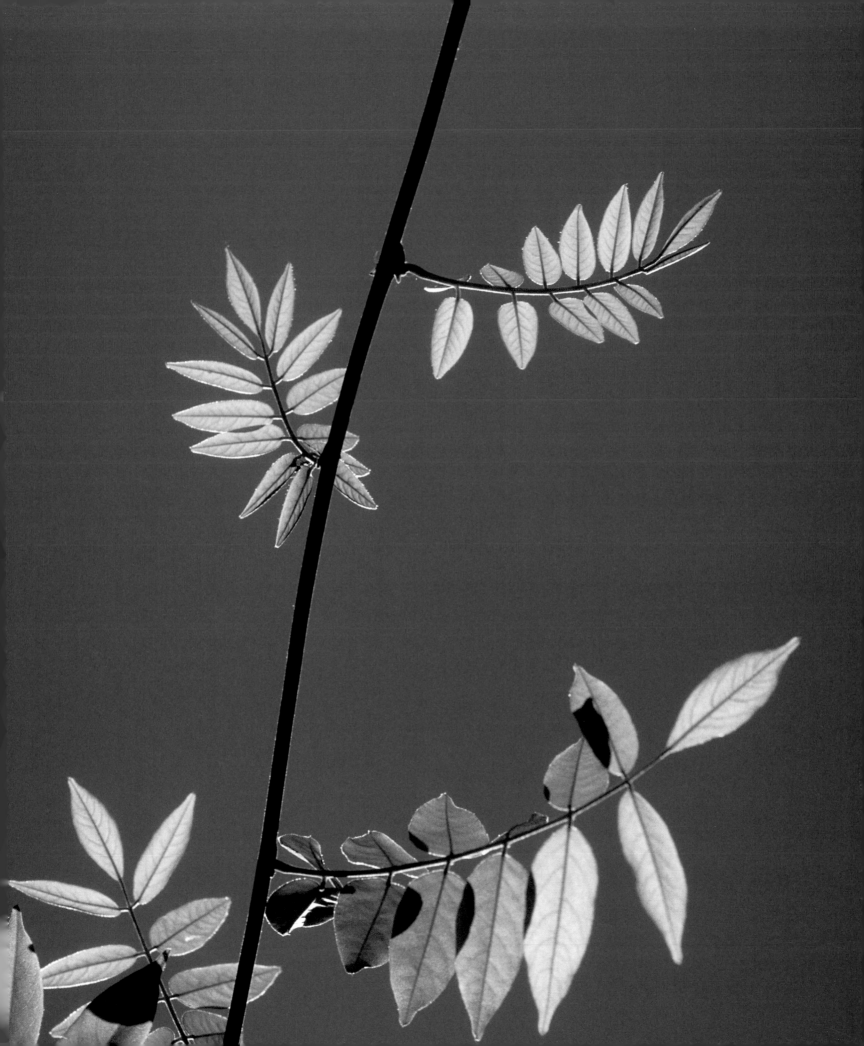

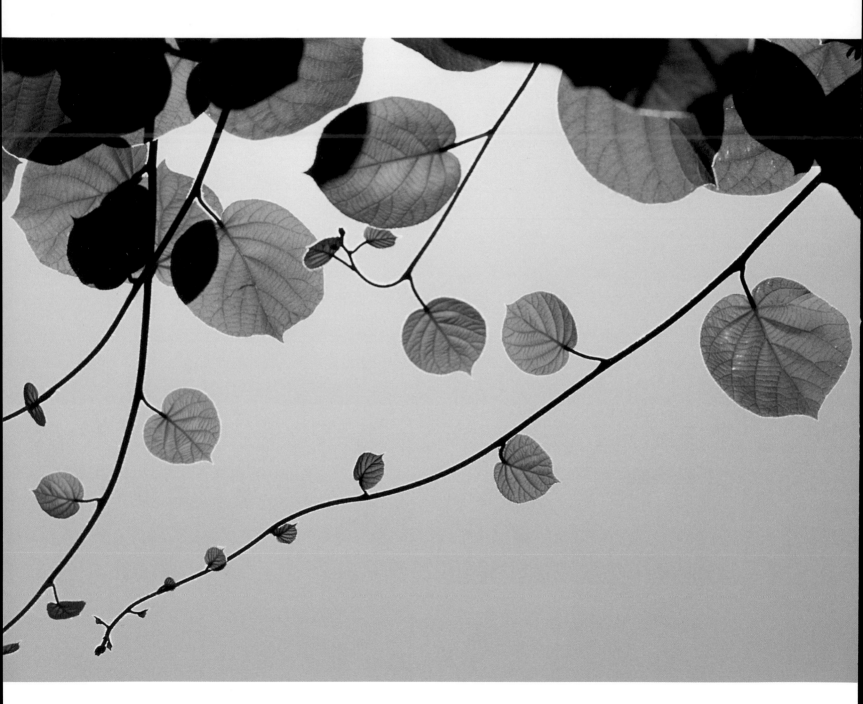

Chinese Gooseberry *(Actinidia chinensis)*

extraordinary leaves

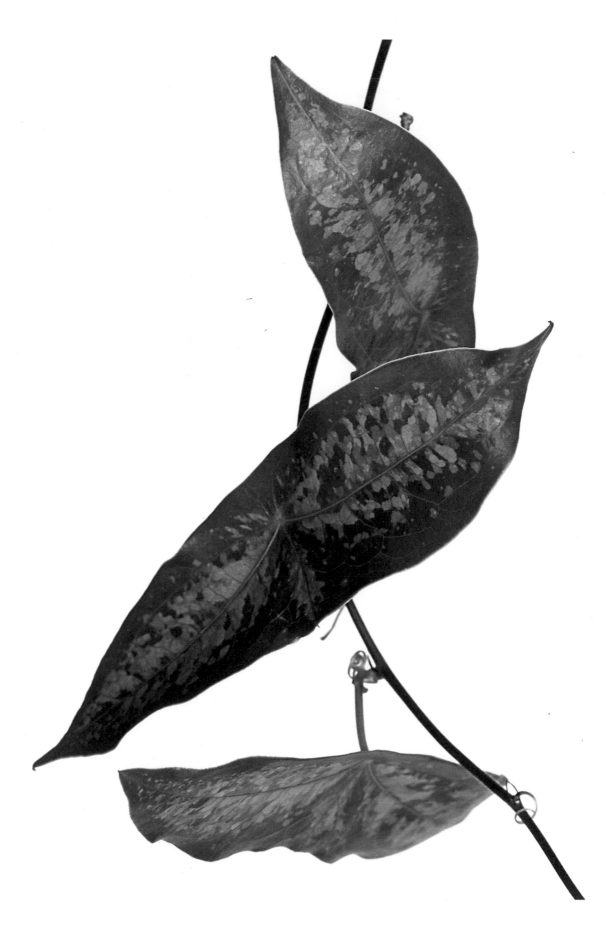

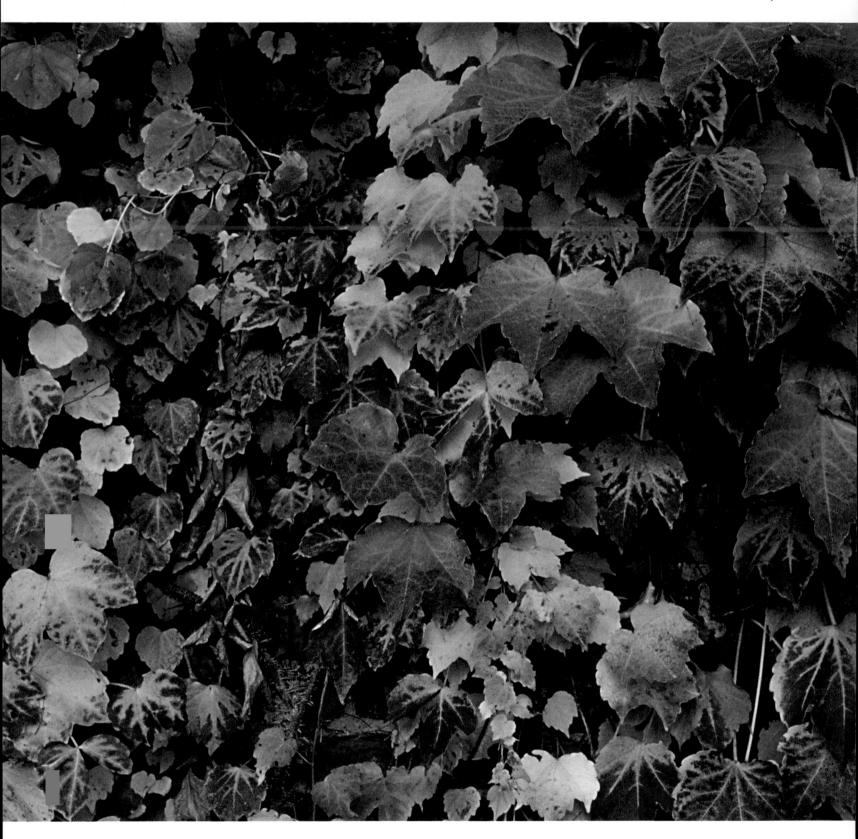

Virginia Creeper *(Parthenocissus quinquefolia)*

extraordinary leaves

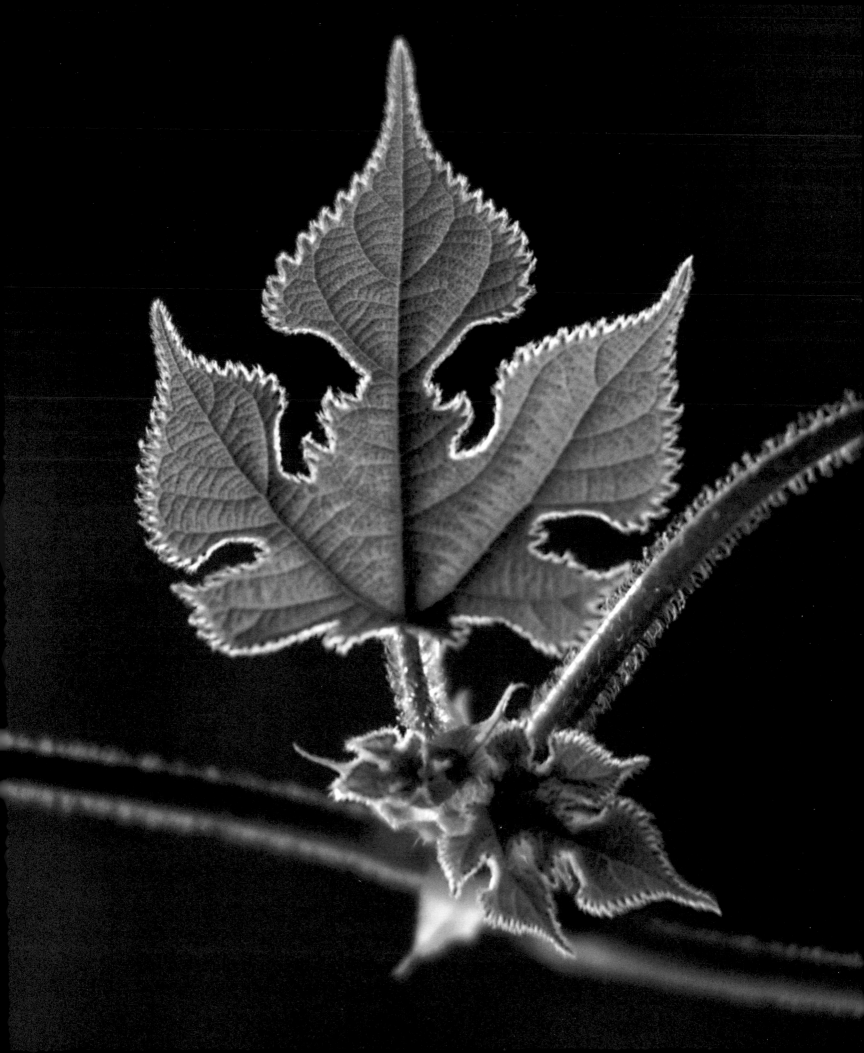

poison ivy

POISON IVY, known in botanical circles as *Toxicodendron radicans*, is a very, very troublesome plant — the bane of many a gardener and outdoors person. It's actually not ivy at all but a woody vine that can grow up to 50 feet (15.2 m) or more in height. The trunk of the vine can be as thick and tough as a weightlifter's biceps.

Sometimes poison ivy can be hard to recognize. It can grow as a shrub or climb up a tree, where it produces branches to form a canopy all its own. It grows just about everywhere in North America and is frequently found in woods as well as open fields. After blooming, poison ivy forms berries, or drupes, which supply one of the most abundant winter foods for birds who lovingly disperse the seeds everywhere. Unfortunately, humans and a few upper primates are allergic to poison ivy. Deer, on the other hand, love its nutritious dark green leaves and are not affected at all.

The toxin that bothers most of the population is urushiol oil, also found in mangos and cashews. It is present in all parts of the plant — roots, stems and leaves — and can remain active for years on gardening tools, shoes, gloves and clothes. Pets can carry it on their fur for a long time, passing it onto unsuspecting humans.

Poison ivy has been planted for erosion control and was actually introduced to the Netherlands as a ground-stabilizing plant to prevent dyke erosion. It has also been planted as an ornamental for its brilliant red fall foliage. One redeeming characteristic of poison ivy is that at least it doesn't have thorns!

Something to remember ... Leaves of three, let it be; Berries white, it's a poisonous sight.

Poison Ivy *(Rhus radicans)*

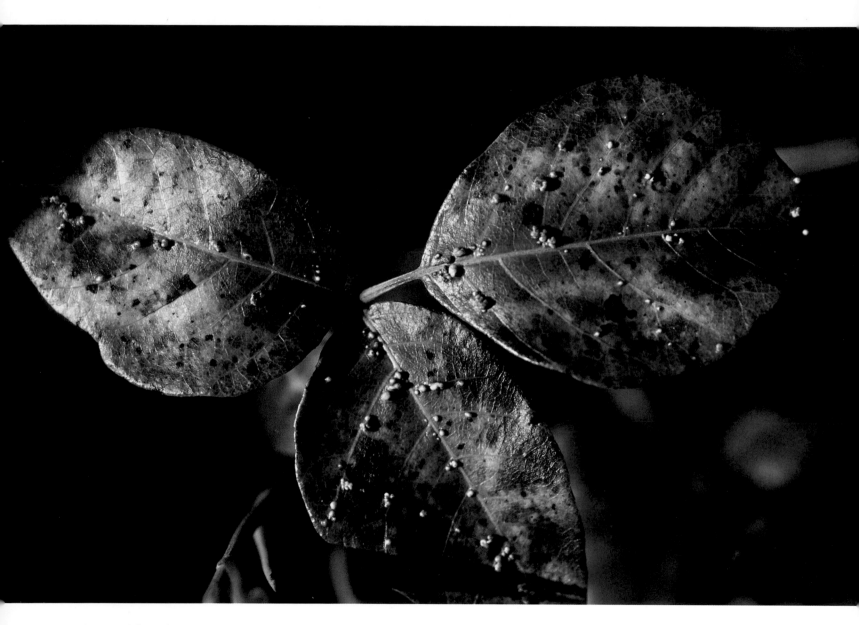

Poison Ivy *(Rhus radicans)*

golden hops

REPORTEDLY FIRST NAMED by Pliny the Elder, *Humulus lupulus* has the common name of 'Hops,' which is derived from *hoppen*, the Anglo-Saxon word meaning "to climb." And climb it does, easily twining up 20 to 30 feet (6 to 9.1 m) in one growing season. Its native habitat stretches across Western Europe to Asia, but it can be found growing in all temperate regions of the world. Male and female flowers are born on separate plants, but the unfertilized female flower, called a strobile, is the one that has commercial significance. Once fermented, it is the ingredient that provides the bitter taste in beer.

Golden Hop Vine *(Humulus lupulus 'Aureus')*

The association between hops and beer making is legendary, but a few other relationships should also be noted. For thousands of years hops have been used for numerous maladies and health issues, including the treatment of headaches, stomach and intestinal diseases, menstrual problems, heart disease, sleeplessness, neurosis, jaundice, delirium, gingivitis and gastritis.

The expression "hopping mad" came about in the 1600s in reference to laborers who harvested the hops. Their constant daily contact with the plant would supposedly induce rages of drunken behavior. Hops were also believed to be the cause of melancholia and suicide, and there is thought to be a high correlation between impotence in men and beer drinking.

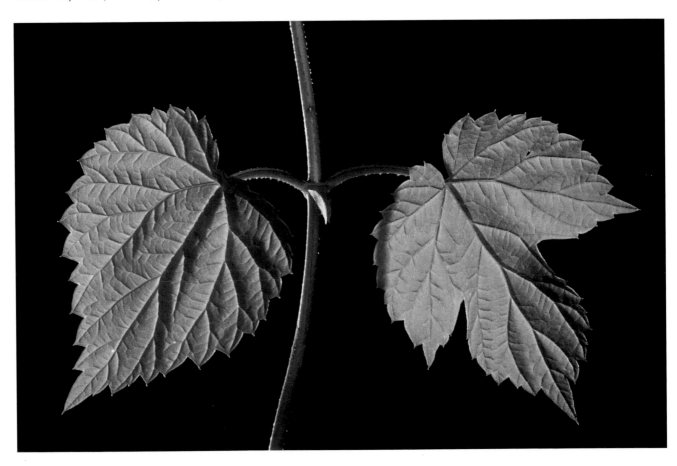

argyreia nervosa

RECOGNIZED BY A FEW common names such as Wooly Morning Glory, Hawaiian Baby Woodrose and Elephant Creeper, *Argyreia* has a few notable characteristics, such as its leaves. They are large and heart-shaped, easily reaching 8 to 10 inches (20.3 to 25.4 cm) across and covered with silver-white velvety hair. The silver down reflects light so perfectly that the stems and leaves seem to radiate with an electric charge.

Wooly Morning Glory *(Argyreia nervosa)*

The fast-growing vine will attain a height of 30 feet (9.1 m) or more, with the growing tips and new leaves being the most intensely colored. When its ropy arms reach out to find support and find only thin air, they double back on themselves, climbing off in another direction and forming intricate knotted patterns. The patterns can become even more fantastic, astonishing, mind-altering designs, and be studied for hours if viewed under the influence of *Argyreia*'s other claim to fame. The seeds contain LSA, a chemical analog and less potent form of LSD.

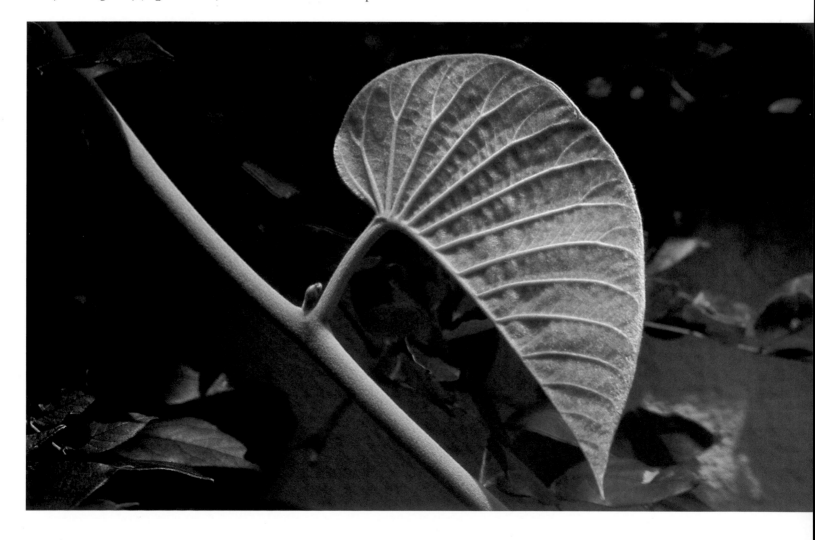

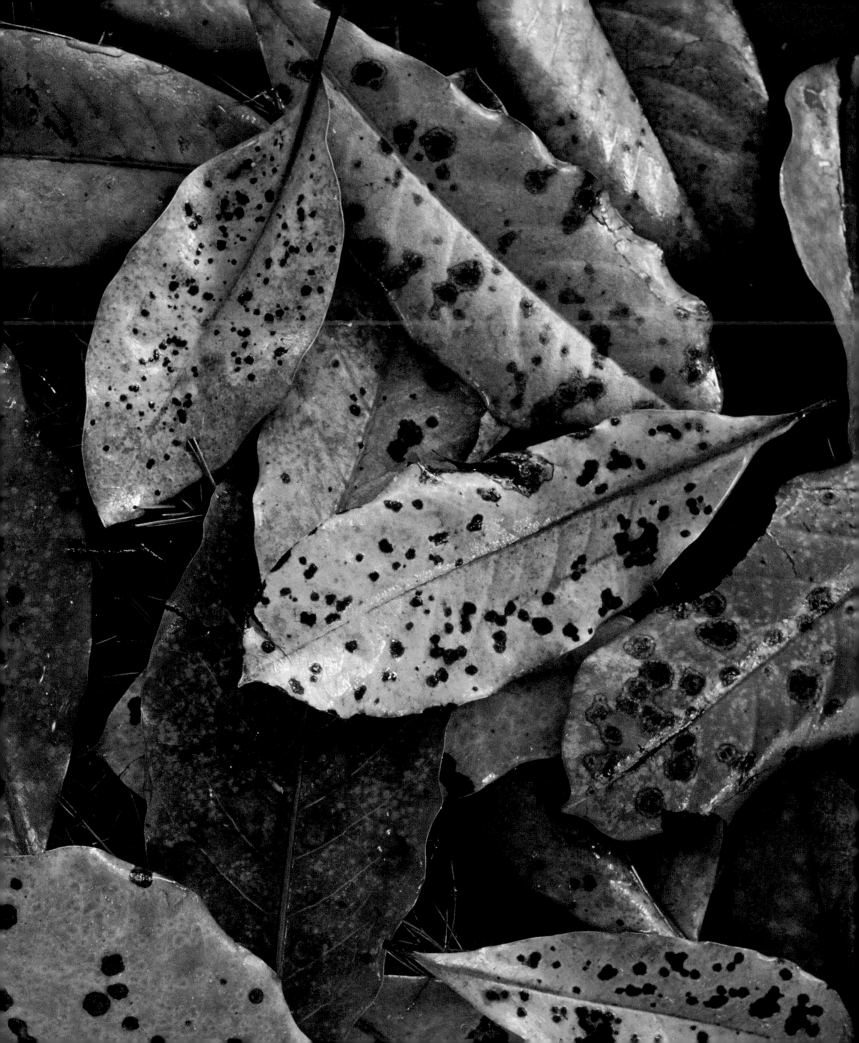

autumn

AUTUMN, the period between September 22 and December 21 in the northern hemisphere, is a transitional season. With the onset of autumn, gradual changes occur, signaling to us that summer is over and winter is on its way. One of the signs is a visual one, very bright and very clear. Throughout New England, Northern Europe, Russia and especially in China, Japan and Korea, foliage colors change from predominantly green to vivid yellows, oranges and fiery reds.

Eastern Canada and the Northeastern United States have become international destinations for leaf tourists, aka "leaf peepers." They can enjoy colorful foliage for miles while driving along country lanes, with the hillsides a patchwork of color. What makes for a good leaf-peeping season? Weeks of cool sunny days, and cool but not yet frosty nights. The bright colors start in the northernmost reaches and spread southward like a slow-moving wave. Brilliant reds, yellows, oranges, golds and rust colors are on display for a few short weeks in each area, and then are followed by a wake of brown dried foliage or bare branches.

Some regions that have vast stands of a particular species of tree are especially bright, as broad areas of woodland burst into a blaze of color. Tree species also regulate the order of appearance of fall colors; first the yellows, then oranges and finally the reds and purples, although some golds hold back until the end. The temperature at different elevations will affect the way leaves change as well. The top of a hill can be brilliant with fall color and at the base just a few hundred feet further down, trees can still be sporting their summer greens.

The science behind the great color change is fairly simple as far as chemistry goes. Summer's green leaves are showing off their abundance of chlorophyll, which masks the presence of pigments of other colors. The chlorophyll in a leaf is constantly being renewed and replaced, much like our own skin. When summer's end approaches, temperatures start to drop and leaves slowly stop producing chlorophyll. The chlorophyll gradually moves from the leaves to the branches, the trunk and finally to the roots. With the chlorophyll gone, the other pigments — the yellows and oranges that were there but hidden throughout the whole season — are revealed on the leaves.

Carotenoids, which provide the characteristic yellow-orange colors, are found in other plant life as well, including the obvious plants and vegetables like carrots, oranges and daffodils. But they also provide color in unexpected organisms such as canaries and salmon.

Fiery reds and deep purples come from another set of pigments not present in the leaf during the season. They develop in late summer when the sugar breakdown process occurs, producing anthocyanins, which act as antioxidants or sunscreen for the leaf. Antioxidants protect the leaf from harmful UV light rays — the more intense the sun the more brilliant the leaf colors will be. Antioxidants found in leaves are similar to those found in blueberries, cranberries, cherries, eggplant and other red or purple fruits. Red pigments are also present in young leaves, where the anthocyanins work to protect new tender leaves from strong sunlight.

When pigments are combined, they create intense colors like deep orange, burgundy red and golden bronze. Leaves can become multi-hued, with wildly colored strips fashioned by prominent veining. Blotched, splashed and streaked leaves can rival the most outrageous coleus leaf. In heavily wooded lots, trees positioned half in sun and half in shade will have an astonishing amount of color on the sunny side and then be pale yellow or pale green on the other. There are a few trees that don't take part in celebrating autumn's glory. The leaves of elms and some of the oaks turn from green to a drab brown and drop off with little or no celebration.

The best trees for oranges and yellows are: Ash (*Fraxinus*), Aspen (*Populus* sp.), Birch (*Betula* sp.), Ginkgo (*Ginkgo*), Hickory (*Carya* sp.) some Maples (*Acer* sp.), Sycamore (*Platanus* sp.) and Sassafras (*Sassafras* sp.).

The best trees for reds are: Dogwood (*Cornus* sp.), some Maples (*Acer* sp.), Oak (*Quercus* sp.), Sourwood (*Oxydendrum* sp.), Sumac (Rhus sp.), Sweetgum (*Liwuidambar* sp.) and Tupelo (*Nyssa* sp.).

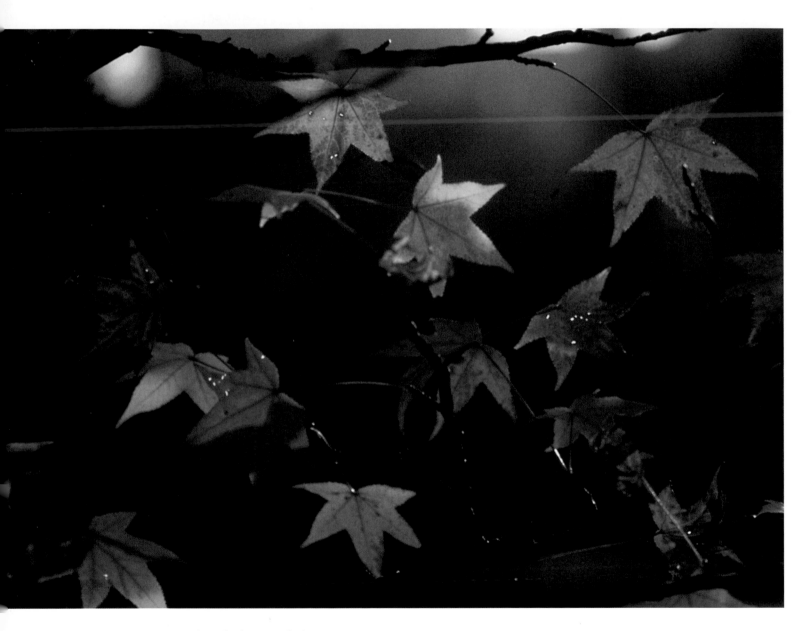

Sweet Gum *(Liquidambar styraciflua)*

extraordinary leaves

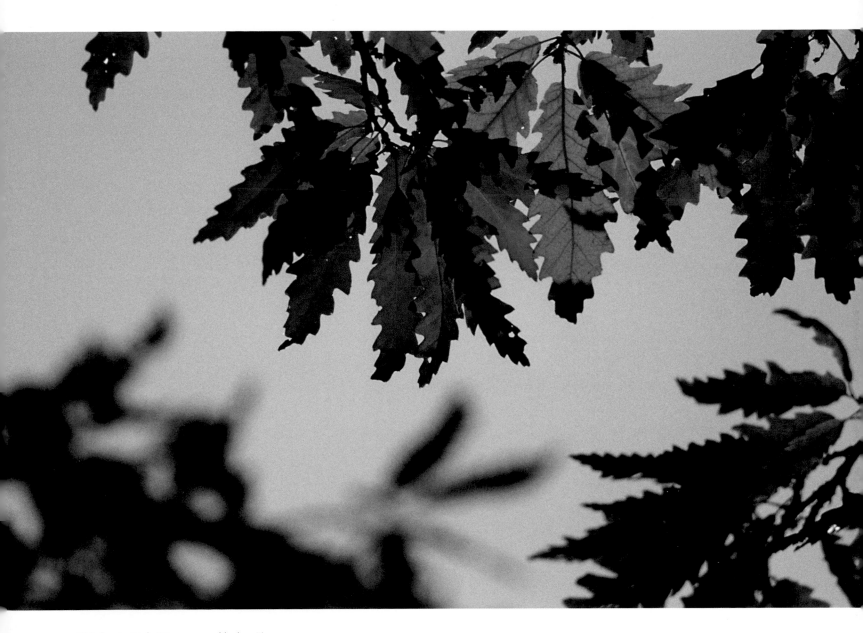

Chinkapin Oak *(Quercus muehlenbergii)*

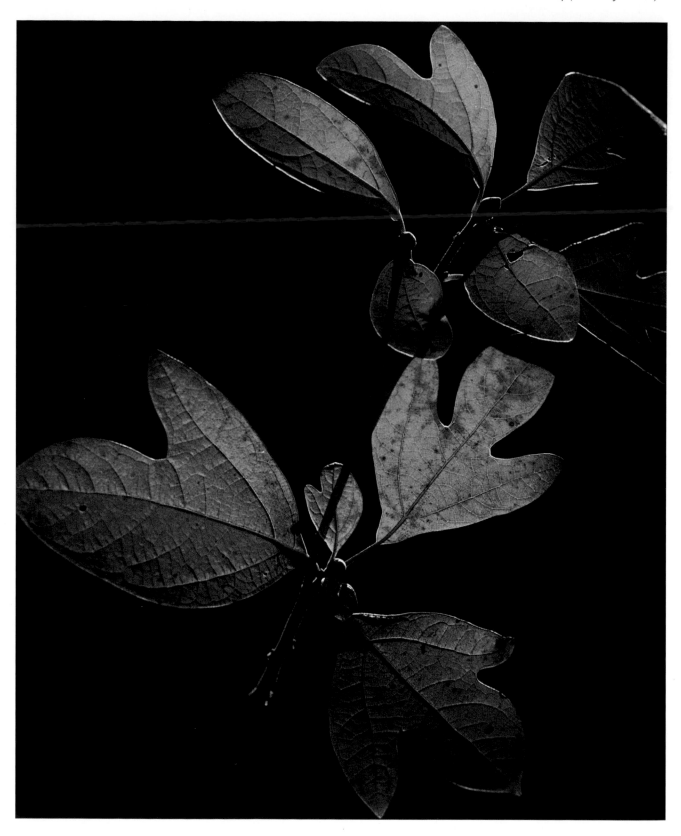

Sassafras *(Sassafras albidum)*

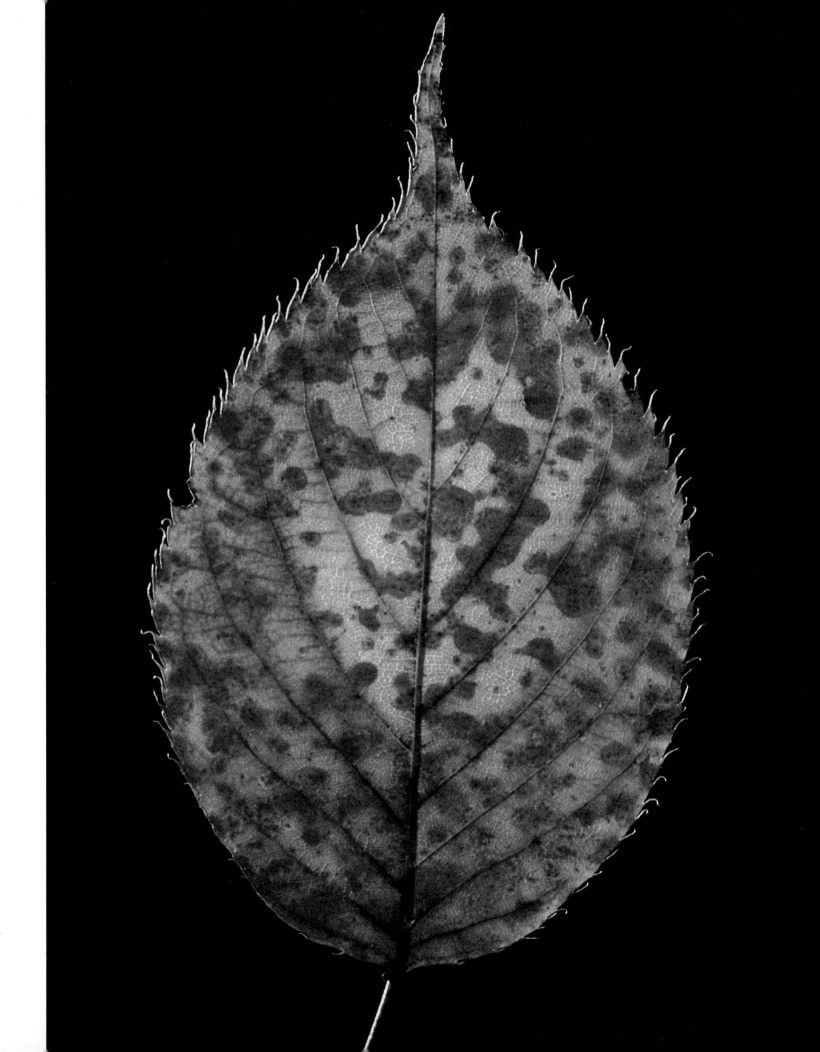

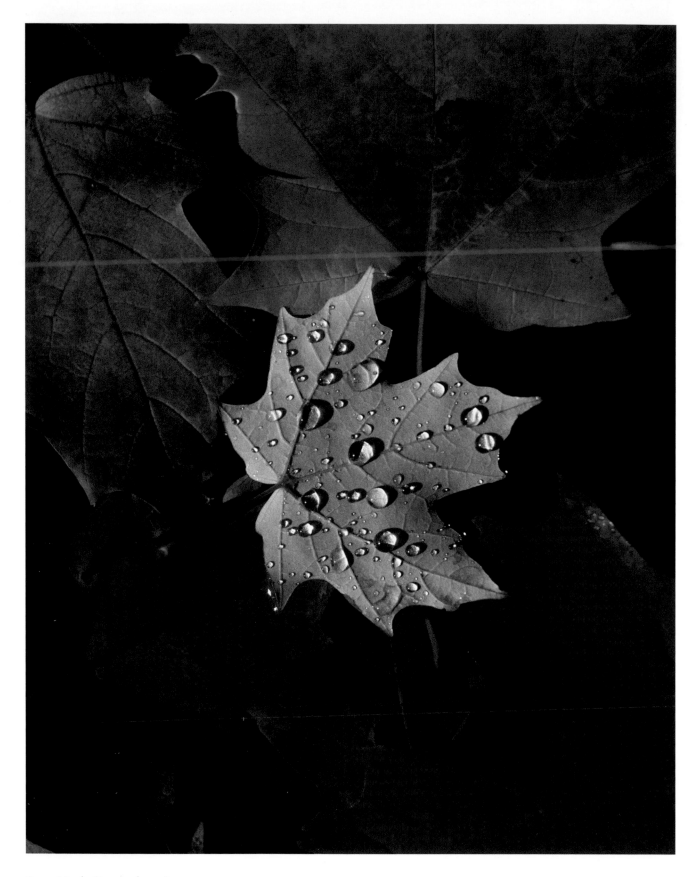

Sugar Maple *(Acer saccharum)*

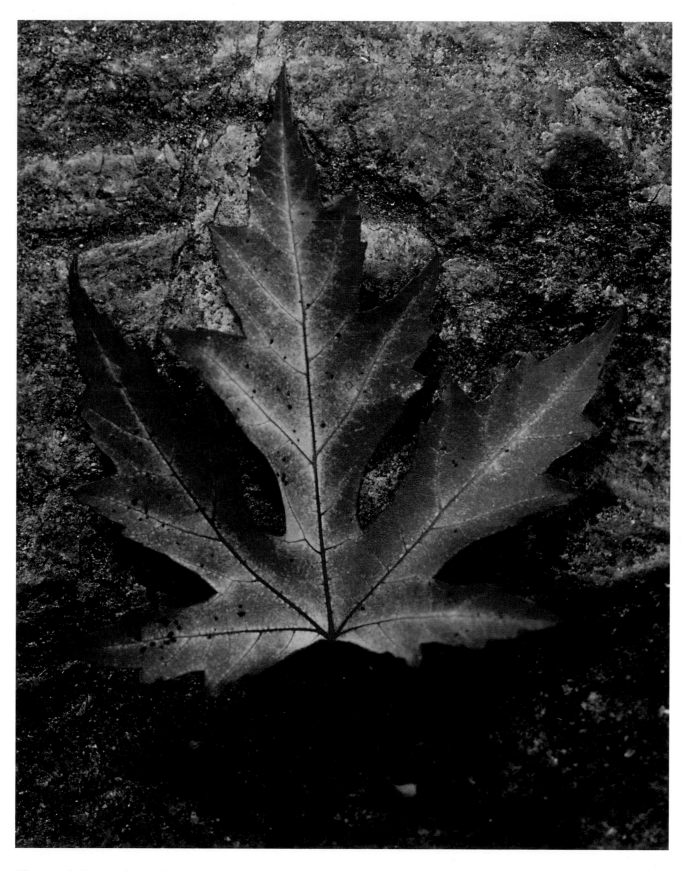

Silver Maple *(Acer saccharinum)*

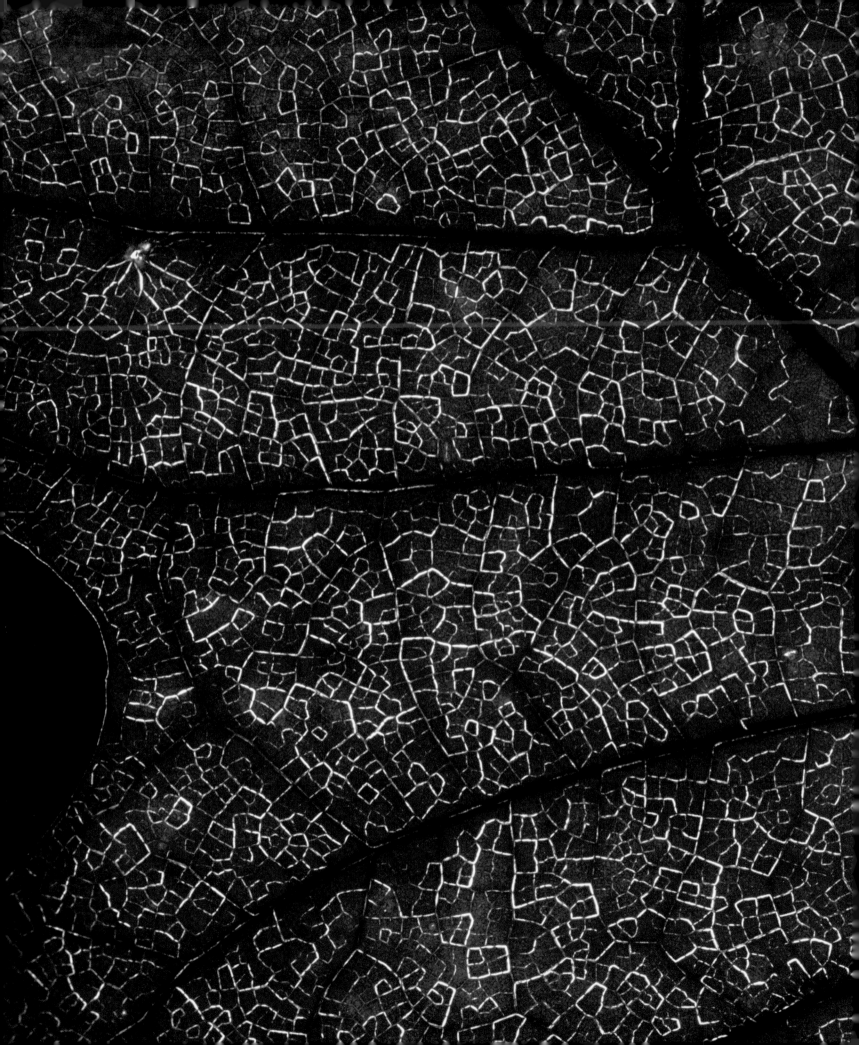

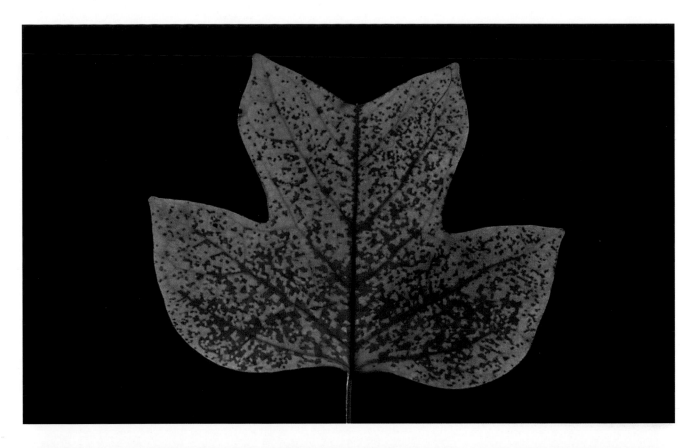

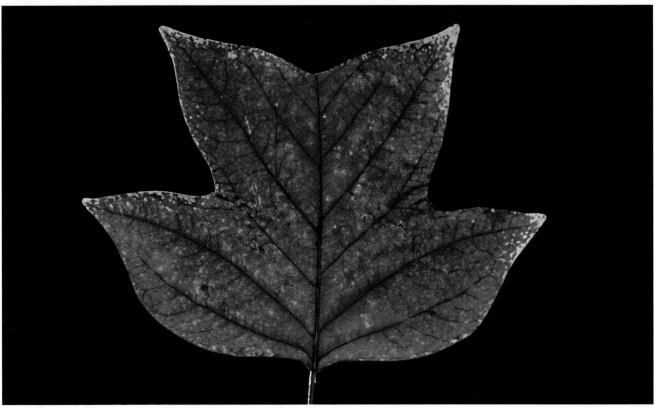

Tulip Tree *(Liriodendron tulipifera)*

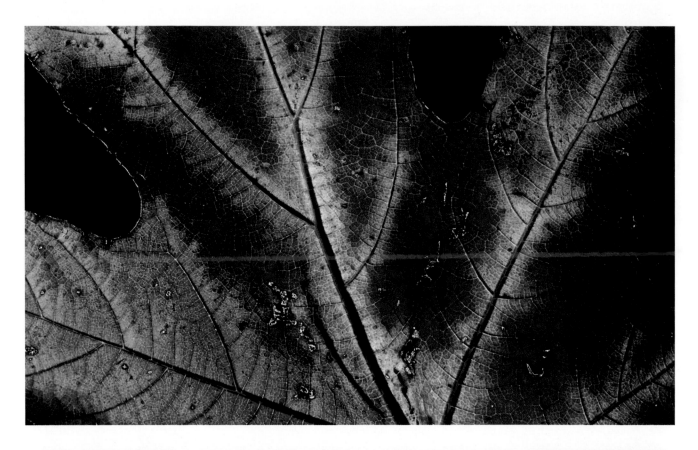

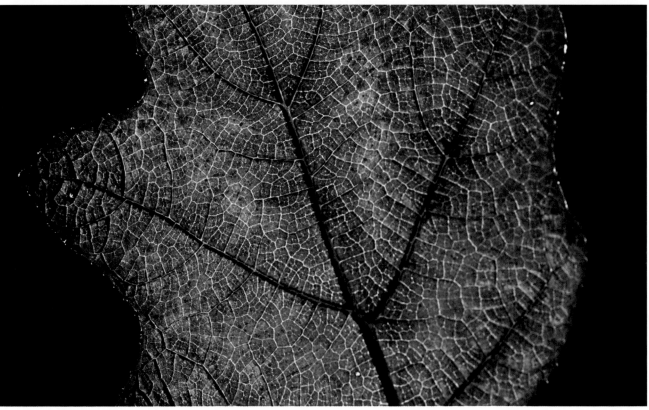

Oak Leaf Hydrangea *(Hydrangea quercifolia)*

extraordinary leaves

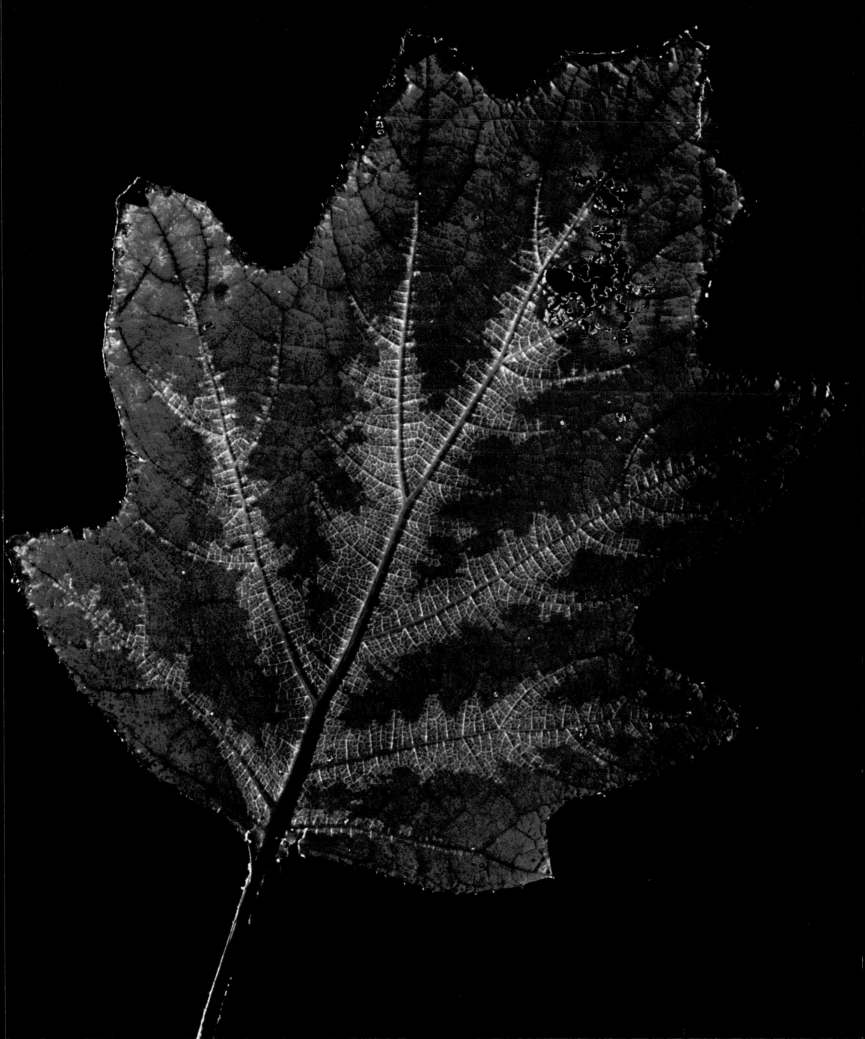

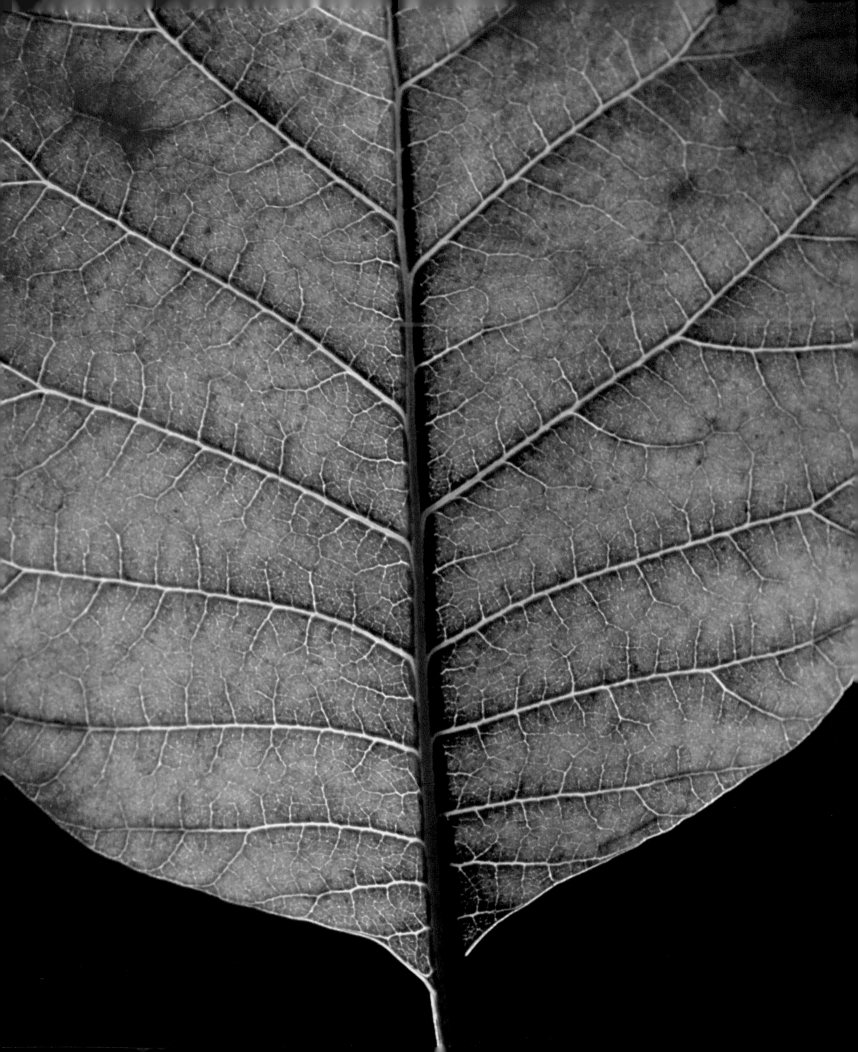

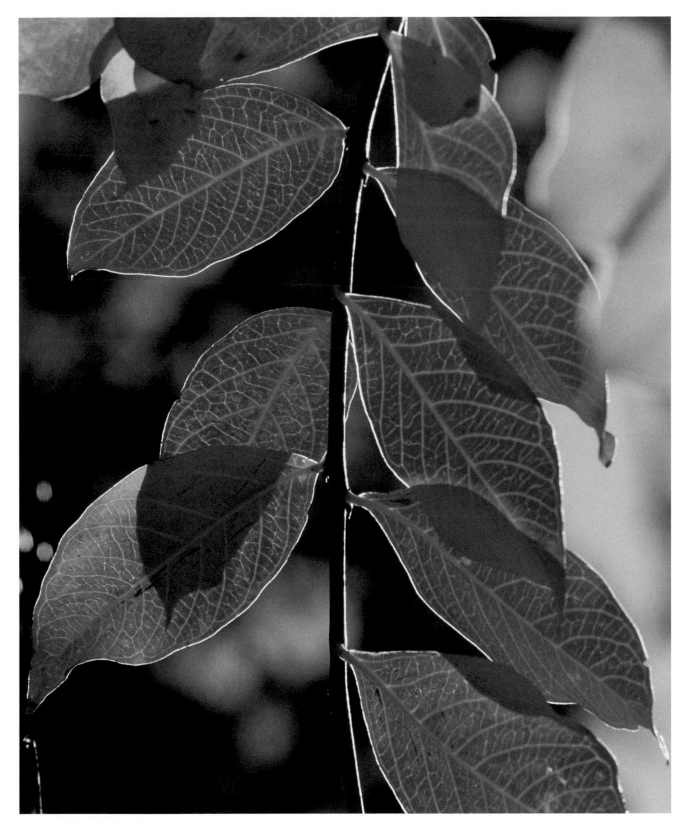

Spiketail *(Stachyurus praecox)*

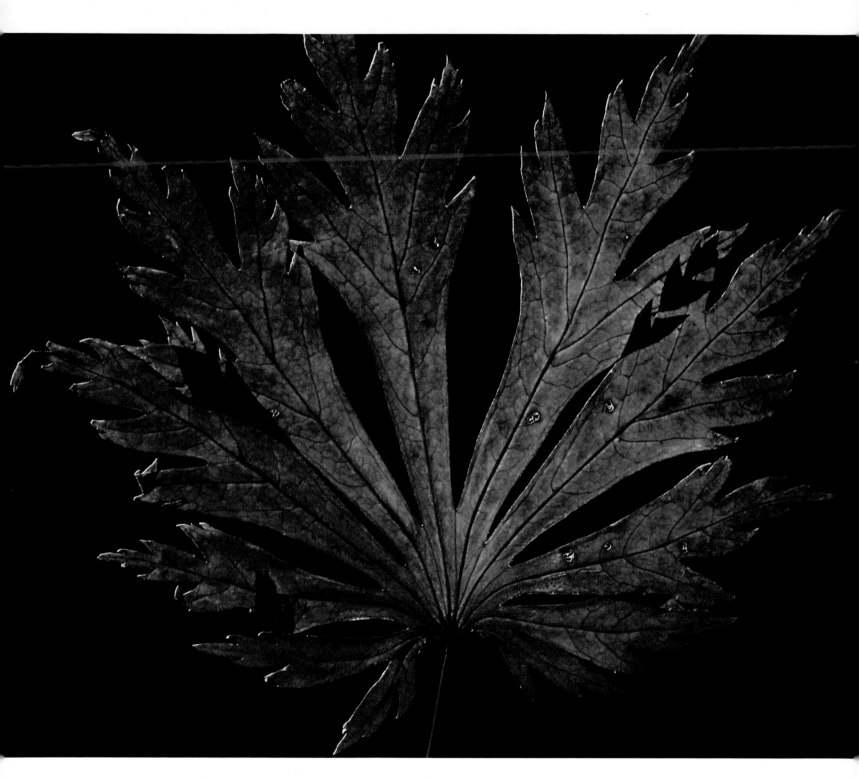

Japanese Maple *(Acer japonica sp.)*

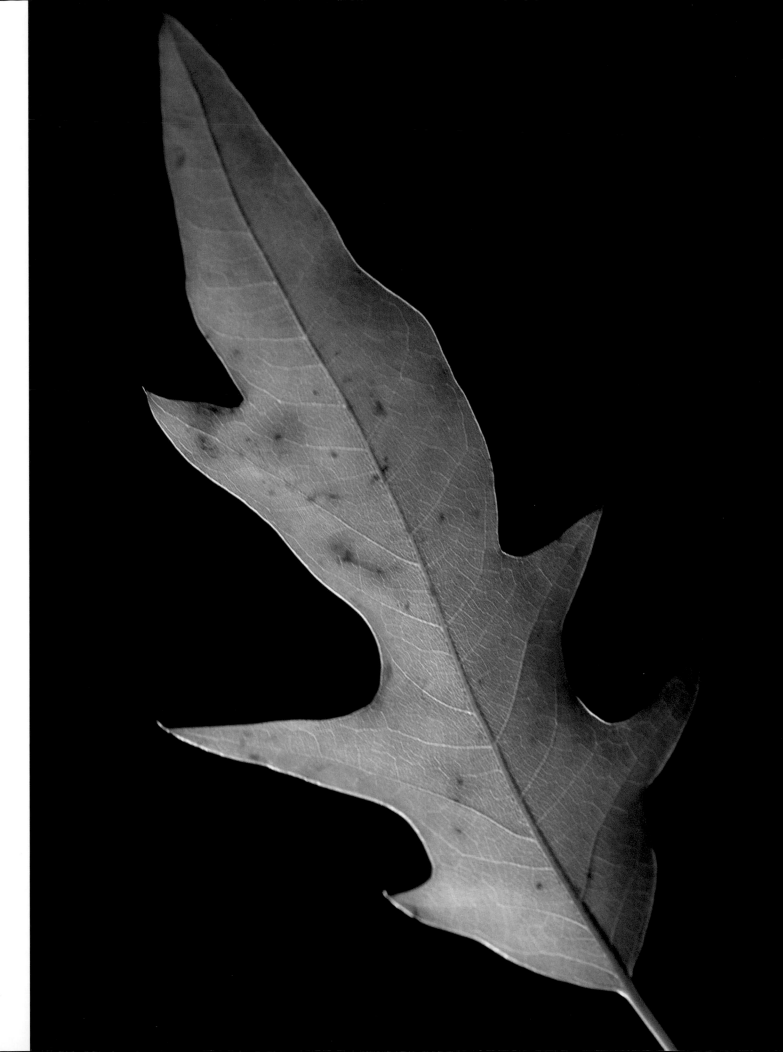

grape leaves

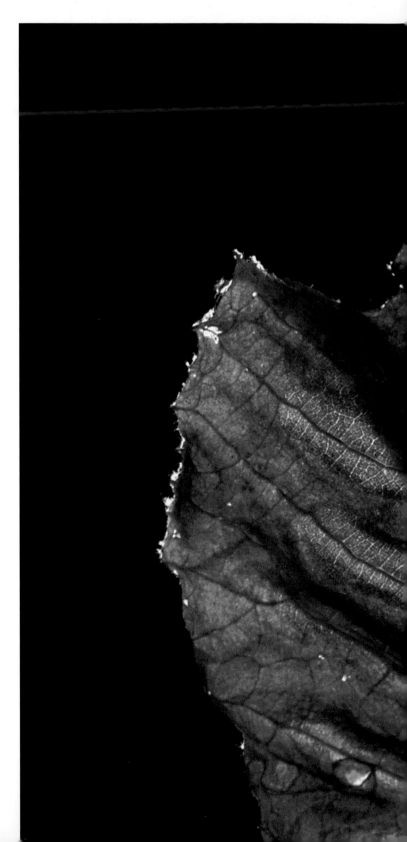

WHEN WE THINK of *Vitis*, as the grape plant is called in Latin, what usually come to mind are fresh plump table grapes, dried raisins, delicious jellies and jams, grape juice and wine. We rarely admire grape leaves. Occasionally, when we're passing a vineyard in its full autumnal glory or paging through a menu in a Greek restaurant, the grape leaf is more likely to enter our thoughts. Dolmas aside, the grape leaf is gorgeous to behold.

One of the more common grapes visible in the wild is the native North American species (*Vitis riparia*), a vigorous and robust grower that scrambles into treetops, occasionally masking entire trees with its vivid colors of yellow and red. The best way to appreciate grape vines for the merit of their leaves is to travel the back roads of wine-growing regions during harvest, scanning the acres of vineyards that carpet the landscape with their golden yellow foliage.

Grape (*Vitus sp.*) >

japanese maple

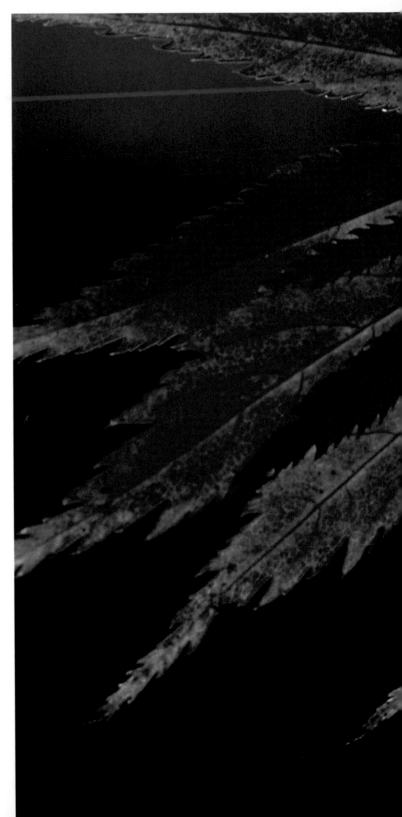

THE JAPANESE WORD *momiji* can be translated with two seemingly different meanings: "baby's hands" and "becomes crimson leaves." When combined, however, these phrases perfectly describe the Japanese maple leaf. Small and delicate — but with a few extra little fingers — the leaf's shape resembles a baby's hand. With over 1,000 cultivated varieties dispersed throughout the temperate world, Japanese maples (*Acer palmatum*) are among the most prized and collected of trees.

The extraordinary diversity of their leaf shape, size, summer, and especially fall color is what propels Japanese maples' popularity. New spring leaves can be vividly painted in all shades of green, golden yellow, chartreuse, shrimp, red, burgundy and purple. They can also appear in variegated, flecked and patched patterns. In the autumn, the intensity of their colors can surpass their spring beauty, whether they are setting an entire hillside aglow or highlighting a solitary miniature bonsai.

Japanese Maple *(Acer palmatum)* >

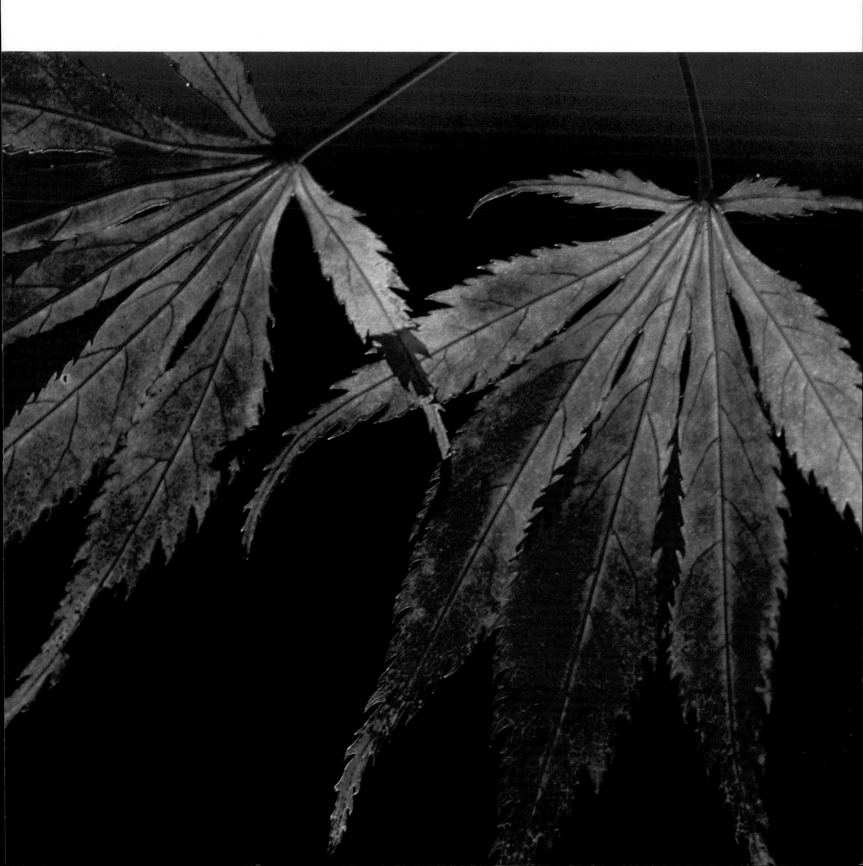

ginkgo

Ginkgo (*Ginkgo biloba*) is commonly known as the Maidenhair tree because of the resemblance of its leaf shape to the Maidenhair fern (*Adiantum fragrans*). Ginkgo's claim to fame is that it is one of the best examples of a living fossil. Fan-shaped ginkgo leaves preserved in stone date back 270 million years to the Paleozoic era, when the ginkgo was widely dispersed in temperate regions around the globe.

Ginkgo's ability to outlive major extinction events throughout its long history may help explain its hardiness in urban conditions. It seems to tolerate smog, pollution and soil compaction, and is rarely attacked by insects. What better demonstration could there be of Ginkgo's determination to overcome adverse conditions than the fact that ginkgos in the city of Hiroshima were among the few living things to survive the atomic blasts of 1945?

Maidenhair Tree *(Ginkgo biloba)*

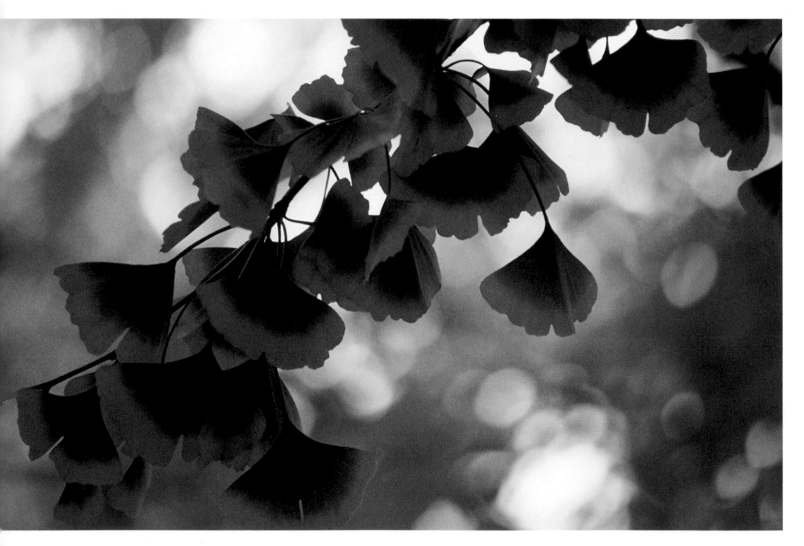

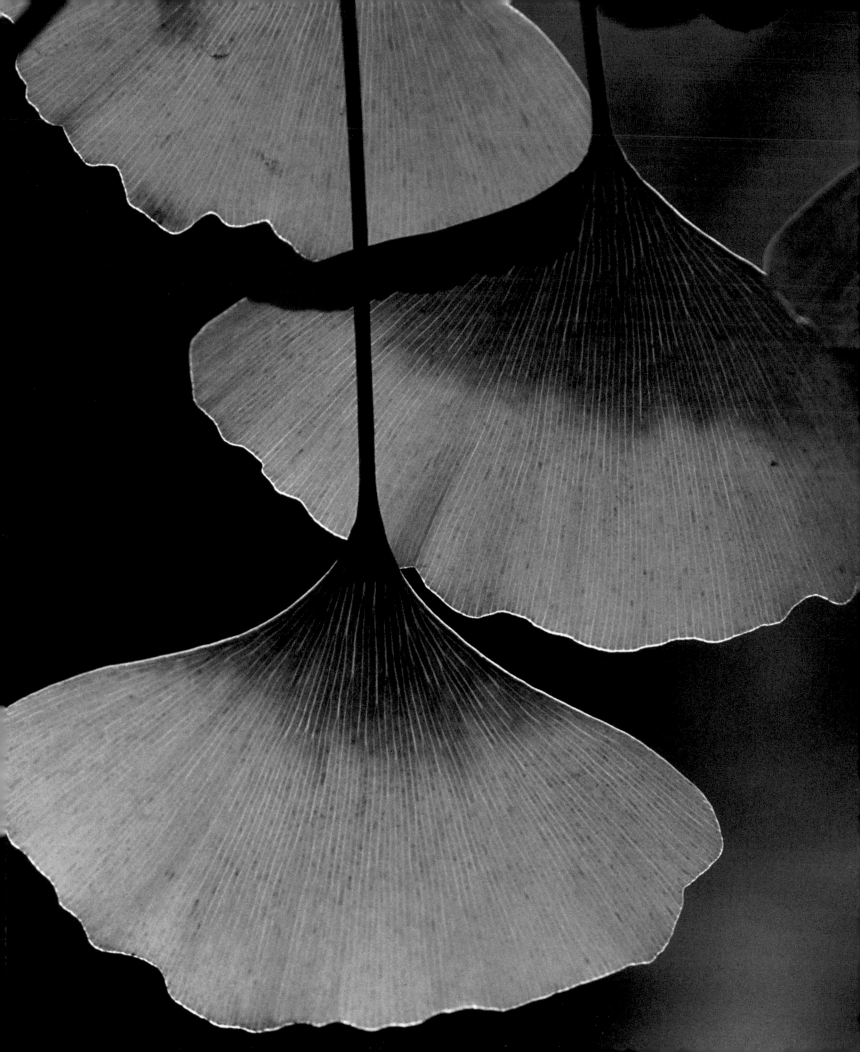

decline

EVERYONE HAS SEEN a leaf that has been skeletonized. All too often it involves a slug and a hosta leaf, but this destruction can take on any manner of seemingly diabolical combinations. Wind, insect damage, hail and just plain old decomposition all hasten leaves' decline.

Our initial response to dead leaves is to remove them or rake them up. On closer inspection, we can find beauty in the death of a leaf. An oak leaf that has spent a season on the forest floor can be transformed into a delicate object as intricate as the finest filigree. The

Grape (Vitus sp.)

abstract sculpture created by a caterpillar as it carves out a leaf, or the ragged contours of wind-torn banana leaves can be seen from an entirely fresh perspective. Although a plant's original beauty may be fleeting, its swan song still deserves fair recognition.

It's not all war when it comes to insects and leaves; some plants actually have hidden reasons for wanting their leaves to be eaten. As a leaf is being eaten, seeds may be carried off to grow somewhere else or its pollen be transported to pollinate a neighboring flower. Some plants even have a very special relationship with insects, offering food and lodging in exchange for the insect's work in providing protection and seed disbursement.

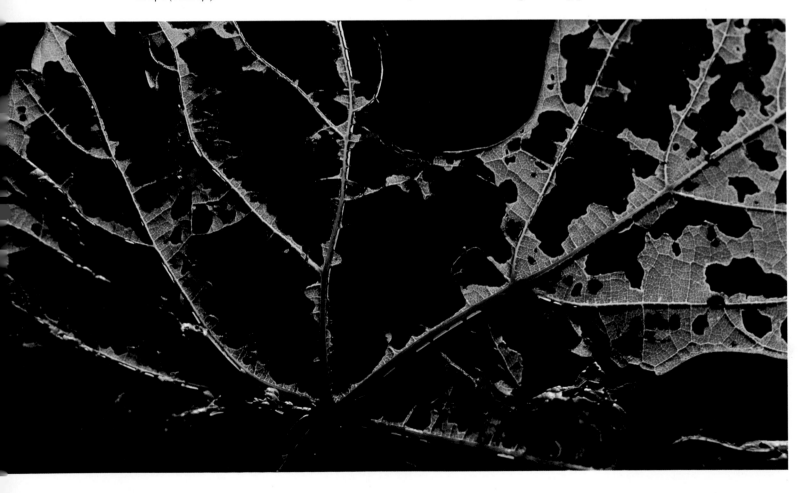

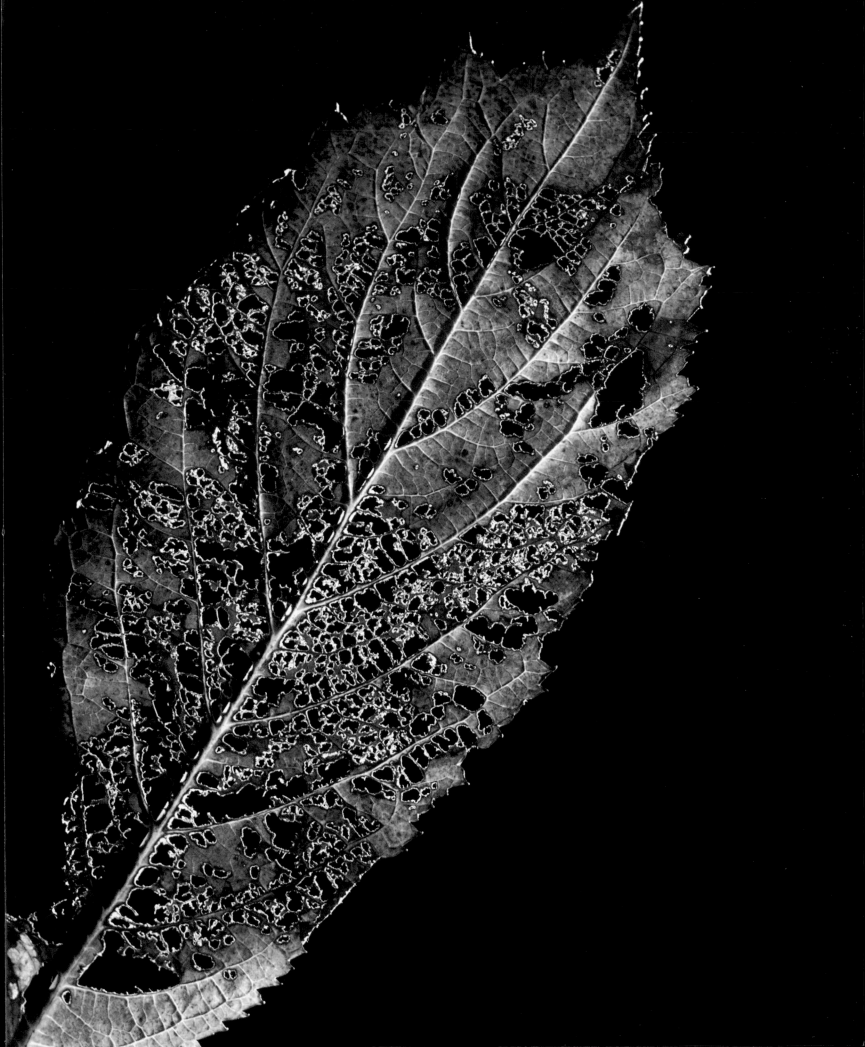

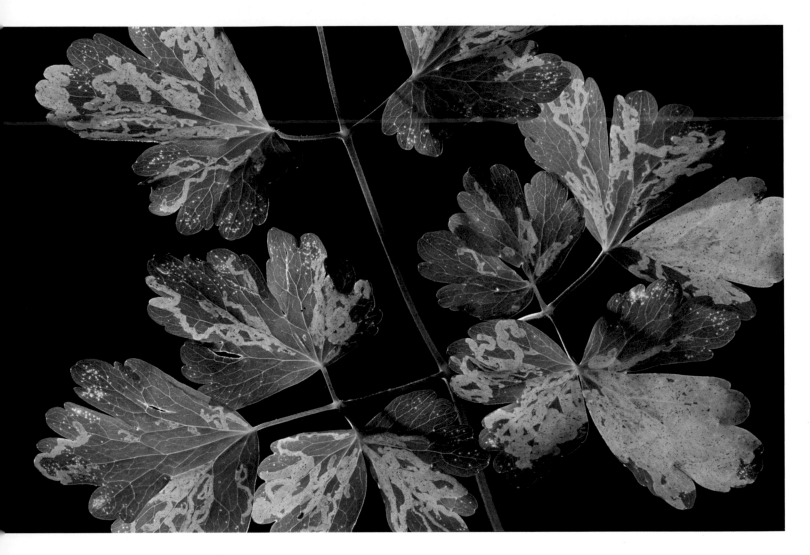

Columbine *(Aquilegia sp.)*

extraordinary leaves

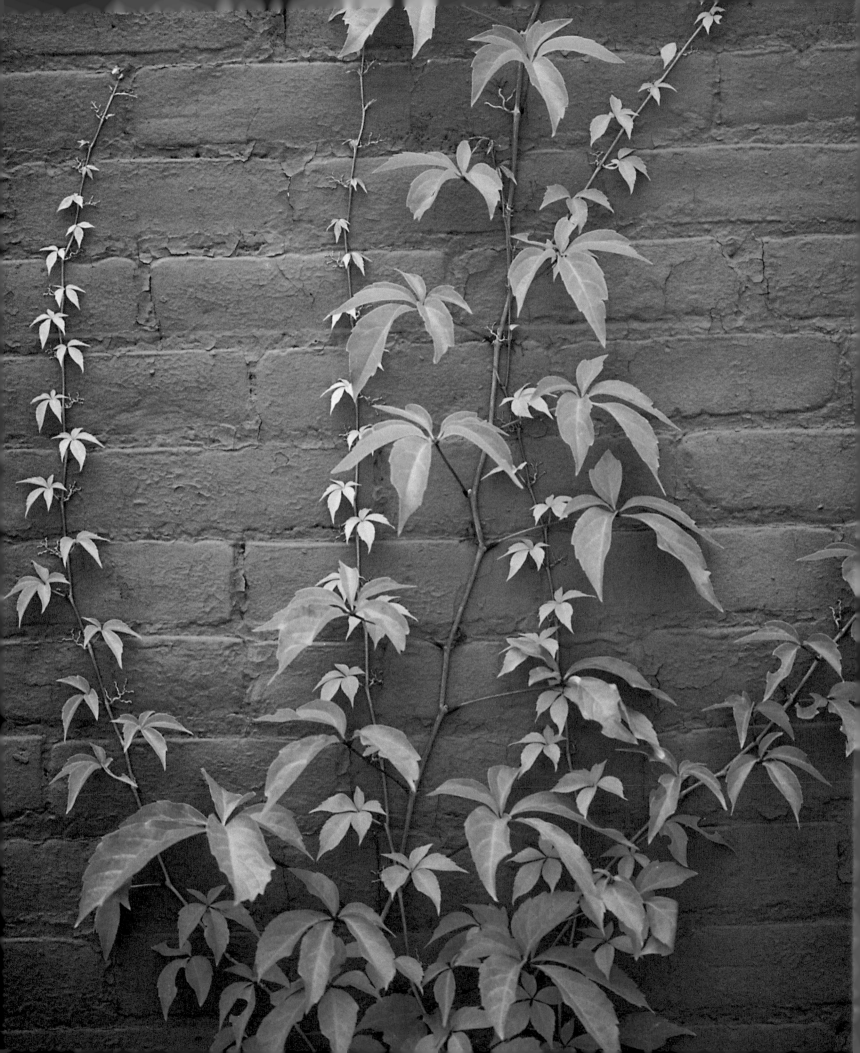

climbing
patterns

WHILE MOST LEAVES grow in a three dimensional space, a few thrive on the flat canvas of a wall, climbing and spreading in two dimensions. Sometimes they create interesting and attractive designs as they climb.

When we look at leaves as they grow on a tree or a bush, we see them against the distracting background of other leaves, and in photographs background leaves are partly obscured, partly blocked from the light, and perhaps out of focus. But when a plant grows on a flat vertical surface such as a man-made wall, all its leaves can be seen clearly and they are all on the same plane of focus. Here the two-dimensional medium of photography can work with a two-dimensional subject.

These few pages are different from all the others in this book. Previous chapters have celebrated the beauty and variety of leaves themselves, but this section lets us admire the beauty achieved by a whole plant, a plant that appears to use leaves as its brush strokes. When given a flat canvas, some plants become amazingly creative, designing fascinating — sometimes strikingly beautiful — patterns as they grow.

Presumably, a plant's predominantly upward climb on a wall is motivated by its instinct to grow closer to the sun, and that the less vertical growth occurs when the weather is dull. Patterns must also be affected by where the plant can achieve the best grip on a surface. A rock climber cannot always move vertically, but often has to move sideways, or even briefly downward, in search of a route that offers good handholds and solid footholds. A sensible rock climber will not choose to attempt a vertical surface in the rain, but plants, being already committed to the ascent, cannot abandon the effort while waiting for a dry day. So we may assume that temporary wet surfaces also affect growth patterns.

It might even be possible to influence and direct the growth patterns of climbing plants by building walls with deliberately varied textures. A glassy smooth area might discourage plants that prefer to grip onto a rougher surface, while on the other hand a smooth surface might be ideal for plants that rely on little suction cups along their branches.

Toward the end of the summer, we can stand back and look at what the plant has achieved. In some cases, an entire wall surface is covered, so the result is texture rather than design. In other cases, there are distinct patterns, although not always beautiful or interesting patterns. When I see a design that I like — and if I have a camera with me — I can record the design so that it lives on film long after the leaves have fallen.

During the fall itself, the climbing plants may change color, and the months of green briefly become a few weeks of yellows and browns, oranges and reds, perhaps mixed with some surviving greens. During this period, it becomes more possible to see that in some cases plants of different types are sharing the same wall. They may be climbing over each other and complicating the designs, like musicians laying the track of one instrument on tracks of others.

Even if we don't try to direct patterns, we have certainly been encouraging their proliferation. In recent years, many highways have seen the construction of miles and miles of high walls to separate the traffic and resulting noise from the nearby communities. Many of these highway walls have been made more attractive by being covered with climbing ivy and similar plants. Although the effect for the motorist is not quite like the experience of driving through a forest, it is certainly more pleasant than driving through a canyon of plain concrete. The greenery is more restful on the eyes, and perhaps even adds to the noise-buffering effect for local residents.

While we cannot pause to admire and photograph ivy patterns on the sides of fast-moving highways, plenty of other examples are accessible to pedestrian traffic. Many buildings are decorated with climbing plants — some deliberately, some by chance. It is not without reason that many of North America's older universities are called "Ivy League Colleges." And country houses and cottages, particularly in Europe, are often made to blend in with flower gardens and landscapes by being covered, or partly covered, by leaves.

Some of the photographs on the following pages were taken during the preparation of this book, but most of them have been taken over a period of years. I am delighted that this book offers a little gallery space for nature's designs.

Stephen Green-Armytage

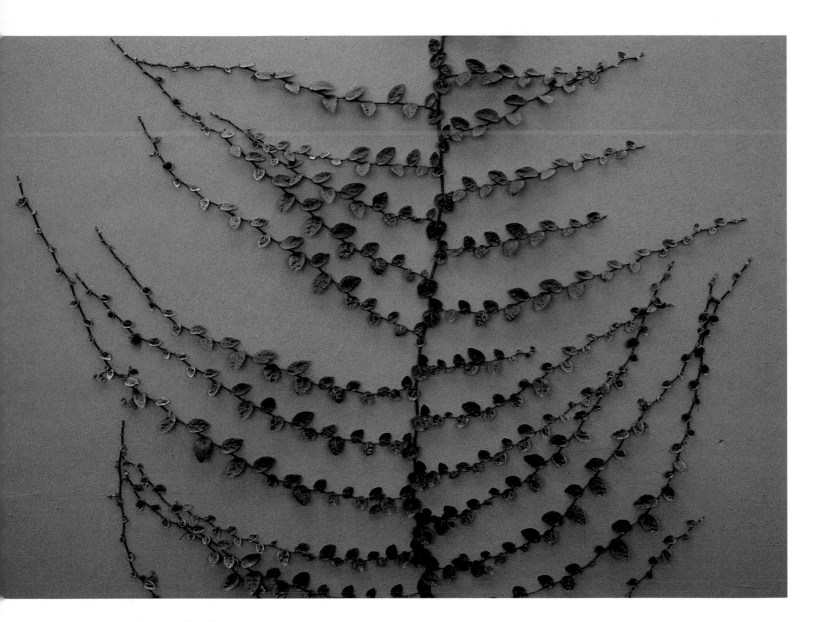

Creeping Fig *(Ficus pumila)*

extraordinary leaves

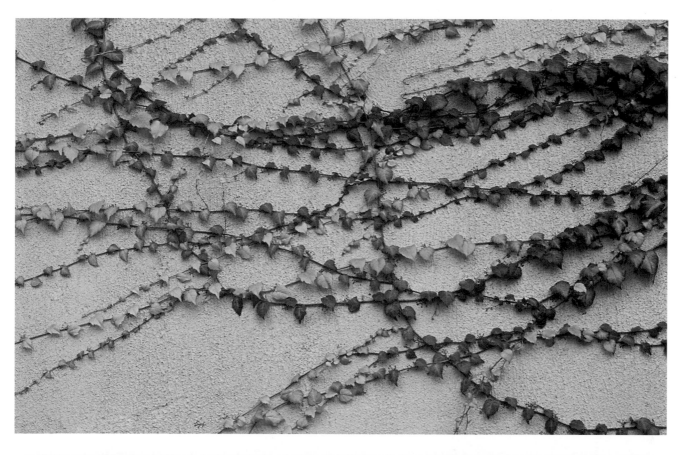

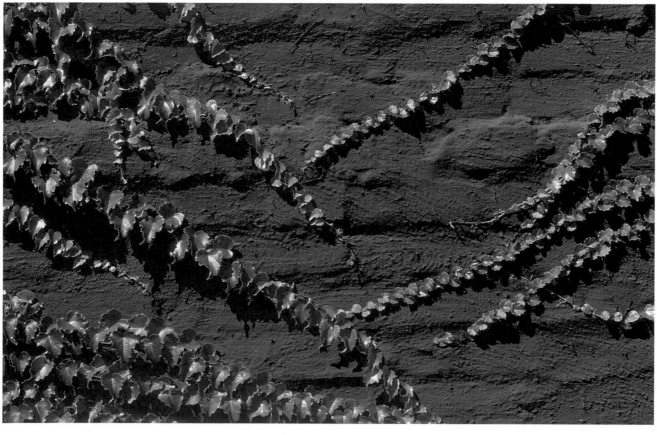

Virginia Creeper *(Parthenocissus quinquefolia)* >

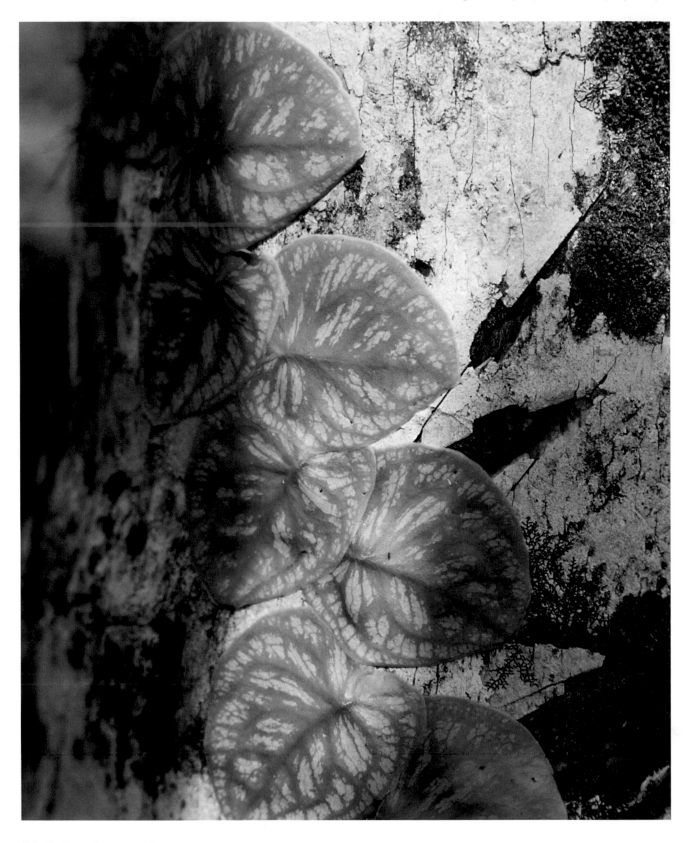

Shingle Plant *(Monstera sp.)*

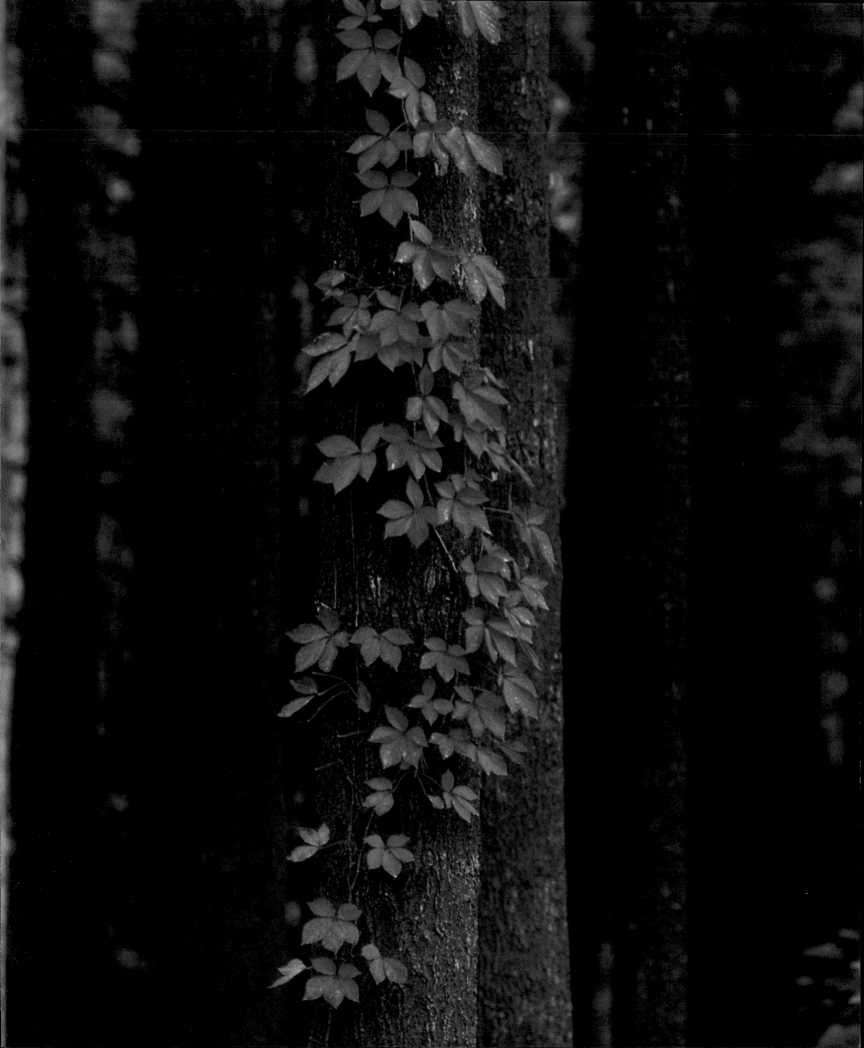

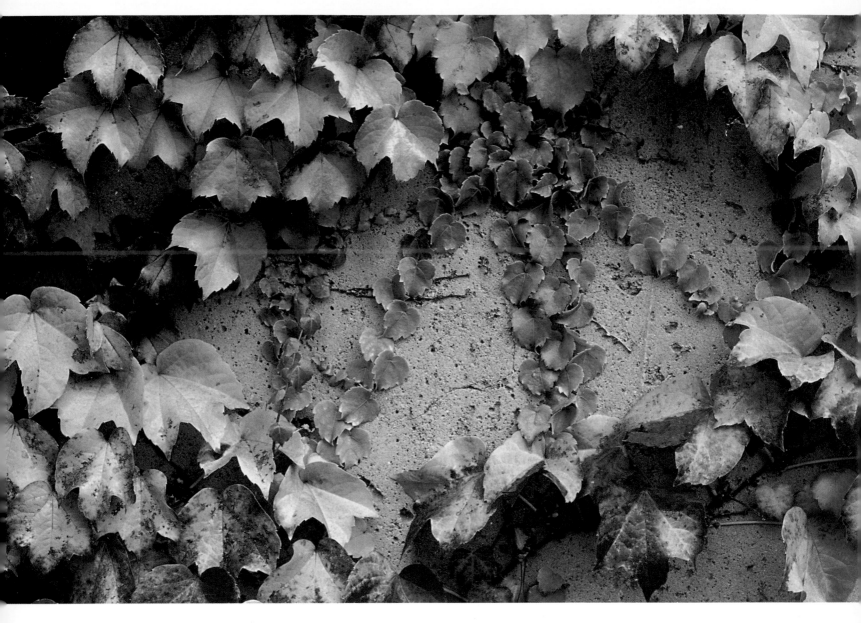

Virginia Creeper *(Parthenocissus quinquefolia)*

acknowledgments

A BOOK LIKE THIS would have been inconceivable without the generous help of many nurseries, public gardens and arboretums. We are particularly grateful to places that provided an area for a temporary photo studio. In many cases we wanted photographs that would isolate individual leaves or small groups of them against plain backgrounds, so as to show more clearly their shapes, patterns and colors. For this to be possible, we needed permission for leaves to be discreetly clipped and brought to the studio. Of course it meant that the selected specimens died prematurely, though perhaps there was compensation in the knowledge that photographs of these leaves would now survive for decades, and that those selected for the book could be admired around the world by many more people than could hope to see the leaves themselves.

We prefer to thank the nurseries first, partly because their business operations were clearly inconvenienced by the photography, and partly because it is not their normal role to participate in editorial or educational projects. *Plant Delights,* in Raleigh, NC, had interesting plants in many greenhouses as well as in two attractive landscaped gardens, and we thank owners Tony and Michelle Avent and their colleagues Julie Picolla, Adrienne Roethling, Mike Spafford and Candi Morgan. At *The Plantage*, in Cutchogue, NY, statistically the sunniest area in the state, some fine plants from June Croon's well-disciplined beds were photographed, and nearby Jim and Joanne Glover had a number of intriguing small plants at *Glover Perennials,* so we thank all concerned.

Five gardens open to the public also kindly provided facilities for the studio sessions. In Southeast Pennsylvania there are two fine gardens with very different styles. Bill Thomas was our host at *Chanticleer*, where an imaginatively planted landscape slopes down from an elegant "Main Line" mansion, with formal gardens close to the house. Our thanks also to Bill's colleagues Robert Herald, Fran Di Marco, Jonathan Wright, Doug Croft and Dan Benarcik. *Longwood Gardens* is a facility on an expansive scale and is justly famous, featuring many greenhouses, some of which are architecturally impressive. We thank Patricia Evans for making all the arrangements, and Curt Hawkins and Colvin Randall for setting things in motion. For help with the actual plants, we are very grateful to Rodney Eason, Timothy Jennings and Joyce Rondinella.

Also remarkable are the *New York Botanical Gardens* in the Bronx. For help in the magnificent landmark conservatories, we thank curator Francisca Coelho and her gardeners Jessica Savage and Robert Berner, and at the same time we are grateful to Sarah Carter, curator of the outdoor gardens, and her assistant Jessica Arcate. Arrangements were efficiently made by Karl Lauby, Nicholas Leshi and Melinda Manning. Terry Skoda helped make available a room in a lab building, and of course we appreciate the overall permission granted by Todd Forrest, NYBG Vice President for Horticulture and Living Collections.

Photographic studios were also set up at Duke University's *Sarah P. Duke Gardens* in Durham, NC, and at the *JC Raulston Arboretum* at North Carolina State University in Raleigh. At Duke we thank coordinator Ashley Carmichael and taxonomist Alice Le Duc with her encyclopedic knowledge, both of them enthusiastic for our project. We thank Dennis Werner, the friendly director at JC Raulston, and also Christopher Glenn for tolerating a day and a half of powerful flashes right outside his office. Head gardener Tim Alderton was cheerfully helpful in the grounds of the Arboretum.

Although no studio lights were set up at the following places, we are very grateful for general help and

cooperation, including permission to work with a tripod. We thank Vincent Simeone and Peter Atkins at *Planting Fields Arboretum,* Oyster Bay, NY, with its rolling woods and landscapes and interesting conservatories; Craig Kawasaki and his daughter Christina, begonia experts at *Kawasaki Greenhouses,* East Moriches, NY; Pat Gallo at *Gallo's of Woodstock*, naturally in Woodstock, NY; Ken Thompson at *Storey's Nursery* in Freehold, NY; and Fred and Karen Lee at *Sang Lee Farms,* Peconic, NY, where they raise a wide variety of fine vegetables.

We would also like to mention with gratitude some private gardens where photographs were taken; those of Eric and Marva Nielsen, Milton and Shirley Glaser, Paul and Sheelagh Manno, J.J. Kinnersley, and the campus of the University of California, Santa Barbara. Some grapevines were shot at the *Mumms Vineyard,* Napa, CA, and at *Sargon Vineyards,* Orient, NY.

Several public gardens were visited, though without making any special arrangements being made. On more than one occasion photographs were taken at the following: *Brooklyn Botanical Gardens,* NY; *Wave Hill* in the Bronx, NY; The *Arnold Arboretum* of Harvard University in Boston, MA; The *University of California Botanical Garden,* Berkeley, CA; *Red Butte Gardens* in Salt Lake City, UT; The *Desert Botanical Garden* in Phoenix, AZ; the *Conservatory* and *Shakespeare Gardens* and the *Zoo* in New York's Central Park. There were single visits made to photograph at the following: *Thanksgiving Point,* Lehi, UT; the *San Francisco Botanical Garden* and the *Japanese Tea Garden,* both in Golden Gate Park; *Mount Auburn Cemetery,* Cambridge, MA; *King's Park,* Perth, Western Australia; and *Stourhead,* Wiltshire, England.

We would also like to thank several people who made information available to us: Mr. Sorajak Siriborirak and Mr. Surasak Rakmarn from *Neofarm Caladiums* in Bangkok, Thailand, and librarian Matt Yim from the Association of Hawaii Archivists for his information on *Musa AeAe* the "Royal Hawaiian Banana."

We also appreciate the work of those at Firefly Books who devoted their time and talent to handling this complex project. Associate Publisher Michael Worek helped us focus the concept and involved himself in the organization and sequencing of chapters and, along with Managing Editor Barbara Campbell and Editorial Assistant Kate Panek, helped edit over a thousand photographs down to roughly three hundred. Barbara and Kate handled with efficiency the task of organizing all these pictures, and were the competent and tactful liaisons between editors, designer, author and photographer. We also thank copyeditor Jane McWhinney for her professionalism, designer Sonya V. Thursby for her simple yet elegant page designs that give respect and breathing room to each photograph, and publisher Lionel Koffler for seeing the potential of our proposal.

Finally, a word of thanks to the Horticultural Society of New York, whose amazing library was a wonderful resource, so we thank librarian Katherine Powis.

Stephen Green-Armytage and Dennis Schrader

ON A MORE personal note, I would like to mention a few more names. My wife, Judy, has been the family gardener, gradually educating me about plants, and it was when she and her friend Vicki Maerini were shopping at a nursery in Ohio that I first thought of leaves as a book subject. Needing some advice and guidance, I called our friend Lavonne Filipek, then president of the Ulster Garden Club, one of the clubs that collectively make up the Garden Club of America. She suggested I contact Galen Williams, and when Galen understood the book I had in mind, she urged me to try to join forces with Dennis Schrader.

Dennis turned out to be the ideal collaborator, with a vast amount of knowledge, both academic and practical. He was able to guide me toward the best nurseries, gardens and arboretums, and to put me in touch with all the important people at each – often personal friends. And the most photographically rewarding place that I visited was Landcraft Environments, the commercial nursery that Dennis and Bill Smith own and operate in Mattituck on the North Fork of Long Island, New York. Their greenhouses contain all sorts of wonderful plants, including many tropical rarities. Landcraft's outdoor gardens, landscaped in a number of different styles, have been featured in garden magazines around the world. There are probably more photographs in this book from those few acres than from any other place that I visited.

Stephen Green-Armytage

I WOULD LIKE to thank my partner, Bill Smith, for being there as always and for taking on the additional work and responsibilities that I have had to shrug off and pile onto his desk. In addition, a big thank you to all the employees at Landcraft who have been a significant help in one way or another, maintaining our plant collections and ensuring that they were all groomed and looking their best. I would also like to thank family and friends for their support and encouragement during the writing of this book and for opening their homes and gardens not only as a resource for photographing but as a retreat for me to escape to.

Working on any type of publication is usually a collaboration among an assortment of different people, all of whom have particular interests and expertise. Stephen has many talents and made this joint venture a smooth one. He is a superb photographer with a long history of international accomplishments within the publishing industry. I would like to thank him for approaching me with this project. His photographic expertise, his eye for detail and his organizational skills have together made this book what it is.

Dennis Schrader

index